THE
ARTIST'S
MANUAL

THE ARTIST'S MANUAL

EQUIPMENT, MATERIALS, TECHNIQUES

Consultant editors
STAN SMITH
PROFESSOR H.F. TEN HOLT

FOREWORD BY PAUL HOGARTH

Macdonald Illustrated

A Macdonald Illustrated BOOK

First published in Great Britain in 1980 by
Macdonald Education Ltd.
Published in paperback in 1985 by
Macdonald & Co (Publishers) Ltd
Orbit House
1 New Fetter Lane
London EC4A 1AR

Reprinted 1987, 1990

ISBN 0-356-19606 2

This book was designed and produced by
Quarto Publishing plc, 6 Blundell St, London N7

This book was designed and produced by
QED Publishing Limited, 32 Kingly Court, London W1

Art director Alastair Campbell
Production director Edward Kinsey
Editorial director Jeremy Harwood
Editor Kathy Rooney
Assistant Editor Nicola Thompson
Editorial and technical research Judy Martin
Designers Heather Jackson, Marnie Searchwell
Illustrators Elaine Keenan, Edwina Keene, Abdul Aziz
Khan, David Mallot, John Woodcock, Martin Woodford
Editorial Anne Charlish, Carmel Friedlander, Peter
Phillips, Derek Prigent, Jane Struthers, Neil Wenborn
Photographers Clive Boden, Peter Cogram,
Ian Howes, Roger Pring, Robert Unsworth, Jon Wyand
Paste-up Anne Lloyd

Filmset in Great Britain by Tradespools Limited,
Frome, Somerset, Abettatype Limited, Thornton
Heath, Surrey and Tudor Typesetters Limited, London.

Colour origination by Sakai Lithocolour, Hong Kong
Printed in Hong Kong by Leefung Asco Limited

QED would like to thank the many individuals and organizations who have given invaluable help in the preparation of this book:

Acme Gallery, Archer Press, Phillipa Beale, Buck and Ryan Ltd, Chalker and Gamble Ltd, Chrysler Corporation, Croydon College of Art Printmaking Department, Graham Cooper, Bill Culbert, Roger Daniels, R. Denny and Co Ltd, DS Colour, Ealing College of Higher Education Sculpture Department, Julia Farrer, Future Tense, Galena Foundry, M. Grumbacher Inc, Martin Heindorff, Pippa Howes, Maria Lancaster, Robert Lockwood and the staff of Langford and Hill, Len's Photography, Fergus Ennis of Leisure Print, Denis Masi, Henry Moore, O.M., C.H., Pac Art Ltd, Simon Pugh, Purnell and Sons Ltd, George Rowney and Co Ltd, Bruce Russell, Sarah Jacobs of Tate Gallery Publications, Serpentine Gallery, T. R. P. Slavin, Smith Bros, Summit Photographic, Alec Tiranti Ltd, Tudor Typesetters Ltd, S. Tyzack and Son Ltd, James Faure Walker, Winsor and Newton Ltd.

Contents.

Foreword by Paul Hogarth

Painting and drawing.

Graphic design.

Sculpture.

Foreword.

Since the advent of television, color printing and sponsored exhibitions, art has become much more a part of everyday life. Parents no longer discourage ambitions in that direction—on leaving school I was given the option of either taking a job as a bank clerk or else. Thousands of artists are involved in the fine arts, publishing and the media. Thousands more study in art schools, polytechnics and colleges. A back-up army of aspiring artists toil at all sorts of jobs in factories, shops and offices—not perhaps dreaming of creating the award-winning painting or free-wheeling piece of welded scrap metal, or even a magazine cover, but hoping somehow to do nothing more than make a congenial livelihood designing for print, or painting a landscape at the weekend.

The reason for this renaissance of interest in art is not so difficult to understand. In our electronic age, where computer technology increasingly threatens to minimize the human factor, the exercise of human skill, or self-expression becomes vital. Pictures, both moving and still, have also become an integral part of our lives. Reaching back into our childhood, we can sometimes trace the beginnings of a compulsion to depict our hopes, dreams and fantasies; almost as a self-defence mechanism. In being an artist, it is thought, the process is continued; the artist is the free person who experiences total feedback or if you like, job satisfaction from whatever he or she does, apart from any material success which may or may not crown the effort.

How do you *become* an artist? It isn't always clear to me how it happens, simply because it can happen in so many different ways. Whatever the medium, painters, sculptors, illustrators, photographers, caricaturists and designers emerge from a wide variety of divergent social backgrounds, professions and interests.

Most artists—but not all—studied art in one form or another: art school, correspondence course or apprenticeship programmes with a studio or advertising agency. Often, people start by making tea or wrapping packages; anything that permits them to slowly edge their way into the field. Some start with a foundation course at college and then hope to find a studio job. Few are prodigies of nature, the instant successes, who take off like rockets after finishing their years at art school, never touching the depths of the great swamp of self-doubt, frustration and poverty many have had to wade through.

Whichever group you are part of, you will find this handbook an invaluable guide, to which you can turn again and again. For all the training you may or may not have received, the practice of art in all of its branches, is about as unstructured a career as one can possibly choose. If you freelance, as I do, the hours are whatever you let them be. Your studio set-up, materials, equipment, work techniques and level of performance are invariably wide open to improvement through a continuing process of self-study. If you are a student,

you can never hope to absorb all tuition inside the walls of an art school.

In *The Artist's Manual,* a team of practising professional artists pass on an incredible amount of information about art techniques couched in the clearest step-by-step terms. The book also covers the nature and use of materials and equipment.

The biggest lesson I have learned in being an artist is to stay with it and not to be discouraged when nothing seems to work out the way you hoped it would. At that moment, or perhaps the next day, taking this book from your bookshelf may enable you to solve the problem.

The Artist's Manual will, I hope, help you do just that.

PAUL HOGARTH

Painting and drawing.

Development of artist's materials.

History. Wood, Fabric, Grounds, Paint, Media, Pigments and paints, Pens and pencils.

Artist's materials History

Since prehistoric men have ground and scratched their solid, crude pigments straight on to the rough walls of their caves, an incredible variety of surfaces or supports have been used for painting and drawing.

Slabs of stone, copper plates, leather, wood, paper, fabric and, latterly, plastics, have all been used. The most common supports, wood and fabric, were both used by the Egyptians as far back as 2000 BC.

Wood Wood was used by the Egyptians around 2000 BC and remained popular with medieval and some Renaissance painters. Its advantages were obvious: it was easily obtained, strong, light and portable. The types used showed national preferences, probably conditioned by availability. The Germans used mainly linden, the Italians poplar; oak was preferred by the Dutch and walnut by the southern French. Medieval painters chose their wood supports with care—their guilds could fine them for using materials which were of inferior quality.

Fabric Although the Egyptians had also used fabric supports, they did not become popular until painters of religious subjects began to use them in the fifteenth century. They had the advantage that they could be larger than wood supports. Canvas is, of course, the best-known and most popular fabric support. The first large canvas-supported painting on a religious theme is believed to be Titian's *Assumption of the Virgin* early in the sixteenth century (1518).

Grounds Most supports need preparation to take paint. Primers or grounds used for this purpose not only provide a firm, even surface but influence the color and texture of the finished painting.

Grounds consist of an inert filler and a binder. The main binders are size, oil or an emulsified mixture of the two. The medieval Dutch filler was chalk—calcium carbonate—mixed with animal glue, while the Italians preferred gesso—calcium sulphate—as a filler.

By the late sixteenth century, some artists were using fillers which gave darker grounds of red or brown, painting light tones on dark for a change, and often leaving the ground coloration showing as shadow.

Tradesmen caught up with a new demand, and by the seventeenth century artists could buy ready-made grounds and even ready-primed supports.

Paint Paint consists of finely ground color pigment mixed to a smooth consistency with a medium and a diluent such as turpentine or water.

Pigments and palettes The range of colors available to painters—their palette—has vastly widened and improved through the centuries, with explosive advances in the thirteenth and nineteenth centuries.

The palette of the cavemen artists of Lascaux, France, between the fifteenth and tenth centuries BC, was restricted to blacks, whites, yellows and browns, produced by burnt wood and bones, chalk and colored earths.

Bronze Age Egyptians used metal tools to grind naturally-occurring minerals into powder to make up painting pastes. From realgar they got bronze; they produced red from cinnabar, blue from azurite, green from malachite and yellow from orpiment.

It was the Egyptians who made the discovery that some minerals permanently changed color when

Pigments Until the early nineteenth century, when the artist's palette expanded greatly thanks to developments in the chemical and dyeing industries pigments had been made mainly from naturally occurring or easily available substances. Charcoal, for example, produced black while earth gave a range of browns, and chalk produced white. These were familiar to the early cavemen. The Ancient Egyptians developed vermilion from cinnabar, orange from realgar, green from malachite, yellow from orpiment and blue from azurite. The Romans made Tyrian purple from the whelk and manufactured the bluish green color known as verdigris from corroded copper. Ultramarine, popular in the medieval palette, was made from ground lapis lazuli.

Charcoal (black)

Earth (browns)

Chalk (white)

Cinnabar (vermilion)

Realgar (orange)

heated, or fired in ceramic work. Both blue frit and white lead came from the potter and were the first inorganic pigments. Blue frit disappeared around 700 AD; but white lead, which superseded chalk, remained the only white pigment used in easel painting until the discovery of zinc white in the 1830s and titanium white in 1916.

The Romans, although color-conscious in respect of fabric dyes (they developed the famous Tyrian purple from whelks, and indigo from plants of a certain family), cannot be said to have contributed greatly to the artist's palette. They are credited, however, with making a bluey-green pigment from the verdigris of corroded copper plates.

In the thirteenth century, the palette expanded and improved greatly both in color range and brightness. As with the Egyptians, craftsmen in other fields made their contribution. Lead-tin yellow came from the glass-makers; madder from commercial dyers.

Two of what may be described as the 'great' colors came from the Arabs: vermilion and ultramarine. Vermilion, a combination of sulphur and mercury, was a brighter red than cinnabar; vivid blue ultramarine was made by powdering the semi-precious stone lapis lazuli. Many medieval paintings owe much of their richness to the contrast between these two colors.

Except for the discovery of the intense Prussian blue by a Berlin dyer in 1704 and the substitution of lead-tin yellow by Naples yellow in the 1750s, there were few developments in the palette until the nineteenth century—and then there was an explosion of new colors.

The rapidly-expanding chemical and dyeing industries were responsible. Cadmium yellow was in use early in the century, followed by chrome yellow in 1820. In 1828, synthetic ultramarine was made from a mixture including soda ash, charcoal and sulphur. Viridian, the deep green pigment with blue overtones, was discovered in 1838. Cobalt yellow came in 1861, followed by at least nine other yellow pigments. These, mixed with Prussian blue, vastly increased the range of available greens.

Mauve, first produced from coal-tar in 1856, was the forerunner of many deeper purples from the same source. Purple became a highly fashionable color. It was worn by Queen Victoria, and the Pre-Raphaelites used it extensively in their paintings.

A few artists today still prefer to make up their own colors, adding pigments to various media and manipulating proportions to their own special requirements. However, even as early as the Renaissance colormen and other artists' craftsmen were beginning to produce ready-made materials and tools for drawing and painting.

In England in 1789 the colormen Thomas and Richard Rowney began their business, which later became George Rowney and Co., while in 1832 William Winsor and Henry Newton became partners—a partnership carried on even today. In 1920, Max Grumbacher imported artists' brushes into America, starting a business that now handles more than 6,000 products for the artist.

Media The media which convey pigments to the prepared supports both modify and make more manageable the resultant colors. They include wax, gum, egg, oil and—in recent years—acrylic.

Wax and gum were two of the earliest media. Encaustic painting, in which pigments were mixed with molten wax, was known in pre-Christian times but had become unfashionable by the eighth century.

For thousands of years, gum arabic or tragacanth has

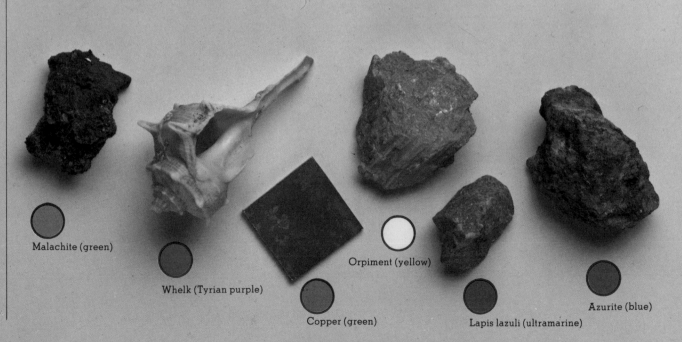

Malachite (green)

Whelk (Tyrian purple)

Copper (green)

Orpiment (yellow)

Lapis lazuli (ultramarine)

Azurite (blue)

been mixed with finely-ground pigments and made into blocks for dilution with water to provide the material for a form of painting that has never gone out of fashion—watercolors.

Egg tempera was widely used in the Middle Ages. The oil in the yolk made the paint strong, pliant and waterproof and particularly suitable for use on wooden panels. Pigment suspended in beaten egg white was employed in delicate manuscript illumination.

There is some evidence of oil being used as a medium in twelfth century Germany and thirteenth century Norway; and in the fourteenth century it was discovered that lead and oil oxides mixed with oil during purification speeded up drying, enabling the artist to complete a picture more quickly.

But it was not until the fifteenth century that the great Flemish artist and innovator Jan van Eyck (c.1390–1441) introduced oil colors basically as we know them today. In one of his many experiments, he added linseed and nut oil to a kind of turpentine to see if the resulting medium would dry more quickly indoors, out of the sun, without cracking. The experiment worked.

Pens and pencils Line-drawing tools and implements, as essential to the artist as to the calligrapher and scribe, have a history as long as that of painting itself, if one includes the pointed stones with which the cave-men artists scratched outlines.

The ancient Greeks, Egyptians and Romans made reed pens to use on papyrus and parchment. Later Romans manufactured pens of bronze surprisingly similar in shape to many of those in use today. The feather quill was in general use for many centuries, from around 700 AD until the steel point (or nib, as it is known in Britain) was invented in the early 1800s.

Pencils were a comparatively late development. Many great artists including Albrecht Dürer (1471–1528) used an alloy of lead and tin called silverpoint which required a specially-prepared ground. The first pencil which would be recognized as such today was made in 1662, from graphite, gums, resins and glues. (Graphite, a form of carbon, was thought to be lead until as late as 1789).

Faber began the first pencil-manufacturing company in 1761. He mixed two parts of graphite to one of sulphur for the lead. Another forerunner of the modern pencil was also made in the eighteenth century by the French artist, Conté. He pressed a hardening mixture of graphite, clay, water and paste into grooves in wood.

Today a huge range of artists' materials is made by complex modern techniques. However, in some cases the traditional still holds sway—it is impossible to make pure ultramarine other than by grinding lapis lazuli and the best canvas is still made from pure linen.

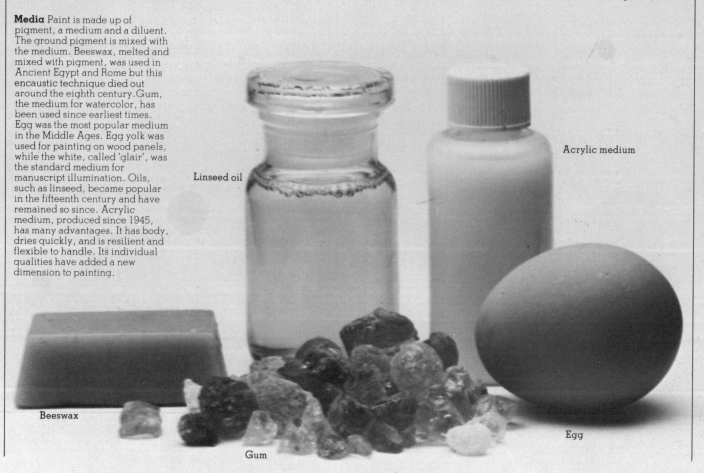

Media Paint is made up of pigment, a medium and a diluent. The ground pigment is mixed with the medium. Beeswax, melted and mixed with pigment, was used in Ancient Egypt and Rome but this encaustic technique died out around the eighth century. Gum, the medium for watercolor, has been used since earliest times. Egg was the most popular medium in the Middle Ages. Egg yolk was used for painting on wood panels, while the white, called 'glair', was the standard medium for manuscript illumination. Oils, such as linseed, became popular in the fifteenth century and have remained so since. Acrylic medium, produced since 1945, has many advantages. It has body, dries quickly, and is resilient and flexible to handle. Its individual qualities have added a new dimension to painting.

Linseed oil

Acrylic medium

Beeswax

Gum

Egg

Principles of painting and drawing.

History. Shape and form. Proportion. **Perspective:** Principles, History. **Color:** Theories and principles.

A rt rules and principles have been formulated after much experiment and of course they must be known before they can be broken or ignored to satisfy personal aesthetic values. The subject and the artist's intuition and feel—not the rules—should always be the guiding force.

Shape and form

European Renaissance artists were deeply concerned with rules of proportion, but the shape of the space between objects in a picture is as important as the solidity of those objects. Shape is a part of form and a work of art may be seen as consisting of form and content.

The forms of an art work are its individual masses, shapes or groupings, and how the artist presents the subject matter. Form is the result of the artist's creative intent, organization, design and composition and how he or she handles the materials.

Proportion

It is usually necessary to have good perspective and consequently good proportions to create realistic illusions. In this context 'realistic' means giving an impression of solidity or three-dimensionality. In any composition, proportion is the mathematical relationship of the parts to the whole and to each other. The 'Golden Mean', for example, was a general law of proportion first in architecture and then applied to painting and sculpture.

The 'Golden Mean' was first worked out in the first century BC by Vitruvius in his treatise *De Architectura* to establish standards for the proportions of columns, rooms and buildings. It was based on the concept of the ratio between two unequal parts of a whole, where the proportion of the smaller to the larger is equal to that of the larger to the whole.

In figure drawing, the 'Golden Mean' provided for a continuous halving of the body lengths and of the sections of the lengths resulting from each previous division. It dictated, for example, that the distance from the foot to the knee was half the length of the whole leg and that the whole leg was half that of the whole body.

The 'Golden Mean' was also used to determine the ideal proportions of a rectangle, where the longer side is equal in length to the diagonal of a square the side of which is equal to the shorter side of the rectangle: a 5 to 8 ratio or, more accurately, 0.618 to 1. The width is five-eights of the length.

During the Renaissance, the 'Golden Mean' was referred to as the 'Divine Proportion' in a work of that title published in 1509 and illustrated by Leonardo da Vinci (1452–1519). Albrecht Dürer (1471–1528) wrote a treatise on the application of proportion to figure drawing.

Some art historians believe that Egyptian and Greek art and architecture of the fifth century BC used a concept of proportion which they term dynamic symmetry because it related closely to the symmetry of living things—such as the ratio of leaves to the plants that produce them.

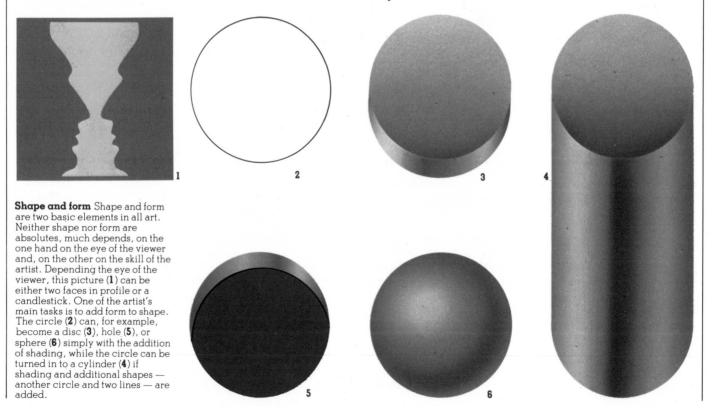

Shape and form Shape and form are two basic elements in all art. Neither shape nor form are absolutes, much depends, on the one hand on the eye of the viewer and, on the other on the skill of the artist. Depending the eye of the viewer, this picture (**1**) can be either two faces in profile or a candlestick. One of the artist's main tasks is to add form to shape. The circle (**2**) can, for example, become a disc (**3**), hole (**5**), or sphere (**6**) simply with the addition of shading, while the circle can be turned in to a cylinder (**4**) if shading and additional shapes — another circle and two lines — are added.

The Golden Section This principle, important particularly in the Renaissance, governed the ideal proportions of a rectangle where the sides are in the proportion of 5:8. These proportions were seen in nature.

A ————————— B

1. Divide the line A-B into two sections of equal length.

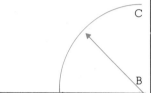

2. Put the point of the compass on B and draw an arc from the midpoint of the line to point C, at right angles to A-B.

3. Join C to points A and B. This forms a right-angled triangle.

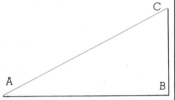

4. With the compass on C, draw an arc from B to cut A-C at point D.

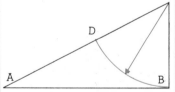

5. With the compass on A, draw an arc from B to cut A-B at point E. In proportion, E-B is to A-E as A-E is to A-B. A rectangle can be now drawn according to the golden section.

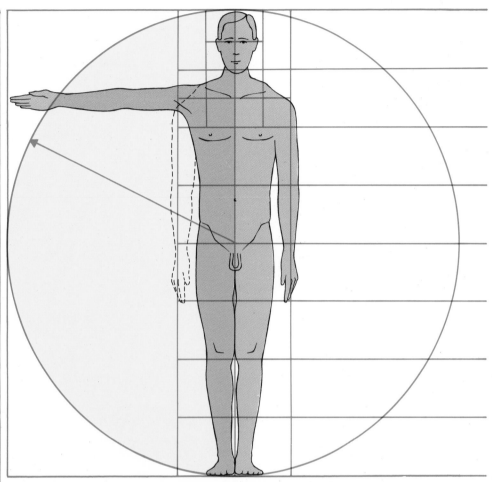

Proportion The rules and laws governing proportion have occupied artists since earliest times. During the Renaissance, artists such as Leonardo da Vinci and Albrecht Dürer began to apply the principles of proportion to the study of the human body. This development, which was accompanied by the first scientific explorations of human anatomy, perhaps reflects that age's preoccupation with Man. It was found that the body divides into eight equal sections and that these divisions almost exactly reflect the proportions of the Golden Mean. For example, the head, if measured from the chin to the crown, is one eighth of the height of the whole body, and the navel is at five eighths of the height of the whole body from the ground. This way of dividing the body in proportion is an extremely useful guide for all artists, whether beginner or expert.

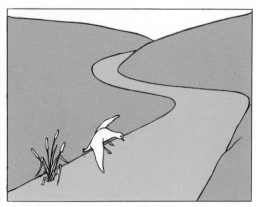
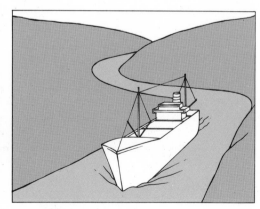

Scale In painting, scale is particularly important. The scale in a painting or drawing can be determined by the shapes in the foreground. For example, in the two pictures (**above**) the same background is given an entirely different scale according to whether the image in the foreground is the ship or a bird.

2 | **Perspective** Development and Principles

Perspective is a system of creating an illusion of three dimensions in objects drawn on a two-dimensional surface. Although an important technique, it should not be allowed to become more important than the subject.

Principles

The artist's eye, or the position from which the object is seen and drawn, is called the station point or point of sight. A line representing the position of the horizon is the horizon line or eye level.

The horizontal plane where the artist stands is the ground plane. Perspective is formed on the picture plane (also known as the perspective plane or plane of delineation). This is perpendicular to the point of sight, and where it meets the horizontal plane it forms what is termed the ground line.

The center of vision or principal point is that point on the horizon line immediately opposite the position of the eye, established by the intersection of a straight line drawn at right angles from the station point to the picture plane.

Vanishing points are where parallel lines appear to converge at one or more points. A measuring point is a point on a vanishing line from which lines are projected to the picture plane so that perspective heights and widths can be measured.

Perspective can be separated into aerial and linear categories. Aerial perspective is related to atmospheric effects on objects in space—as can be seen, for instance, in the changing tones of receding hills with distance being conveyed by diminishing the intensity of the color.

The layman's idea of perspective is usually that of the plane-linear perspective seen in architectural drawings where objects closer to the point of sight appear bigger than those further away.

Various aspects of linear perspective can be considered by envisaging a cube. If one of its faces is parallel to the picture plane, all parallel lines seem to converge to a single vanishing point and the picture conveys what is known as parallel or one-point perspective.

In two-point or angular perspective, a cube is placed so that two of its faces are oblique to the picture plane and parallel lines appear to converge on two vanishing points on the horizon. With three-point or oblique perspective, three of the cube's defining faces are turned obliquely to the picture plane and parallel lines seem to converge on two points on the horizon line with another point either below or above that line. There can be as many extra vanishing points— accidental points—as there are extra systems of parallel lines. A terrestrial accidental point is below the horizon, an aerial one above.

Curvilinear perspective, as its name suggests, is made on a curved rather than a flat picture plane. Cylindrical or panorama perspective shows the picture like a panorama and the picture plane may be a cylinder. Spherical perspective is projected on a

Perspective In one point perspective, only two faces of the cube are visible and receding lines appear to meet at the vanishing point. In two point perspective, three planes of the cube are visible and two sets of lines can be drawn to converge at the vanishing points. If the cube is well above or below the viewer's horizon, three sets of lines appear to converge. Three point perspective thus includes vertical as well as horizontal lines.

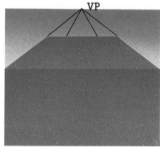

One point perspective

VP = Vanishing point

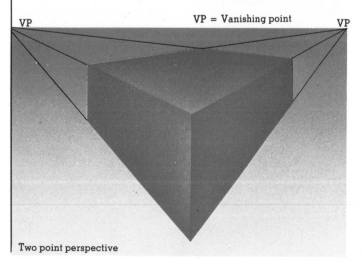

Two point perspective

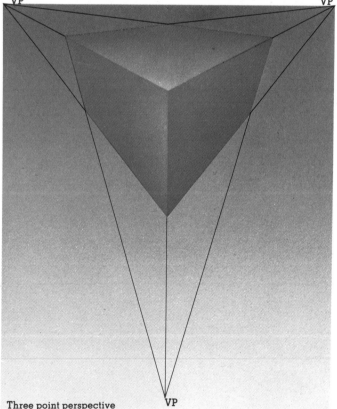

Three point perspective

spherical picture plane. A good example of this is when a photograph is taken with a wide-angle lens and lines which are usually straight appear bowed. Images in a convex mirror show this, as in *Giovanni Arnolfini and his Wife* by Jan van Eyck (*c.* 1390–1441) and the *Self Portrait* by Francesco Parmigianino (1503–1540).

History

The ancient Egyptians attempted to convey foreshortening by overlapping objects and suggested distance by drawing objects bigger, smaller, higher, lower or in strata. The Greeks understood some fundamental principles of perspective in the sixth century BC, and were familiar with foreshortening. By the next century they were using aerial perspective, implying a horizontal plane by representing shadows of objects. The Romans also used aerial or atmospheric perspective with changing colors and shades conveying the illusion of distance and depth.

However, it was not until the Renaissance that perspective became codified into a system similar to that followed by Western artists today. Pioneers of this included the architects Brunelleschi (1377–1446) and Alberti (1404–1472) and the painter Paolo Uccello (1396–1475). Leonardo da Vinci saw perspective space in a formal linear framework. His study for the *Adoration of the Kings* (*c.*1481) showed a knowledge of one-point perspective.

The search for the rules of perspective was long and varied. Alberti's concept of perspective was correct but technically difficult to apply. It involved measuring distances with a plan of squares with connecting diagonals—the tiers-points. Albrecht Dürer in 1525 used a network of squares known as craticulation, while Vignola simplified the practical construction of the perspective drawing in 1583. In 1630 De Vries used Dürer's theory and devised rules for finding vanishing points.

Such studies had an impact in painting. Uccello's *Vase* was drawn according to a system of proportions and vanishing points laid down by Brunelleschi and Alberti. Michelangelo da Caravaggio in *Supper at Emmaus*, dramatic with its sweeping contours and color, employs many vanishing points. However, painters from as early as Piero della Francesca (*c.*1415–1492) and Vermeer (1632–1675) to Canaletto (1697–1768) knew that it was not possible to transfer all that the eye could see on to a flat surface without some distortion—as is obvious in drawing a two dimensional 'map' of the world. So they tended to avoid putting geometrical patterns, in which distortions would stand out, in the outer edges of their pictures.

Things have changed, however. Modern painters often deliberately distort perspective to alter shapes and space; or, as with the modern Dutch artist Piet Mondrian (1872–1944), use blocks of color and geometric patterns to express certain feelings and ideas. Some go even further and deny any system of rules whatever.

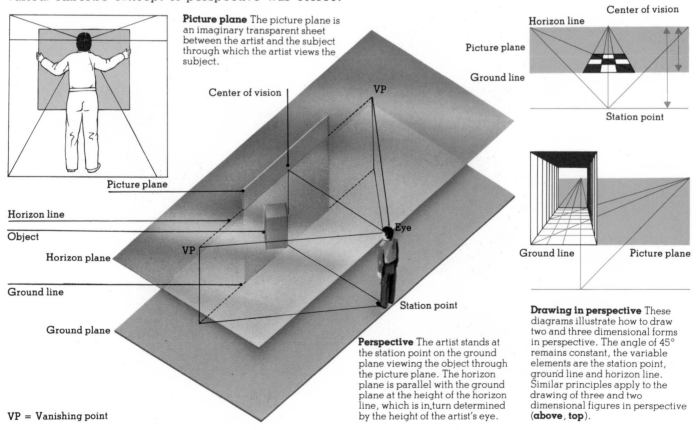

Picture plane The picture plane is an imaginary transparent sheet between the artist and the subject through which the artist views the subject.

Center of vision

Picture plane

Horizon line
Object
Horizon plane

Ground line

Ground plane

VP = Vanishing point

VP

Center of vision

VP

Eye

Station point

Perspective The artist stands at the station point on the ground plane viewing the object through the picture plane. The horizon plane is parallel with the ground plane at the height of the horizon line, which is in turn determined by the height of the artist's eye.

Center of vision
Horizon line
Picture plane
Ground line
Station point

Ground line Picture plane

Drawing in perspective These diagrams illustrate how to draw two and three dimensional forms in perspective. The angle of 45° remains constant, the variable elements are the station point, ground line and horizon line. Similar principles apply to the drawing of three and two dimensional figures in perspective (**above, top**).

2 | **Color** Theories and Principles

Purely scientific principles involving direct and reflected light of different colors—and thus different wavelengths—are more the concern of the physicist than the practising artist; but this has not prevented artists from trying to evolve 'scientific' theories of color harmony, or scientists attempting to apply theoretical discipline to the artist's subjective perception of color.

All painters use color and color quality to achieve the effects they seek. Even the Romans, for example, used color to indicate perspective while Renaissance painters—particularly the Venetian school—used warm and cool tones in juxtaposition to emphasize form and shape.

The earliest attempt to formulate a set of principles based on applied science was made by Michel-Eugène Chevreul in Paris. He was chief of the dyeing department at the Gobelin tapestry workshop. His treatise published in 1838 was translated into English in 1872 as *The Principles of Harmony and Contrast of Colors*. He described harmonies of similar colors and harmonies of contrasts; and devised tables of induced color effects.

The critic and art historian Charles Blanc followed Chevreul in 1867 with *Grammaire des Arts du Dessin*. The American Ogden Rood in *Modern Chromatics* (1879) arranged color combinations in pairs and triads to discover principles of harmony. David Sutter in *Les Phénomènes de la Vision* (1880) believed it was possible to learn laws of aesthetic harmony as one learned music harmony.

Delacroix (1798–1863) and the Impressionists were greatly influenced by Chevreul, developing and improving his ideas over a long period. For example, Seurat (1859–1891) applied Chevreul's principles in his paintings *Une Baignade* and *La Grande Jatte*. He covered his canvasses with tiny dots of color—the pointilliste technique—chosen and arranged to merge at viewing distance into the harmonies suggested by Chevreul.

In the twentieth century color theories have been less influential. A group of revolutionary Post-Impressionist painters which included Henri Matisse (1869–1954), André Derain (1880–1954), Maurice de Vlaminck (1876–1958), Raoul Dufy (1877–1953) and Georges Rouault (1871–1958) broke away from the earlier masters and rejected certain principles including the breaking-up of color. A critic described them as *les Fauves*—the wild beasts—because of the wild lawlessness with which they used color and sometimes form. 'Fauve' technique was to express in brilliant, explosive colors what the artists believed to be the inner qualities of the subject rather than its actual appearance. They responded emotionally to color,

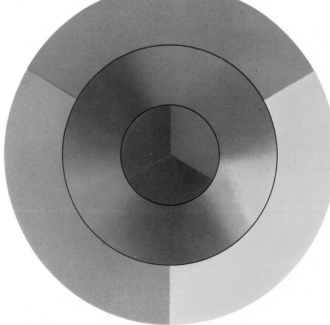

Mixing colors Combining colors (**left**) to create new colors or a variety of shades is an important element in painting. The Primary colors in painting are red, blue and yellow (**left**). Combining red and yellow produces orange; a mixture of blue and yellow makes green. Mixing red and blue does not create a clearly defined color, it makes a brownish purple.
Color wheel A color wheel (**above**) indicates the colors produced by combining the different primaries.

using it without the theory-oriented restrictions which had influenced earlier artists.

Many artists, although making use of techniques based on theory, have had harsh words for theories as such. Renoir (1841–1919) commented that nature destroyed theories. Cézanne (1839–1906), Kandinsky (1866–1944) and Matisse felt that theories were difficult to make—and even more difficult to hold up.

Piet Mondrian (1872–1944), co-founder in 1917 of the architectural style called *De Stijl*, wanted to create a purely logical art. He excluded all secondary colors and diagonals and curves, drawing only rectangular colored areas in primary colors or black and white bounded by heavy black lines.

Optical illusion art, or op art as it came to be called in the 1960s, is a style in which sharp-edged, abstract patterns produce a 'dazzle' illusion of movement. If color rather than black and white is used and certain complementary colors are placed beside each other, the dazzle effect is increased. Op.art has been successfully adapted to textile designs.

With all the color theories, principles and analyses, no precise and universal concept has evolved—and possibly cannot evolve. For each artist sees color in a subjective and therefore possibly different way from another. Harmonies are evolved by artists from experiment and personal aesthetics.

Color and light White light consists of a mixture of the different colors of the spectrum. They are separated out if the light is passed through a prism. Each color represents light waves of different frequencies.

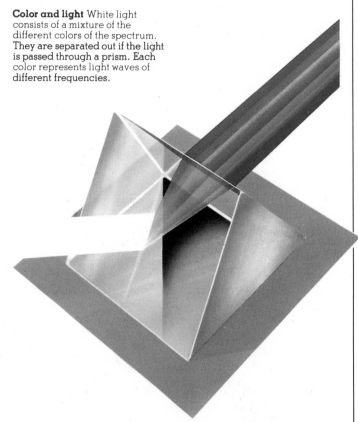

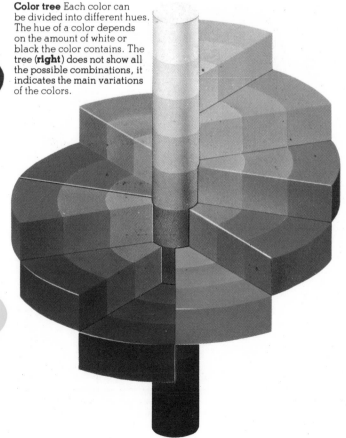

Color tree Each color can be divided into different hues. The hue of a color depends on the amount of white or black the color contains. The tree (**right**) does not show all the possible combinations, it indicates the main variations of the colors.

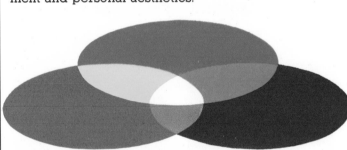

Additive primaries Red, green and blue are classified as additive primary colors because, when they are combined, white light is produced. It is extremely important for any artist to be aware of the color properties of light. When any two of the additive primaries are combined, a third color is formed. This is known as the complementary of the third color — thus yellow is the complementary of blue.

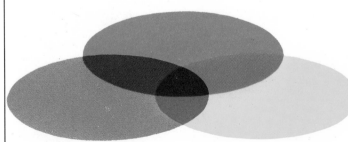

Subtractive primaries The colors formed when two of the additive primaries are combined are known as subtractive primaries. The colors thus produced are cyan (a mixture of blue and green with no red), yellow (a mixture of red and green without blue), and magenta (red and blue, with no green). If white light is passed through filters of all three subtractive primaries, black is produced.

Color hues and values A color computer (below) is a useful aid to the artist in identifying colors and establishing complementary color harmonies. Color harmony can be established using either closely associated hues of the same color, or using complementary colors. The rotating color wheel helps the artist to visualize the color harmonies. The computer cannot give the full range, but it provides a good working guide. The other side of the color computer illustrates different color mixtures.

Perception of color The individual's perception of color is affected by the background color (**right**).

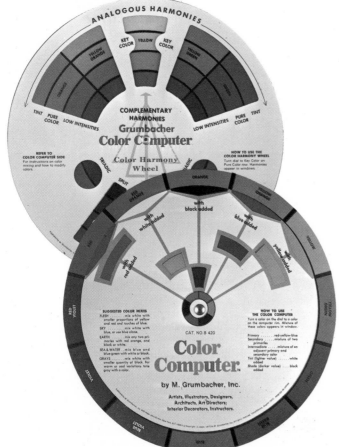

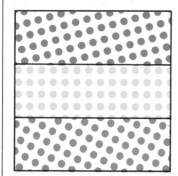

Process colors 1. In printing, a full color reproduction is created using small dots of cyan, yellow and magenta.

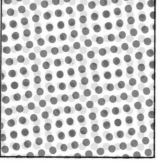

2. Cyan and yellow combine to produce green.

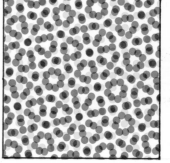

3. Dots of all three process colors are seen here in combination.

Pointillism In painting, pointillist technique uses dots to create apparently solid colors and subtle tonal variations.

Oils.

History. Constituents and properties: Binders, Diluents, Varnishes, Mediums, Dryers. **Supports:** Fabric, Wood or paper, Metal. **Preparing the canvas:** Size, Grounds. **Equipment:** Paints, Brushes, Knives, Palettes, Dippers, Mahl sticks, Easels. **Techniques.**

3 | **Oil painting** History

The Flemish painter Jan van Eyck (c.1390–1441) has been called the inventor of oil painting; and although historians may argue about the technical accuracy of this description—since oil had been used as a medium for pigment many years before—his discoveries and techniques certainly laid the foundations for the art.

Around 1420, when he found that one of his egg tempera paintings had split in the sun, van Eyck experimented to find an oil that would dry in the shade. He hit on a formula consisting of a little Bruges white varnish, a kind of turpentine, mixed with linseed or nut oil. He first used this as a varnish for the tempera, in which pigments were mixed with yolk of egg; then started mixing his raw pigments directly with the oil mixture.

Not only did this dry satisfactorily out of the sun, but he discovered he could apply his colors in transparent layers or glazes, giving an inner luminosity to his paintings. He found, too, that he could correct shades and colors without spoiling their original brightness.

A follower of van Eyck, Antonello da Messina (1430–1479) spread the use of oil paint to Venice, where Giovanni Bellini (1430–1516) succeeded in achieving something like van Eyck's beauty of surface and glowing color. But it was a pupil of Bellini, Titian (1490–1576), who started to develop the full potentialities of the 'new' oil technique.

He laid in the picture lightly in monochrome, then painted the lighter parts with thicker, opaque color. Shadows were painted thinly and glazes of transparent color gave a glowing depth to the whole. The brilliance, fluidity of design and depth of tone were the hallmarks of this 'classical' technique.

The next marked advance in oil painting came with Rubens (1577–1640). He worked from a white ground with a thin gray wash, laying down his tonal and linear design in a golden umber on top of which he used cool, semi-opaque half-tones showing some of the underpainting. The dark shadows on one side of the halftones and the brighter, lighter tones on the other side were thin coats, finished in part with transparent glaze.

Rubens influenced both Velasquez (1599–1660) and Rembrandt (1606–1669), although both masters added their own variations. Velasquez painted tastefully and sensitively, with supple but sometimes thick brushwork.

His portrait, *Lady With a Fan*, shows this rather haunting sensitivity. Rembrandt often worked areas of his paintings in a single solid color which was later covered with glazes and opaque strokes of brushwork. His method of grisaille—covering white or gray modelling with light glazes of color—became an accepted technique by the eighteenth century and was used by Reynolds (1723–1792) among others.

Such a laborious glaze-layering technique, except in the hands of a master, was thought by some artists to lead to heaviness and a lack of spontaneity. Two artists who reacted against it and returned to the freer, more direct style of Rubens—if not to his precise methods—were the English artist Gainsborough (1727–1788) and the Spanish master Goya (1746–1828).

In the eighteenth century, professional colormen were already putting ready-made oil colors in skin bladders—forerunners of the metal tubes of the mid-nineteenth century. This was a boon to out-of-the-studio artists and pioneering landscape painters such as Constable (1776–1837), but some artists and art historians regretted the move away from total control of the medium which they believed could only be achieved by craftsmen-painters who made, or supervised the making of, paints in their own studios.

However, the increasing range, flexibility and availability of prepared colors signalled the establishment of new, more direct techniques and new standards of craftsmanship. As an exponent of direct vision in the open air and with his analysis of 'broken' light, William Turner (1775–1851) became the direct precursor of the Impressionists.

The chief characteristic of the Impressionists, including Monet (1840–1926), Cézanne (1839–1906), Pissarro (1831–1903) and Sisley (1839–1899), was their broken-color technique in which strokes or dabs of opaque color were laid side by side to blend into the correct tones in the eye of the viewer. As they tried to 'paint light', their palettes contained few earth-colors and no black.

Quite early in the twentieth century, consideration of the Impressionists, and the highly individual, tradition-scorning techniques of van Gogh (1853–1890) and Gauguin (1848–1903), led many artists to the conclusion that there was no single 'right' way to paint at all.

However, before an oil painter can develop a personal technique, it is still necessary for him or her to learn something about the limitations as well as the potentialities of the medium.

The contrast in approach has perhaps never been greater. On the one hand, artists such as Salvador Dali (born 1904) use a technique of building up layers of paint which is in a direct line of descent from van Eyck. On the other hand, artists such as the Abstract Expressionists particularly Jackson Pollock (1912–1956) have extended the scope of oil painting to include previously unheard of approaches, such as throwing paint onto the canvas and allowing it to drip. Oil painting still demands a high degree of skill and knowledge. If the paint is not of a suitable consistency or is applied in a careless manner, the painting will deteriorate. This applies today as much as it did in the time of Leonardo, whose paintings have often suffered because of his excessive use of oil in his paints. Technique is closely linked to the materials being used.

Basically, oil paint for artists consists of dyes or pigments mixed with binders such as linseed and poppy oils which oxidize in the air and form solid skins in which the particles of color are evenly distributed.

The chemistry of the oxidation process causes gases to form under the drying oil. These force their way through the surface layer, making it porous and admitting more oxygen to the layer beneath so that the process is continuous until a solid skin is formed.

If paint is applied in layers, the first coat must be dry before the next is laid on. The second or subsequent layer usually contains more oil than the first. This is absorbed by the pores in the lower layer. The process is known as the 'fat over lean' principle. The paint surface can be varied—opaque or transparent, matt or gloss—according to the amounts of oil and thinners used by the artist.

Binders

Linseed oil is the most widely-used of all binders. It comes in various forms and qualities.

Raw linseed oil is obtained by steam-heating the flax before pressing the seeds. This produces a good quantity of oil, but it is dark and of poor quality for most painting purposes.

The finest quality oil is made by cold-pressing the flax seeds, but it is expensive and not easy to obtain. The best substitute is refined linseed oil, produced by bleaching and purifying steam-pressed oil with sulphuric acid and water. The sulphuric acid and water are then removed. The resulting oil varies from pale straw to golden amber or deep gold. It is better to use an oil from the middle of that range rather than a light one which may turn dark with age.

Stand oil, as thick and viscous as honey, is produced by treating linseed oil under heat and in a vacuum to change its molecular structure. It dries to a smooth, enamel-like film which is free of brush marks and does not become as dark with age as other linseed oils. It can be thinned with turpentine, making it a good ingredient into which to grind pigment for glazes.

Linseed oil was once sun-refined—oxidized, bleached and thickened—by standing it in the sun for several weeks in glass jars. This was the version of stand oil used by Rubens.

Poppy oil, expressed from the seed of the opium poppy, is very light in color when fresh and is used as a medium for whites and pale colors, keeping them bright and clear. But it is a slow dryer and cracks more easily than linseed with age. It is useful for *alla prima* painting or in modifying a linseed oil color.

Walnut oil, obtained by cold-pressing young walnuts, is pale, thin, and a faster dryer than poppy—almost as fast as linseed. However, it is costly, not easily obtainable and cannot be kept for long periods without going rancid.

There are many other naturally-drying vegetable oils which can be used by painters, including safflower, tung, oiticica and stillingia, but none have the versatility of linseed and poppy oils.

Artificial drying oils can be made by adding chemicals such as manganese or cobalt to vegetable oils. They can cause cracks and discoloring if not correctly mixed and used, but they are useful in damp conditions; and ready-prepared mixtures are available from some colormen.

Diluents

Solvents and thinners, which are called diluents, are added to paints ground in oils or varnishes to give them the right consistency for application. Those in current use include turpentine, oil of spike, refined petroleum, gasoline, benzol and acetone.

An ideal thinner should evaporate evenly and completely and mix thoroughly with all the other ingredients in the medium in any ratio without reacting chemically with them. It should not dissolve the underpainting, its fumes should not be harmful to the user, its odor should soon disappear from the dried film, and it should not be readily inflammable.

While research chemists work on the problem—and there have been recent advances in the field—the nearest to this ideal is the familiar turpentine, distilled from the gum of pine trees.

There is a wide range of quality. That sold for art purposes is known as rectified turpentine, doubly distilled and purified, and should not leave a ring or stain when blobbed on to blotting paper. A passable quality of turpentine can be bought in quantity from paint stores where it goes under the name of pure gum spirits of turpentine.

Two other turpentines, which still contain their natural gum or resin, are occasionally used by artists. They are Venice turpentine, from the exudation of larch trees; and Strasbourg turpentine, from the Tyrolean silver fir.

Mineral or white spirits, distilled from crude petroleum oils, is similar in its properties to turpentine and has replaced it in industrial paints. But although it leaves no sticky residue and does not deteriorate with age, many artists do not like using it in the studio. It has an unpleasant benzine-like smell and, since damar resin is not fully soluble in it, cannot be used in making damar varnish medium.

Gasoline or petrol was once quite widely used as a thinner, but lost popularity with the addition of substances which made it more valuable as an automobile fuel—and useless in the studio.

Varnishes

Varnishes, which are basically resins in solvents, have been used in oil painting for many centuries. They have been used as pigment-binding media for glazes, and for paint protection.

They are divided into hard and soft varnishes: hard

when the resin is dissolved in an oil such as linseed; soft when turpentine is the solvent.

Simple solution varnishes which can be made in the studio have many uses. Picture varnish can be used to provide a final protective coat for the painting. Retouch varnish contains more turpentine so that it does not leave a high-gloss skin. Mixing varnish is used for adding to tube colors to make glazes. Isolating varnish, for use over recently-dried oil paint, acts as sizing between the coats and allows overpainting and correction without affecting the underpaint.

Damar varnish, which is damar resin dissolved in turpentine, stays colorless longer than other common varnishes because of its lack of impurities. It can be bought ready-made. To make it in the studio, break the resin into small pieces, wrap in muslin or cheesecloth and suspend the bag in a container of turpentine. Make sure the wrapped resin does not touch the side

of the container, which should be covered to keep out dust. The solution should be ready for use in two or three days.

To make damar varnish medium for glazing, mix nine parts of the varnish with nine parts of turpentine, four parts of stand oil and two parts of Venice turpentine. If it is to be used for overpainting, an extra drop or two of stand oil in the mixture ensures an oilier, more flexible surface. A simple thick varnish medium for glossy glazes can be made by adding one part of stand oil to three parts of Venice turpentine.

Mastic resin, dissolved in turpentine, is easier to use than damar varnish, but tends to yellow in time. The bad preservation of many eighteenth and nineteenth century paintings is often put down to the use of megilp, a thick medium made from mastic varnish and linseed oil.

Mastic and sandarac were the main resins used in early painting. Sandarac, from a North African tree, is very hard, and a simple solution can only be made in strong solvents such as alcohol; but it can be 'cooked' into a varnish by dissolving it in heated oil. The surface it gives is liable to be very brittle.

Shellac makes a strong, hard but flexible varnish. Its main use in painting is as a sizing for a ground which is too porous. It can be made in the studio by slowly adding broken white or brown shellac to alcohol—in the proportion of one part of the resin to seven parts of the solvent—and shaking the mixture until all the shellac is dissolved.

Synthetic gels for mixing with tube paints are now on

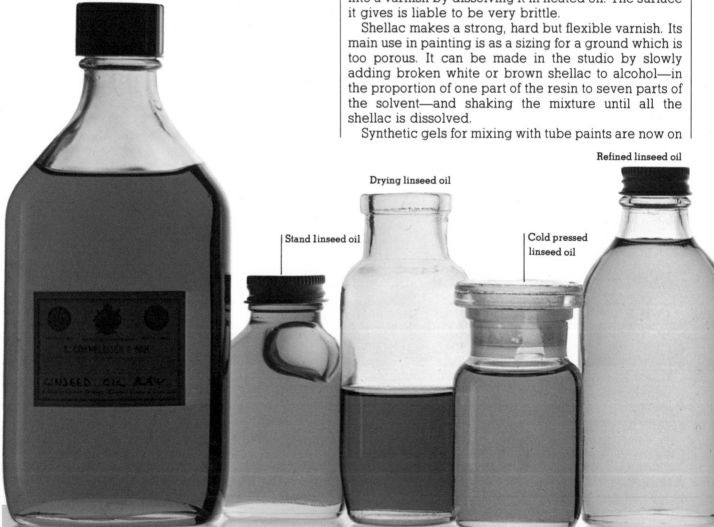

Raw linseed oil

Stand linseed oil

Drying linseed oil

Cold pressed linseed oil

Refined linseed oil

sale. Synthetic resins form the base of most of our household enamels, paints and varnishes, replacing materials of natural origin. Laboratory resins include polyester, vinyl, epoxy, plastics and—most interesting to the artist—alkyd and acrylic resins.

Alkyd paints have now been made up into an artists' range by Winsor and Newton. They can be thinned with turpentine or white spirits and used with oil media. Their main advantages are that they dry within 18 hours and resist cracking and yellowing. If quick drying is not desired for some reason, the process can be slowed down by adding petroleum distillate.

Mediums
Wax added to oil varnishes produces a matt surface. This is vulnerable, however. Rubbing it makes it smooth and shiny, as with a wax polish. Artists may like to experiment with varying proportions of wax to produce different effects.

Beeswax medium is made by warming one part of fragmented white beeswax to three parts of turpentine in a double boiler. Stir until dissolved and, when cool, store in a wide-necked container.

Beeswax oil medium is thick, dark and discolors pigments mixed with it; but its versatility—it was used by Rubens—can compensate for this disadvantage. It is a drying medium and can be stirred into thick paint for impasto and into thin paint for glazing. The drying element in it is litharge, a form of lead monoxide. This heavy yellow powder is poisonous and must be used with care. Take ten parts of raw linseed oil, two parts

of beeswax and one-sixteenth part of litharge. Mix the litharge first with a little oil. Slowly warm the rest of the oil in a large metal container. The next part of the process should be carried out near an extractor fan or even in the open, avoiding the fumes. Add the litharge and small pieces of beeswax to the warm oil, stir and heat to 250°C, or until the mixtures looks black and gives off brown fumes. When the mixtures cools, pour into wide-necked containers and cover. The liquid sets like wax.

Maroger's medium, which has been popular for years and is pleasant to use, can be bought ready-made. It consists of an emulsion of boiled linseed oil, mastic varnish, gum arabic and water. Two nineteenth century media still available are Bell's: brown linseed oil thinned with spike oil; and Robertson's: copal varnish, poppy oil and white wax.

Dryers
Dryers, which are also called siccatives, are metallic salts mixed with the normal paint and varnish ingredients. They may affect permanence adversely, but have as old a history as drying oils themselves. Some pigments are naturally fast dryers and only very small amounts of the drying ingredients—lead, cobalt or manganese—are needed. The thin glazes of many of the early Masters contain them. Pictures in which drying media have been used throughout should be given a thin coat of protective varnish immediately they are thoroughly dry. A normal painting can take several months to dry before it is ready for varnishing.

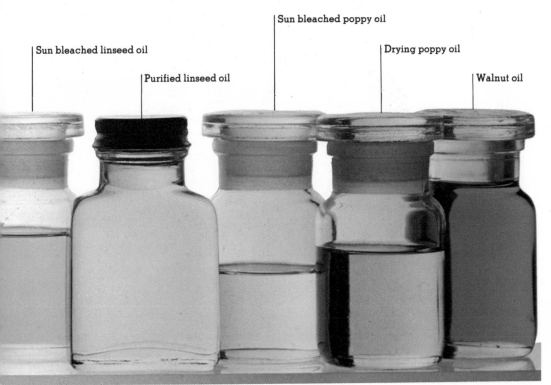

Sun bleached poppy oil

Sun bleached linseed oil

Purified linseed oil

Drying poppy oil

Walnut oil

Drying oils for oil painting
Linseed oil is the most versatile and widely used binder for oil paint. It is available in various forms for use as a binder or medium. The flow, texture and drying rate of oil paint depend on the type of oil used. Stand linseed oil retards the drying speed, but improves the flow of the paint whereas drying linseed oil speeds up the drying process. Cold pressed and refined oils give greater transparency to the paint but are relatively slow-drying. Sun bleached linseed and poppy oils are both mediums which improve the flow of the paint but linseed is the more quick drying. The advantage of poppy oil is that it is light in color and keeps pale colors fresh and clear. Walnut oil is less commonly used than linseed oil, although it dries almost as fast; it is more expensive and difficult to find, and does not keep well.

Ingredients for varnishes and varnish mediums Resinous varnishes can be used as a protective layer over finished work and may also be mixed with solvents such as turpentine and alcohol and with oils and wax, to make a wide range of mediums to be mixed with the paint. These vary the transparency or plasticity of the paint and also affect the drying speed of the paint and the flexibility of the finished surface. Many preparations are now commercially available ready-made, but it is possible, and often desirable, to make up the varnishes as required from basic ingredients. The following substances are used in the preparation of various basic varnishes and varnish mediums: (from **left** to **right**) copal varnish, linseed oil, turpentine, damar varnish, stand oil, Venice turpentine, shellac, alcohol, damar resin, beeswax, litharge. White spirit cannot be substituted for turpentine in making up a varnish, as it is harsh and may devalue the color of the paint as it dries. It is not possible use it with damar resin, which will not dissolve in white spirit.

Varnish medium
1 part copal varnish
1 part linseed oil
1 part turpentine
Pour the measured ingredients into a clean, dry bottle and shake well until the liquids are blended. This makes a basic, thick varnish medium which dries quickly and can be further thinned if required.

Damar varnish
1 part crushed damar resin
4 parts turpentine
Put the turpentine in a pot. Wrap the resin in muslin and tie it so that it is suspended in the pot of turpentine but does not touch the sides of the container. Cover the pot so that no dust falls into it, and leave it to stand for two or three days. The resin gradually dissolves and a varnish is produced which will not yellow with age. The process can be speeded up slightly by occasional agitation of the muslin bag.

Damar varnish medium
9 parts damar varnish
9 parts turpentine
4 parts stand oil
2 parts Venice turpentine
Pour all the ingredients into a clean, dry bottle and shake it vigorously until the substances are completely mixed. This medium can be encouraged to dry more quickly by adding one drop of cobalt drier for each pint of liquid. Damar varnish medium is clear and is used to thin paint for glazing.

Stand oil medium
1 part stand oil
3 parts Venice turpentine
Pour the liquids into a jar or bottle and shake well until they are blended together. This medium retains the gloss and brilliance of the paint as it dries.

Shellac varnish
1 part shellac (white or brown)
7 parts alcohol
Put the alcohol in a bottle and gradually add the shellac, a little at a time. Shake the bottle until all the shellac has dissolved in the liquid. Shellac varnish can be used as a diluent, but is often applied to grounds which are too absorbent, so that they will not soak up the paint. It can also be used as a fixative.

Beeswax medium
1 part white beeswax
3 parts turpentine
Put the beeswax and turpentine in a double boiler and heat gently, stirring until the beeswax is dissolved. The wax in the medium will produce a matt surface to the paint, but it can also be polished carefully to create a sheen.

Beeswax oil medium
10 parts raw linseed oil
2 parts beeswax
1/16 part litharge
Use a little of the oil and mix it with the litharge. (Take extra care when using litharge which is poisonous.) Put the rest of the oil in a metal container and warm it through slowly. Add the litharge and the beeswax in small pieces to the warm oil. This produces fumes, so work in the open or near an extractor fan. Heat the mixture to 250°C, stirring constantly. Let it cool for a while and pour it into a wide-necked container. The liquid sets hard like wax. As a medium it is useful to thicken paint for impasto techniques, or it can be added to thin paint for glazes.

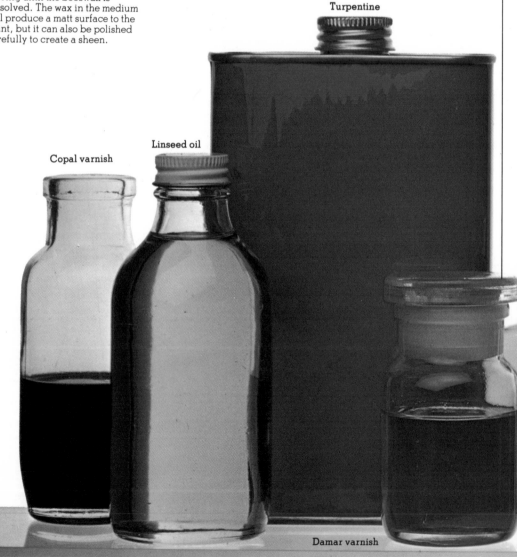

Turpentine

Linseed oil

Copal varnish

Damar varnish

Mediums, solvents and diluents and varnishes A great variety of different products are now commercially available for use in the process of oil painting. Mediums are actually mixed with the paint to alter the thickness and flow of the paint, and to speed or slow the drying rate. Solvents are used to thin wet paint, and varnishes may be used as a final overall protection to the painting, or mixed with the wet paint and oil as mediums.

Copal oil mediums (**1**, **2**) give the paint extra transparency and gloss. They tend to increase the drying speed. Oil vehicles (**3**) are mediums which thin the paint and improve the flow. The example shown is light and especially suited to mixing with pale colors or white. Opal medium (**4**) gives a matt effect to the paint surface and is relatively slow drying. Oil painting medium (**5**, **6**) has been specially developed as a paint thinner. It shows the least tendency to cause cracking or yellowing in the paint surface, which is always a danger when the drying process is interfered with. Liquin is also a thinner and its free flow and speed of drying make it valuable in detailed work. Turpentine (**9**, **10**) and petroleum distillates (**11**) are used alone or mixed with oil and varnish to control the consistency of the wet paint. Special substances have been developed to deal with dried paint. The picture cleaner (**7**, **8**) removes dirt which has settled on a dried paint surface without disturbing the painting itself,

whereas the paint remover and solvent (**17**) is designed to soften and remove hardened color. Picture varnish (**12**) is clear and quick drying for final surface protection. Crystal damar varnish (**13**) and paper varnish (**14**) protect the paint surface with a high gloss finish. Picture mastic varnish (**15**) is also glossy but dries to a more

brittle film. Heat resisting varnish (**16**) and weather resisting varnish (**18**, **20**) have been specially developed to withstand hard conditions. The former can also be used as a medium for oil painting on china or glass. Copal varnish should be used only when the painting has completely dried out, or as a medium mixed with oil.

Retouching varnish (**22**) is a temporary varnish for newly completed work, or for use during painting. Wax varnishes (**19**, **23**) give a soft sheen to the final picture. Varnish is also available in aerosol spray form (**21**) for convenience.

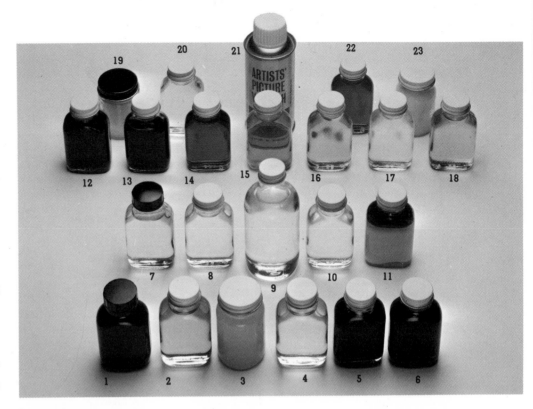

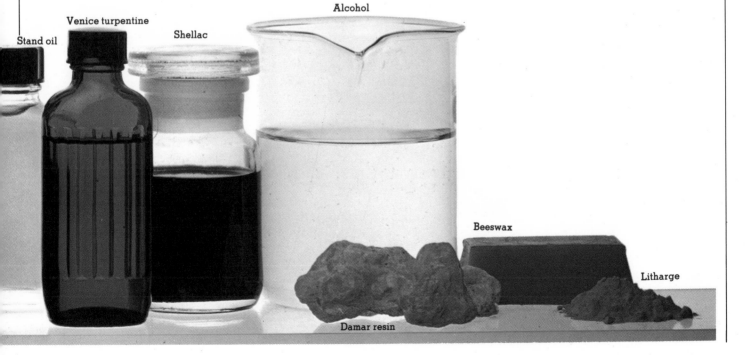

Stand oil

Venice turpentine

Shellac

Alcohol

Beeswax

Litharge

Damar resin

Fabric

The most common supports for oil painting are fabric stretched over wooden frames, and panels of wood or wood composition. But any inert surface that can be primed and prepared to take paint will do, including cardboard, paper and even thin sheets of metal.

The term 'canvas' applies to any stretched fabric. An artist's canvas can be made from linen in several weaves; cotton and cotton weaves such as unbleached calico, duck and twill; mixed linen-cotton weaves; hessian; or man-made fibers.

Linen is considered the best canvas, with a finely-woven, knot-free linen the best of all—and the most expensive. But some artists, with revealed texture in mind, prefer a well-woven coarser weave. Cheaper linens include linen crash, which usually has knots; and linen scrim, which needs a good deal of priming because of its wide weave.

Cotton weaves stretch badly and do not prime well; but ready-primed cotton is available and, although the surface is flimsy, it may lend itself well to particular light techniques.

Wood or paper

Wood as a support has a longer history than canvas. Only that which has been properly seasoned and treated should be used or it will warp and crack. The best is mahogany. To prevent it buckling, it must be braced or cradled by wooden strips attached to the back by screws or strong adhesive.

Mahogany-faced plywood can be used, but it should not be less than five-ply—preferably eight-ply; and although it is not as liable to crack as solid wood, it should also be properly cradled.

Chipboard is made from either wood chips compressed with a resinous or oily binder, or is composed of wood fiber which needs plenty of priming. The corners and edges of chipboard tend to wear a little, but it does not warp as much as wood and needs no cradling.

Linen-cotton weaves are even less satisfactory than cotton alone. The mixed threads absorb the primer, oil and pigments to different extents and at varying rates, causing unequal tension and eventual distortion of the surface. Hessian, a very coarse jute weave, needs a good deal of priming and becomes brittle in time.

Many canvases of man-made fibers are available. Some are ready-primed with an acrylic resin. They are cheaper, lighter, clearer and more resistant to chemical action than natural fibers; but their lasting qualities, including how brittle they may become, are not yet known.

Canvases of linen or cotton weave can be bought, fully primed with size and ground, in rolls cut to any length; but many professionals prefer to prepare their own to suit their particular needs. Prepared canvas is sold in two grades: single and double primed. The double is more rigid, although not necessarily as lasting as the thinner, more pliable surface.

If the canvas is being mounted at home or in the studio, these things are necessary: stretcher or chassis, ruler, knife, a pair of canvas pliers, and either a staple gun or a hammer and tacks.

Buy stretchers with keys or tiny wedges of wood which fit into the inside angles of the corners so that the canvas can be tightened or slackened as needed. Check that the stretcher corners are securely fitted together, then make sure it is square or true. This can be done either by measuring the diagonals, which should be the same length, or by checking the inside corners with a T-square or right-angled drawing triangle. Cut the canvas with knife and ruler, allowing 1½in (3.9 cms) for overlap around the stretcher.

Lay the stretcher on the canvas—so that the weave is parallel with the sides. Fold the canvas over one side of the stretcher and staple or tack it on the inside edge of the center of the side. Then, with the pliers, stretch the canvas, fold, and repeat the central tacking or stapling in the center of the opposite side. Do this with the other two sides. Stretch and tack or staple on alternate sides, working round all four sides until the whole canvas is taut and smooth. Fold and attach the corners as flat as possible so that the mounted canvas will fit easily into a frame. If done correctly the first time, it will be unnecessary to stretch or loosen the canvas with corner keys.

There are a number of theories about protecting the back of a canvas to control or even completely to prevent moisture affecting it. Some artists completely prime it; others coat with a wax varnish, or cover it with layers of tin foil and shellac. The simplest method is to tack cardboard to the back of the stretcher so that moisure and temperature affect the canvas more slowly.

Canvas can also be 'marouflaged' on to wood or hardboard with glue or size, obviating the need for a stretcher; but for technical reasons, this is a task best left to specialists.

Muslin can be marouflaged on to chipboard with size to give a textured support. All creases must be brushed out and edges and corners pasted down and glued at the back.

Hardboard wiped with alcohol can be used unprimed, but it is better to size and prime it, treating both sides of the board at the same time to prevent it from buckling.

Laminated boards are types of heavy cardboard made from wood pulp and paper waste. They are brittle and not considered of much value as supports. Essex board, however, a laminated cardboard, makes a good support if sized on both sides. It can also be marouflaged with muslin.

Cardboard also needs sizing on both sides and should be cradled. Many artists, including Toulouse-Lautrec (1864–1901), Walter Sickert (1860–1942) and the German-born painter George Grosz (1893–1959),

painted on cardboard, using the natural brown tone of the board as part of the painting.

Paper with a rough surface can be glued to hardboard and sized with casein as a support for oils. Plain, smooth paper sized with gelatin and bound into a pad is used by some artists for small paintings and color notes. Oils on paper tend to crumble and lift after a while, but there are special methods of restoring them.

Metal

Metal plates were used by the Dutch for small, finely-wrought oil paintings from the time of van Eyck. They were usually of copper. Zinc and aluminium have been tried in recent years; but ferrous–iron or steel–sheets present chemical and corrosion problems, which may have been solved for the automobile industry but not for the artist. Metal supports need no priming, but must be roughened to hold the paint.

Metal is, in fact, the only support that does not need to be separated from the oil in the grounds. Underpriming is needed for all other types of support. Oil rots the fibers of canvas after making them weak and brittle first.

Stretching a canvas 1. Fit the ends of two pieces of a stretcher together to form a corner. Fit the opposite sides and join all four.

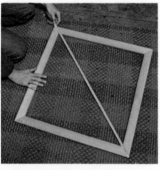

2. Check that the assembled stretcher is square by measuring the diagonals. They should be of equal length.

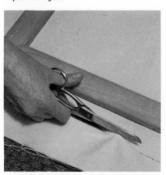

3. Lay the stretcher on a piece of canvas and cut a rectangle at least 1½ in larger than the stretcher on all sides.

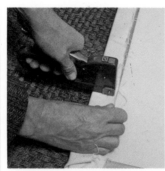

4. Fold the overlap round the wood, and staple in the center of each side. Keeping the canvas taut, staple along the sides.

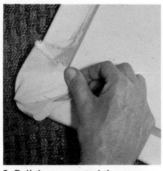

5. Pull the canvas tightly across the corners diagonally, making sure it is smooth and taut on the right side. Put in a staple.

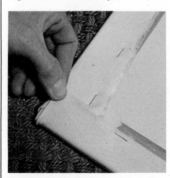

6. Fold in the remaining flaps of canvas so that the corners are neat and tight. Secure them with another two or three staples.

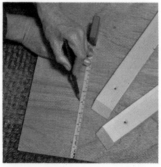

Cradling a board 1. Mitre the ends of two pieces of batten. They should be a little shorter than the width of the board.

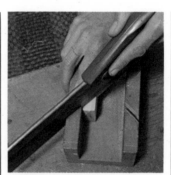

2. Drill holes for screws in the battens. Measure a position for each on the board, several inches in from the edge.

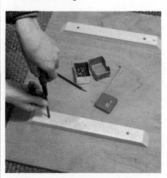

3. Place the battens carefully on the marked places, parallel with the short sides of the board. Screw them down firmly.

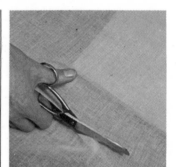

Sticking muslin to board 1. Cut a suitable sized piece of muslin, allowing at least 2 in to overlap each side of the board.

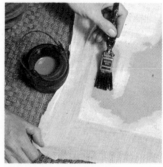

2. Lay the muslin on the board and smooth it flat. Brush over it with size to adhere it to the board, making sure no creases form.

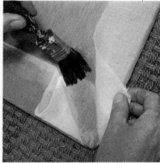

3. Turn the edges of the muslin over on to the back of the board and glue them down. Fold in the corners and glue them firmly.

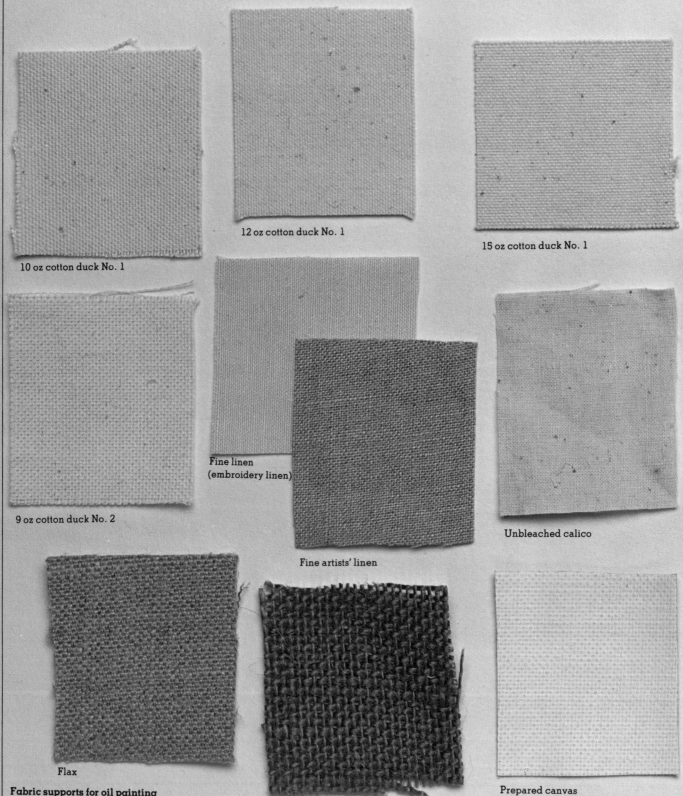

10 oz cotton duck No. 1

12 oz cotton duck No. 1

15 oz cotton duck No. 1

9 oz cotton duck No. 2

Fine linen
(embroidery linen)

Fine artists' linen

Unbleached calico

Flax

Coarse hessian

Prepared canvas

Fabric supports for oil painting
Although a large variety of surfaces can be primed for oil painting, the traditional canvas, a term referring to a stretched fabric support, is still the most widely used. The lightness and flexibility of the fabric are a great advantage, as opposed to, for instance, wood panels, especially if the work is on quite a large scale. Different types of fabric can be used according to the tone and texture required. Linen has been considered the most suitable, as it has a fine, even weave and stretches reliably. However, it is relatively expensive and cotton duck has become widely used as a substitute. This has its drawbacks, as there are often knots and impurities in the surface and it does not always stretch well and may sag. However, it is available in a variety of weights, and in fine and coarse weaves. Calico is similar to cotton duck and has the same disadvantages. Hessian and flax are suitable if a coarse surface is required, and artists often exploit the color of these fabrics, and of linen, as a feature of the painting. Ready-primed canvas is very expensive and can be difficult to stretch, as it is less pliable than unprimed fabric, but it can be more convenient.

Card Most types of card, or even paper, are suitable for oil painting, provided they are well primed before the paint is applied.

Rough hardboard

Smooth hardboard

Card

Metals Since metal cannot be rotted by the paint, it does not require priming, but the surface must be roughened to provide a tooth so that the paint will adhere. Copper plates are a traditional support, but metal has not on the whole been widely used. Some metals are simply not suitable for use with paint owing to chemical changes which are liable to occur, particularly ferrous metals. An oily primer may be applied to metal if it seems necessary. A smooth surface finish can be achieved on metal.

Brass

Copper

Hardboard Either side of a piece of hardboard can be used for painting, according to whether a rough or smooth surface is required. Hardboard should be primed on both sides.

Plywood

Chipboard

Mahogany

Wood Many types of wood can be prepared as painting supports, but the main problem is the tendency of wood to warp and split. Well-seasoned hard woods, such as mahogany, are very suitable, but even these must be protected by careful priming and should be braced on the back with wood battens to prevent warping. Chipboard is more resilient and the composition is tough so it may not require extra strengthening. Plywood or blockboard can also be used, but these must be thick and solid. It is possible to join wood panels, glueing them together, but careful attention must be paid then to the direction of the grain in the different pieces, so that they are least likely to split apart through warping. The slightly rough surface of wood means that there is a suitable surface to which the ground can adhere, but if a particular texture is required on a panel, wood can be covered with canvas or muslin to obtain the effect of the weave. Wood is less suitable than canvas for use on a large scale, owing to the problems of preventing it from buckling, or of joining panels, and even quite small panels can be heavy and awkward to handle.

Size

The most common form of underpriming is that provided by a weak glue size solution. The finest but most expensive is leather waste size from the skins of animals. Bone glue size is the most commonly used.

Sprinkle bone glue into cold water and stir into a smooth paste. For every cup of powdered glue used, add seven cups of cold water, then heat the whole mixture gently until all the size is dissolved. Apply it to the canvas while it is still warm, brushing in every direction so that the size penetrates every part of the weave. When it has dried, apply a second coat.

To make size from casein glue—also known as milk glue—sprinkle the casein powder into cold water, in the proportion of one part of casein to seven of water, and stir until the casein is dissolved. Casein size must be used on the same day it is made. It resists moisture better than glue or gelatin size, but is more brittle.

Grounds

A ground forms the layer between the sizing and the paint and provides a suitable surface as well as further protecting the canvas or other support from the oil in the paint. Most grounds are white to lessen the effect of the age-darkening of the paint. Ready-prepared oil-based or acrylic-based primers can be bought for use on sized canvases.

Oil grounds should be used in two coats for the best results. An excellent ground for canvas is made from six parts of turpentine or white spirit and one part of linseed oil stirred into flake white until the mixture is thick and creamy. The second coat should be applied twelve hours or so after the first. If the ground is not dry after four to six weeks and the canvas is needed for painting, it can be given a thin coat of shellac varnish which can be painted on when dry.

Gesso grounds have been used since the Middle Ages for oil and tempera, and are still popular for tempera. Gesso can still be used for oil paintings on hardboard or wood, but it dries rigidly and in time cracks finely. Use one part of whiting to one part of heated glue size. Mix a little of the two constituents separately into a smooth paste, then add the rest of the glue and size slowly and stir until the mixture is creamy in consistency.

Emulsion grounds are a mixture of white pigment suspended in size and oil. Emulsion dries quickly—a canvas coated with it can be used after a week—is more absorbent than an oil ground and more flexible than gesso. It will also take pigment for those who want to work on a tinted ground. Mix one part of whiting with one part of zinc oxide and one part of hot glue size. Use only a portion of the size to make a paste and into this mixture slowly beat a half-part of linseed oil drop by drop until it has completely dispersed. Then add the remainder of the hot size. Keep the ground heated in a double boiler and apply it while it is still warm.

Acrylic grounds are now available for both oils and acrylics and can be applied directly on to the support without size. They have been in use for some twenty years and have not shown any major disadvantages.

Ingredients for grounds There are two stages of applying a ground for an oil painting, first the sizing of the raw canvas, then a thick layer of priming, which is applied in two or three thin coats. The following ingredients are used in sizing and for the preparation of various primers: turpentine, linseed oil, Gilder's whiting, flake white, or other white pigment, glue size crystals, zinc oxide. The ground serves to protect the canvas from the oil and provides a smooth, fresh surface for painting. As long as the canvas or other support is properly protected, the thickness and smoothness of the ground are a matter of personal choice. Although it is usual to apply white grounds, it is possible to add colored pigment if a colored ground is required, or to paint a thin layer of color over the dry ground. The powder ingredients in general add body to the mixture and make it opaque. The white pigment adds brilliance to the whiteness of the ground. Powdered ingredients must be kept dry in order to mix smoothly.

Turpentine

Recipes for preparing grounds

Various types of grounds can be made from the ingredients shown. A ground which contains oil will be less brittle when it dries than one made only from size and powder. A higher proportion of powder in the mixture will make it thicker and less flexible in application. From the materials shown here, all three types of grounds for oil painting can be made — oil ground, gesso ground and emulsion ground. Priming layers should always be applied in successive, thin coats rather than one thick layer, otherwise they will crack severely while drying and the paint will not adhere.

Glue size

1 cup glue size crystals
7 cups water
Sprinkle the glue size into the water and stir. Heat the glue in a double boiler, until all the size has dissolved, but do not allow it to boil. Apply the size to the canvas while warm.

Oil ground

6 parts turpentine
1 part linseed oil
A quantity of flake white powder
Mix the turpentine and linseed oil together and gradually pour them into the flake white, stirring continuously until the mixture is of a thick, creamy consistency. Apply in two thin coats, allowing the first to dry out before applying the second.

Gesso ground

1 part Gilder's whiting
1 part glue size
Heat the glue size gently. Add some of the warm size to the whiting and stir until it forms a thick paste. Gradually add the rest of the size until a smooth, creamy mixture is obtained. Apply gesso carefully in thin layers, or it will crack. To increase the brilliance of the white, add white powdered pigment.

Emulsion ground

1 part Gilder's whiting
1 part zinc oxide
1 part glue size
½ part linseed oil
Add part of the glue size to the whiting and zinc oxide and mix it into a paste. Add the linseed oil one drop at a time and beat it into the mixture. Mix in the rest of the glue size and keep the whole mixture warm in a double boiler until use.

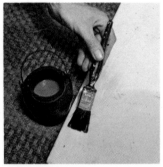

Applying size and ground to a canvas 1. Heat size in a double boiler and brush it on the canvas, working well into the weave.

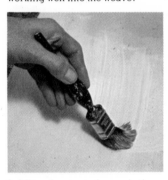

2. When the size is dry apply the white ground in an even coat. Do not lay it too thickly. Let it dry out, and apply another coat.

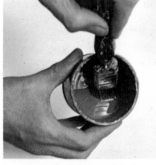

Staining a white ground 1. Mix up paint with plenty of turpentine in a tin or jar. Make enough to cover the whole canvas.

2. Brush the paint generously over the white ground so that the surface is completely covered with wet color.

3. Wipe the canvas with a dry rag to soak up the excess paint, leaving a stain of color. Repeat as necessary.

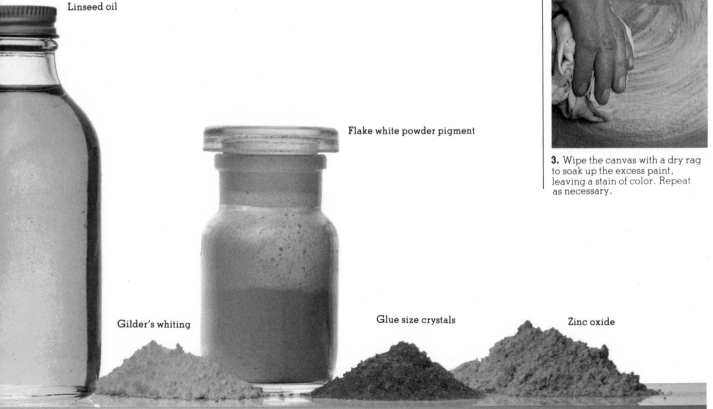

Linseed oil

Flake white powder pigment

Gilder's whiting

Glue size crystals

Zinc oxide

3 | **Oil painting** Equipment

Paints

Two grades of ready-made oil paints are sold: those labelled 'Artists' and a cheaper kind, called 'Students', or by some trade name. The cheaper contain lower-quality pigments and may be less permanent.

In general, the same pigments are used in oils as in watercolors, gouache, tempera and acrylics. Only three pigments are comparatively unaffected by conditions which alter the properties of other pigments: heat, light, moisture, acidity or alkalinity. These are carbon black, cobalt and viridian.

Most permanent are the earth colors such as yellow ochre, terre verte, raw and burnt sienna, raw and burnt umber, light red, Indian red, Venetian red and natural ultramarine. These are natural earths. Artificial mineral pigments include aureolin, the cadmiums, viridian and cobalt blue. Organic pigments are divided into animal: sepia, carmine, Indian yellow; vegetable: gamboge, the madders, sap green, indigo; and artificial: Prussian blue. It is vital to use good quality whites, as nearly all colors are mixed with them.

Most pigments are susceptible to chemical interactions and atmospheric conditions. Lead white, for instance, a metal-based pigment, can be discolored by sulphur fumes in the air. Ageing oil yellows, and can turn chrome yellow into a green. Strong sunlight darkens madder, sepia and carmine. Metal-based pigments blacken if mixed with sulphides such as the cadmiums; and should not be mixed with certain synthetics, including vermilion and ultramarine.

Many made-up paints contain an excess of oil to increase their shelf life; and although this can be removed by placing the paint on an absorbent surface, many artists prefer to make up at least some of their colors from scratch, adding just as much or as little oil as they need, experimenting with textures and direct blending of pigments.

Raw pigments can be bought at most artists' supply stores, together with the equipment for home mixing: a glass slab or old litho stone, a glass miller or muller and a palette knife or spatula. Pour enough binder on the powdered pigment on the glass to make it glutinous and blend it with the palette knife. Stir the paint with a circular motion until it is of an even consistency, exerting pressure with the glass muller. The paint can be stored in a glass jar, covering it with water if it is to be kept for long.

Brushes

Oil painting brushes are usually of bleached hogs' hair and red sable hair. The making of good quality brushes, even on a mass production basis, is a skilled craft. A brushmaker will never trim the painting ends of the brushes, but will shuffle and arrange the hairs or bristles and adjust them within the metal grip or ferrule to give the right shape, even utilizing the natural curve of some bristles so that they form a gentle curve inwards instead of splaying out.

Hogs' bristle has split ends, which help hold the paint to the brush; and this is reckoned an advantage over sable brushes which, nevertheless, give a smoother stroke and find a place in any good collection of brushes. They are generally thinner and smaller.

The basic brush shapes are bright, round, flat and filbert. Brights are short-bristled with square ends; rounds are round and round-ended, good for thin paint; flats are similar to brights but with longer bristles, giving a longer stroke; filberts are similar to rounds but wider; 'longs' in sable oil brushes are similar to bristle flats; chisel edges, good for painting straight edges, are not often seen today.

Wide, supple badger blenders, made from badger hair, are used to take out brush strokes or blend wet areas into each other. Wipe them often on absorbent cloth when employing this technique. Fan brushes of red sable are used for the same purpose as badger blenders but give a softer effect.

Brushes should be cleaned immediately after each day's use. First rinse them in turpentine or white spirit and wipe them dry, or shake them in warm water with a strong household soap and wash the soap off thoroughly under warm running water.

Brushes which have been caked with paint for a long time can be cleaned with paint stripper, but this shortens their lives. Never leave a brush soaking with the bristles or hairs touching the sides or bottom of the container.

Other oil painting equipment

Knives Palette knives, made from smooth flexible steel, come in many shapes and sizes and are used for mixing the paint on the palette; painting knives, with thin, delicate blades and often longer handles, are used to apply paint directly to the canvas.

Palettes Palettes can be oval or rectangular and made of wood, china or glass. Palettes with thumb holes are made for easel painting; but, in the studio, palettes of almost any non-porous material can be placed handily on a nearby steady surface.

Treat new wooden palettes with linseed oil to prevent the wood feeding on the oil in the paint. Disposable paper palettes, with paint-proof peel-off sheets, are now made.

Dippers Dippers are small open-topped cans made to hold oil and turpentine and clip on to the edge of the palette. But in the studio it may be more convenient to use containers resting on a nearby steady surface.

Mahl sticks A mahl stick is traditionally a cane with a chamois tip which rests on the canvas to steady the painting arm. Some are now made of aluminium with a rubber tip and come in 12, 24, and 36in sizes. But they are easy to make by tying a bundle of rags to the end of a garden cane.

Easels Easels vary greatly in size and weight. The most comfortable is the traditional artist's donkey, a

studio easel at which the artist can work sitting down; but the simplest kind of radial easel is substantial enough for most needs. It has short tripod legs and the upright column can be tilted and fixed by a screw, while the tray and top grip for the stretcher or board slide up and down the column.

Paint and palettes

Although commercially available tube paints are a relatively recent development in the history of oil painting, the researches of color chemists since the nineteenth century have provided an enormous range of colors for contemporary artists, from both natural and synthetic pigments. The type of pigment affects the cost of the paint and charts produced by manufacturers (**above**) generally code the colors to indicate the price, and also include notes on the permanence of colors. So very many colors can be bought that it is now less common to find that artists have mixed their own paint from basic ingredients, but this may still be necessary where a specific color or paint quality is required.

The traditional oil painter's palette is a flat piece of wood with a thumbhole and indentation at one end for the fingers (**4, 8**). These are intended for easel painters, so that the full range of color can be laid out and held ready while working. Small dippers (**5**) can be attached to the palette with clips to hold oil or turpentine. Palette boxes (**1, 2**) are useful for outdoor work and oil sketching, as they can be closed up and carried with the colors still in place. Recessed palettes are available in plastic (**3**), aluminium (**7**) and china and may be useful for mixing thin paint for glazes. Paper palettes (**6**) are disposable and can be torn off as they are used to save cleaning. For studio use, a large sheet of glass or wood may be all that is required

Oil and painting kits Boxes (**above**) with basic equipment for oil painting are available in several sizes. This is an expensive way of buying materials but can be useful for travelling or outdoor work. A brush holder (**left**) is also handy and can be hung on a small easel. The brushes can be fixed into the holder so that they are suspended in turpentine and kept moist.

Brushes for oil painting

The three basic shapes of oil brushes are shown **above.** Flat brushes (**left**) are very versatile, as broad strokes can be made with the flat of the brush, or fine lines and dabs of paint with the tips or side of the bristles. Filbert brushes (center) are shaped slightly at the tip to produce a smooth, rounded stroke. Round hair brushes (**right**) are useful for applying thin paint and for covering large areas which contain no detail.

There are a number of different types of brushes (**right**) which vary according to the type of hair used for the bristles and the overall size. Hogs' hair or sable are the best bristles, but many different synthetic materials have been developed for brushes which are often perfectly adequate. Flat brushes may be made with long bristles, or with shorter hairs in which case they are known as brights. The examples shown here are: (from **top** to **bottom**) red sable bright, synthetic flat, Russian sable bright, hogs' hair filbert, hogs' hair flat, synthetic bright, synthetic round, red sable round, red sable fan blender. Fan brushes are made for one purpose. The splayed bristles make it easy to feather wet paint and blend colors together. The strength of hogs' hair makes it more suitable than sable for applying large areas of thick paint quickly; but if detailed work is to be done, sable is better because a point can be obtained. Hogs' hair is too stiff and thick to make a real point. Synthetics vary in quality, but some have the advantage of being quite firm, but less coarse than hogs' hair. Flat brushes, carefully handled, can be ideal for working into a definite outline, as they do not splay out so much under pressure as round brushes. In this respect also, brights may be easier to control than flat brushes with long bristles. To lay paint with a smooth, flat surface, the brush should be handled firmly while applying the paint, but then used lightly in all directions to feather over the surface and remove brushmarks.

Mahl stick and palette knives A mahl stick (**1**) is a useful aid in painting and can be bought ready made, or assembled from easily obtained materials. It is used as a rest for the hand which holds the brush, to steady it when painting details, and consists of a length of bamboo or dowling with a cushion at one end. The stick is held across the canvas with the cushioned end resting lightly on the painting. Care must be taken not to mark the canvas by pressing too hard. Palette knives have several uses. As the name implies, they were principally used to mix up color on the palette, but they are a good alternative to brushes for certain techniques, such as impasto, and may be used to scrape away wet paint when making alterations to the picture. The particular uses of the different shapes and sizes are to some extent a matter of the painter's own preference. The broad, rounded blades (**2**, **6**) are flexible along the whole length and exert the necessary pressure for mixing the colors on the palette. The long side of these knives can be used to scrape away wet paint without damaging the ground or the canvas. Painting knives with small, angular blades (**3**, **4**, **5**) are used to apply and shape small dabs or broad sweeps of paint to the canvas. A plastic palette knife (**7**) is also useful.

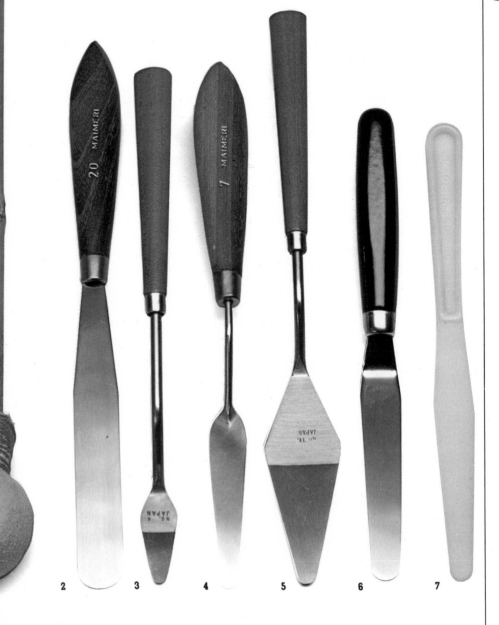

1 2 3 4 5 6 7

Brush sizes Brushes are produced in series, a range of sizes in which the composition of the brush remains the same. As shown here, for instance, a series of round hogs' hair brushes may be produced in twelve sizes, the smallest numbered 1, and so on up to the largest, 12. This applies to all shapes of brushes and types of bristles. A painter may prefer to use only one shape of brush, perhaps filberts, and will then require several different sizes. On the other hand, if all types of brushes are used, only three sizes of each may be necessary, small, medium and large. Large sable brushes can be extremely expensive, and it may be preferable to find a substitute. The type of brush needed will obviously also depend upon the style of the work and could be quite limited. A useful, all-purpose range of brushes might contain two or three sizes of each.

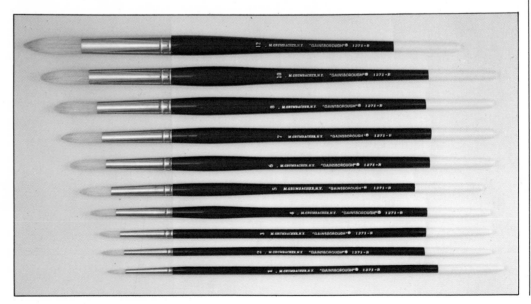

3 | **Oils**: Equipment

Easels for oils Easels provide a firm support for painting. A good easel is therefore an essential piece of equipment for all artists, including the beginner. A wide selection of easels is available to suit the artist's needs. Modern easels vary considerably in size, weight and style. Easels that are permanently in a studio tend to be heavy and made of a durable hardwood such as beech. They should be positioned carefully in a studio to receive the best possible light. If the studio is small, consider buying a collapsible easel which may be stored away when not in use. Lightweight aluminium easels provide an alternative to sturdy wooden ones. They are inexpensive, but they are not as stable as wooden easels. Portable folding easels are convenient for work done outside the studio. The combination sketch box-easel-canvas carrier (**1**), made from a seasoned hardwood, is very compact and weighs only 13 lbs when empty. This makes it suitable for artists who travel or who do not have a large studio. By unfolding the legs, the sketch box is quickly converted into an easel. The legs should be adjusted to the desired height and position. The canvas carrier section of the easel should also be set at a convenient angle at a comfortable height. There is a useful drawer in the easel where paints and brushes may be kept. Another popular easel is the

traditional artist's donkey (**3**). This is a large easel that incorporates a bench. Although it takes up a good deal of space, it is often used by artists who prefer to work sitting down. It is particularly used for detail work which can be tiring if done standing up. The angle of the easel can be adjusted readily and the drawing board or canvas held firm by wooden sliding blocks. A table easel (**4**) can be used on a low table or on a high chair. This is a handy easel that is compact when folded for carrying or storage. It can be adjusted either backwards or forwards to a working angle. For outdoor work a collapsible easel (**5**) is required. This model has telescopic legs that are easily adjusted to the right height. Although it is fairly light, it

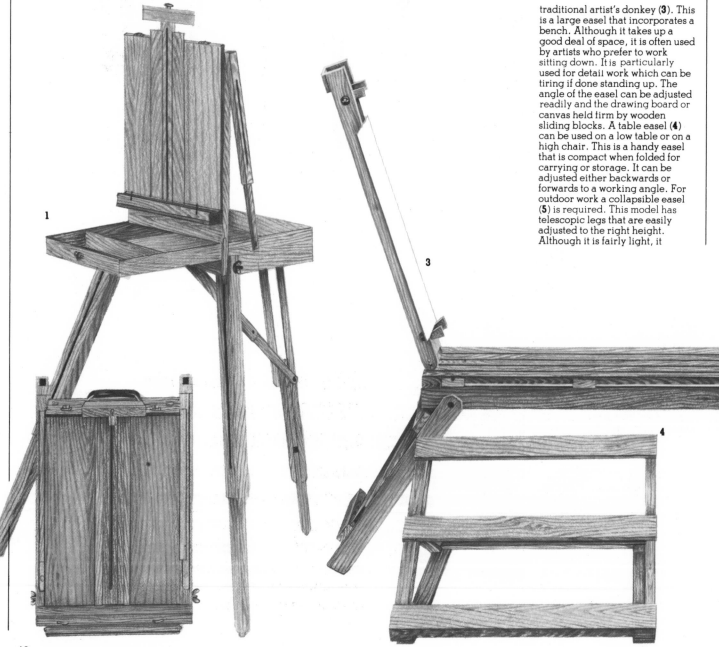

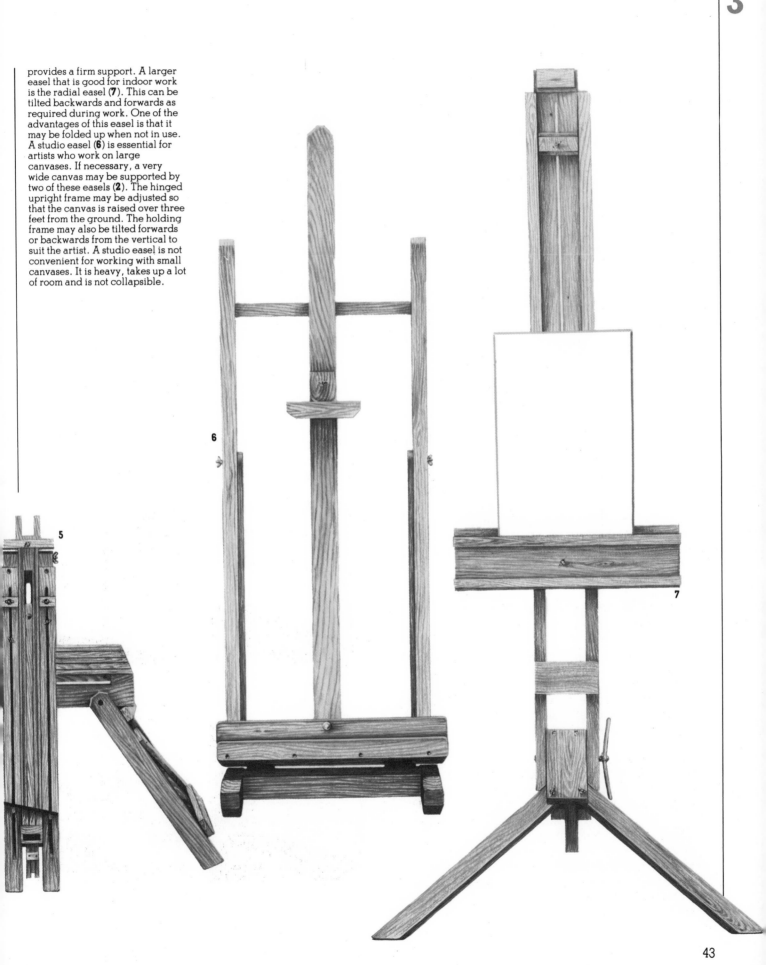

provides a firm support. A larger easel that is good for indoor work is the radial easel (**7**). This can be tilted backwards and forwards as required during work. One of the advantages of this easel is that it may be folded up when not in use. A studio easel (**6**) is essential for artists who work on large canvases. If necessary, a very wide canvas may be supported by two of these easels (**2**). The hinged upright frame may be adjusted so that the canvas is raised over three feet from the ground. The holding frame may also be tilted forwards or backwards from the vertical to suit the artist. A studio easel is not convenient for working with small canvases. It is heavy, takes up a lot of room and is not collapsible.

3 | **Oil painting** Techniques

Every artist develops a personal style in time, after mastering his or her chosen medium, and today's painters are fortunate in having the wealth of the past, conveyed in modern color reproduction, over which to ponder and consider along what paths their own stylistic leanings and aesthetic values may lead them.

In very broad terms, there are two contrasting types of oil painting; the carefully considered work, built up slowly over weeks, months or even years; and the *alla prima* type, in which the artist is concerned with directly conveying a first impression of the subject, usually in a single session, without a preliminary drawing stage.

Titian used this direct method, applying his color immediately without any preliminary sketching: drawing, so to speak, as he painted. Michelangelo was slyly derogatory about this method, saying that it was a pity the Venetians did not start painting by learning to draw first. Velasquez also liked to work *alla prima*.

One of the main features of modern *alla prima* painting is the wet-into-wet technique. While the first layer is still wet, the artist paints or scumbles into it, at times making the colors deliberately run into each other. This technique is clearly shown in *The Fifer* by Edouard Manet (1832–1883) in the Jeu de Paume Museum in Paris. Flat areas of color are thrown into contrast by the impasto on sash and spats.

Monet was a leading exponent of *alla prima* painting. Like van Gogh, he took his canvases to his subjects, often outdoors, and painted rapidly with little or no underpainting. Sisley, Gauguin and Cézanne used solid strokes of opaque color with the many variations of scumbles and glazes and transparencies. Even Turner, long before the Impressionists, realized the advantages of *alla prima* as can be seen in his fluid preliminary landscape studies. The British artist L. S. Lowry (1887–1976) sometimes blended thick colors while they were still wet, as in his *Yachts at Lytham*.

'Frottage' on oils is another wet technique started by Max Ernst (1891–1976). It is a method of forming an uneven texture on wet, flat opaque color. A sheet of non-absorbent paper is put over it, gently pressed on to the paint, then peeled away.

Planned and pre-drawn oil painting goes back to van Eyck. Other major practitioners include Rubens, David, Turner, Degas and Salvador Dali. These artists sketched their designs first, either with charcoal washed over with a thin glaze which still showed the lines; or painted on with thin brush strokes.

Some artists draw a whole sketch separately and then transfer it to the canvas by squaring-up: drawing a squared grid on the original sketch, then a respectively-sized grid on to the canvas. Then they copy the picture in each sketch square on to the canvas.

Underpainting is a method of putting down neutral tones and colors in lean paint as part of the design to form a basis for light and shaded overpainting.

Rembrandt and the grisaille painters who followed him underpainted in grays and whites overlaid with thin glazes, with dark tones for shadows also glazed over.

Glazes reflect light from the color beneath them, giving a painting a glowing, three-dimensional quality. The medium should contain beeswax in preference to linseed oil, which tends to move. Glazes can be laid over underpaint, impastos, or opaque paint. Titian and El Greco (1541–1614) painted lustrous rich red tapestries by using glazes over underpaint and impasto.

'Impasto' is thick paint applied with a knife or brush to give a three-dimensional effect. It is mainly used under glazes, but some painters have made whole pictures from impastos, giving a rich-textured effect. Impasto is best mixed with a resinous medium.

Scumbling is the application of opaque paint over darker opaque paint in an uneven manner so that the paint underneath shows through. It can be brushed on in a circular motion, dabbed, stippled, smudged or streaked. Scumbling can also be done with the edge of the hand, the fingers, or a cloth.

It is not vital to varnish all oil paintings. Most will not suffer if hung in reasonable conditions; and varnish does tend to yellow with age. However, if varnishing must be done to protect the painting, wait for six months or so until the paint is really dry. For a glossy finish, use a soft resin or spirit varnish; for a slightly matt surface, use a wax varnish.

Squaring up 1. Draw a light grid of squares over a drawing. Place the drawing on an easel beside the canvas.

3. Draw in the basic outlines of the composition using the grid as a guide. Work until there is enough detail to start painting.

2. Mark out on the canvas a grid proportionate — either enlarged or reduced — to the grid on the drawing.

Underpainting 1. Using paint well thinned with turpentine, start to lay in basic areas of tone and work the color into the canvas weave.

2. Continue working over the area with the thinned paint, following the drawn outlines so that the main shapes begin to emerge.

3. The colors underneath glow through the glaze but the hues are modified. Allow each layer to dry fully before adding more glaze.

Glazing over impasto 1. Lay thick paint with a knife, making a coarse, craggy texture. Leave it until the surface has dried out.

3. Block in large areas of basic tone with thinned paint in a neutral color. Let the drawing show through the paint.

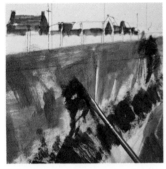

3. Use thinned paint in another color to provide darker areas of tone and start to work in the detailed shapes.

Glazing over oil crayon.
1. Draw directly on the canvas with oil crayons, varying the thickness of the marks.

2. Mix up thin paint for glazing, brush lightly over the impasto paint and let it settle into the pitted surface.

4. Use thicker paint to establish the main colors and basic shapes.

Glazing 1. Mix paint for glazing with a medium, not with turpentine alone, so that it has a thin but oily consistency.

2. Mix up a quantity of paint thinned with medium to make a transparent glaze. Paint lightly over the crayoned area.

Underdrawing with charcoal
1. Draw out the composition quite freely with charcoal using line and tone; correct as necessary.

5. Gradually obliterate the drawing as the painting develops.

2. Apply the glaze in a thin layer over the dried underpainting to form a transparent film of color.

3. Thick areas of crayon show clearly through the thin paint. Light areas of crayon form a textured sheen underneath.

2. Dust the drawing over lightly with a clean rag before starting to paint, to remove charcoal dust from the canvas.

Making a mahl stick 1. Cut two small grooves around a piece of dowling 3 feet long, about 1 inch from the end.

2. Fit absorbent cotton on the end of the dowling. Tease it out so that it forms a soft knob over the cut end.

3. Wrap a clean piece of cloth over absorbent cotton and tie with string so that the grooves hold it firmly. Trim the cloth.

4. To use the mahl stick, rest the soft end gently on the canvas or edge of the stretcher and steady the brush hand on the stick.

Scraping back and wiping 1. To retrieve the surface for repainting, scrape back paint from the canvas with a palette knife.

2. Wipe the scraped area with a rag soaked in turpentine. Clean away as much paint as possible from the canvas.

Painting wet into wet 1. Lay a patch of color. While it is wet work into it with a second color and blend together.

2. Work in another color and blend it into the others, making a range of tones develop. Keep the paint wet and brush into it loosely.

3. Add more paint until the required effect is achieved. Lay in more color to redefine the tones if necessary.

Blending with a fan brush 1. Paint stripes of different tones of one color side by side on the canvas.

2. Brush lightly with the fan brush over the line where two colors meet. Wipe surplus paint off the brush while working.

3. Continue to work across the bands of color until they are all blended together smoothly and no harsh lines are visible.

4. The completed area shows a soft progression through the tonal range. Use a fan brush also to blend different hues.

Brushmarks 1. The mark left by a brush depends on its shape and the hair from which it is made. This is a hogs' hair filbert.

2. This chisel-shaped brush is also made of hogs' hair. Hogs' hair has a split end which helps hold the paint.

3. The main brush shapes are bright, flat, round and filbert. This hogs' hair brush is a round.

4. This smaller round brush is made of sable. Use this brush to touch in small areas. Sable gives a smooth, soft stroke.

5. This small hogs' hair filbert is useful for making long tapering strokes. Filberts curve gently to a point at the top.

6. This large hogs' hair chisel is being used to allow the paint to dribble.

7. A fine sable brush like this can be used with a ruler. Any artist needs a selection of brush sizes and shapes.

Cleaning a brush 1. Rinse the brush in a jar of turpentine and wipe it thoroughly with a rag.

2. Clean the bristles with soap under running water. Work the soap well into the brush to remove all the color, rinse well.

Impasto with a brush 1. Mix up thick paint on the palette, adding only enough turpentine to make it malleable.

2. Load the brush with paint and apply it thickly to the canvas in short, heavy strokes, leaving brush marks.

3. Build up an impasto layer with small, thick dabs of different colors. The brushmarks help to describe form and texture.

Impasto with a knife 1. Mix thick paint on the palette with a knife, add medium if necessary to give the paint extra body.

2. Scoop up a generous amount of paint on the knife and spread it on the canvas. Work it into broad, textured ridges.

Mixing sawdust with paint 1. Lay out paint and sawdust on the palette and mix them well together.

2. The textured paint should be thick but not too dry. Spread it over the canvas, work it into the weave to make it adhere.

Scratched textures 1. Lay an area of thick paint and while it is wet, scrape away small marks with the end of a palette knife.

2. Use a stick or the wood end of a brush to scratch into thick, wet paint, as if drawing. A variety of marks can be made this way.

Scumbling Load the brush with fairly dry paint and dab lightly with the brush, making an area of broken color.

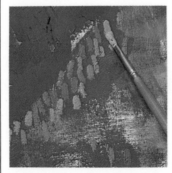

Frottage with flat paper 1. Using paint thinned with oil and turpentine, lay an area of flat color.

2. Lay a sheet of paper over the paint and press it down gently. Rub lightly over the paper with the fingertips.

3. Peel the paper away. It lifts some of the paint to form a textured surface. Experiment until you get the right effect.

Frottage with crumped paper 1. Crumple paper into a tight ball and open it out carefully. Press the paper into a patch of wet paint.

2. Peel the paper back from the paint. If it has not lifted enough paint, repeat the process with a clean piece of paper.

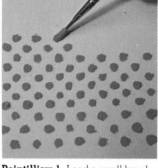

Pointillism 1. Load a small brush with paint and, using the tip of the brush, make a pattern of regular dots.

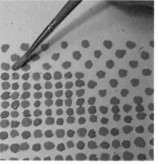

2. Work over the area with dots of another color. Keep the colors separate at this stage and do not let them overlap.

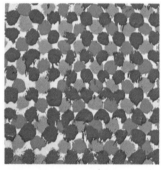

3. Add a third color. Start gradually to cover the white space and let the dots begin to join up and overlap.

4. To alter the impression of the spotted area, change the relationships of warm and cold hues and light and dark tones.

5. Work over again in a fourth color. The number of colors which can be used is virtually unlimited.

6. Different stages of the process show how the colors are successively modified. At a distance, the colors merge.

Stencilling 1. Hold the stencil firmly against the canvas and dab on fairly dry paint with the flat of the brush bristles.

2. Peel back the stencil carefully and check that the painted shape is clean. If the paint is too wet the edges will blur.

3. Repeat the stencilling with a different shape and color. Be careful, if overlapping shapes, not to disturb the color beneath.

4. Bought stencils can be used for letter forms and figures. You can cut any shape required from stencil film or thin card.

Varnishing Apply varnish evenly with the brush held almost flat to the canvas. Oils should dry for some months before varnishing.

Acrylics.

Development and characteristics. Surfaces: Canvas, Wood, Metals, Paper and card, Murals. **Paint and equipment. Techniques:** Glazes, Flat color, Brushing, Hard edge design and drawing with line, Impasto, Airbrushing, Cleaning, Varnishing.

Paints comprising pigment bound in a synthetic resin are usually known as acrylics. Even if the resin is not an acrylic but a polyvinyl acetate, for example, the paints are still loosely referred to as acrylics.

Acrylic paint in art developed from the need to combat atmospheric conditions. Artists working in Mexico in the 1920s found that oil paint and even fresco was not sufficiently durable in a permanently exposed position. For work such as murals they required a paint which would dry quickly and remain stable under all weather conditions.

Notable pioneers of the use of acrylics in art were painter and illustrator José Clemente Orozco (1883–1949), Diego Rivera (1886–1957), noted for his murals, and David Alfaro Siqueiros (1896–1974). Siqueiros delivered a paper on *The Mexican Experiment in Art* as a delegate to the American Artists' Congress in New York. Shortly afterwards, in 1936, he established an experimental workshop, named after him, where artists studied the new medium of acrylics.

Almost every traditional method of art is still being used today, but until acrylics first appeared artists had used the same materials for over 400 years. At first painters used acrylics similarly to traditional media, but it was not long before they exploited the special characteristics and extended their use far beyond exterior murals.

Acrylics resemble watercolor, gouache and tempera in body and substance of color. They dry to an even, matt finish. Acrylic paints are emulsions and can be diluted with acrylic media or water or both. Their great advantage is that, although they can be diluted with water, they dry within minutes and once dry do not change in color or texture. The surface is sealed, and the artist can either lay more paint or a glaze over the top without either coat altering, each layer being sufficiently porous to allow total evaporation and of such adhesive strength as to form almost indestructible strata. The paints resist chemical decomposition and oxydization. Both acrylic paint and PVA are stable, do not reflect light and are opaque, although they can be diluted to obtain transparency. Rapid drying can be halted by adding a proprietary retarder or pure glycerin to the paint on the palette.

By the 1950s acrylic paints were on sale in the United States and being widely used by such artists as Jackson Pollock (1912–1956), Mark Rothko (1903–1970), Kenneth Noland (born 1929) and Robert Motherwell (born 1913). Much of their work was abstract or Pop in form. Pollock was much influenced by Orozco's expressionism and by the techniques of the Surrealists in the 1940s. Pollock often poured paint on to a canvas on the floor and he used many glazes and impastos. Noland uses solid areas of opaque color which have hard edges.

It was not until the 1960s that acrylic paints were widely available in Britain. They are now used by such well-known British artists as David Hockney (born 1937), Leonard Rosoman (born 1912), Bridget Riley (born 1931), Peter Blake (born 1932) and Tom Phillips (born 1937).

Acrylics Paint and equipment

A selection of the basic colors, not necessarily more than 15, can provide a wide range of colors and tones. Winsor and Newton's Liquitex and Aqua-Tec encompass a wide choice as does Rowney's Cryla. Although PVA colors are cheaper, they lack permanence. A basic palette would include black, white, lemon yellow, yellow ochre, raw sienna, Venetian red, cadmium red, deep violet, cerulean blue, cobalt blue, ultramarine, Hooker's green, monastral green and bright green. As a result of laboratory research new colors such as phthalocyanine green and dioxazine purple are available as well as the traditional colors. The nozzle of the tube of paint must be cleaned after use and before replacing the cap to prevent air penetrating and solidifying the contents.

Gouache colors, available from Rowney, can be mixed with acrylic medium on the palette, allowing layers of paint to be laid over each other without the color underneath being affected—which ordinary gouache will not do. Medium is added to the paint as described in this chapter in the section on glazes.

Apart from the materials described in connection with each technique, equipment for painting with acrylics, such as knives, easels, palettes and drawing-boards, is common to oil and water-color painting. It is usually easier, however, to clean acrylic paint from white plastic palettes than from wood. Sable water-color brushes are best if using diluted acrylic for fine work. Acrylic paint dries so hard so quickly that brushes must be thoroughly washed of all pigment in warm water immediately after use. A completely solid brush can be soaked in methylated spirits for about 12 hours; the paint can then be worked out between the fingers and the brush washed immediately in a mixture of soap and water.

Airbrushes must be cleaned thoroughly and the parts checked regularly to ensure that they have not worked loose. Spitting could mean that the needle is stuck on a coarse particle of pigment or that the paint needs thinning. If the paint comes out irregularly it could be that the needle is out of place or fitted too tightly, the nozzle is worn, or the pigment has dried in the nozzle's fluid passage; the latter requires the nozzle to be soaked for a long time and cleaned. A bent needle or an obstruction in the air cap can cause a lop-sided spray. The nozzle cap can cause the paint to build up; it should be cleaned either by removing it and placing the tip flat on a piece of paper and blowing, or by unscrewing it and cleaning it inside and out with a stiff brush, a damp lint-free cloth or a toothpick.

Acrylic paints, mediums, varnishes Rowney Cryla (**2**) is just one example of the wide range of acrylic paints on sale today. Grumbacher, and Winsor and Newton manufacture similar ranges. The liquid texture of Rowney Flow Formula (**1**) is used for covering large areas with flat color. The canvas should be primed with an acrylic primer (**3**) or gesso (**4**). Mediums are available in gloss (**5**, **7**, **11**, **13**) or matt (**6**, **10**) textures. Retarding medium (**16**) slows the drying time of the paint. Like mediums, varnishes can be matt (**8**, **9**) or gloss. Acrylic varnishes are normally insoluble, but Rowney make a soluble gloss variety (**12**). Also useful are gel medium (**15**) and water tension breaker (**14**).

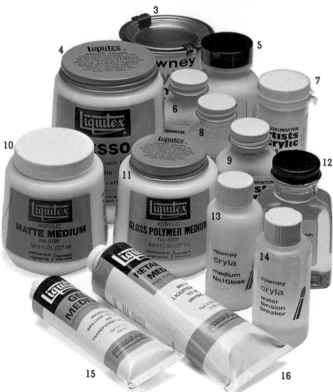

Mixing tube paint with medium
1. Squeeze out some paint on to the palette and drop in a quantity of the medium.

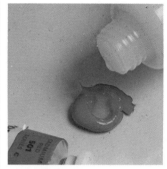

2. Mix with a brush. Medium can give the paint a matt or gloss finish. Thin with water if required. Mix two colors like this also.

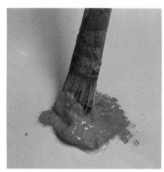

Making up acrylic paint 1. Large quantities of paint can be mixed up using raw acrylic medium, gel and powder or liquid pigments.

2. To make the gel, pour the liquid acrylic medium into a large container and slowly add the thickening agent.

3. Stir the mixture vigorously as it begins to gel. Do not add too much thickening agent. Let it stand for 8-12 hours to gel.

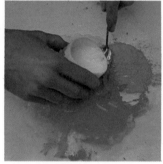

4. To mix the paint, place the powder pigment on the palette and pour on the liquid acrylic medium. Mix them with a knife.

5. Add a few drops of water, mix in the gel gradually until the paint is the right consistency.

6. The mixed paint has a thick, smooth consistency but can be thinned with water as required.

Acrylic paint can be laid on almost any practical support. A ground is not necessary, but an acrylic primer is generally used. This is an acrylic medium mixed with inert titanium white, and two or three thin coats are usually applied. Unprimed surfaces dry to a matt finish. Paint on a primed surface produces a slight gloss, but this can be prevented by adding water to the paint. Oil-primed canvas cannot be used for acrylic paints; nor are ordinary emulsion grounds compatible with acrylic. Polymer primer is often referred to as polymer gesso, but it is not a real chalk-glue mixture gesso which is fully absorbent.

Canvas

All types of canvas are good supports for acrylics, and glue size is not required. When stretching unprimed canvas a little slack should be allowed, because the primer or paint makes it contract and become taut. If a canvas such as hessian with a very coarse weave is being used, an acrylic medium is required; the two chief types are the standard or gloss and the matt. The latter can be used as a final protective coat. Both can be used without water. There are also glaze media which produce a transparent effect.

Wood

Acrylic paints and wooden panels combine well; natural wood, plywood, compressed woods, block-boards and hardboard can be used. Hardboard must be cradled at the back to prevent buckling; its smooth side should be sanded and an acrylic primer applied before painting.

Metals

Copper and zinc are the most suitable metals for acrylic paints. Coarse sanding and an application of primer is recommended.

Paper and card

Acrylics can be painted on almost any card and heavy paper, whether primed or unprimed. Paper may buckle under the weight of the primer, and it should therefore be stretched over a frame if big washes of paint are contemplated.

Murals

External walls usually require some preparation, but acrylic paints are particularly suitable since they weather better than oils and do not reflect light. Plaster should be sanded smooth before priming or painting.

Preparing surfaces for acrylic paint Acrylic paint can be used on a wide variety of surfaces, but it is important to prepare the surface correctly. If a primer is used, it must be of the acrylic variety; ordinary primer will not bind with acrylic paint. Acrylic primer is a mixture of acrylic medium and titanium white. Ready-made varieties are not expensive. It is best to coat the surface carefully and evenly with two or three coats, allowing each to dry thoroughly before the next is applied. A primed surface will dry to a slightly egg-shell gloss finish, while an unprimed, absorbent surface will dry to give an even matt finish, because the surface absorbs the pigment.

Staining raw canvas 1. Thin the paint so that it is liquid and wipe it evenly over the canvas weave, using a sponge.

2. Staining with a brush is a slower process. Load the brush with thin paint and work it well into the canvas weave.

3. A canvas may be stained evenly in one color, or with different patches of color. These will mix where they overlap.

Acrylics Techniques

Acrylic paints have a transparency which is similar to watercolor in that a white ground will shine through a color without needing further white overpainting. The paints take on a transparency when mixed with water or acrylic medium.

Glazes

Acrylic paint for glazing, mixed with water or glaze medium, is used in the initial stages of the painting. Medium is added to paint on the palette by dripping a little into a well made in a small blob of paint and

mixing it thoroughly with a wet brush or palette knife. A little water added in the same way further dilutes the paint. When mixing more than one color with medium, the separate blobs of color should be mixed together on the palette and the medium then worked in. The paint is brushed thinly on the canvas so the ground shows through, and successive layers can be applied as each dries. A very watered color may need a little gloss or matt medium added to maintain the paint's adhesive properties.

Flat color
Few acrylic colors can be laid as flat color without dilution, and these few need several solid coats of paint applied with a brush or palette knife. Rowney's Flow Formula range, for example, flows and brushes out more easily for painting large areas in opaque color. Well-diluted Flow Formula applied to an unprimed canvas leaves the weave visible as part of the finished painting. Hyplar is a similar range of acrylic colors manufactured by Grumbacher.

Brushing
Brushmarks can be eliminated by brushing a thin layer of diluted paint well into the canvas and then into the weave with a dry rag. After a few minutes a second coat is applied which can be either lighter or darker. When dry, a third coat is applied evenly.

Many styles and techniques can be achieved with acrylic paints and brushmarks can be made into a feature of the work. The British artist Tom Phillips, for example, uses stippling, hatching and dry brushing to achieve particular effects and hard straight edges with masking tape. His acrylic painting *Benches*, which reproduces postcard images, measures 9 feet by 4 feet (2.74m by 1.22m) and consists of three separate canvases. He applied all the paint—19 Aqua-Tec colors—with long, square signwriting brushes.

The dry brushing techniques, used in oil and water-color painting, can be used with undiluted or diluted acrylic paint. The brush is kept dry, the bristles being fanned under slight pressure during the painting.

Hard edge design and drawing with line
The lines are drawn in pencil for a hard edge design and masking tape is then stuck along the edges. The paint is taken up to and over the tape which is then carefully peeled away. The paint dries and the tape is then stuck on another pencil line. Very fine lines can be drawn by using masking tape according to a finely drawn design—and this is known as drawing with line. Thinned paint is applied with soft sable brushes.

Impastos
The British artist John Bratby (born 1928) makes impastos by squeezing acrylic paint directly on to the canvas. Although this method involves a longer drying time than mixing first on the palette with a little water or medium and applying with a brush or knife, it adheres to the support immediately. Impastos are made more quickly and easily with acrylic paints than with oils. A textured paste made for impastos can be applied to the support and painted over, but it does not handle like paint and does not reflect the characteristics of an artist's style.

Airbrushing
Acrylic paint can be used in airbrushes in the same way as oils, gouache and watercolors. As with oils, acrylics can be airbrushed on to canvas, board and metal sheets, and walls provided that the surface has been prepared. The smallest form of airbrush today is an atomizer. Airbrushes are precision instruments which can produce extremely fine lines and tonal gradations which give a photographic effect. Those used for delicate work have a small paint or dye reservoir which is filled with an eye-dropper or paint brush. Those used for larger works have a bigger nozzle and a paint reservoir into which the paint is poured. Sprayguns are used for really large areas: the paint is diluted until it is as thin as milk.

Air is blown through the airbrush before filling the reservoir to clear any moisture or dust. It is held like a pen at different angles to the paper, depending on the effect sought. The brush is controlled by pressing the button down for the air supply and backwards for the paint supply. The color can be changed by pouring the paint out of the reservoir, filling it with water and spraying it through until it sprays clear; the reservoir can then be refilled.

Fine lines are drawn by holding the airbrush close to the paper and pressing the control button back very slightly. Straight lines can be drawn by resting the nozzle on the raised edge of a ruler which is held with the other hand, and sliding the nozzle along the ruler while spraying. Colors which contain finely ground pigment are best for fine work.

Flat, evenly colored patches are obtained by spraying opaque paint in parallel lines about 4 inches (10cm) above the paper, each stroke slightly overlapping the last.

Areas of graded tone are achieved by working from the lightest tone to the darkest, again in parallel lines, using a little backward pressure for the first stroke and increasing it with each stroke. A gradation can also be obtained by using a light tone of the color first, mixed on the palette with white, and then a darker tone. Transparent colors are the most suitable for graduating and merging different colors; two colors can be combined to produce a third by this method.

Spattered or mottled effects can be achieved either by fitting a special spatter cap instead of the air cap or by lowering the air pressure, or by pressing the control button back, but not down.

Masks are essential to prevent other parts of the painting being sprayed, and they can be used to

define specific shapes and edges. A design can be traced and lightly cut with a scalpel from masking film, a transparent adhesive plastic. The cut pieces of the film are lifted out for airbrushing color on to the painting and are then replaced to protect that piece while another segment is lifted out. A soft or hard edge design can be made using a thin piece of card from which a shape has been cut. The card edge is held a little above the painting and moved after each spraying. The closer the card, the sharper the edge.

Masking fluid can be painted on to form a thin coat of latex over the areas not to be sprayed. Intricate patterns of fine lines and dots can be scored through the latex so that the paint penetrates them—this is a form of hatching and stippling. When the paint is dry the mask is rubbed gently with an eraser and then peeled off.

Other forms of masks include stencils which are available in many shapes and patterns, and pieces of absorbent cotton or cloth.

Cleaning and varnishing
An acrylic painting is waterproof and can be cleaned with soap and water and finally sponged with clean water. Although varnishing is not needed, a matt acrylic varnish can be applied to exterior murals if desired. The varnish can be removed with turpentine or white spirit.

Laying flat, opaque color 1. Apply a broad area of thick paint, using a soft brush.

Applying impasto 1. Use the paint thickly, direct from the tube or with added gel. Spread it on the canvas with a knife.

3. The paint is used without medium so that it is opaque. Repeat the application if a thick coat of flat color is required.

2. Apply thick blobs of paint with a brush. The adhesive and quick-drying properties of acrylic mean it can be used thickly.

Glazing 1. Mix a small amount of color with a lot of gel or medium. Acrylic mediums are white when wet and reduce the color value.

3. A more transparent glaze can be achieved by adding extra medium. Note that at this stage the color is even further devalued.

3. The paint is used without medium so that it is opaque. Repeat the application if a thick coat of flat color is required.

Splattering 1. Mix up thin paint in a small jar. Hold the jar over the canvas and drag paint over the lip of the jar with a brush.

2. Apply the paint with a soft brush. Because acrylic dries so quickly, it can be supplied in any thickness, layer by layer.

4. Glazes may be laid in smooth layers over a stained or painted area, but can also be applied thickly, showing brushmarks.

Laying broken color Load a brush with undiluted paint. Draw the brush lightly across the surface of the canvas.

2. The splattering makes an irregular pattern. Allow it to dry and repeat with another color, or use a glaze or stain over the top.

3. Fine splattered lines and drips are made by flicking a brush loaded with wet paint over the canvas.

4. Lay another area of tape, and paint over the whole with diluted medium. Let it dry.

2. Hold the mask firmly on the canvas and paint over the shape. Work away from the cut edges. The paint must not be too wet.

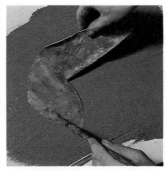

Collage with paint. Collage can also be done using acrylic paint which has adhesive properties.

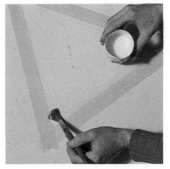

Masking with tape 1. Lay tape firmly along the edges of the required shape. Paint over the whole area with diluted medium.

5. Paint over the taped area with a different color, taking care not to disturb the edges of the tape. The paint must not be too wet.

3. Lift the piece of card away from the canvas to check that the painted area is clean and sharp. Remove the piece of card.

Acrylic paint over oil crayon 1. Draw on the canvas with oil crayons. Build up the crayoned marks quite thickly.

2. Paint evenly over the whole shape, working over and away from the edges of the tape towards the center.

6. Peel back the tape carefully. Any number of layers can be built up, but each must be dry before more tape is used.

Collage with medium 1. Acrylic medium can be used for collaging. Cut a canvas shape and paint one side with medium.

2. Thin the paint with a large amount of water and brush it lightly over the crayoned area with a large soft brush.

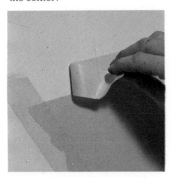

3. Let the painted shape dry thoroughly. Lift one corner of the tape and peel it back carefully from the canvas.

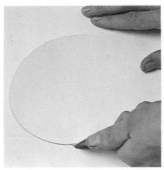

Masking with card 1. Draw the required shape on a thin piece of card and cut it out with a knife. Use masking film or tape.

2. Press the shape, glue side downwards, on to a stretched canvas. Rub over the back with a clean, dry brush.

3. The oil crayon resists the paint and the drawing shows up clearly through the colored wash.

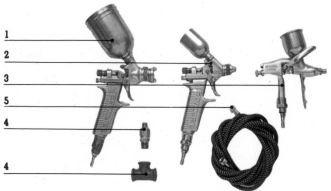

1
2
3
5
4
4

Sprayguns Sprayguns used with acrylic paint have larger nozzles and reservoirs than normal airbrushes. The range includes the DeVilbiss MPS (**1**), DeVilbiss MP (**2**), and Binks Bullows L90 (**3**). Also important are adaptors (**4**) and the hose (**5**).

7. When the paint has dried, lift off the tape carefully, using a scalpel if necessary, to reveal the pattern.

Blotting 1. Another effect can be achieved by spraying water on to the surface and, before it dries, spraying on paint.

Masking 1. Different types of masks — such as wood, paper or tape — can be used to achieve a variety of effects.

4. Using a tape and paper mask gives the sharpest line of all.

8. Masking fluid can be sprayed through the gun to create a pattern.

2. When the paint has dried but the water is still wet, blot the water off with absorbent paper or a sponge.

2. A wood mask gives a soft edge. Do not stick the wood down, just place it on the surface.

5. Mask out the desired area. The masking tape can be curved and used to create positive or negative lines.

9. On top of the dried masking fluid, spray a layer of paint.

3. The paper lifts off the water and leaves a mottled effect where the paint has dried and the water has not.

3. A paper mask produces a much sharper line because it is thinner than the wood. Again, do not stick the paper down.

6. Spray and even area of color over the masked area. Work horizontally and vertically with even strokes.

10. When the paint has dried, rub off the masking fluid with your hand. This leaves a distinctive mottled pattern.

Different pressures Spraying with varying pressures creates different effects from an even spread of color to a clear dot pattern.

Tempera.

History and principles. Equipment and techniques:
Pigments, Egg-yolk tempera, Surfaces, Sizes, Grounds.

The traditional method of tempera painting is to use color pigment mixed with egg yolk and thinned with distilled water. After this has been brushed on to the painting surface, the water evaporates and the egg and pigment set to form a hard, thin layer of color.

Tempera does not have the flexibility of oil mediums and, because it dries so very fast, colors cannot be painted into one another as they can with oils. But it does have its advantages. Tempera paints dry much truer to the original pigment color, so an artist can more accurately control the final color of his work. Tempera does not yellow or darken with age as most oils do. A work in tempera, painted on to a firm surface will retain the freshness of its original colors, as many of the great paintings of the Middle Ages have done.

Oil, wax, or gum arabic can be added to the egg yolk and pigment mix to make an emulsion that gives the medium more flexibility and adds an extra gloss to the finished work. It was this practice of mixing oils into tempera that undoubtedly led the Flemish master Jan van Eyck (c. 1390–1441) to experiment so successfully with a pure oil medium. The brilliant results led the Renaissance masters to desert tempera almost entirely for oils, although many continued to use a tempera ground.

Ancient artists of Babylonia, Mycenaen Greece and China all used tempera mediums. Tempera paintings decorate gravestones in Egypt, the early Christian catacombs and the altar pieces of Byzantine churches.

The first great Florentine artist, Giotto (1266–1337), famous for his fabulous frescoes in the little churches at Assisi and Padua, worked in tempera, producing paintings as exciting today as when they were unveiled more than six centuries ago. The first description of the pure egg method of mixing pigment, written down by Cennini (c.1390), probably came from Giotto's studio.

These early masters built up their works by painting layer on layer of tempera over a gesso base. They began often with a green underlayer, as clearly shown in an unfinished work by Cima de Conegliano (1459–1517). The age-long freshness of tempera can be seen in *The Annunciation*, painted in the late fourteenth century by the Catalan Pedro Serra (1345–1405). The versatility of the medium can be seen in the work of Fra Angelico (1387–1455) who used layers of different colors to give depth to his backgrounds and almost unearthly qualities to the faces of his saints. Piero della Francesca (1410–1492) built up the outlines of his figures, then laid faint washes for the backgrounds, finishing with a single, heavy layer of paint for the final colors. His *Nativity* is an example of this style of tempera painting. Other painters of the same age, such as Duccio (1255–1319) in *Christ Healing The Blind Man* and Piero Lorenzetti (active 1320–1345) in *Madonna and the Angels*, built up their finished colors in layers.

Sandro Botticelli (1446–1510), another Florentine master, overlaid a drawn design with neutral washes, building up deeper tones. He used this method to achieve great physical beauty and intricate detail in his masterpiece *The Birth of Venus*.

For most of the seventeenth and eighteenth centuries the great painters were mesmerized by the luminosity, fluidity and heavy impastos possible only with oils. Except for use as a base, tempera was largely ignored. Its revival stemmed from the English artist Samuel Palmer (1805–1881), who achieved dramatic effects by building up layers of paints in some parts of his pictures and scraping down to the gesso base in others. Simultaneously, the Austrian, Gustav Klimt (1862–1918), the German Brocklin (1827–1901) and the French artist Gustave Moreau (1826–1898) established tempera techniques.

Some of Palmer's impressive techniques can be seen in the work of the fine American contemporary Andrew Wyeth (born 1917). His use of the gesso base has given some of his work a luminosity almost matching that of oils, and fine textures have been produced by the inter-weaving of lines of color. With his contemporary, Ben Shahn (1898–1969), Wyeth and the American school of modern painters have dramatically influenced the new popularity of tempera painting.

Tempera Equipment

Pigments

Most pigments will combine with egg yolk to give a tempera medium, but there is no need to begin with a vast palette. Pigments are easier to use if mixed first into a thick paste with distilled water and kept in airtight jars. Bear this in mind when choosing your palette, because some pigments, such as French ultramarine, set hard if left as a paste. Whites must always be mixed directly into egg yolk, but avoid flake white, which is poisonous; so are the chrome pigments. If you do choose them, take care. Monastral blue is best left out because it does not combine well with egg. Other colors, such as Prussian blue and Alizarin red, will not form a lasting water paste unless a little

alcohol is added.

A useful palette to begin with might consist of lamp black, titanium white, burnt umber, Indian red, French ultramarine and yellow ochre.

You can buy ready mixed tempera paints, but there is little advantage in doing so—and there are several drawbacks. To start with, it is not difficult to mix tempera mediums and in making your own you can create a wider range of colors than you can buy. The manufactured products tend, also, to dry more slowly and this can lead to the artist lifting an underpaint instead of putting on a new layer.

It is not essential to keep your pigments ready-mixed in little jars. Some painters prefer to mix the pigment, egg and water in one action on the palette, and this is obviously necessary when mixing the whites or French ultramarine. When covering a large area with one color do not leave it exposed to the air on your palette, or it may harden off before you can finish the job. Keep the paint in little jars, and if you do not want to keep screwing a top on and off, use a moistened rag as a stopper.

Egg-yolk tempera This is the classic medium for tempera painting. An egg yolk contains albumen, a sticky protein that sets hard when exposed to air, a non-drying oil, and lecithin, a fatty substance that helps liquids to combine in a stable mixture. It makes an ideal painting emulsion when mixed with pigment and distilled water.

Always use fresh hen's eggs—the fresher the egg the longer the emulsion will take to set. Separate the yolk completely from the white, then wipe it dry on a paper towel. Puncture the yolk skin with a scalpel or sharp point and let the yolk flow into your mixing jar. Add the distilled water and stir with a glass rod until it is like thick cream.

Most pigments will mix ideally with egg yolk in equal measure. Examples are: French ultramarine, cadmium yellow, scarlet lake, Indian red, yellow ochre, raw umber and ivory black.

Use ¾ measure of egg to 1 of paste when mixing cerulean blue, cadmium red, viridian and zinc white. Use 1¼ measure of egg to 1 paste when mixing titanium white, Venetian red, burnt umber, burnt and raw sienna.

Never mix more paint than you think you will need—none of it will keep until the next day. Keep everything scrupulously clean. Wipe off all old traces of egg from your mixing jars and do not let egg get into your pigment pastes, or they will be set hard when you next go to use them.

Use an eye dropper when mixing small quantities. Lay pigment paste on a paper palette, then add the mixed yolk and distilled water, stirring with a plastic palette knife.

Once you have mixed your paint, use it as quickly as possible. Test first by painting a thin strip on a sheet of glass. If it peels off in a strip when dry it is ready for use. If it crumbles, add more egg to the mix.

Surfaces

Tempera paints were first used to decorate walls and panels and the best results are still obtained on a firm surface.

Seasoned wood is ideal, but it is hard to obtain and expensive. Do not use wood that has been seasoned with chemicals. Softboard and plywood are unsuitable because they tend to warp.

The best surfaces to use are chipboard, hardboard and Masonite—all are easy to find and not too expensive. Rub down blockboard and Masonite with fine sand paper in a backwards and forwards motion, then coat with methyl alcohol. Buckling can be prevented by sizing the back with glue.

Canvas can be used, stretched as for oils, but it must be the finest quality, fine-weave canvas and it is essential to stretch it really taut. Alternatively, the canvas can be stretched and glued to a hardboard backing. Size the back of the hardboard or glue paper to it to prevent buckling.

Use thin board and sand down the top surface. Coat with glue size, then press it down on to the canvas. Turn the whole board over and smooth down the canvas through a sheet of thin paper.

Sizes

Size all painting surfaces with rabbit skin glue or artists size before laying a ground. Rabbit skin glue is the best but it is expensive. Mix the size in the proportions 1:10 with water, then brush on.

Stand one part glue or size in 10 parts water overnight. Warm to blood heat, then apply with a brush.

A good size can be made by soaking six gelatin leaves in 1¼ pints of water for 15 minutes. Heat until the gelatin dissolves, then apply. Leave to dry overnight.

Grounds

Apply gesso grounds to board or canvas for all tempera painting. For a board surface, make a gesso from Gilder's whiting mixed into a warm size until it can absorb no more. Stir, scooping off any bubbles with a spoon. Paint on to the board between four and eight coats, allowing 20 minutes drying time between each coat. Leave to dry for several days before sanding and polishing with a moist cloth.

For a canvas surface mix the gesso as above, but adding one part of zinc white to every three of Gilder's whiting. A serving spoonful of linseed oil to every half-pint of gesso will prevent the canvas cracking.

Equipment

Use paper palettes or an easy-to-clean glass palette. Keep china bowls for holding large quantities of mixed paint, a plastic palette knife for mixing, eye droppers and a wide selection of sable brushes. Do not store paint in a container that may rust.

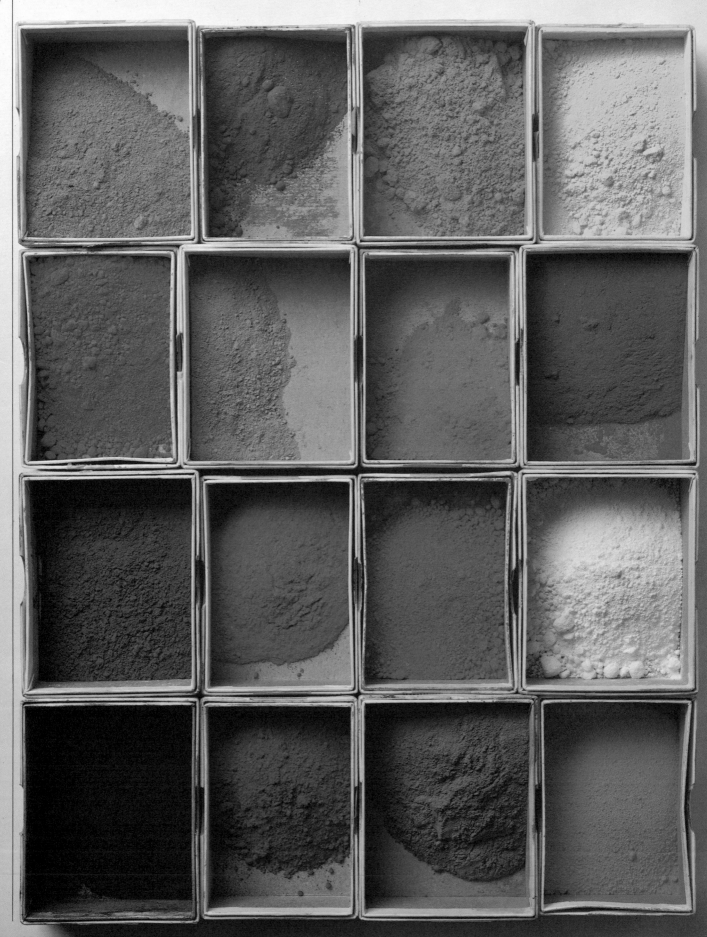

Pigments Tempera paint is made by mixing powdered pigment with an egg solution. An extremely wide range of pigments can be used to produce tempera (**left**) in a vivid range of hues. Ready-manufactured tempera (**below**) is available in a limited selection of colors. For the artist, whether beginner or expert, it is usually best to make up the paint when it is needed — tube tempera colors do not dry as quickly as hand-made paint. The main advantage of hand-made tempera is that it can be made in a wide range of colors to suit the artist's purpose exactly.

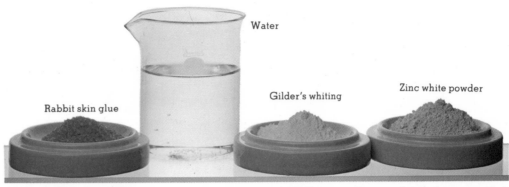

Rabbit skin glue

Water

Gilder's whiting

Zinc white powder

Size and gesso ingredients
For making size, mix 1 part rabbit skin glue with 10 parts water. To make the gesso ground, which is necessary before applying tempera to a canvas, Gilder's whiting and zinc white are needed. Add linseed oil to the gesso to prevent the canvas cracking.

Preparing gesso 1. Mix 1 part of whiting with 1 part of titanium white. Use an enamel pan and a wooden spoon.

4. Continue adding the size slowly, until the mixture has a liquid, creamy consistency. If it is lumpy, strain it through muslin.

3. Brush gesso on the panel, working evenly and lightly in 1 direction. When it is dry, apply a second coat across the first.

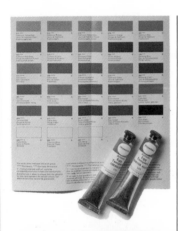

Making size 1. Measure out a quantity of size crystals. Soak them overnight in 10 parts of water to 1 part size.

2. When the powders are well mixed together, measure out 1 part of size (the same volume as 1 part of powder).

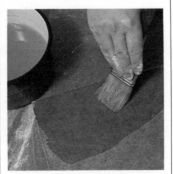

Preparing a panel 1. Sandpaper the surface of the panel lightly to provide a tooth for the gesso.

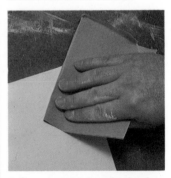

4. Repeat applications for 6 to 8 coats of gesso. When dry, rub the surface lightly with fine sand-paper. Gesso the back of the panel.

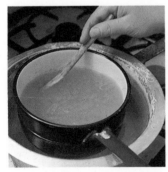

2. Heat the size in a double boiler until the crystals are dissolved. Do not overheat — it should not be allowed to boil.

3. Add size to the mixture to form a thick paste. Stir well, but do not allow air bubbles to form in the gesso.

2. Apply size evenly over the whole surface of the panel. Leave it until it is completely dry. Size the back of the panel.

5. Give the surface a final polish with a damp linen rag, so that the gesso is completely smooth and clean, ready for painting.

Equipment for tempera
A paper palette is best for mixing and applying tempera because it is then easy to remove any paint or egg from the surface completely, by tearing off one of the sheets of paper. To mix the paint, use an eye-dropper to put the pigment paste and egg on the palette and mix with a plastic palette knife. If large quantities of paint are needed, they can be made and kept in a porcelain bowl. A glass rod can be used to mix the paint, however, a plastic palette knife is more than adequate.

Wide brushes for tempera work
For detail work in tempera, it is best to use brushes which would be suitable for oil or watercolor painting. Wider brushes (**right**) are useful for painting over large areas, particularly with size or gesso, although large areas of paint can also be applied in this way. However, the brush should not be so harsh that it would scratch any underlying layers. Possible sizes and types of bristle include: ox hair and bristle, 1½in (**1**), white, unbleached bristle, 1½in (**2**), white bristle, 1in (**3**), camel hair, 1½in (**4**) and badger hair, 2in (**5**).

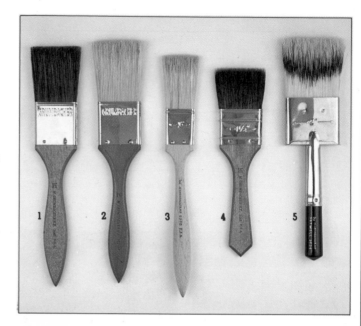

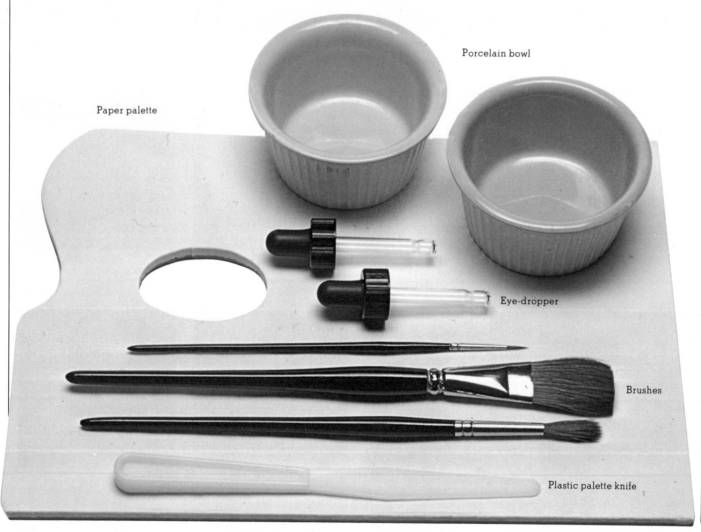

Porcelain bowl

Paper palette

Eye-dropper

Brushes

Plastic palette knife

Tempera Techniques

Be methodical when painting in tempera. It is not a spontaneous medium like oils. Plan your picture first, working out the order in which you will mix and use your colors.

It is wise to draw your design on to the ground before you begin painting. Use fine charcoal or silverpoint, or paint the design with a thin wash and a pointed brush. Never use graphite pencil—it will show through your finished work.

Use only fine sable brushes to apply the paint. Keep a container of distilled or cold, boiled water beside you and dip your brush in it frequently. Never overload the brush, this will give a pasty, unattractive finish and, in any case, tempera more than ⅟₂₅in (1mm) thick will not stick to the painting surface.

Brush in single strokes in one direction only. Do not paint immediately over the same spot, you will either pick up the first coat or leave a clogged effect.

Glazes Tempera is ideal for transparent glazing, as any number of coats can be laid one on top of the other. Apply glazes in quick brush strokes before the paint dries.

Dry-brushing Load the brush, then squeeze out half the paint between the thumb and forefinger. This gives fine, parallel, translucent strokes.

Hatching This is shading with parallel lines—the traditional tempera method. Fine inter-weaving of lines can produce dramatic effects. Practise hatching with different colors on scrap boards to work out effects.

Spattering Load a brush with thin paint and flick it on to the surface. Use paper templates to mask the areas where no spattering is wanted.

Removing paint Keep a piece of damp muslin at hand to wipe off fresh paint. Dried paint has to be scraped back with a scalpel. Never draw on a painted surface. If over-drawing has to be done, use a fine pointed brush and a thin wash.

Storing Chemically, tempera paint remains dry for a long time. Work should be protected for at least a year by glass which does not touch the painted surface.

Egg-oil emulsions Oil added to an egg emulsion gives the medium some of the painting qualities of oil. The paint dries more slowly and it is possible to paint wet on wet, achieving crisp, textural contrasts. Completed work has a glossier finish than pure tempera. Egg-oil emulsions are innovations, and it is wise to try out their effects before using them in a painting.

Egg yolk and linseed oil Add a teaspoonful drop by drop to an egg yolk, then mix with distilled water before adding the pigment paste.

Whole egg and linseed oil Mix as above, then add four drops of white vinegar and strain before mixing in equal quantities with the pigment paste.

Egg yolk, stand oil and damar varnish Mix one yolk, one level teaspoon of stand oil, one of damar varnish, then add to the pigment paste. This dries hard, glazes well and does not crack on a stretched canvas as pure egg tempera can.

Making egg binder 1. Crack an egg with one hand and pour the yolk and white into the palm of the other hand.

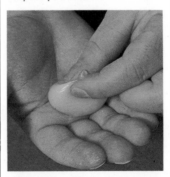

2. Roll the egg from hand to hand, allowing the white to drain away through the fingers into a bowl, till only the yolk remains.

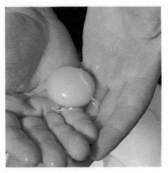

3. When the yolk is quite separate, hold it in the palm of one hand and pick it up carefully with the other, without breaking the sac.

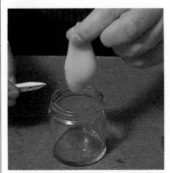

4. Hold the yolk over a small glass jar. Slash the sac with a scalpel, and let the liquid yolk drain into the jar.

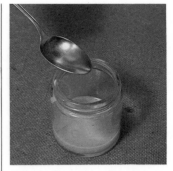

5. Add water to the yolk with a spoon, a small amount at a time, and stir it in. The volume of water required varies.

Making pigment paste 1. Measure a quantity of dry powdered pigment into a small glass jar. Fill over half the jar.

2. Add enough water to the pigment to form a thick paste. The amount required depends on the absorbency of the pigment.

3. Put the top tightly on the jar, and shake it vigorously until the pigment and water have mixed to a stiff paste consistency.

4. Mix and store several colors. Note that some pigments dry very quickly and cannot be stored. Mix these on the palette when needed.

Mixing pigment paste with egg yolk binder 1. Place a small amount of each substance side by side on a clean sheet of glass.

Crosshatching 1. For a finely meshed texture, work with a fine brush and make slanted strokes, first one way then the other.

3. The difference in the marks obtained when spattering from above or from the side can be clearly seen on the surface.

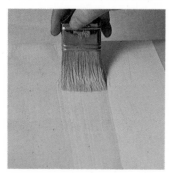

Laying a wash 1. Dilute the paint with water and load a large brush. Paint evenly across the panel horizontally.

2. Take up a little of each and mix together with a palette knife. The pigment must be firmly bound in egg to paint well.

2. For a rich textural effect, crosshatch again in another color. Any number of layers can be applied in this way.

4. Fine spattering is done with a short bristle brush. Load the brush with paint, and draw the finger up through the bristles.

2. Use a bristle brush and drier paint for a streaky, textural wash. The quick drying paint retains the brushmarks.

3. To test the binding of the mixture, paint a small strip on the glass. When dry it should peel away in a thin skin.

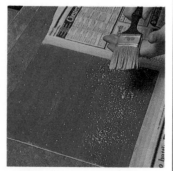

Spattering 1. Mask off an area with newspaper and paint. Hit a brush loaded with paint sharply against the palm of the hand.

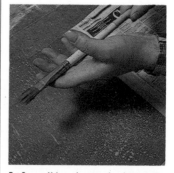

5. A small brush can also be used for spattering by tapping it against the palm of the hand. The paint must be wet but not too runny.

3. Wash over again with another color. The underneath layer shows through. Washes of one color build up a flat color layer.

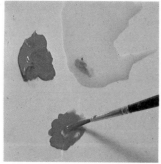

4. The paint can also be mixed with a brush during painting. Pick up binder and pigment on the brush and mix them together.

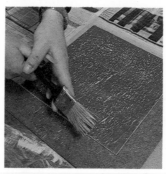

2. Spatter from the side in the same way to produce oblique marks rather than dots. Let the paint fly freely from the bristles.

6. Tempera paint is very quick to dry, and a densely spattered area can be built up quickly without the colors running together.

Stippling Load a bristle brush with paint (not too wet). Dab over the surface. For fine or coarse marks, vary the brush size.

Egg oil emulsion ingredients

Egg oil emulsion produces a glossier finish than pure tempera. To increase the degree of gloss, add more oil and varnish. Although the drying time may, at first, be more difficult to predict than for pure tempera, the emulsions will dry out harder. The following ingredients are required for making various egg oil emulsions: (from **left** to **right**) egg, linseed oil, stand oil, damar varnish, white vinegar, oil of cloves.

Egg-oil emulsions

Adding oil to the egg medium for tempera paint changes some of the characteristics of the paint. The paint handles more like oil paint — for example, it can be used to create fuller impasto effects than pure tempera. An egg-oil emulsion dries to give a glossier finish than pure tempera; and adding more oil gives a heavier gloss. However, egg-oil emulsions must be made up and handled with some care — the ingredients must be pure and the utensils scrupulously clean, as impurities may cause the oil to separate out. When dry, an egg-oil emulsion gives a harder finish than that of pure tempera. A recommended way of mixing the different types of emulsion is to place the ingredients in a screw-top jar or bottle, and mix them by shaking thoroughly. Emulsions can be made with both egg yolks and whole eggs. It is important to try out the various emulsions to see which best suits your purposes. Paint a sample out on paper, which may have been coated with gesso. Check carefully on its brushing, binding and drying qualities, as well as its flexibility, yellowing, and adherence.

Egg yolk and linseed oil emulsion
Ingredients
1 egg yolk
1 teaspoon linseed oil
distilled water

Add the linseed oil to the egg yolk drop by drop. Use the yolk and oil in the proportion 3 to 1 — the amount of oil will be about 1 teaspoonful. Stir with a glass rod. Using an eye-dropper, add the same amount of distilled water as egg yolk to the linseed oil and egg mixture. Add the water drop by drop to aid the emulsification.

Egg yolk, stand oil and damar varnish emulsion
Ingredients
1 egg yolk
1 teaspoon stand oil
1 teaspoon damar varnish
distilled water

Mix this emulsion in the same way as the egg yolk and linseed oil emulsion. Combine the prepared emulsion with an approximately equal amount of pigment paste. Initially, apply the paint very thinly. This mixture dries to an extremely hard finish which can even be polished with a silk or paper tissue pad to increase the shine of the finish. If applying several layers of paint, add an extra drop or so of oil to each succeeding layer to produce the necessary flexibility. This emulsion does not need to be varnished.

Whole of egg and linseed oil emulsion
Ingredients
1 egg
1 teaspoon linseed oil
4 drops white vinegar

Mix the yolk and white of the egg. Using an eye-dropper, add the linseed oil drop by drop, then mix in the white vinegar. Strain the mixture. Paint made with this type of emulsion is not so clear as pure tempera and it does not polish up like the egg yolk, stand oil and damar varnish emulsion. However, it dries to a hard finish. Mix with pigment paste in approximately equal proportions. Use distilled water if necessary to dilute the mixture.

Whole of egg, damar varnish and oil of cloves emulsion
Ingredients
1 egg
¾ teaspoon damar varnish
20 drops oil of cloves
distilled water

Crack a whole egg into a screw-top jar. Mark the level on the jar, replace the lid and shake. Add a further mark above the first equal to 1¼ of the height of the original mark. Fill the jar to this level with damar varnish. Add 20 drops of oil of cloves with an eye-dropper. Shake the jar thoroughly. Make another mark 12 times the height of the mixture, fill to this level with distilled water. Replace the lid tightly and shake thoroughly. This type of emulsion should be mixed to a paste with dry powder pigment. The paste can only be diluted by adding more of the emulsion. Use this emulsion for covering a large area with thin paint.

Scratching 1. Paint 2 even layers of flat, opaque color. Let them dry out thoroughly for at least a day.

2. Reverse the colors. Paint over each layer with the other color; keep the paint flat and opaque. Let it dry.

3. To reveal the color underneath, scratch lightly into the top layer of paint with a scalpel or razor blade.

4. To achieve an effect of drawn lines in the different colors, continue scratching into the layers of paint.

Sponging 1. Lay an area of plain color. Pick up some paint in a contrasting color on the sponge and dab over the painted area.

2. In the first layer, the texture of the sponge shows clearly, making a mottled, grainy surface.

3. Repeated sponging can be used to build up an area of flat color, which is modified slightly by the color underneath.

Tapping Work over the surface dabbing evenly, with the side of the brush. Increase pressure for large marks and coarser texture.

Scumbling 1. Load a brush with paint, wipe off excess. Work over an already painted layer with a circular motion.

2. A light scumble over a sponged or spattered surface will soften the texture and merge the tones of the color underneath.

Drybrushing 1. Take up paint on the brush, and wipe it to remove moisture. Draw the brush across the panel, leaving broken marks.

2. Drybrushing makes a light, feathery texture. Add a different color to change the effect. Any number of colors can be applied.

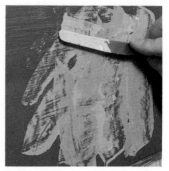

Laying paint with a palette knife Mix up a quantity of thick paint. Load a knife with paint, spread over the surface.

Scraping with a palette knife Scrape into a layer of thick paint working with the knife held flatly against the surface.

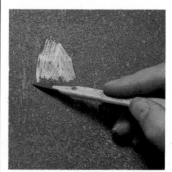

Making corrections 1. Scrape back dried paint by scratching carefully over it with a scalpel. Do not dig into the gesso.

2. Sandpaper lightly over the scratched area to uncover the clean gesso ground. Wipe away dust. Repaint over the gesso.

Watercolor.

History. Supports. Stretching paper. Equipment: Paints, Brushes, Easels, Water. **Techniques:** Alla prima, Washes, Stippling, Scumbling, Dry brush technique.

6 **Watercolor** History

Transparency and the soft harmony of color washes, with highlights and lighter areas rendered by leaving the white paper bare or faintly toned, are the main characteristics of 'pure' watercolor painting.

The color cannot be worked on its ground to the same extent as with oils or other opaque media—errors cannot be merely painted over, for instance—so that a higher initial standard of technique may be involved to produce a satisfactory watercolor painting. But the freshness and brilliance of a good watercolor are ample compensation for the time spent in acquiring sound technique.

Since the time of the ancient Egyptians, water has been used as a diluent in many types of paint, including size paint, distemper, fresco, tempera and gouache. True watercolor, however, consists solely of very finely ground pigment with gum arabic (known sometimes as gum senegal) as the binder.

The water-soluble gum acts as a light varnish, giving the colors a greater brightness and sheen.

Other substances may occasionally be added to the water in making up the actual paint, including sugar syrup and glycerin. The syrup acts as a plasticizer, making the painting smoother; and the glycerin is said to lend extra brilliance and in warm weather prevents the paint from drying too quickly.

White pigment is never used in a pure watercolor palette. Its addition creates, in effect, a different medium—gouache.

Although many medieval illustrators used pure—that is transparent—watercolor in small works and on manuscripts, others added opaque or body color to make a background on which gold leaf was laid. The first European fully to recognize the value of the medium in larger works, using it extensively in landscape paintings, was the German artist Albrecht Dürer (1471–1528). Although strong lines and opaque passages played their part, the unique transparency of watercolor washes was a major feature of these works.

One of the earliest English artists to make full and effective use of the medium was John White, a draftsman with Sir Walter Raleigh's 1585 expedition to the coast of North America. White's use of the full range of watercolor in clean washes when making drawings for the record of the life and scenery of the North Carolina coast have caused some historians to claim him as the 'father' of the English watercolor school.

Indeed, on the Continent, watercolor became known as 'the English art'; but it was not until nearly two centuries later, in the latter part of the eighteenth century, that the art blossomed into its full pride and distinction in the hands of such painters as Paul Sandby (1725–1809), William Blake (1757–1827), Thomas Girtin (1755–1802), J.M.W. Turner (1755–1851), John Crome (1763–1821), John Sell Cotman (1782–1842), John

Varley (1778–1842), David Cox (1783–1859), and Peter de Wint (1784–1849).

Only those who have mastered a basic technique and recognized the limitations of a medium can afford to depart from the rules and, in doing so, evolve new styles. Thomas Girtin, for instance, regarded the limitations of watercolor as a challenge and, in effect, increased the challenge by deliberately restricting the range of his palette. He used only five basic colors: yellow ochre, burnt sienna, light red, monastral blue and ivory black. He applied the paint in thin washes, allowing each wash to dry before applying the next, building up deep tonal gradations and contrasts. Like most of the 'English school' he left areas of white paper untouched to provide highlights; but occasionally, and effectively, broke a 'rule' by using gouache for the odd highlight.

William Blake devised something akin to offset printing to apply his first layers of color, painting on an impervious surface such as glass, porcelain or a glazed card or paper, and pressing this over his painting paper. When the 'print' was dry, he worked over it in opaque or body color to elaborate and enliven it.

J.M.W. Turner virtually forced the paint to obey his rules, shifting it while wet, scumbling and scratching it on heavy paper until gleaming and glowing effects were produced—unrecognizable at first as true watercolor. He mixed techniques and made them compatible. In *Tintern Abbey* he built up strong tonal contrasts with flat and broken washes. Heavy wet-into-wet methods, scumbles and dry-brush strokes were all combined in the harmonies of *Kilgarran Castle*; while *Venice from the Ciudecca* is alive with thin, wet washes and delicate touches of opaque paint.

The Victorian age saw a rise in the general popularity of watercolor painting, particularly in Britain; and some Victorian artists, including John Everett Millais (1829–1896), found a ready sale for watercolor copies of their larger oil paintings. Watercolor had already been used for the opposite process—making quick color sketches for later rendering as larger works in oil—by such masters as van Dyck (1599–1641), Gainsborough (1727–1788) and Constable (1776–1837).

They discovered that quick-drying watercolor enabled them to experiment with color contrasts and make swift notes of passing atmospheric effects, such as mists, rainbows, changing reflections and fast-altering cloud formations.

America's tradition of watercolor painting, although not so long as that of England, is soundly based on the work of fine exponents like Winslow Homer (1830–1910) who did much for the art in the States (although appreciation was slow to come: fine paintings of his were selling for as little as 75 dollars in 1880). The tradition was carried on by Thomas Eakins (1844–1916), Edward Hopper (1882–1967) and Andrew Wyeth (born 1917). Ben Shahn (1898–1969) used the

medium with great fluidity especially in the expression of social ideas, exemplified by his *Martin Luther King* painted in 1966.

The English tradition has been carried on strongly by such major artists as Edward Burra (1905–1976), Paul Nash (1889–1946) and David Jones (born 1895). In Europe, Paul Klee (1879–1940), a founder member of the Bauhaus, used watercolor for some of his most significant work. His *Motif of Mammamet* shows a striking use of colors contrasted in small, rough-edged, carefully-proportioned washes which reveal the texture of the paper beneath.

The distinction between fine art and the art of the illustrator, always blurred, became more so in the nineteenth century with the invention of half-tone reproduction. Overlaying of red, yellow and blue inks, broken down by screens to produce many tones, made possible the reproduction of illustrations in full color. Watercolor was found to be an ideal medium to submit to the process, which enabled books containing full-color illustrations to be produced comparatively cheaply for the mass market. Among the many fine artists who used watercolor for their illustration originals are Rackham (1867–1939) and Edmund Dulac (1882–1953). Dulac outlined and pointed up many of his drawings with Indian ink. In printing—although the black itself could not be reproduced by the three-color process—this tended to soften and enhance the watercolor washes lying within his outlines.

Watercolor Supports

T he most widely-used watercolor support is paper, which is manufactured for the purpose in a wide variety of weights and textures.

Ignoring the many cheap papers made up into children's 'drawing and painting books', there are three main categories of real watercolor paper: hot-pressed or HP; cold-pressed (CP)—also known as 'not' paper in Britain ('not' for 'not hot-pressed'); and rough.

Hot-pressed is very smooth, and suitable for line and wash. Many artists find it too slippery for pure water-color work. Cold-pressed is the most popular all-round paper. Its semi-rough surface takes large, even washes very well, but a quickly-dragged dryish brush will also bring up what roughness it possesses, so that smooth and rough surfaces are obtainable on the same sheet. Fine detail can also be rendered on cold-pressed paper.

Rough paper has a definite 'tooth' to it. It drags at the brush. This produces a speckled effect, with pigment settling in the lower parts of the surface, leaving the rest white. This is fine for rendering, say, the sparkle of sunshine on water; but the overall appearance of the picture is inclined to be monotonous in the hands of a beginner if he or she cannot achieve, as contrast, the deep, even, wet washes which the expert can produce on the roughest paper.

Hand-made papers are of the highest quality—and the most expensive. They are mainly of pure linen rag, bleached without chemicals, or with chemicals which are thoroughly neutralized; and they are sized on one side only. This correct painting side faces the artist when the paper, held up to the light, shows the maker's water-mark the right way round.

Japanese rice papers, fragile and absorbent, are obtainable in Europe and America; and some Western artists have experimented with them successfully for delicate work. Those available include Kozo, Mitsumata and Gambi. Kozo is the strongest.

Tinted papers are sometimes used, especially for reproduction work; but the basic tint may not be as permanent as the colors laid on it, and its change could affect the overall tone of the picture in time. Many artists prefer to apply their own tint with a very thin wash and a sponge.

The weight or thickness of a watercolor paper is as important a consideration as its surface. Weight is measured by the ream. A 70lb paper, for instance, means that 480 sheets of it—a ream—weighs 70lb.

Light papers may need stretching to prevent them buckling under heavy washes. Heavier papers, of 140lb and upwards, can be clipped to a board and used for direct work.

In general, the weight of the paper, and its price, increases in proportion to the size of the ready-cut sheets, so that an artist who wishes to use a heavier paper in a smaller size may have to cut it from a larger sheet. However, the medium and most popular size, 30 by 22in (75 by 55cm) has the greatest range of weights associated with it: from 70lb to 300lb.

Names associated with good artists' papers include Saunders, R.W.S. (Royal Watercolour Society), Bockingford, Crisbrook, d'Arches, Arnold, Green, Fabriano, Michallet and Ingres. Hand-made papers include the 90lb R.W.S., Saunders, and tinted Fabriano paper.

A good paper for beginners in the medium is Saunders machine-made 90lb, 30 by 22in, with cold-pressed surface. It is tough, stretches well if needed to

take heavy washes and stands up well to drawing and erasing.

A wide range of papers similar to the best made in Britain, France and Italy is manufactured in America by the Strathmore Paper Company.

All watercolor papers should be stored in as dry a place as possible. Damp may activate chemical impurities producing spots which will not take color.

Watercolor paper Good handmade or machine made papers for watercolor painting will have a clearly visible watermark (**left**). The right side of the paper to work on is the side on which the watermark can be seen the right way round. Three main surfaces (**below**) are available (from **left** to **right**) hot-pressed, a fairly smooth surface, not (or cold pressed) paper, which is semi-rough, and rough.

Types of watercolor paper A number of manufacturers produce excellent papers for watercolor work. A number of different examples are shown **below.** When a paper is selected the weight, texture and tone required must be carefully considered. It may be preferable to use white paper and, if a tint is required, apply a wash of paint all over to achieve the right color, but a good range of tinted papers is available. The texture should be chosen according to how much white will be seen through the paint. A smooth paper will rapidly become covered with color, but the heavily textured papers leave tiny white flecks showing through a watercolor wash.

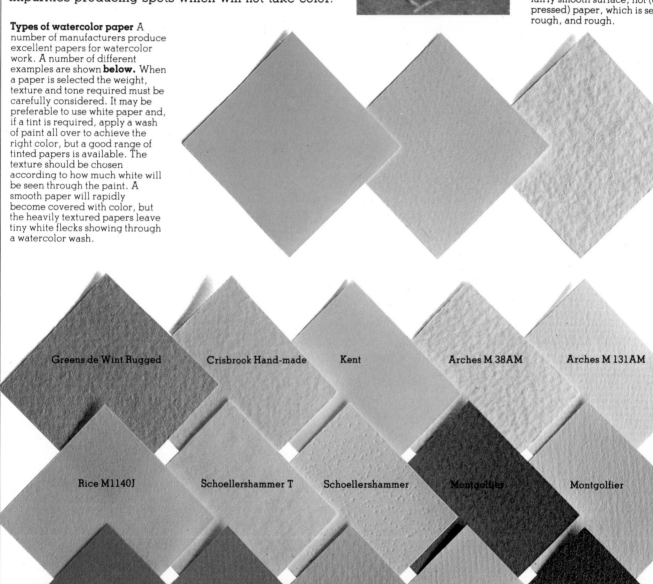

Greens de Wint Rugged Crisbrook Hand-made Kent Arches M 38AM Arches M 131AM

Rice M1140J Schoellershammer T Schoellershammer Montgolfier Montgolfier

Canson Canson Fabriano Canson Mi Teintes Ingres

Watercolor Stretching Paper

Lighter-weight papers, which tend to buckle when washes are applied, should be stretched before use. There are a number of different methods.

The simplest, for studio use, is to wet the paper thoroughly by laying it in a tray of water. Holding it by the edge, shake off the surplus water and lay the paper, painting surface up, on a drawing board, preferably of a size which gives 2in (5cm) clearance all round from the margin of the paper. Stick the edges down with strips from a roll of gummed brown paper. Put a drawing pin (thumbtack) in each corner. As the painting paper dries, it will pull itself smooth and tight.

For field work, some artists use a light panel of wood or Masonite smaller than the cut paper. Two or three sheets of dampened paper are laid over the thin board, folded down and under, and held in place with a number of spring clips. The toughness of the dried stretched paper holds it in place when the clips are removed; and a completed sheet can be taken off without disturbing the lower sheets.

Ready-prepared watercolor boards—light papers mounted on cardboard—are pleasant to use and do not of course need stretching. But they are more expensive than paper and heavy to carry in quantity.

Home-made boards, with light paper strongly glued to pasteboard, can be satisfactory for practice; but paper should always be glued to the back of these boards to prevent buckling.

Special stretching-frames or striators can be bought, on to which heavier weights of paper can be stretched and held taut, with the edges crimped between an inner and an outer framework. These are for experts, providing a pleasant 'give' to the paper similar to that of an oil canvas. But even experts have been known to hole their wash-weakened paper; and some artists believe that such stretching adversely affects the surface texture of the paper.

Paper samples Manufacturers often produce small swatches of paper samples, which enable the artist to compare the different weights and textures of the various types. As the quality papers are quite expensive, there may be a charge for a sample swatch, but it is very useful reference material for artists working mainly in watercolor.

Stretching paper 1. Check which is the right side of the paper. Hold it to the light so the watermark appears the right way round.

3. Soak the paper in a tray or sink full of clean water. The amount of time needed to soak varies with the type of paper.

5. Take the paper out of water and drain it off. Lay it on the board and stick dampened gummed tape along one side.

2. Trim the paper to size for the drawing board, leaving a good margin of board so that the gummed tape will adhere.

4. Measure out lengths of gummed paper tape to match each side of the drawing board.

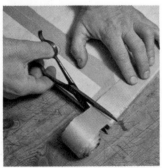

6. Stick gum strip along the opposite side of the paper. Tape the other two sides. Keep the paper quite flat throughout.

7. To secure the paper, push a drawing pin into the board at each corner. Let the paper dry naturally or it may split.

6 | **Watercolor** Equipment

Paints

In buying watercolors, price more accurately reflects the quality than in any other medium. Large, cheap multi-hued boxes of so-called watercolor, muddy, impermanent, and consisting more of filler than pigment, may delight the eye of a child but are useless for serious work. 'Students' Colors', usually put in smaller boxes or in tube-color sets, are good for practice especially if made by a reputable firm. But only those paints labelled 'Artists' Colors' can be relied upon to give the transparency, glow and permanency that the keen artist, professional or amateur, requires.

In this expensive, highest-quality range, there is no essential difference—except in terms of portability and convenience—between 'solid' and tube colors. The quality names to keep in mind are Winsor and Newton, Rowney, Reeves and Grumbacher.

Dry cakes and semi-moist pans are little-used nowadays; half-pans, also semi-moist, are the best-known form. The best-quality half-pans can be bought singly in their tiny white boxes, and are often sold as sets in small flattish tins which double as palettes.

Semi-liquid tubes of watercolor are preferred by artists who wish to apply large washes. Fully liquid watercolor can be bought in bottles, with an eye-dropper provided to transfer paint to palette. Good ranges include Luma and Dr. Martin's. It is obviously quicker to use these, or the watered-down 'liquid' tube color, then to lift color from a half-pan with a wet brush to make up a wash.

Few watercolor artists, even the most expert, would claim to use more than 11 or 12 colors, from which the whole range could be mixed. But early English watercolorists, like Thomas Girtin, painted masterpieces using a palette of no more than five basic, permanent colors. There is certainly no need for any artist to keep any more than 10 or 11 colors.

An adequate modern palette is: ivory black, Payne's gray (optional), burnt umber, cadmium red, yellow ochre, cadmium yellow, Hooker's green, viridian, monastral blue, French ultramarine and Alizarin crimson.

Professional artists may argue about the 'best' basic palette, but few would disagree that a beginner or early student is best advised to stick to a restricted palette, which not only forces him or her to consider the basics of color mixing but imposes a pleasing harmony and consistency on the finished work.

Some pigments with a chemical dye base will stain paper rather than create a transparent wash on the surface. The 'stainers', which might be quite useful for certain purposes, can be quite easily discovered: blob the color on paper and let it dry. Then rinse under running water. 'Stain' pigments will remain.

Purists—and experimenters—can make their own watercolors at home or in the studio—a time-consuming process, but some may find it worthwhile. They will need finely-ground pigments of the finest quality, a plate glass slab, a grinding miller or muller, a plastic palette knife or spatula, and gum arabic, glycerin, distilled water, ox gall, sugar solution and carbolic acid solution.

Pour one part of mixed sugar and glycerin solution plus two or three parts of gum arabic and a few drops of ox gall into a little pool on the glass. Then, with the palette knife, slowly draw in and mix the little heap of pigment placed beside it until there is a stiff paste. Grind this with the muller, and scrape the mixture into a pan.

Brushes

The patient craft of the brushmaker is tested to the full in making brushes that meet the demands of watercolor artists. They want flat or chisel brushes that lay good even washes, and brushes that can be drawn to a fine point to render detail as well as lay a lot of color in one even stroke.

In the various sizes that are also demanded, the nearest to a perfect bristle that the brushmakers have found is red sable, from the tail hairs of Siberian mink. These make the most expensive but the longest-lasting of brushes, providing they are well cared-for.

Squirrel (so-called 'camel') hair, and ox hair are the best substitutes. Man-made fibers—synthetics—have still to make an adequate mark as far as artists are concerned.

The very fine brushes (000, 00 and 0) are rarely used. Fine is reckoned to start with 1, going through to 12. A beginner's range might well start with 4, 8 and 12 in the 'rounds', plus a ½in or 1in (1.25 or 2.5cm) flat. The choice is personal, depending on what the artist needs to do.

Chinese hogshair brushes are now available in the West: long-handled (bamboo), with the bristles tightly-bunched for delicate, fine-point work.

Easels

There are many types of easels, most of which can be set and adjusted for watercolor work. The delicate—it might almost be described as intimate—work of watercolor is best carried out at close quarters, either with the board-mounted surface propped up on a table in the studio, or rested on the knees or a light, specialized easel in the field.

Watercolor easels range from the neck strap and board for sketching to well-patented collapsible wood and aluminium contraptions, to the satchel for materials which converts to an outdoors stool.

Water

In materials, consider the most important adjunct of all: the water. Use distilled water whenever possible. Over-hard or too soft water can play strange tricks with paper and colors. Carry the water in a large screw-top bottle if painting outdoors; and tip it into two jars—one for washing the brushes, one for slaking the colors: delicate tints can easily be muddied by using water in which brushes have been washed.

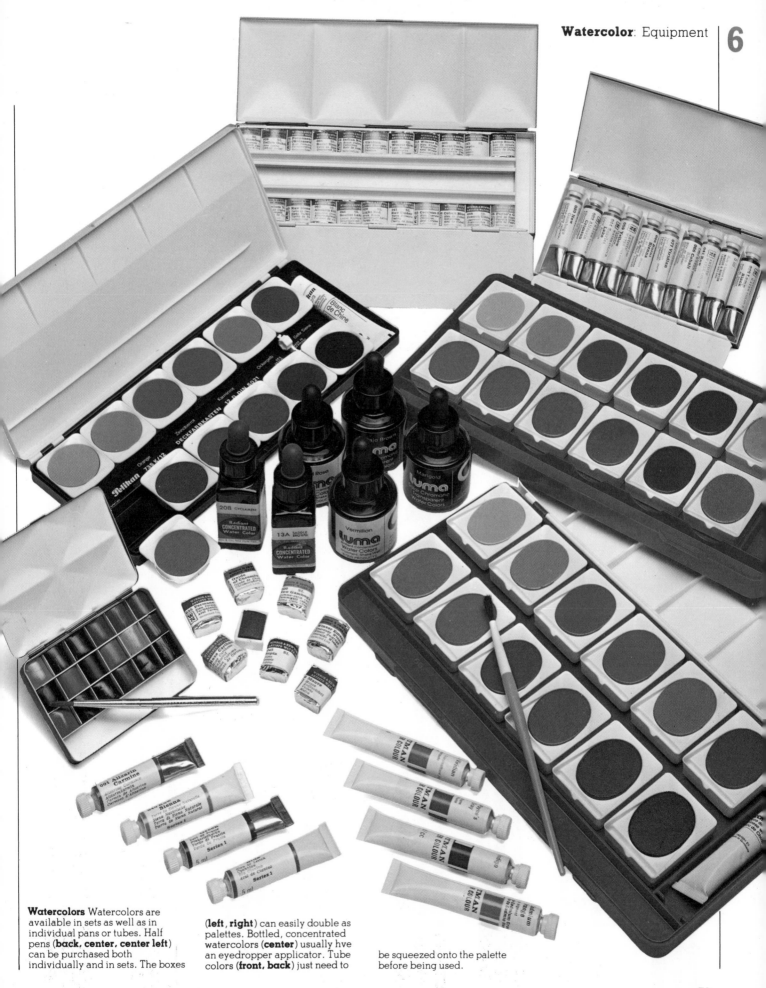

Watercolors Watercolors are available in sets as well as in individual pans or tubes. Half pens (**back, center, center left**) can be purchased both individually and in sets. The boxes (**left, right**) can easily double as palettes. Bottled, concentrated watercolors (**center**) usually hve an eyedropper applicator. Tube colors (**front, back**) just need to be squeezed onto the palette before being used.

Watercolors and brushes A wide range of watercolors is available, and the manufacturers produce charge of all the colors available in each range (**left**). It is common to find that a single manufacturer may produce more than one range, one of which will be more expensive and better quality than any others. The lower quality ranges are produced by avoiding the use of expensive pigments, and usually an attempt is made to standardize prices. There will be differences also between the flow and permanence of the different quality paints. Soft sable brushes are best for most techniques, and these are produced in different series by several manufacturers. This selection of size five brushes from different series (**below**) indicates the variations. The brushes are (from **left** to **right**): Proarte Series 1 and 3, LP Series 38, Winsor and Newton Series 7, LP Series 1A, Winsor and Newton Series 3A, 16, and 33. The Winsor and Newton Series 7 is the highest quality red sable brush available.

Types of brushes Many watercolor boxes include a brush, but these are often of very poor quality, as can be seen (**left**) in a comparison (from **left** to **right**) between a best quality sable brush, a synthetic sable and the extremely cheap type of brush sometimes found in boxes. The series of brushes (**right**) shows all the different sizes available in one type of brush. Japanese bamboo brushes (**right below**) are versatile and convenient both for covering large areas and for detailed work with the brush tip. A range of brushes suitable for watercolor painting are shown **below** (from **left** to **right**): blender, fine synthetic roundhair, broad synthetic round hair, mixed fibers round, ox hair round, squirrel hair round, sable fan bright, sable round, fine sable round.

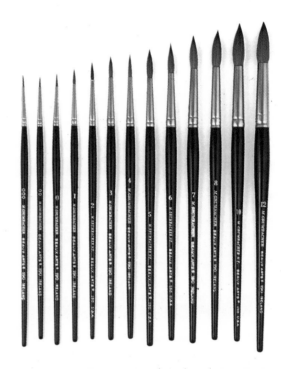

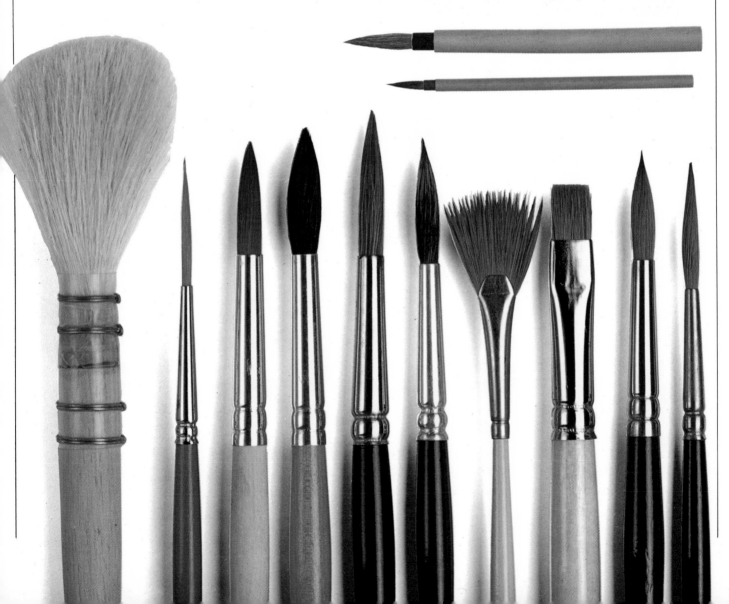

Japanese inks and brushes
Watercolor painting techniques are traditionally associated with ink drawing and wash. To some extent, painting with stick inks combines the two types of work. Soft brushes are used, set in bamboo handles, which can be splayed out for broad sweeps of color, or drawn up to a very fine point for line work. This small ink set (**left**), produced by Grumbacher, gives one colored ink and black, and a fine bamboo brush. Several sizes of brush are available. The materials may be used in the manner of ink or watercolor, or combined with ordinary water-based paints.

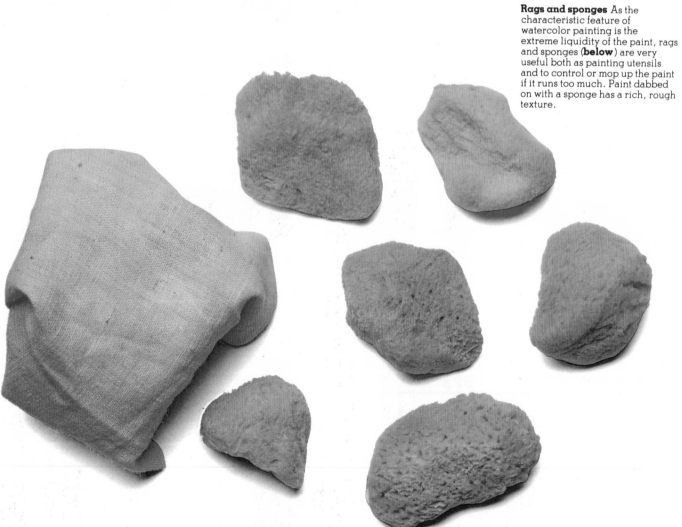

Rags and sponges As the characteristic feature of watercolor painting is the extreme liquidity of the paint, rags and sponges (**below**) are very useful both as painting utensils and to control or mop up the paint if it runs too much. Paint dabbed on with a sponge has a rich, rough texture.

Principles of watercolor painting The essential feature of watercolor painting, which makes it different from other techniques, is that the color values are reduced only by the addition of water, never by adding white paint, and the paint is thus always transparent. These two examples of different dilutions of watercolor paint (**right**) serve to illustrate this point. A strong hue may be applied to the paper by adding only enough water to the paint to make it flow evenly. The traditional watercolor technique, however, is to allow the strength of the color to build up in the painting by successive applications of thin washes of dilute, transparent color, leaving bare patches of paper for white highlights. The brilliance of the white paper also emerges through the thin paint layers, which gives watercolors their clarity and luminosity.

Palettes Recessed or well palettes must be used for mixing watercolor, so that any quantity of water required can be added and colors cannot flow together. Palettes of ceramic material, plastic or metal are suitable, and are available in a variety of different sizes and shapes. It is really a matter of personal choice whether a separate small pot (**2,3**) is used for each color, or whether the paints are kept together in a large palette with several wells (**4, 5,6,7**). The traditional kidney shaped palette with a thumb hole (**1**), which can be held in the hand while painting, may be more useful for outdoor work where flat surfaces may not be available, but for studio work no one style is more valuable than another. If extra palette room is needed, ordinary plates and saucers are quite suitable and the paint is easily washed away afterwards.

Easels for watercolor Before buying an easel the watercolorist should give careful consideration to his or her requirements. A large variety of easels is now available, so the artist should be able to find a suitable one without difficulty. The best studio easels can be adjusted to a horizontal position for sketching. Many watercolorists work outside. For this type of painting, some artists prefer to work with only a drawing board and pad, but there are many collapsible lightweight easels that are also suitable. Some portable easels are provided with a compartment for carrying materials. Generally, aluminium easels are cheaper than wooden ones. However, as these easels are very light, it is advisable to buy one that has spikes on the feet to hold the easel firm in windy conditions or on soft ground. The

sketching easel (**1**) has rubber tipped feet but it can be supplied with spikes if required. It is made from beechwood, a very hard-wearing wood. The adjustable legs enable the artist to work at a comfortable height. When fully extended this easel will hold a canvas at a fixed height, either in a vertical position or tilted forward to any desired angle. It is easy to carry, weighing only 3¾ lbs (1.6 kg). The aluminium sketching easel (**2**) is slightly larger. It is fully adjustable. A disadvantage of this easel is that it only has rubber feet which will not always keep the easel steady. The aluminium table easel (**3**) is extremely light. When not in use it folds up very compactly and can be stored out of the way. The radial studio easel (**4**) is made of wood and it can also be folded to take up less space. The easel may

be tilted backwards and forwards as well as the canvas which can be moved to a horizontal position. There is an extra large wing nut to lock the easel steady. The combination easel (**5**), made of seasoned beechwood, is both a folding studio easel and a drawing table. This makes it extremely practical for artists who have small studios. It will take a very wide canvas, tilted at any angle or kept in an upright position. When it is used as a drawing table, the frame for the drawing board can be adjusted easily to a comfortable height. The frame will hold drawing boards of any standard size or type. A useful piece of equipment for artists who work outdoors is the combined satchel and stool (**6**). A strap is attached to the light metal legs of the stool so it is easy to carry. All the artist's materials, such as paints, brushes

1

2

3

4

and paper can be put in the satchel. Another easel for outdoor work is the combined sketching seat and easel (**7**). This versatile easel can be used with canvas, block, frame and sketching board. It is fully adjustable to any position. When folded up, it is easily carried by the handle attached to the seat.

Drawing board with strap If the artist is sketching a moving subject, a drawing board with a strap attached may well prove useful. The strap is passed around the artist's neck leaving the hands free for work and allowing him or her to walk around.

5

6

7

79

6 | **Watercolor** Techniques

Alla prima Getting the effect right first time around—or *alla prima*—is one of the most difficult watercolor techniques. This accepted representational technique relies on two steps: laying down a thin accurate pencil drawing and filling in with wash, leaving bare paper to provide highlights.

The watercolor painter must work dark on light—never light on dark, as is possible with the oil painter. And strictly speaking, the number of wash overlays should be no more than three, or the overall effect will be muddy. Depth of tone can be lightened after the picture is finished by mopping water over the area with a sponge, blotting paper or absorbent tissues. If the painting is quite dry, tones can be lightened by cross-hatching, or even one-way scraping, with a sharp blade. Purists may wince, but it is most important for the final result to satisfy the artist.

Washes The chief characteristic of all watercolor painting is the wash—flat, variegated in the same tone, or subtly changing from one tone to another.

To lay a flat wash, dampen the whole area to be painted, use a large flat brush and make up sufficient color—which is usually more than you think will be needed. Do this quickly so that the brush strokes flow into each other.

Practice with the board tilted so that the strokes flow downwards into each other, but do not paint downwards—all the strokes should be horizontal. Mop at the bottom of the wash with a dry brush, rag or tissue. Dampen a complicated edge or outline around which the wash is laid, to keep the color from straying.

A gradated wash is laid by progressively strengthening color in the palette as the strokes are made. It is best to lay the dark edge first, and keep in mind that color becomes lighter as it dries.

For variegated washes, mix the colors first. Use no more than three. Let each color dry before using the next, then, when all are dry, sponge or brush them together. In this way, the directness and delicacy of the colors are preserved.

Stippling Stippling is a method of applying color in dots which are mixed by the eye into a tone. Georges Seurat, of the Impressionist school, used it most effectively. It can be employed as a contrast to wash, or over a wash. Use a fine brush, working from the outside of the area to be covered in towards the center.

Scumbling Scumbling means applying the paint with a scrubbing motion so that it is worked into the paper from all directions. It picks up the texture of the surface in a most effective way, but it should not be overused or it can lead to a monotonous overall effect.

Dry brush technique This uses the minimum of color on a fine point to apply the color and is most effective in rendering detail. But dry brush can also be employed, especially in landscape work, to produce broad effects. Spread the bristles below the ferrule with thumb and forefinger. The paint emerges as fine separated lines of color.

Other techniques Pen line and watercolor wash are often used together for their own special and sometimes startling effect, with line defining the drawing and wash blocking-in the outlines. But it is possible, and often effective, to lay the washes first then point up, outline and shade with line. Only practice can decide for the artist which method suits him or her.

Sponges are used by many artists not only to apply broad washes, giving their own special effect, but to lighten tones. A perfectly clean sponge must be used for the latter purpose. Wet the paint then gently 'massage' it with the half-dry sponge. Leave for a few minutes, then mop up the excess water with blotting paper. Repeat the process if necessary until the right tone is achieved.

An eraser can be used to reduce the intensity of a wash. But the paint must be completely dry and the eraser quite clean. The texture of the paper can be picked up by this method and—as J.M.W. Turner discovered—erasure itself can be used as a painting technique.

An even splatter of paint droplets can be achieved with a clean toothbrush. Load the brush with fairly stiff paint, hold it above the paper, and draw a stiff knife across the bristles. By masking areas of the paper, whole pictures can be 'painted' by this method.

Both gum arabic and soap can be added to paint to make 'scratching back' easier. Soap makes it possible to paint on surfaces that would otherwise reject watercolor, such as glass or plastics. Another use for it is to make initial imprints of natural objects like flowers, grasses, leaves and feathers. Coat one side of the objects with soap, apply paint over the soap, then press the object on to paper. The method is sometimes so effective that the imprint does not need retouching.

Masking fluid is sometimes used to leave untouched areas of paper, enabling a wash to be quickly applied. It can be peeled off after the wash has been laid. Candle wax is occasionally used for the same 'resist' purpose, but this cannot be removed and must be left as an integral part of the painting.

Watercolor techniques include air-brushing, which can apply the color from a thin pencil line to a broad spray. This is mainly used in commercial work, employing very finely-ground paint usually on a hot-pressed surface.

Watercolor techniques

The two crucial elements in watercolor painting are the paper and the paint. In this type of painting, the paper is not just used as a surface to which the paint is applied; the paper also influences the color of the paint, which is transparent. The whiteness of the paper can be used as the white in the painting, and for lightening the tones of paint in the picture. The fundamental watercolor technique is the wash. A wash is a thin layer of translucent color which is applied to the stretched paper. When dry, a wash can be overlaid with another layer, and this darkens the tones. There are several main types of wash. The basic flat wash involves laying flat color over an area too large to be covered by a single brushstroke. A gradated wash is in many ways a technique similar to the flat wash except the color is gradually made darker by using various tones of the same color. A variegated wash combines different colors so that they flow together. It is important in watercolor work that the washes should not be heavy or labored. A watercolor painting should be characterized by an impression of lightness.

In watercolor work there is an extremely close link between the painting technique and the palette of colors which the artist chooses. The artist's palette for watercolor painting does not need to be large; indeed, restricting yourself to a limited number of colors can have positive advantages. A range of about half a dozen colors is ample for the beginner and a dozen is about as many as the experienced watercolor artist would normally need. With this type of painting, it is especially important for the artist to experiment and practice and to get to know his or her palette thoroughly. If you find you need a new color, try mixing colors rather than selecting a completely new one. One major advantage of using a restricted palette is that it will give the painting an overall unity of color tone. A small palette can also be used with ease out of door doors. The British eighteenth century watercolor artist, Thomas Girtin, often used a palette of only five colors — light red, yellow ochre, burnt sienna, monastral blue amd ivory black. By mixing the colors and using dark and light washes, Girtin demonstrated the versatility of the medium. A possible larger palette might include two reds (such as cadmium red and Alizarin red), two yellows (for example yellow ochre and cadmium yellow), two greens (possibly viridian and Hooker's green), and two blues (such as monastral blue and ultramarine).Burnt umber and ivory black complete the range.

Laying a flat wash 1. Tip up the drawing board so that it lies at an angle. Rest one end on a piece of wood to keep it steady.

2. Keep two pots of water to hand, one quite clean for dampening paper. Use broad-based, wide-necked jars such as jam jars.

3. Dampen the paper using a large brush and clean water. Make sure that it is thoroughly damp, but not too wet.

4. Mix color with water in a palette. Mix up enough to cover the whole area to be painted so that it will have an even tone.

5. Lay a broad line of color on the dampened area of the paper, working evenly in one direction only.

6. Lay another line directly under the first, working back in the opposite direction. Allow the color to spread and even out.

7. Continue working from side to side in broad sweeps of color until the whole area is completely covered with paint.

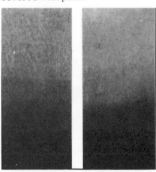

Gradated wash A gradated wash looks very different when it is applied to a rough paper (**left**) and a smooth one (**right**).

Laying a gradated wash 1.
Damp the paper as before. Mix up some color and lay a line of paint at full color strength.

2. Dilute the paint and lay in a second line of lighter color, directly under the first. Repeat with successively lighter tones.

Laying a variegated wash
1. Dampen an area of paper for the wash with clean water. It is sometimes convenient to use a sponge.

2. Mix up some paint and lay in the first color over part of the paper, letting it flow from the brush in an irregular shape.

3. Mix and lay in a second color in an irregular shape as before. Let it spread slightly into the first color but not flood it.

Stippling Use a fine brush to make tiny dots of paint. Keep the pressure even. Vary brush size or pressure for a coarser texture.

2. Fan out the bristles of the brush between thumb and finger and draw the brush over the surface of the paper.

3. To obtain a straight line while the wash is still damp, hold a ruler at an angle to the paper and work along it with a brush.

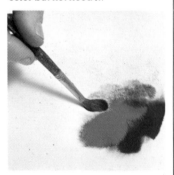

4. Repeat the process with a third color. Any number of colors can be laid in this way. Let the wash dry out before making changes.

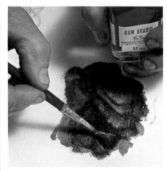

Thickening the paint Add gum arabic to the paint to make it thick and glossy. Mix colors on the paper to create a rich texture.

3. For dry brush technique, use either a round hair brush fanned out or a chisel-shaped brush.

Laying a wash against a complicated edge 1. Draw in an outline lightly with pencil. Dampen the paper up to the line.

5. If the color is too strong or too wet, blot gently with blotting paper to control the flow of the paint.

Scumbling Load the brush with paint but keep it fairly dry. Work over the paper with a circular motion.

Wash and line 1. Lay an area of flat wash with a broad brush. Make sure that the wash is not too damp before adding line.

2. Work in color over the damp area of the design, letting the paint spread slowly into the shape of the drawn line.

Splattering Pick up paint on an old toothbrush and hold it over the paper. Run a knife gently up through the bristles of the brush.

Dry brush 1. Load the brush with paint and wipe away surplus moisture on a piece of blotting paper.

2. Use pen and ink to draw in lines over the wash. A crisp line is obtained where the wash is quite dry. In wet areas the line fans out.

3. Once the edge is completed, work away from the line with a broad area of wash until the required amount is covered.

Blotting paper Use blotting paper to control the flow of paint. Lay a clean sheet to protect areas of finished work while painting.

Sponging Soak a sponge in paint and dab color on the paper, for a mottled, textured surface.

2. Let the paint dry and then work over each patch of color with a clean, wet brush.

2. Take the brush out of the water and reshape the brush by drawing the bristles between finger and thumb.

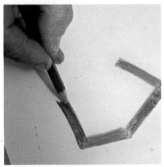

Watercolor pencils 1. Draw with watercolor pencils as with ordinary colored crayons. Leave room to spread the color.

Water on oil Paint white spirit on the paper. Wash over the spirit with watercolor. The paint separates on the oil.

3. Wash the paper with clean water to remove the paint. Run it under the tap or use a very wet sponge.

3. Leave the brush to dry with the bristle end upwards in any handy container.

2. Dip a brush in clean water and wash over the drawn marks. Work the color over the paper, adding more water when required.

Painting with a knife blade Pick up paint on the cutting edge of a craftknife blade and drag it across the paper.

4. Let the paper dry out completely so that it is possible to see which colors have left the heaviest stain.

Blot off 1. Tape a piece of paper to the paper on the drawing board and fold it back so it forms a hinged flap.

Blowing a blot Drop a large blot of wet paint on the paper. Blow hard to spread the paint into spidery trails.

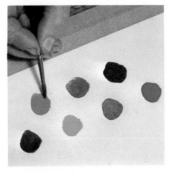

Testing for staining power 1. Paint a small patch of each color on the type of paper to be used for the finished work.

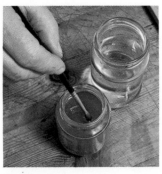

Washing brushes 1. Rinse out the dirty brush thoroughly in a pot of clean water.

2. Load a brush with paint and make a small shape on the hinged paper flap.

3. Fold the flap back on to the paper underneath so that the painted side is face down. Rub over the top sheet.

4. Pull the flap away from the paper to reveal the painted shape transferred underneath.

5. Repeat the process using a different color. Build up a design slowly, using small shapes and frequent blottings.

Laying wet into dry paint 1. Mix up different colors of paint. A plate or any washable utensil will serve as a palette.

2. Make an area of wash using mixed bands of color. Let the paint dry out, then dampen it with a clean, wet brush.

3. Lay broad strokes of contrasting color over the original wash Work lightly and do not disturb the color underneath

Wash off 1. Put down an area of watercolor wash and let it dry. Paint over it thickly with gouache, leaving some watercolor showing.

2. Let the gouache dry completely. Paint over the whole design with waterproof ink in broad, irregular strokes. Let the ink dry.

3. When the whole design is dry, wash it under running water to lift the gouache. Traces of watercolor, gouache and ink remain in the design.

Masking with oil crayon 1. Draw on the paper with an oil pastel. Paint thinly over the drawing with watercolor.

Masking with fluid 1. Paint a design with masking fluid and let it dry. The fluid must be fresh or it will yellow the paper.

2. When the fluid is dry, paint over it with watercolor. it is essential to let the watercolor dry completely before continuing.

3. Use a soft putty rubber to remove the masking fluid. If the paint is not dry the color will smudge.

Masking with tape 1. Draw out the design and tape carefully around the areas to be painted. Dampen the paper with water.

2. Brush in a wash of color over the dampened paper and the tape. The wash can be flat or a mixture of colors.

3. When the painting is completed, lift one corner of the tape and peel it back carefully, without lifting the paper surface.

Gouache.

History. Materials: Supports, Grounds, Brushes, Paints. **Techniques:** Scumbling, Scratching, Laying opaque color, Impasto, Blending.

Gouache History

Somewhere in Europe towards the end of the fourteenth century, a monk found that, by adding Chinese or zinc white to the usual transparent watercolors when he was illustrating manuscripts, the resulting opaque effect set off his gold decoration even more brilliantly.

Gouache had thus been 'discovered' as a medium in itself, although it was—and remains—only one of a family of water-slaked paints, including fresco and distemper, the use of which was already known in pre-Christian times.

Definitions of the word, in terms of the actual composition of the medium, differ among artists. Only one definition is universally agreed, because it is broad enough to include all other definitions—gouache is simply opaque watercolor.

Its opacity and covering power make it a quite separate and distinct medium from pure, transparent watercolor. The effects it produces are not unlike those of matt oils, and brush techniques similar to those used in oil painting are often employed. However, gouache dries far more quickly than oils and lends itself well to a rapid, *alla prima* style of painting.

In all painting, rules are made to be broken by those artists who have mastered basic techniques. Gouache has, perhaps, fewer rules governing its use than any other single painting medium. So long as the main coverage is with opaque watercolor, a picture containing other kinds of media may legitimately be described as 'a gouache.' Individual artists have achieved technically excellent results using combinations of gouache colors, pure watercolor, India ink, charcoal, pastels and even pencil in the same picture.

Although patches of transparent watercolor may be surprisingly effective in a painting that is predominantly gouache, the opposite application—gouache passages in a transparent watercolor—is generally far less acceptable. But even this 'rule' has been broken by many good French artists.

Unlike both watercolor and tempera, which can glow from the light, reflective grounds on which they are laid, the brightness of gouache comes solely from the reflecting power of the pigments in the paint surface itself. Since the flat, contrasting colors are essentially as the eye sees them, gouache is especially suitable for color reproduction work.

There have been no 'grand' periods in gouache; no national schools of painting in the medium, or even special times of heightened popularity, as with pure watercolor in late eighteenth-century England. Nor are there any great, single masterpieces in gouache to compare with those in other media; but it has been, and continues to be, used by fine artists for its own special qualities.

Albrecht Dürer (1471–1528), the masterly German Renaissance painter, used gouache for his studies of landscape and animals. There are gouache works by Rubens (1577–1640) and his Flemish compatriot van Dyck (1599–1641). Other seventeenth and eighteenth century Europeans who were exponents of the medium include Gaspard Poussin (1615–1675) and van Hysum (1682–1749).

The French painter Joseph Goupy (1689–1783) is credited with bringing gouache to London, where he made his home. Marco Ricci (1679–1729) of Venice and Zuccarelli of Florence (1702–1788), both notable gouache artists, also spent periods in the English capital; and Zuccarelli in particular is said greatly to have influenced Paul Sandby (1725–1809), sometimes dubbed the 'father' of English watercolor. Sandby certainly used gouache well and often, but his reputation rests mainly on his examples of the pure watercolors which marked the eighteenth-century English school. Gouache and mixed gouache-watercolor never became as popular in England as in France.

It might be said that, in general, gouache, while never highly fashionable, has never been out of fashion either. There are many modern exponents, including Picasso (1881–1973), Henry Moore (born 1898), Graham Sutherland (1903–1980) and America's Ben Shahn (1898–1969).

Picasso employed large flat patches of red in his costume design gouache *Pulcinella* (1917), a picture that contained many elements recognizable in his later abstract designs.

Social realist Ben Shahn used gouache for a large mural, *Women's Christian Temperance Union Parade* (1934), now in the Museum of the City of New York. In *Vacant Lot* (1939) he mixed transparent washes with gouache, using the opaque paint to highlight stones and rubble.

Gouache Materials

A greater variety of supports and grounds can be used for gouache than for almost any other medium. So long as the surface is free from oil and grease it will take gouache. Cardboard, composition board, wood, and even cloth, properly stretched and sized, are usable.

As with watercolor, paper is the main support for gouache works. For fine art work it should of course be of good, lasting quality. Any watercolor paper can be used for gouache, including lightweight, stretched and tinted papers. Prepared boards can be bought.

The texture of the surface is largely a matter of preference. Some artists believe that a grainy surface, which drags at the brush, is technically more satisfactory, as it 'pulls' paint from the bristles; but good work is done by others on quite smooth, virtually unabsorbent surfaces.

All sizes and shapes of brushes recommended for watercolor can be used for gouache, with hogs' hair or bristle brushes added for certain broad or textural effects, and the easels and boards used for watercolor are also adequate for gouache.

'True' gouache colors come in tubes, jars and, in recent years, pans similar to those in which pure watercolor paint is made up. There is a great range of choice; but the artist should be guided by the names of colormen—paint manufacturers—familiar in other painting fields, or he or she may find the pigment rapidly fading or changing.

Gouache colors can be made up more easily and inexpensively at home or in the studio than either oils or watercolors. A flat glass plate can be used for grinding, with a muller; but since more medium is used than in watercolor a pestle and mortar is more convenient to handle the liquid or semi-liquid color, which should be stored in screw-top jars.

Precipitated chalk, obtainable from colormen, is the main way of achieving the desired opacity in gouache. It should be ground with the pigment, and with a solution of gum arabic and distilled water, to a smooth and syrupy consistency.

Gouache colors The range of commercially available gouache is indicated by these color charts (**right**). Gouache is also referred to as 'designers' color' or 'opaque watercolor'. The colors come in the form of either tubes or cakes. Gouache is extensively used for commercial illustration work because the opacity of the paint is well suited to being reproduced. Gouache is also popular with airbrush artists because the pigment is fine enough not to clog the sensitive brush mechanism.

Gouache equipment For gouache painting, use the same type of brush as you would for watercolor. For applying the paint thickly, round bristle brushes are particularly useful. The range of sizes of brush (**left**) can be used as for watercolor work, as can the different varieties of brush (**below**). However, because gouache does not handle in exactly the same way as watercolor, it is important to experiment to see exactly which type and size of brush suits your purposes best. Palettes for gouache can be made from either plastic or porcelain. They are available in different shapes (**below right**). The round palettes are specially useful for mixing colors. The palette should not be absorbent, so wood is not a suitable surface.

Painting with gouache
When using gouache, it is important to work on a flat surface because the paint is so liquid.

Brush ruling To draw a fine line with a brush, hold the ruler firmly against the paper bunching your fingers underneath it, so that it is not touching the surface of the paper. To make the line, place the ferrule of the brush against the edge of the ruler and draw the brush gently along. This technique can be used with **watercolor** but it is especially useful with gouache, for example when adding highlights.

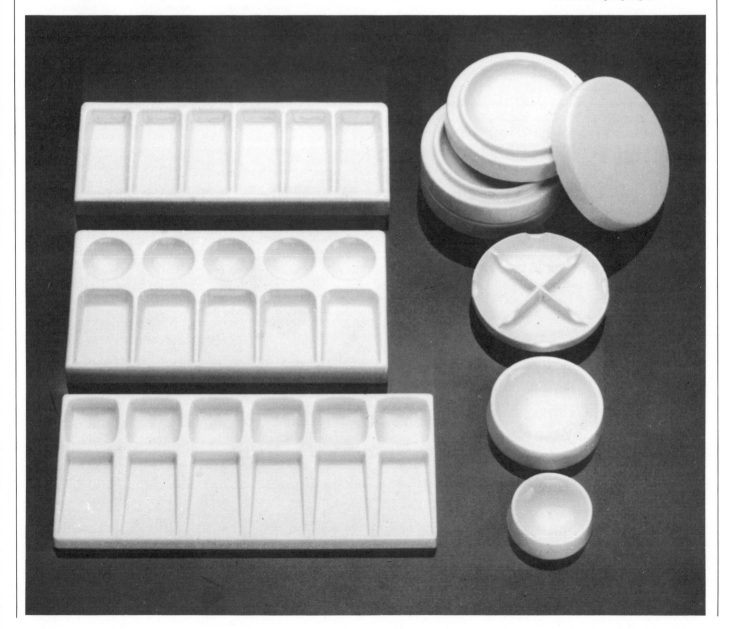

Unlike watercolor, it is possible to work from dark to light with gouache, adding white on the palette to lighten the colors rather than thinning the medium with more water. Adding black can have strange results in gouache. It will not only darken but may change the color to which it is added, turning red into brown and lending a greenish tinge to yellows.

Water-thinned gouache can be used for large variegated or graduated washes in the same way as watercolor, although the same brilliancy cannot be expected. The flat, 'solid' effect of the medium should be fully exploited.

Gouache is, above all, a medium in which to experiment, using it thin or impasto-thick, and employing techniques borrowed from both oils and watercolors, such as scratching, scumbling and daubing with a semi-dry bristle brush.

Thick or near-dry gouache can be worked over or actually applied with any number of instruments or materials to produce surprising textural effects, which can either be left or elaborated on. Combs, crumpled paper and string have been used for this purpose.

As with watercolor, a limited palette introduces harmony to a gouache. One suggested range is: ivory black, cobalt blue, raw umber, burnt sienna, cadmium red, emerald green, Naples yellow (or yellow ochre), and zinc white.

Because of its flat, matt, self-reflective nature and its extreme range of contrast, gouache is extensively employed in book and magazine illustration. For this and other purposes—including architectural drawing— gouache is a most responsive medium when used in an airbrush.

Some of the colors manufactured for reproduction work are 'fugitive'—fast-fading—so should not be used for pictures intended to last. Reliable paints for reproduction are Winsor and Newton's designers' gouache, Pelikan gouache and Vallejo designers' liquid colors.

Laying an opaque wash 1. With the drawing board at a slight angle, dampen an area of paper with a clean, wet brush.

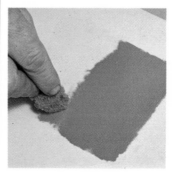

2. Lay in color with a sponge. Draw it evenly over the paper from side to side. A brush can be used, but a sponge covers larger areas.

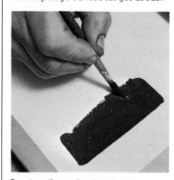

Laying flat color Load the brush with paint and work evenly with horizontal strokes. If the paint is too wet, it will not dry flat.

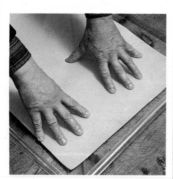

Stretching paper 1. Soak and stretch paper as for watercolor painting. Tinted paper can be used with gouache.

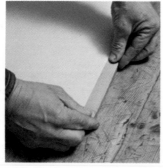

2. To preserve the largest area of paper possible, the tape can be folded over the sides of the board.

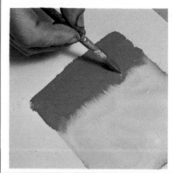

Blending two colors Lay an area of flat color. While it is still wet, work towards it with a second color, till they flow together.

Gouache techniques

Since working in gouache is so different from watercolor, beginners should practice with various brushes before embarking on a painting. It is also advisable to try out the different consistencies which are characteristic of gouache. It may be used thick, but still wet — this is similar to working in oils. Gouache may also be thinned down so that it resembles watercolor.

It is fairly difficult to obtain the right consistency of gouache needed if you are laying a wash, but with practice and perseverence, you will find it as simple as laying a wash in watercolor. A major characteristic of gouache is that you can lay a flat area of consistent color. Successful results will also depend on using gouache which is the right consistency. The paint should be thicker than that used for a flat wash. You may find that when you lay an area of gouache, as it dries the colors will change, leaving some areas dark and others light. However, it is probably best to leave alone any of these areas, as the paint will still look fresh even though it is not a perfect color.

There are many techniques and skill with which the bright colors and opacity of gouache can be exploited. If you first lay a mid-tone wash, you can then develop the image using both light and dark tones. One of the advantages of gouache over watercolor is that colors can be lightened with white rather than by thinning them. Colors with darker tints can then be laid on.

It is also possible to work solid color into washes. As the paint dries, the color will blend into the wash. Other techniques that can be experimented with include scumbling, splattering, scratching lines and using textures.

A three-dimensional texture can be achieved by adding paste to the gouache. Then draw a comb or similar blunt instrument across the paint to give the image detail. You can also, for example, dip thin string into gouache and then press it firmly to paper. As the paint dries, the colored string will remain in place, making an interesting basis for further textural elaboration.

Gouache is a most useful medium for airbrush artists. The bright colors retain their brilliance and are easy to work with, particularly as gouache can be diluted to a very thin consistency. As gouache dries quickly, it is also a practical medium for masking. This is a technique that should be employed if you want to obtain areas of paint with sharp edges which are difficult to paint with a brush.

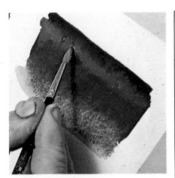

Working into wet color
1. Draw a brushful of color through a still wet patch of paint and let it fan out.

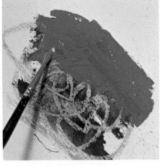

Scraping 1. Make a design combining oil crayon, watercolor and gouache. Finish with a thick layer of gouache.

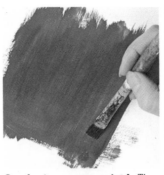

Overlaying opaque paint 1. The advantage of gouache's opacity is that colors can be overlaid. Put down an area of flat color.

2. Brush the two colors lightly together where they meet. Work quickly, and do not apply heavy pressure with the brush.

2. Highlight a dark color by dropping small patches of white paint into wet color. Let the white spread.

2. When the gouache is completely dry, paint all over with black waterproof ink. Let the ink dry.

2. When the color is nearly dry, a second color can be added which will not mix at all with the previous hue. Light can be laid over dark.

Ruling lines 1. To make a fine line, tilt a ruler and draw the brush along it, with only the tip of the brush on the paper.

Laying broken color Work over a dry wash. Load the brush with thick paint and brush lightly across the surface of the paper.

3. Scrape away some of the ink and gouache with a craft knife blade. Work until a part of each layer of the design shows through.

3. If required, a previous layer of color can be obliterated by continuously adding paint. The paint should not be too wet.

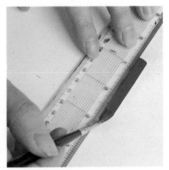

2. A broad, heavy line can be applied by holding the ruler flat on the paper and drawing along it with the side of the loaded brush.

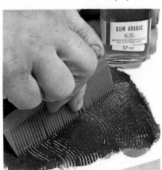

Comb texture Mix the paint with gum arabic and put down a thick layer. Work into the paint with a comb in different directions.

Impasto Load a brush thickly with paint, and draw a broad mark on the painting. Let the paint lie in a raised layer on the surface.

Blending dry color 1. Lay two broad bands of thick color. Do not add more water than necessary to spread the paint.

3. To imprint a line of paint, apply paint to the edge of a plastic ruler. Paint it on thickly, but keep it fairly dry.

4. Press the edge of the ruler down firmly on to the paper. Lift the ruler to leave a ragged, thin line of color.

2. Work into the charcoal drawing with a second color. Variations of tone are achieved by brushing the charcoal into the color.

3. When the whole area is covered, peel back the paper mask. A clean-edged shape is left, if the paint used is not too wet.

4. Peel back the paper to leave a rough imprint of the shape in textured paint. This does not give as clean an image as masking.

Scumbling Load a brush with paint, and wipe off surplus. Fan out the bristles and work with a circular motion.

3. As the paint dries, further charcoal can be added and the colors enhanced or modified by applying fresh layers of paint.

Printing off shapes 1. Cut small shapes from a clean sheet of thick paper. Any kind of shape can be made in this way.

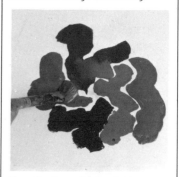

Transferring a design 1. Paint a design on a clean sheet of smooth paper, using very thick, wet paint. Let it blend in some parts.

Scratching lines Lay a thick, wet patch of paint over an area of dry color. Scratch into it with the wood end of the brush.

Masking with paper 1. Use a scalpel to cut a shape out of a clean piece of thick cartridge paper.

2. Paint one side of each cut shape using thick, wet paint. Be careful not to let the paint dry too quickly.

2. Place the painted side of the paper down on a second sheet, and rub over the back firmly with the palms of the hands.

Gouache with charcoal 1. Draw over dry paint with charcoal. If the paint is still wet, the charcoal will not take.

2. Lay the cartridge paper over the paper to be worked on, and paint into the masked shape, away from the cut edges.

3. Press the shapes, painted side down, on to a clean sheet or the painting being worked on. Rub over the back with the fingers.

3. Peel back the top sheet. The design is transferred to the second sheet with added textural effects. The colors also spread.

Pastels and chalk.

History. Equipment and techniques: Pigments, Home-made pastels, Surfaces, Equipment, Techniques, Protecting pastels, Fixatives, Illustration in pastel and chalk.

Pastels as we know them came into use a little more than 200 years ago. In appearance, they are as opaque as watercolor is transparent, and their velvety bloom, softness, and fresh, bright colors make them one of the most attractive of all media. The effect of pastel is immediate from the moment it is applied to paper.

Pastel sticks are made from a paste composed of powdered pigments bound together by weak gum or resin; their name, in fact, is derived from this paste. They offer the artist the advantage of employing a variety of techniques, from that of graphics to oil painting, without a liquid medium to complicate the way they are used.

As against this, pastel is the least durable of all media. Chemically it is extremely pure but it is particularly difficult to protect against accidental damage, except by very careful glazing. The tonal range of pastel, too, is limited, and a further drawback is the difficulty of correcting mistakes. Although the color can be lightly brushed off with a bristle brush or a putty rubber, this can often lead to damage or flattening of the support. The drawing must, therefore, be planned and the initial design laid down very carefully.

Pastels should not be confused with the harder chalk crayons in which pigments are mixed with wax or oil. Colored chalks were used on tinted papers by the early draftsmen. Peter Paul Rubens (1577–1640) used black and red chalk, highlighted with white chalk, on white paper in his portrait study of his wife *Isabella Brandt*. The French artists, Jean Honoré Fragonard (1732–1806) and Antoine Watteau (1684–1721), also drew with colored and white chalks, but on tinted paper.

During an era when it was rare for a woman to achieve eminence in the arts, Rosalba Carriera (1674–1757) of Venice was a famous and skilful exponent of pastel drawing. The fineness and delicacy of her pastel portraiture can be seen in her sketch of Watteau, made before his death in 1721. Even greater was Quentin de la Tour (1704–1788) who, together with Jean-Baptiste Perroneau (1715–1783) and Jean-Baptiste Chardin (1699–1779), brought pastel work, especially in portraiture, to unsurpassed heights in the France of Louis XV and XVI.

The Impressionist painter Edgar Degas (1834–1917) became a great admirer and collector of La Tour's pastels, and developed a technique that his forerunners would have marvelled at. Yet despite his achievements in the medium, and those of Odilon Redon (1840–1916) and Mary Cassatt (1845–1926), pastels have, on the whole, remained relatively unregarded by artists, compared with, say, oil painting or even gouache.

Pastels Equipment, techniques

Pigments

Unlike watercolor and oils, pastel cannot be mixed on the palette to form other colors and tones. These have to be manufactured separately, and, in all, some 600 tints are marketed by various colormen. Sennelier puts out a range of 551 colors and tints. Grumbacher 336, and Rowney boxes an assortment of 72. Pastels in pencil form are made by Carb, Othello and Conté.

Selecting a suitable range of colors is very much a matter of individual taste. A basic selection might consist of about 48 colors, while a small range of 12 sticks would be adequate for outdoor sketching. Begin with a ready-made range and expand the selection as needed. Sennelier, Rowney, Grumbacher, Winsor and Newton, and Rembrandt all supply ready-boxed selections.

Pastels are made in three qualities: soft, medium and hard. Soft pastels offer the most brilliant range of colors. They are easier to handle than the other grades and tend to be used more.

It is wise to buy pastels which are labelled with the names of true pigments, such as viridian, ultramarine or yellow ochre. Others, although initially brilliant, may prove to be fugitive. For the beginner, a simple choice of four colors can be sufficient: black, white (to provide a cool contrast), red (Venetian red or sanguine) and brown. Rectangular black, sanguine and brown Conté crayons are useful for preliminary drawing and for accenting the lines of the design.

Manufacturers usually designate their colors by name and number, employing a scale from 0 to 8 to indicate relative lightness or darkness of tone. There is no standard system, however. Some firms, such as Talens, incorporate decimal points with the number as a guide to the degree of white that has been added to the basic color. If you are making your own choice of tones, a light, medium and dark tone of each color is perfectly adequate to begin with, rather than the complete range. Note, also, that the tint charts accompanying the boxed sets are printed on white, so that for work on darker or colored paper it is best to make your own tint chart.

Oil pastels are stronger and less brittle than ordinary pastels. They are ideal for laying down the initial design for an oil painting or for sketching.

Home-made pastels

Making your own pastels, although it requires patience, is a skill that is not too difficult to master. The end-product will certainly be cheaper than the shop-bought article and may well prove more satisfactory from the point of view of creating a particular tint.

For the binding solution you will need powdered gum tragacanth or gelatin leaves and distilled water. To prepare a quantity of solution mix 1oz (25gm) of powdered tragacanth with 1¾ pints (1 liter) of distilled water and let it stand overnight in a warm place. If the solution is to be kept for any length of time, add half a teaspoon of beta naphthol to the mixture, beat it well, and store in well-corked bottles.

Shake out the pigment on to a glass slab, pour some of the solution over it, and mix with a palette knife. Different pigments react in different ways, and for softer pastels you will need to add more distilled water to the original solution.

An even simpler method is to make a paste of the pigment on the glass slab first. Begin by putting equal amounts of zinc white and the chosen powdered pigment on a sheet of tissue paper and mixing them by rolling the paper from side to side. Set half the mixture aside to be blended later with an equal amount of white to make a lighter tone.

Tip the other half on to a glass slab, pour on enough distilled water to make a very stiff paste, then add a little gum solution or leaf gelatin solution and work it into the mixture with a palette knife. Roll the paste between a sheet of absorbent paper and a piece of cardboard, also covered in absorbent paper. If the crayon is to be rolled by hand, lay the forefinger along its length, not at right angles. Set the pastel aside to dry at room temperature for at least 24 hours, and preferably for 48 hours.

Surfaces

A pastel picture depends to a considerable degree for its effect on the color and texture of the support. Paper must have sufficient 'tooth' to rasp off the pastel as it is drawn across the surface. Color is important because some of the background may be left showing through as highlights or, in the case of the darker papers, to provide dramatic contrasts or shadows.

Paper suitable for pastel work includes white or tinted fibrous paper with a properly pigment-receptive grain, such as good-quality watercolor or drawing paper. A type of soft, fine sandpaper-surfaced paper is specially made for pastel, and a very soft, velvety flock paper is also available. Prepared canvas or a thin muslin-type cloth glued to card or wallboard can also be used.

Ingres papers are the most reliable colored papers for pastel work. There are two weights of Fabriano Ingres, 90 and 160 grams, and stone gray, mid-gray and fawn are recommended for use with pastel. Also specially textured in a range of colors are Tumba Ingres (15 colors) and Causon Ingres (21).

To avoid the risk of a tinted paper fading some artists prefer to tint their own supports. One method is to rub the paper with a damp rag that has been dipped in the powdered ends of pastel sticks. Excess powder should be tapped off when the paper is dry.

Pastels can be mixed with other media and applied over paper that has been tinted with watercolor, or over drawings in gouache, ink or watercolor, or combinations of all three. Mildew can occasionally attack pastel drawings, but this can be prevented by proofing the paper beforehand with a weak fungicide solution or a 10% solution of formalin.

Equipment

An easel and a drawing board are items of equipment that the pastellist shares with the watercolor artist. In addition, you will need a glass slab and a palette knife, together with torchon stumps—tightly rolled paper 'pencils' that serve either as dusters or to rub over the pastel for special effects. Chamois stumps are wooden sticks tipped with chamois which can also be used for blending the colors.

Other equipment includes a kneaded putty eraser and a sharp knife, together with a mouth atomizer, fixative, and sandpaper or glasspaper for sharpening pastel sticks. Charcoal, too, will be needed for outlines. Finally, of course, you will require a set of carefully chosen pastels.

Techniques

Before beginning a picture, lay out your pastels on a piece of soft cloth or corrugated cardboard, arranging them carefully according to color and tone. In this way you will avoid having to break off in the middle of working to search for the appropriate pastel.

Begin by practising various strokes, colors and effects on paper similar to that to be used for the picture itself. You will find that the pastel stick can be manipulated to produce thick and thin lines and textures. For instance, the sharp edge of a broken-off pastel, drawn lightly across the paper, will produce a fine line. By laying the end of the pastel flat on the paper a flat, even area of color can be laid down.

Heavy pressure forces a lot of pastel into the grain of the paper; light pressure reveals more paper through the color. Pastel laid on flock gives a velvety patch of color; on fine canvas it produces a fairly flat color. On glasspaper and Ingres paper much of the texture shows through the pastel.

Delicate contrasts can be achieved by covering a stiff brush or torchon with powdered pastel and applying it lightly across a picture. Fine hatching, cross-hatching or alternating strokes of different colors and

tones produce effective shading. Wide, regular strokes can be used for open work.

Once the pastel has been applied, take care not to rub it too much or the surface may become smooth and blurred and lose its texture. A good way of applying powdered pastel is with the finger, and the same means may be used to fuse or blend colors by rubbing gently over different colored strokes. Always draw with the paper tilted so that the pastel dust falls to the bottom ledge. Tap the board to get rid of excess dust, or blow it off the surface.

Colors can be mixed in a number of different ways: by stroking different colors over each other, as in hatching and cross-hatching, although without blending; by cross-hatching at a different angle; by stippling with dots in different colors; or by blending slightly, using the fingers or a stump.

Begin the picture with an outline in charcoal. Plan your colors and strokes before starting, as pastel is difficult and sometimes impossible to correct. Sometimes lines can be redefined on the finished picture by drawing over the pastel in charcoal, although this is obviously best avoided. Always draw bold, well-defined strokes or the picture will appear blotchy and undefined. A well-sharpened pastel pencil, such as those in the Othello range, can be used for very precise definition.

Degas devised a method of building up an impasto in pastel by spraying every layer of color with fixative as it was applied, and overlaying it when dry. The top layer was often left unfixed. In his later pictures in the medium he used broad bold strokes to achieve rough textured masses of dark and light. *Extras* (1877), *Three Dancers at their Toilette* and *Dancers* (1899) reveal his mastery of unusual lighting effects.

Georges Seurat (1859–1891) applied his experimental pointillist technique to his work in pastel. In his gouache *Café Concert*, he used black chalk for effects of density and shadow.

Pierre-Auguste Renoir (1841–1919) drew in red chalk, black grease crayon, and later in sanguine chalks with white highlights and black accents. His pastels *Young Girl with a Rose* and *Laundress and Child* show the velvety quality of his tonal changes, as well as the fine lines and hatchings which help express the light and shade melting into each other, and the softness of his subjects.

Paul Cézanne (1839–1906) made drawings which looked as though they had been done at great speed, as in his study in black chalk for *Afternoon in Naples*. In fact, he was always very particular with his composition, taking great care with perspective, contours and movement of line. Paul Gauguin (1848–1903) used the same direct approach in his pastels as in his oils. In his charcoal and pastel drawing *Two Women from Martinique* and in his pastel drawing of a *Girl* his figures have the serene look of those in his flat, simplified paintings, although the open overlays and careful

patterning reveal a new and interesting aspect of his talent.

Protecting pastels

Great care is needed to safeguard the condition of work in pastel if any degree of permanence is to be achieved. Only the best-quality paper should be used and the most durable pastels. The best protection is framing under glass, in such a way as to avoid contact between the glass and the picture. The work should be pasted to the mount along the top edge only, using a flour or starch paste, and the picture should be hermetically sealed against dust and other pollution.

If the picture is not to be framed, it may be stacked with other pastels, each interleaved with paper tissue, cellophane or greaseproof paper, and pressed down evenly by a board. In the course of time the pastel will gradually become fixed into the grain of the paper.

Fixatives

Although there are reliable fixatives on the market, the use of fixative has a number of drawbacks in practice. Foremost among these is that the colors lose their brilliance and some may darken; white tends to disappear, unless there is plenty of titanium white present in the pastel. In addition, the pastel can become rather heavy and gluey because of the fixative moving particles of dust. Too-heavy spraying can result in the pastel taking on the appearance of a painting in distemper. Some commercial fixatives on a shellac or mastic base may cause staining.

The most reliable fixative is a fast-drying one and can easily be made at home by dissolving 2 parts of damar varnish in 98 parts of benzine. The fixative can be sprayed on with a mouth atomizer or blower, or a sprayer of the bulb-and-jar type.

A pastel picture can be fixed after each layer but leaving the final one free (as was Degas' practice); or only the initial design may be fixed; or only the finished work. In all of these cases spray the fixative from the front, keeping the spray at the same distance from the surface of the picture. Begin spraying into the air before moving across the surface, and end in the same way.

Pastels may be fixed from behind by spraying on to a card pasted to the back of the picture.

Illustration in pastel and chalk

Subjects taken from classical antiquity, from history, and from the Bible were among the earliest to be used for chalk illustrations. These were often in silverpoint or charcoal overlaid with chalk and served as preliminary studies for a larger work. A good example of this are the studies of the *Heads of Two Apostles and their Hands* by Raphael (1483–1520), which is in black chalk highlighted with white, and the same artist's red chalk drawing of *Christ Giving the Keys to St Peter*.

Tiepolo (1690–1770) created frescoes on sacred,

mythological and historical themes, using pen and wash, and bistre and white chalk, for his preliminary sketches. Some drawings were conceived as works of art in their own right, including, in Dürer's time, copper-engravings and woodcuts. With the advent of mechanical forms of reproduction, drawings were made during the eighteenth and nineteenth centuries intended specifically for the new processes.

Today, pastels have fallen out of favor as a medium for illustration; pen and ink, watercolor, tempera and acrylics are preferred. During the eighteenth and nineteenth centuries, the increased demand for illustrations in books, pamphlets and magazines led to the growth of commercial art, which was considered quite different from fine art. Even though Toulouse-Lautrec (1864–1901) insisted that there was no difference between them, the barriers still remain today.

Pastel surfaces Paper (**below**) is an excellent surface for pastel work. Tinted paper is also much used with pastels. The available range includes Ingres Causon (**1**), Ingres Swedish Tumba (**2**), Fabriano Ingres (**3**), vellum (**4,5**) and glass paper (**6**). The Causon and Swedish Tumba papers are made in a wide variety of colors. The texture of glass paper retains the pigment well. Vellum is good for a delicate and detailed approach.

Types of pastels and chalk Pastels (**right**) are available in a wide range of colors, as well as different degrees of hardness. Manufactured varieties include Castell Polychromos (**1**), Inscribe soft pastel (**2**), Guitar oil pastel (**3**), Pentel oil pastel (**4**) and chalk (**5**). Oil pastels are radically different from pure pastels; they can be used in the preparatory stages of oil painting. They can also be combined with watercolor washes to give unusual effects.

Sharpening pastels 1. Rub the pastel lightly on a piece of fine sandpaper to chamfer the end for fine work.

2. Oil pastels are more firmly bound and harder than true pastels, so can be pointed carefully with a knife.

Pastels Grumbacher, the American company, market a very wide range of 336 colors and tints. The tints are graduated on a numerical scale; 8 is the darkest and 0 the lightest. A range of about 48 will be adequate in most instances. One light, medium and dark gradation of each color is a practical combination, while a set of 12 pastels may be sufficient for sketching out of doors.

Pastel strokes 1. Diagonal, hatched strokes can be laid with the side of the pastel. Press firmly for a broad line.

2. Hazy, tones can be added to pastel hatching by rubbing the lines with the fingertip to spread the color.

3. Light pressure using the side of the pastel achieves quite crisp fine lines.

4. The same technique, used to work across the lines in the opposite direction, results in a cross hatched texture.

5. Work along the grain of the paper with the blunt end of the pastel. Use firm, even pressure, and work in one direction only.

6. Peel back the protective paper from the pastel and use the long side to lay a broad area of grainy color.

7. A kneaded rubber can be used to highlight and lift the color and to create a linear texture of pale tones.

8. Make brisk strokes across the grain of the paper with the blunt end of the pastel. This creates a vibrant, stippled effect.

Oil pastel with turpentine wash
1. Rub an oil pastel over canvas or thick, grainy paper, to lay an even area of tone.

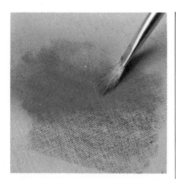

2. Moisten a brush with turpentine and work into the pastel, spreading the color in a wash and working it into the grain.

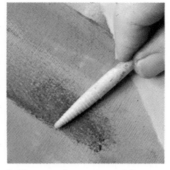

3. Use a torchon to spread the pastel color accurately into the shape. This is more precise than rubbing with the fingers.

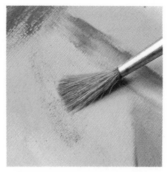

Lifting pastel with a brush Use a soft sable brush to lift the excess pastel and lighten the tone. Blow away surplus dust.

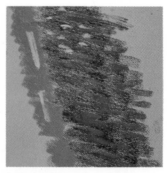

4. Highlights can be added by using thick, brief strokes of light tone. They can be used to link different areas.

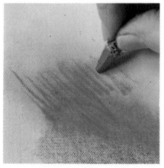

3. Soft strokes of pastel can be applied into the turpentine wash to build up a layer of textured color.

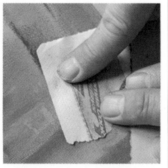

4. Place a piece of newspaper over the area of color and rub it to push the pastel into the paper grain and set the color.

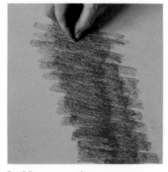

Building up surface texture
1. The grainy texture of pastel work is well suited to colored paper, which glows through.

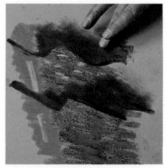

5. Strong, dark tones can be laid in with charcoal. Put down broad, black lines and spread them out with the fingertip.

Laying an area of tone 1. Draw in a small area of thick color using the blunted end of the pastel.

Highlighting with a kneaded eraser Knead the eraser to a point and lift small areas of the pastel to obtain lighter tones.

2. Mix the colors in short, open strokes. Do not apply the pastel too thickly at first; allow the colors to work together.

6. Highlights can also be worked into the charcoal. Eventually the colors will clog together so do not overwork the surface.

2. Spread the color out lightly from the center using the fingertip. Work it roughly over the area required.

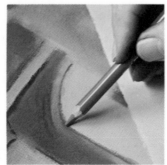

Adding detail with pastel pencil
Pastels can be bought encased in wood like pencils. They can be sharpened and used for detail.

3. Contrast hatched and grainy areas with layers of solid color. The hues are modified in combination.

Adding detail with charcoal
1. For fine work, sharpen the end of the charcoal by rubbing it lightly on sandpaper.

2. Add strong, linear detail with the point of the charcoal to make crisp shapes. Protect the drawing by resting on paper.

3. Start to block in areas of basic color; keep it quite thin in the early stages. Spread the tones with a torchon.

7. Leave the most intense shadows and highlights to the end. Add final details of shape and color to all areas of the drawing.

Tinting paper To tint paper, spray on thinned poster color or powdered pastel mixed with water.

3. Continue to work in pastel, blending it together with the charcoal to soften lines or mix colors to a darker tone.

4. Continue to build up the color areas until a basic image emerges. Use pastel pencils to hatch in small areas of color.

Spraying fixative A pastel may be fixed by spraying the back of the paper. The fixative permeates without dulling the color.

Pastel with watercolor wash
1. Areas of watercolor can be used in conjunction with pastels. Lay in soft pastel marks.

Working up a pastel drawing
1. Rough out the basic shapes in line with the charcoal and lay in tonal areas lightly.

5. Contrast warm and cool colors and allow the hues to mix and offset each other as you add more detail to the drawing.

Oil pastel with watercolor
1. Rub oil pastel over coarse watercolor paper to form a stippled pattern.

2. Wash over the pastel with a light toned watercolor wash to spread the pastel color. Remove surplus moisture with blotting paper.

2. Try out the pastel colors on a piece of paper the same tone as the drawing paper to establish a range of suitable hues.

6. Dark areas can be strengthened with charcoal and crisp linear detail added to increase the tonal effects.

2. Lay a watercolor wash over the oil pastel. The oil repels the watercolor, which settles into the grain of the paper.

3. Draw into the damp wash with pastel. When the wash dries, more pastel marks and watercolor areas can be added.

Charcoal.

History. Equipment and Techniques: Surfaces, Types of charcoal, Stick charcoal, Compressed charcoal, Powdered charcoal, Kneaded putty erasers, Techniques.

Charcoal is the oldest drawing medium. Charred wood from the fire furnished prehistoric man with a tool to draw the outlines of animals on the walls of his cave. The charcoal in use in today's art schools differs little from that used by early man.

In ancient times, bundles of twigs were charred in clay pots with air-tight lids. More recently, the charcoal-burner and his kiln were a familiar sight in our woodlands until well within living memory. Today, charcoal is produced from vine and willow twigs in special kilns from which air has been excluded.

Charcoal particles are inert and not bound to the surface of the paper, making them easy to smudge and blur, or to shake off and erase. A line drawn with charcoal should be of equal intensity along its entire length.

Charcoal was used on frescoes from ancient times until the Renaissance. It was favored, too, by many artists for making preparatory studies from life for oil paintings and for outlining the design on the canvas, as well as being a medium in its own right for drawing.

Honoré Daumier (1808–1879) one of the greatest graphic artists of the French Second Empire, made thousands of drawings in all media. He employed a distinctive curly scribbled line to record the everyday life of the people of Paris. In his vivid rendering of *Three Gossiping Women* he used pen and ink over charcoal, while his illustration of *Don Quixote and Sancho Panza* was executed in charcoal washed with Indian ink. His near-contemporary, Jean-François Millet (1814–1875) even succeeded in evoking light and color in his skilful charcoal drawings.

Among the artists to combine charcoal with other media were Edgar Degas (1834–1917), Pierre-Auguste Renoir (1841–1919) and Henri de Toulouse-Lautrec (1864–1901). Lautrec's work covered a wide range and included portraits such as that of the *Comtesse Adèle de Toulouse-Lautrec*, as well as carefully constructed scenes such as *The Bar of the Café de la Rue de Rome*, which is in charcoal heightened with white chalk. His sketch of the woman jockey *La Macarona*, was executed in black chalk, oil and charcoal.

Paul Cézanne (1839–1906), like many other artists, used charcoal for preliminary sketches. His *Head of a Painter, Adulle Emperaire* displays a firm line, and rapid but even shading. In his study for *The Autopsy* he relied on heavy line and very black outline shadow.

Charcoal Equipment and techniques

Surfaces

Charcoal paper has a fairly sharp 'tooth', strong enough to withstand rubbing and erasure. Even a fine-textured paper will show its grain through charcoal. Smooth papers are best for compressed charcoal, while colored paper will bring out the intense black of the medium.

Types of charcoal

Stick charcoal Charcoal sticks made of vine or willow are supplied boxed in 6in (15cm) lengths, and in varying thicknesses and degrees of hardness. Thin sticks have to be sharpened with sandpaper, but the thicker ones, which range up to ¼in (0.6cm) in diameter, can be sharpened with a fine blade. The best stick charcoal is made from vine twigs, and, with this type of charcoal, errors can be dusted off the paper.

Compressed charcoal This is made from powdered charcoal and a binder. It is stronger than ordinary stick charcoal but mistakes are harder to dust off. Sometimes known as Siberian charcoal, these compressed sticks are supplied in 3in (7.5cm) and 4in (10cm) lengths and are about ¼in (0.6cm) in diameter.

Charcoal pencils Made from thin sticks of compressed charcoal, encased in wood or rolled paper, charcoal pencils, besides being cleaner to handle than charcoal sticks, have a fine tip that makes them ideal for detailed work or very small drawings. The casing, however, means that they cannot be used for broad side strokes. Like ordinary graphite pencils, charcoal pencils are graded for hardness or softness, ranging from a hard HB through to a medium 2B, a soft HB, and an extra-soft 6B.

Powdered charcoal is used with stumps or torchons. These are made from blotting paper rolled to form a hard pencil with which the grains of charcoal are spread over the paper to obtain varying tonal effects.

Kneaded putty erasers are essential for charcoal work. Besides their property of being able to be shaped to a fine point to pick out detailed errors, they can also be used to blot up mistakes and unwanted lines simply by being pressed against them. However, if the drawing has been loosely executed, it may be better to leave the error and draw a fresh line. At some time, all the Old Masters have made *pentimenti* (repentances) and left them uncorrected.

Techniques

Charcoal has many uses: as a medium for large mural design; for making preliminary sketches for oil and

acrylic paintings; or for line and tone drawing in its own right. Among its advantages as a medium are that errors can be easily dusted off with chamois, kneaded putty or bread, which can also be used to pick out highlights by rubbing away the charcoal to reveal the support. Charcoal can be rubbed with a finger and blended with a stump; it can form part of a pastel picture, or be used for special effects with pencil, wash, gouache and chalk.

Honoré Daumier (1808–1879) used it as a wash, laying down solid strokes and patches, and working over it, softening the line with a brush dipped in clean water. In this technique, tone can be added by rubbing with a finger, by using lighter pressure or harder sticks, or by spreading powdered charcoal with a torchon or stump.

Because charcoal comes off the support so easily, fixative may be added lightly as the work progresses.

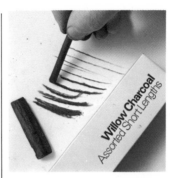

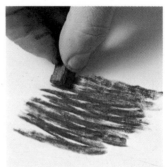

Charcoal 1. Charcoal is available in many thicknesses and lengths, each of which produce a different mark and density of black.

2. A thick stick of charcoal will quickly cover large areas with heavy black lines and deep tone, but is not suitable for detailing.

Forms of charcoal Compressed charcoal pencils (**1,2**) are available in soft, hard and medium. Sticks of charcoal can be bought in varying widths — thick (**3**), medium (**6**) and thin (**7**). Sticks of compressed charcoal (**4**) can be used to make broad blocks of tone. Powdered charcoal (**5**) is used in conjunction with a stump.

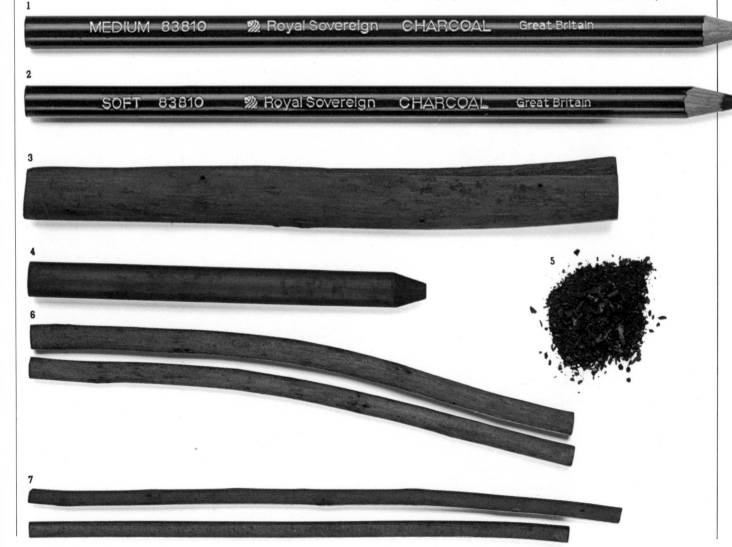

1

MEDIUM 83810 Royal Sovereign CHARCOAL Great Britain

2

SOFT 83810 Royal Sovereign CHARCOAL Great Britain

3

4

5

6

7

Charcoal techniques 1. Use fine, hatched lines to build up an area of graded tone. Work in one direction and vary the pressure.

2. Loose cross-hatching can be used as an alternative method of applying texture and tonal areas in a drawing.

3. Lay broad areas of tone with the side of the charcoal stick. The grain of the paper is an important factor in this method.

4. Richer texture can be added to tonal areas by working in line over the top, hatching or cross-hatching.

5. Spread charcoal dust gradually across the paper with the fingers to vary the tone and soften and lift black marks.

6. A soft putty rubber can be used to erase unwanted marks, or to work in extra texture. Use a clean piece to erase completely.

7. A plastic rubber is harsh on the paper surface, but can be used to draw into black and gray areas and to highlight with fine lines.

Making an erased texture 1. An eraser can be used to shape the charcoal marks into textures. Draw a thick, black line.

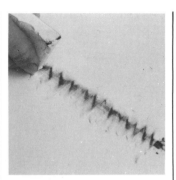

2. Rub lightly down the line of charcoal with a putty eraser. Do not lift the charcoal completely, but work into a pattern.

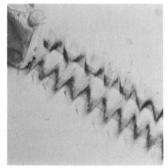

3. Repeat with another line of charcoal. This kind of technique can be used to form areas of pattern and texture.

Spraying fixative Charcoal dust lifts and smudges easily. Spray a finished drawing lightly with fixative from an aerosol.

Charcoal wash 1. Charcoal can be spread with water to soften the tones. First, make the drawing with line and tonal areas.

2. Moisten a soft brush with clean water and brush lightly into the charcoal drawing, spreading the tonal areas.

3. Allow the wash to dry before further work, or the charcoal will scratch the damp paper. Build up the layers of tone as required.

Highlighting with white crayon Use a white chalk or pastel to add highlights to a charcoal drawing, effective on tinted paper.

Charcoal with white gouache White paint can be used to highlight a charcoal drawing, or to overpaint errors.

Pencil.

History. Equipment: Varieties of pencil: Graphite pencils, Charcoal and carbon pencils, Standard clutch pencils, Colored pencils, Surfaces, Sharpeners, Knives and blades, Erasers, Fixatives. **Techniques.** Drawing for illustration. War artists.

Lead or graphite pencils are a comparatively new medium in the long history of graphic art, for it was not until 1662 that the first graphite pencil was made. Graphite had been discovered in Bavaria in 1400, but its potential for the artist remained unexploited until the first English find of pure graphite in 1504 at Borrowdale in Cumberland. The popular but misleading designation 'lead' pencil stems from this discovery, as the deposit was at first thought to be lead. Only later was graphite identified as a separate mineral and even then did not receive its present name until 1789.

Jean Auguste Dominique Ingres (1780–1867) is considered by many to be one of the world's greatest draftsmen. His study for the portrait of *Louis-François Bertin* reveals the great emphasis that he set on line work. Eugène Delacroix (1798–1863), Honoré Daumier (1808–79) and Edgar Degas (1838–1917) were among those most influenced by Ingres' tight drawing and smooth accurate line, although, as they matured, they developed very definite styles of their own, Daumier, for instance, drew mainly from memory, using loose-knit lines, seemingly endless and curling, as in his rapid pencil sketch of *A Group of Men*.

Paul Cézanne (1839–1906) makes fear visible in his sketch of a *Boy Surrounded by Rats*, and in his *Dog Studies* employs very fine cross-hatching to show tonal variations and shadows. Pierre-Auguste Renoir (1841–1919) reveals his love for the body in his pencil study for *The Bathers*, with its soft, merging curved lines.

Silverpoint

Until the development of the graphite pencil most sketching and preliminary designs for painting were carried out with a brush or charcoal, or with silverpoint. This precursor of the pencil was a stylus of silver or a similar metal, and to produce its characteristic delicate silver-gray lines called for a specially prepared background. It was a medium favored by many great artists, including the German artist Albrecht Dürer (1471–1528), who sketched his *Reclining Lion* (1521) with fine silverpoint hatchings and shadings on white paper. Leonardo da Vinci (1452–1519) drew a study for the *Virgin of the Rocks* on light-brown prepared paper, while Rembrandt (1606–1669) drew his wife *Saskia in a Straw Hat* with silverpoint on white prepared vellum (1663).

Modern silverpoints may be inserted into a pencil holder or into an ordinary lead pencil which has been split, the lead removed, and the two halves glued together again. The silver tip should be kept rounded off with a sandpaper pad otherwise it may dig into the support.

A silverpoint ground must have sufficient 'tooth' to retain the silver particles, and a gesso or chalk ground applied to paper will serve this purpose. Care must be taken not to oversoak the paper when brushing in the ground. A smooth coating of casein paint on an illustration board is a good silverpoint support.

With time the silvery-gray lines of silverpoint will tarnish and take on more definition. Erasure of errors in silverpoint or other metal-point drawings is best carried out with a damp cloth or steel wool. However, extreme care should be taken while making such corrections as the surface can easily be damaged.

Pencil Equipment

Varieties of Pencil

Graphite pencils Manufacturers grade graphite or 'lead' pencils according to their relative hardness or softness. The commonly accepted scale runs from 8B (the softest) through 7B, 6B, 5B, 4B, 3B, 2B, B, F, HB, H, 2H, 3H, 4H, 5H, 6H, 7H to 8H (the hardest). Another system employs a scale from 1 to 4, with 1 being the softest grade.

Charcoal and carbon pencils Both of these special types of pencil produce a very black line. Like the ordinary graphite pencil, they are available in soft and hard grades, of which even the hardest, unlike graphite, retains a high degree of blackness. Wolff's market a range of carbon pencils, while three of the best-known makes of charcoal pencil are the Royal Sovereign, the General 557, and the Blaisdell.

Standard clutch pencils A variant of the propelling pencil, the clutch pencil is designed to take a range of leads similar to that employed in the ordinary wooden pencil. A special clutch pencil is available which will draw a thin line of constant thickness.

Colored pencils The constituents of colored pencils—filler, binder, lubricant and coloring—result in a fairly soft lead whose marks can usually be removed only by a blade. An exception is the Venus range of colors which can be erased with a rubber. Derwent, Eagle, Faber, Conté and Staedtler all market colored pencils in a large range of colors.

Surfaces

Smooth paper, Bristol board or ivory card provide the best background for soft black leads, although when a

special effect is sought other types of paper may prove suitable. Hard leads are more successful on grainy textured papers, such as rough cartridge, watercolor and Ingres papers, white or tinted. If a tinted paper is needed that is not included in a manufacturer's range, a watercolor wash may be laid on white paper. Pencil drawings on a watercolor background are capable of producing dramatic effects.

Sharpeners, knives and blades

Pencil sharpeners are useful but not as easy to control as blades or knives, and have the irritating habit of breaking off the lead just as it is sharpened to a suitable point. There is a special sharpener made for sharpening the leads in clutch pencils.

Scalpels and craft knives are among the most useful adjuncts for the draftsman, although a one-edged safety-razor blade is an efficient, if less safe, substitute. A pencil that has been properly sharpened with a blade will reveal more lead and retain its point longer than one sharpened by a pencil sharpener. Blades can also be used to scratch out pencil marks that are impervious to an eraser—although this should be avoided where possible.

Never sharpen a pencil down to a stub so that you cannot see the point when you draw. Some art supply stores stock metal holders that enable a pencil to be used almost down to the end. For controlling a flowing line, a short pencil (not a stub) can be more useful than a long pencil, but this is a matter of individual technique.

Erasers

Nearly all hard erasers have some adverse effect, however small, on the surface of the paper. The familiar India rubber is efficient but inclined to become dirty, and can cause bad smudging. Plastic and artgum erasers are better in this respect, but artgum erasers have the drawback of crumbling so much in use that the paper has to be constantly 'swept', with the consequent risk of damage to the drawing. Best of all are kneaded or putty erasers. As well as being cleaner in use than other erasers, they can be molded into any shape, including a delicate point to pick out a small error. They can also be used to reveal areas of white paper to pick up highlights.

Fixatives

For graphite, charcoal, pastel and chalk, fixatives play the role of a binder similar to that of oils, gums and glues in paint. They can be bought ready-made, either in aerosol spray cans, or in bottles so that they can be used with an atomizer or mouth spray. Alternatively, an acceptable protective varnish or fixative can be made up by adding two or three parts of alcohol to one part of white shellac.

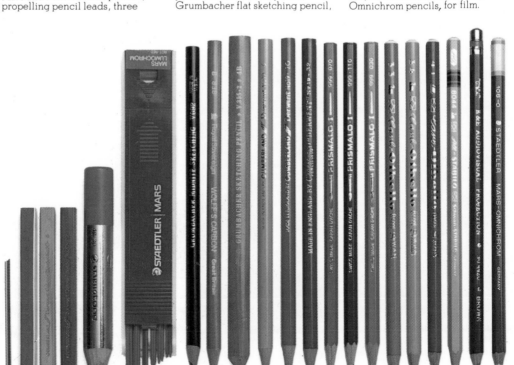

Pencils The wide range of pencils available to the artist includes (from **left** to **right**): Venus graphite drawing pencil, Staedtler Mars and Pentel clutch pencils, propelling pencil leads, three Derwent color blocks, Stabilotone wax pencil (for writing on film), clutch pencil leads, Grumbacher Midnite sketching pencil, Wolff Carbon pencil, Grumbacher flat sketching pencil, 3 Derwent color pencils, 3 Caran d'Ache Prismato pencils, 3 Carb Othello colored pencils, All-Stabilo, K & E Audiovisual Projection and Staedtler Mars Omnichrom pencils, for film.

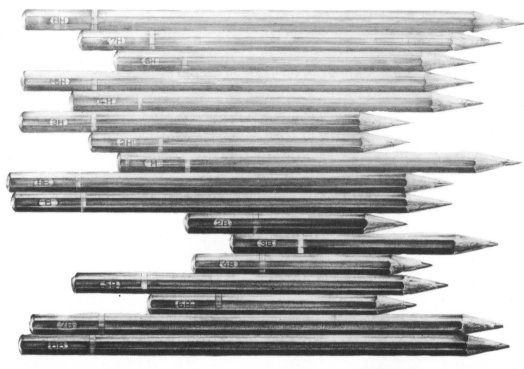

Grades of pencil It is general practice to grade graphite pencils according to their relative hardness or softness. The range of leads is numbered from 8H (very hard) to 8B (very soft). To illustrate this range, each pencil (**left**) was drawn with the appropriate pencil.

Surfaces for pencil There is a wide range of surfaces suitable for work in pencil. Each drawing of the dog's head (**below**) is divided in half. The top halves have been drawn with a soft lead and the bottom with a hard one. Different grades of pencil show up best on certain papers. Smooth surfaces such as line board (**2**) and cartridge paper (**4**) respond well to most soft leads. Hard leads however, are better used on a textured paper like Ingres (**3**) and watercolor paper (**1**).

1

2

3

4

Equipment for pencil drawing Artgum (**7**) and plastic (**12,17**) erasers can be used on any surfaces. A kneadable putty eraser (**6**) will rub out pencil, pastels or charcoal. The Mars eraser (**16**) removes pencil from drafting film or tracing paper. The Rotring B20 will erase pencil from beneath an ink line, and ink should be rubbed out with the T20 (**15**). Pencil sharpeners for crayons and pencil (**1,8**) differ from clutch pencil sharpeners (**2,10**). The Project 992 model (**3**) can be fitted with adaptors (**9**). A scalpel (**14**), craft knife (**11**) and razor blades (**13**) can be used to cut paper. To preserve the final drawing, apply a fixative, either using an aerosol spray (**5**) or a spray diffuser and jar (**4**).

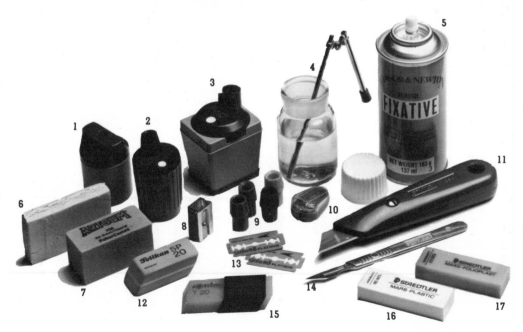

Pencil Techniques

Always start with a sharp pencil. This advice applies particularly to the softer grade of pencil, as well as to charcoal and carbon pencils. Unless these are kept well sharpened they will produce coarse thick lines which will spoil the effect of your drawing. Softer pencils are excellent for quick sketches, requiring less pressure than the harder pencils which demand more accurate control.

Pencil lines vary in appearance according to the speed with which they are drawn, the pressure exerted on the pencil, and the grade of pencil used. Hatching and cross-hatching, dots, short jabbed lines, marks and lines in random directions, fine lines, thick lines, thick lines trailing into fine, all these can be used to create tonal differences.

Silverpoint artists such as Dürer and Leonardo originated a method of reproducing tone by line which is still used today. They found that by drawing parallel lines close together they could achieve effects of shadow with dark and heavy lines, and of lighter areas with fine light strokes.

Rubbing, either with the finger or an eraser, can also suggest a different tone. Highlights can be reproduced by erasing down to the background, preferably with a putty rubber.

Different textures can be achieved, either on grainy paper or by drawing on paper laid over a textured surface such as wood, stone or cement—a technique known as 'frottage'. Try to work as cleanly as possible, and where necessary—in soft, flat areas of 'color', or pale gray and fine light line—fix the drawing as you work.

Fine color work can be accomplished with colored pencils. The Welsh artist, David Barlow (born 1948), works almost exclusively in this medium, and his *Alice* (1978) utilizes a range of 200 colors to virtuoso effect. He normally employs Staedtler pencils, as they are soft and with a relatively unwaxy texture that allows for overlays. *Alice* was drawn on CS (Colyer and Southey) 10-line board, full Imperial size.

Drawing for illustration

Barlow's *Alice* illustrates Lewis Carroll's *Alice in Wonderland*, and is in the tradition of eighteenth and nineteenth century book illustration. This was an era when many artists turned to pencil for illustration. Jean-François Millet (1814–1875) began a series of drawings in 1857 that were inspired by Perrault's tales for children, returning to the theme many years later in his *Tom Thumb's Parents Leaving for the Forest*.

In our own century, Picasso (1881–1973) employed long, simple, continuous lines to illustrate a tale from Greek antiquity, *Nessus and Dejanira*. Modigliani (1881–1920) used a similar technique in his *Nude Girl*. The spontaneity of the *Figure Disrobing* by Rodin (1840–1917) derives from quickly drawn, continuous lines.

War artists

Sketching techniques acquired a new impetus when newspapers and magazines employed artists to record the sights of modern war. For such front-line artists rapidity of execution was all-important, and the dry drawing media—pencil, crayon, charcoal and pastel—were ideally adapted to the conditions of the battlefield. In the Crimean and Franco-Prussian wars, the American Civil War, and in both World Wars, artists accompanied the fighting troops, and have left vivid and graphic records of the battlefront. Outstanding among these is the work of the American Civil War artist, Henry Lovie, which now hangs in the New York Central Library.

Pencil effects 1. A huge range of effects can be achieved with different pencils and papers. Here a 2B pencil was used.

4. For this effect, draw on the paper with the reverse end of the pencil, creating an indentation. Rub over the paper gently.

2. A soft pencil (4B) was used to create this gradated tone on moderately smooth paper.

5. An eraser can also be used to create specific effects. Here parts of the 2B pencil lines were erased.

3. Using the same 4B pencil on rough paper gives a coarser result.

6. These lines were drawn with pencils varying from 6H to 6B. This shows the differences in the weight of line produced.

7. These gradated tones were made using different colored pencils and blending the strokes made with each.

8. A wax pencil, such as a Chinagraph, picks up the texture of the paper.

9. This subtly varied effect is a result of blending different colors of crayon dust.

10. Here 4H pencil lines have been blended together.

11. For this effect, a 4B pencil has been drawn over crayon.

12. These soft lines have been created by drawing in Caran d'Ache over wet watercolor paper.

13. Carbon paper can also be used to create a strongly colored and textured mark.

14. This combination of tones was drawn using Caran d'Ache pencils.

15. Here a wash was applied over cross-hatched Caran d'Ache lines, creating a softened effect.

16. Graphite dust can be rubbed into the paper with the fingers to give a dense black surface or gradated gray tones.

17. Crayon tones can be gradated to show the texture of the paper.

18. For this effect both a 2B and a 5B pencil were used.

19. Here the tone has been blocked in with a 2B pencil.

20. Colored paper can also be use used to good effect. Here a 4B pencil has been applied to red paper.

21. White pencil can be used effectively for highlighting.

22. Pencil can also be combined to good effect with colored crayon.

Pen and ink.

History. Equipment: Dip pens, Fountain pens, Reservoir pens, Stylo-tip pens, Brushes, Artist's drawing ink, Non-waterproof inks, Paper and boards. **Techniques:** Tone, Erasing.

11 **Pen and ink** History

Pen and ink has been a tool of artists and illustrators for many centuries. Artists working in pen and ink are on the whole particularly fortunate, since their basic requirements are so modest. He or she needs only a sheet of paper, a pen and some ink to practise their craft. The medium itself allows an enormous variety of individual expression, whose possibilities can never be exhausted.

One of the special interests of any study of pen and ink drawing is the contrast between the very different temperaments of the artists who have been attracted to the medium and how, historically, the methods they evolved for themselves were adapted by their successors. Thus, the spirited attack of Salvator Rosa (1616–1673) leads through to present-day artists, such as Claes Oldenburg (born 1929) and Ian Ribbons (born 1924). Cooler in feeling, the sensitive and probing penmanship of Leonardo (1452–1519) and Botticelli (1445–1510) is echoed in the work of many modern pen and ink artists.

Medieval monks brought the use of the pen to its first flowering. The base on which their drawings were made was normally prepared skin—either goat, sheep or the less robust calf, lamb or kid. The quills they used for drawing were usually made from goose feathers.

Such pictures were not the first to be drawn with a quill, but it was more common for artists of previous eras to prefer incision or brushwork. The basic principles for the use of the pen and the techniques on which the formidable draftsmen of the fifteenth century built were thus established.

During the Renaissance, techniques and methods began to be more exploratory. The choice of subject matter broadened and considerable media mixing began. Renaissance artists started to use crayon, watercolor and white highlighting. The post-Renaissance period was particularly rich in gifted pen-draftsmen.

The approach and techniques of Rubens (1577–1640) and van Dyck (1559–1641) contrast with the less theatrical, almost intimate, approach of Rembrandt (1606–1669), whose drawings in ink and wash are deeply moving.

During the eighteenth century, Hogarth (1697–1764) was a line draftsman of the first order. Hogarth spent little time on preparatory sketches and his nervously energetic penmanship carries the viewer straight to the heart of his subject.

By the mid-nineteenth century, magazines as well as books had established themselves and provided work for pen and ink artists such as Charles Keene (1823–1891). Another celebrated artist of the period was George du Maurier (1834–1896).

In the USA, Charles Dana Gibson (1867–1944) introduced a crisp robustness to the use of the pen, quite new to the medium. Across the English Channel, the wit and vivacity of Caran d'Ache (1859–1909) and Forain (1852–1931) added a characteristically Gallic flavor to the graphic art of the times.

Major twentieth century exponents of pen and ink also include Matisse (1869–1954), Picasso (1881–1973) and Pascin (1885–1930). Its development in Britain by the short-lived Gaudier-Brzeska (1891–1915) continues to this day in much magazine and fashion illustration.

Pen and Ink Equipment

Types of pen
There are many types of pen available today: dip pens with a great variety of nibs; fountain pens; reservoir pens; and the more traditional reed pens, bamboo pens and quills.

Dip pens These are the most versatile and the cheapest available and are particularly good for the beginner. Buy a handful of different nibs (dip pens take a vast number) and try them out to see which are the most suitable. Nibs of different gauges range from fine crow quills to blunt points. The nibs are known commercially as pens, the holders as penholders. Small holders will take small nibs, such as mapping pens or crow quills, which make very fine lines. Dip pens will take any ink in varying amounts, heavy or light, and do not clog unless the paper has a bad surface which breaks up and sticks to the tip. Besides the standard penholders, some holders can be fitted with small brass reservoirs, but they are unsatisfactory in comparison with fountain or reservoir pens, and need to be cleaned fairly regularly after use to avoid clogging. Among the many fine and blunt-tipped nibs for dip pens are: italic, script, five-line nib and copperplate. A 'slip' nib has an open oval-shaped barrel; narrow crow quills and mapping pens have tubular barrels.

Fountain pens Except for the Osmiroid, these should only be filled with non-waterproof and writing inks—the Osmiroid takes waterproof drawing ink. Ink is drawn up into a fountain pen by suction through the nib. The nib range is very limited compared to that of the dip pen.

Reservoir pens Special ink in a wide range of colors is made for these pens. The ink is poured into the

reservoir, not drawn up by suction as in the fountain pen. Reservoir ink has a great similarity to drawing ink: it has waterproof qualities, but is smoother flowing. The Graphos reservoir pen has a range of 13 nibs that can be changed quickly to produce wide, thick, narrow or fine lines.

Stylo tip reservoir pens These, too, have a number of interchangeable tips which produce various widths of line. The stylo tip is a narrow metal tubular point which writes or draws with the same consistency in whichever direction the pen is pushed. Commercial illustrators now use them more than the precision draftsmen for whom they were initially designed. Like the airbrush reservoir, the reservoir pen must be emptied and washed out regularly with warm water after use. If ink is left in the reservoir for a short while, the nib should be covered so that the ink does not dry in the channel before use.

Brushes Buy good sable brushes if you are going to brush-draw your ink lines and always wash the ink off your brushes after use. You will need to practise brush drawing with various inks as well as watercolors. Watercolor dilutes better than Indian ink which becomes grainy in a watered wash. Chinese brushes used with a Chinese ink stick can produce very thin, transparent washes. The ink stick is rubbed on a soapstone palette with distilled water until the color is as black or as gray as desired.

Types of Ink

Artists' drawing inks These are waterproof and dry to a glossy film which can be overlaid. Inks are sold in a range of colors: Grumbacher offer 17, for example, Pelikan make 18, and Winsor and Newton have 22. Reservoir pens have a special range of colored drawing inks. Indian ink is the black drawing ink most commonly used.

Non-waterproof inks There are several non-waterproof inks available in a range of colors. They give the effect of diluted watercolors, drying to a matt finish, and sink into the paper more than other inks. Writing inks can also be used for drawing, but they only have a small color range.

Pigment in ink settles at the bottom of a jar left unused for some time so the jar should be shaken before use. If ink evaporates slightly in summer while uncorked during a day's work, the color becomes deeper and the ink thicker. The addition of just a small amount of distilled water (not a heavy dilution) will thin it again and cause an easier flow.

When choosing an ink you must bear in mind certain of its qualities; for instance, brown and sepia inks tend to fade in time. Some non-waterproof varieties of carbon ink are useful because they dilute easily with water, giving tones which can be blended still further when water is washed over them with a brush.

A wide variety of drawing inks is available at artist's stores. These include colored inks made by Faber Castell, Rotring, Winsor and Newton, and FW. Indian inks include Higgins, Grumbacher, Winsor and Newton and Chinese ink sticks. Fountain pen inks include Quink, Faber Castell, Rotring and Pelikan. Rotring make filler bottles of drawing ink for Graphos and stylo-tipped pens; drawing inks for film, and Type K for foliograph or Graphos steel nibbed pens.

Papers and boards

A very thin paper is often insufficiently sized and so the ink will sink in and spread unevenly. For ink drawing it is best to use a heavy cartridge paper, about 60lb; this will take washes and watercolors and even corrections without harming the paper. Hard calligrapher's paper is as good as expensive hard cartridge, when a sharp precise line is required. Fluffy textured paper is not good as the ink can soak right through and the paper eventually becomes yellow and brittle. It also tears easily and pieces can stick in the nib.

It is best to stretch the paper on a drawing board first (as for watercolor painting) if you are going to apply a heavy wash of ink or watercolor.

Nibs for dip pens Dip pens can be used with a wide variety of nibs. The slip nib (**1**) produces a fluid line and the map pen (**2**) a line of varying width depending on the pressure which the writer applies. The line produced by the crow quill (**3**) is of constant width because the nib is less flexible. The italic nib (**4**) writes with alternating thick and thin strokes.

The script nib (**5**) produces a line which, like the italic, is thin on the upstroke and thick on the downstroke, but it is less angular. The five-line nib (**6**) is particularly useful for crosshatching, as it produces 5 lines of equal thickness. The copperplate nib (**7**) which is angled to accommodate both vertical and horizontal strokes.

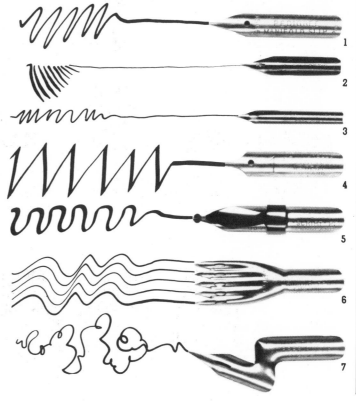

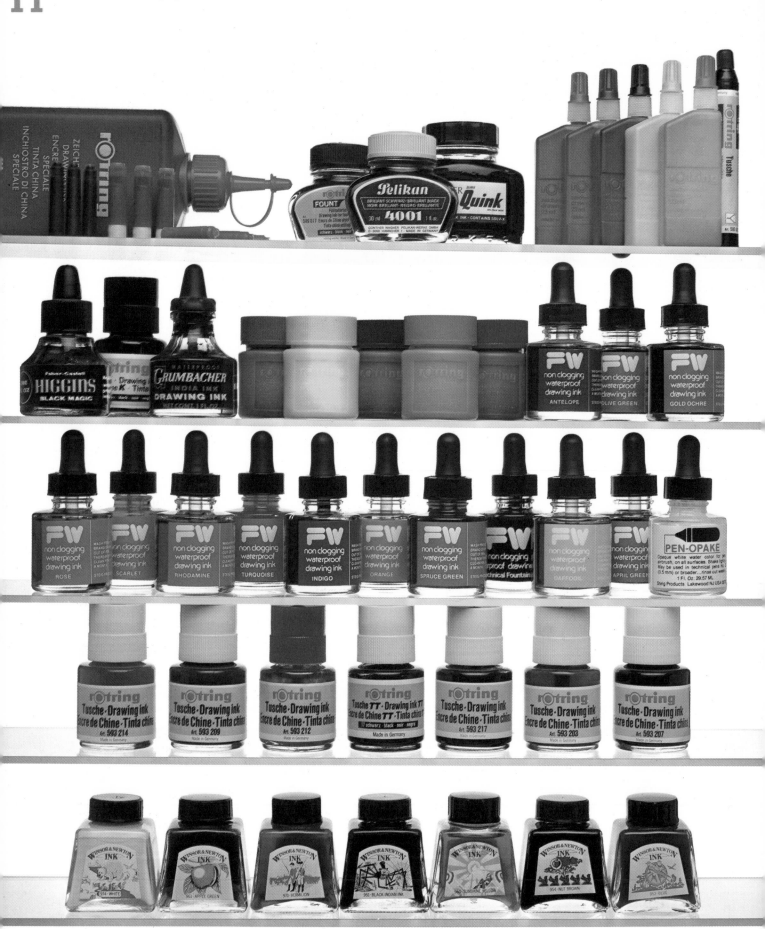

Inks The range of inks available to the artist includes: (from **left** to **right**) Rotring special drawing ink in a large container, ink cartridges in different colors, Rotring, Pelikan and Quink fountain pen ink, smaller bottles of Rotring special drawing ink (**top row**); Higgins, Rotring and Grumbacher Indian ink, jars of Rotring special drawing ink in jars, and FW waterproof drawing ink (**second row**); FW ink and Pen Opake (**third row**); Rotring drawing inks (**fourth row**); and Winsor and Newton drawing inks

(**bottom row**). Rotring special drawing inks are for use in stylo tip and reservoir pens. Pen Opake can be used in airbrushes or technical pens.

Reservoir pens The Rotring Graphos reservoir pen (**above**) is an extremely versatile drawing pen. There are almost 70 different, interchangeable nibs available· with 8 basic nib shapes. The ink feed from the reservoir can be adjusted by regulating the ink feed. This is an invaluable tool for the pen and ink artist.

Pen and Ink Techniques

Technique is a matter of experimenting until one or more methods are discovered which suit your own style or produce certain effects for special purposes. With pen and ink, the basic technique is the use of line and dot. These can produce an infinite number of textures and can also be combined with other media. Like all art, it is always worthwhile to study the good artists in the medium, copying their drawings and techniques in order to learn how to handle the materials yourself.

Do not begin a pen and ink work until you have tried drawing and practising movement and line with a pen and a brush. Work on a smooth paper and learn to use a minimum of pressure to get an even flow of ink from the nib on to the paper. Try to use exactly the same amount of ink on your nib each time if you are practising with a dip pen, and learn to judge when the ink will run out, so that you are not in the middle of a long unbroken line or movement when it happens.

It is a great advantage to make a very light preliminary design with a soft pencil if an accurate pen and ink drawing, rather than a quick sketch or note, is wanted. But once the technique of pen and ink drawing becomes more familiar, the spontaneity of free-flowing lines and observations translated instantly on to paper often make a far more exciting ink drawing than one which is premeditated and planned.

If a fine designer's brush is going to be used, the flexibility of its tip requires adept handling, and this too should be used a great deal in practice first. Brush, pen and ink drawing requires wide gestures and movement of the whole forearm, not merely of the hand from the wrist.

Tone In watercolor, tones come from applications of different washes. These can be used similarly in pen and ink drawing, but, as an ink drawing is basically composed of lines, there are many techniques which may be employed to convey depth of shadow and tonal variations: stippling, hatching and cross-hatching, dots and dashes, toothbrush spattering, scribbling, straight parallel lines graded from thick to fine, for example. A variety of effects are given by overlaying washes of watercolor or diluted inks with all the above techniques. Other effects can be created using the texture of sponges, fabrics (wool and lace), fingerprints and wood. It is also possible to draw pen lines on turpentine, using ink mixed with white spirit or ink over candle wax or masking fluid, to use blown ink blots, running ink blots and paper folded over ink blots to make a pattern. But it is the quality of the line that always counts.

An ink drawing must be completely dry before preliminary pencil lines are erased or any watercolor added. Drying time is at least 12 hours, and thick ink on very hard paper will taken even longer—about 18 to 24 hours. Ink can be picked up in a watercolor wash if it is applied too soon.

Erasing Mistakes such as an unwanted blot can be removed by dabbing it or gently overlaying it with small pieces of clean, dampened blotting paper. Another way to remove a blot is by brushing it with clean water and blotting it with tissue or blotting paper. Slight remaining stains can be erased with a soft India rubber and the disturbed paper surface smoothed down with a finger nail. A glass fiber eraser or a sharp blade can be used on dry ink. Use a shield to protect the rest of the drawing.

Pen and ink effects
Indian ink can be used with either a pen or a fine brush to create a variety of effects. The ink can be used by itself or can be combined with water and blotted or masked. The range which can be achieved means that it is important to experiment to find which suits your purposes best.

4. These faint lines were drawn through a layer of paper tissue which had been placed on top of the paper surface.

8. For this streaky effect, paper tissue was folded into a concertina and blotted.

12. Masking fluid painted on to the surface and covered with a thick ink wash was used to create this contrasting image.

1. Candle wax was rubbed over the paper and ink applied as a wash. The wax repels the ink, leaving the image in negative.

5. To create this mottled effect, fixative was sprayed on to the paper and ink applied with a brush.

9. For this blotted effect, ink was applied to canvas and this was printed off on to the paper.

13. Splatter ink on to the surface with a tooth brush. To give a softer result, blot the wet ink off.

2. These gradated tones were created using an ink wash and a brush.

6. This effect was achieved by lifting ink off the surface of the paper with a wet brush.

10. The combination of line and wash was created by laying a wash and adding pen lines when the wash had dried.

14. Pen and brush are not the only tools which can be used with ink; fingerprints can also be used effectively.

3. For this blurred effect, a wet paintbrush was drawn through thick ink lines.

7. Here a wet brush was passed through the ink lines, creating a combination of wash and line.

11. Lay a gradated wash by painting a block of color with a brush and feathering it out progressively with a wet brush.

15. Here wet ink was blown across the paper to create spidery streaks.

Stylo tip effects
A stylo tip pen gives an even line width and can be fitted with a wide variety of nibs. The stylo tip is particularly useful for drawing straight lines of even thickness and for dotting in the pointillist manner. Stylo tip pens are extremely good to use with Indian ink.

4. For straight lines, it is best to use a ruler. For evenness of pattern, be careful to space the lines equally.

8. Lines drawn freehand are not as precise as those drawn with a ruler.

12. These lines of varying widths were drawn with a ruler to give extra precision.

1. Lines of varying widths have to be drawn with different nibs. These were drawn freehand.

5. Crosshatching ruled lines gives a complex visual pattern.

9. This criss-cross pattern was drawn freehand.

13. This criss-cross pattern was drawn with a ruler using nibs of different widths.

2. A tartan effect is created by crosshatching freehand lines of different widths.

6. A criss-cross pattern drawn freehand with feathery strokes creates an uneven result.

10. These spidery lines were drawn in faintly with a stylo tip pen.

14. Simple scribbles can look effective, particularly if varied in intensity.

3. These dashes were made with a fine stylo tip nib.

7. A thicker nib creates a heavier pattern of dashes than a thin one.

11. A fine nib was used for this pointillist pattern.

15. Nibs of different widths were used for this pointillist effect.

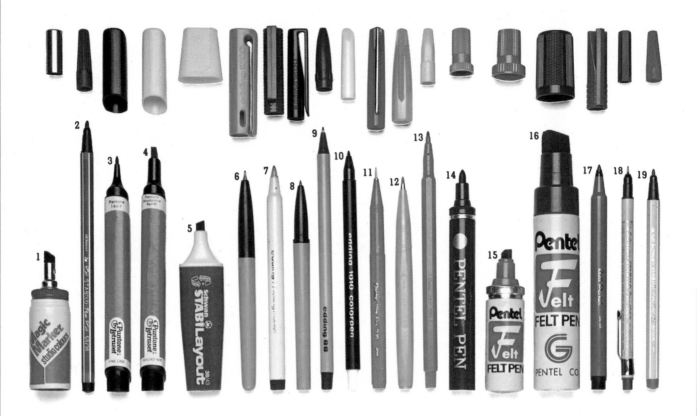

Markers Felt and fiber tip pens are increasingly used in design work. Since they come in a wide range of sizes and colors, they can be used in all stages of work, from roughs through to the finished design. Felt tip pens — Magic marker (**1**), Pantone pen (**4**), Stabilo layout pen (**5**), Pentel pen (**14**) and Pentel felt pens (**15**,**16**) — give a broad width line. These are mainly used for layout work and have a shorter life than fiber tip markers. The Stabilo series 68 (**2**) has a medium width tip and is available in many colors. Pentel ultra fine (**11**) and sign (**12**) pens have acrylic points and ink which dries instantly. This makes them extremely good for drawing. The Pentel ball pen has a very fine nib which enables it to be used for making carbon copies. All the Edding markers (**6**, **7**, **8**, **9**, **10**), the Pantone fine line (**3**) and the Pentel 67 (**13**) produce a thin ink line which is useful for detail work. The Stabilo overhead projection markers (**18**, **19**) dry instantly and do not run. They are heat-proof and do not fade.

Effects with markers 1. This pointillist effect was achieved by dotting the paper at random with an assortment of fine pens.

2. This mottled design was drawn with water-based felt pens and sprayed with a spirit solution.

3. These pink and red stripes have been blurred by drawing through a paper handkerchief placed on top of a piece of paper.

4. These water-based colors were blended by laying a wash on top of the design. Surplus water was blotted away afterwards.

5. This design was drawn using the same procedure as in (**2**). The softer effect was made by lifting excess ink with layout paper.

6. For this faded effect, thick spirit based markers were used to draw stripes on very thin paper.

Airbrushing.

Principles. Types of airbrush. Preparation and techniques: Preparing colour, Filling the brush, Techniques.

An airbrush is an essential part of the modern designer's or technical artist's equipment. The first airbrush was patented by the British artist Charles Burdick in 1893. Since then the airbrush has been developed and refined into a highly sophisticated instrument.

It takes considerable practice to learn to use an airbrush well. But, given time, a skilled artist can produce a wide variety of light, tone and shade of an almost camera-like precision.

All types of airbrush work on the same principle and have the same basic parts. Compressed air at an average pressure of 30 pounds per square inch passes through the venturi, a narrow passage which opens out into a wider space, where the air expands to create a partial vacuum. Paint, which is at normal atmospheric pressure, flows from the reservoir, mixes with the stream of air and is atomized. The spray which is produced passes through a conical air cap on to the surface being painted.

There are several different sources of air—an aerosol can, a foot pump, a refillable canister like that used by divers, or an electric compressor. For the serious artist, the compressor is the best method—although it is also the most expensive—because the air supply is at a much more constant pressure than with the other sources.

An airbrush is an extremely expensive piece of equipment and needs to be carefully treated. It should be thoroughly cleaned after use because, for example, the effect of the spray will be altered if the shape of the air cap becomes distorted, or if paint is allowed to congeal in the workings of the brush. To ensure proper functioning, the brush should always be cleaned and maintained precisely according to the manufacturer's instructions.

There are two types of airbrush operating mechanism. In the simplest form of airbrush, the single action lever model, the artist cannot alter the pattern of spray except by changing the distance between the brush and the surface. This is because the mixture of paint and air fired by the brush is in a fixed ratio. Some variation—into either fine or coarse spray—can be attained by attaching a separate adjuster. The advantage of this type of brush is that it is simple to maintain; its disadvantage that it can only be used for simple background work because it cannot produce precise detail.

For such work the artist needs to use the second, more sophisticated type of airbrush, the double action lever. With this type of brush the artist can vary and control the proportions of paint to air. Pressing the lever releases air, not paint. Pulling the lever back makes the paint meet the stream of air. If a greater proportion of paint is required, the lever should be pulled further back.

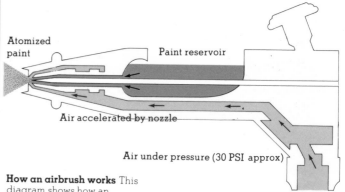

Atomized paint

Paint reservoir

Air accelerated by nozzle

Air under pressure (30 PSI approx)

How an airbrush works This diagram shows how an airbrush works. Pressurized air flows through a channel and is mixed with the paint lying in the reservoir at normal pressure. As a result, the mixture is expelled as an atomized spray.

Airbrushing Types of airbrush

There is a wide range of airbrushes on the market today. Choice of a suitable instrument will depend on what it is to be used for. For precision work of all types, the double action lever Aerograph Super 63 A-504 is ideal, while the Super 63E-504 is good for covering large areas quickly because it has a larger reservoir. For changing colors quickly, the Conograph, a single action lever model, is suitable. For a wide range of work the Wold A1 is suitable. For work with a wide tonal variety, for example from broad wash tones to fine line rendering, the Wold A1, which has both a coned and a flared aircap is ideal. Thayer and Chandler models AA and A are double lever models which can produce both broad coverages of tone and fine lines. For freehand drawing or photographic retouching, the Paasche AB is recommended. The Paasche H1, H2, and H3 are single lever models with pre-adjustable controls for air and color. Paasche also manufacture an air eraser which sprays abrasive instead of ink and erases ink or paint without smudging. It can be used for blending highlights and shadows.

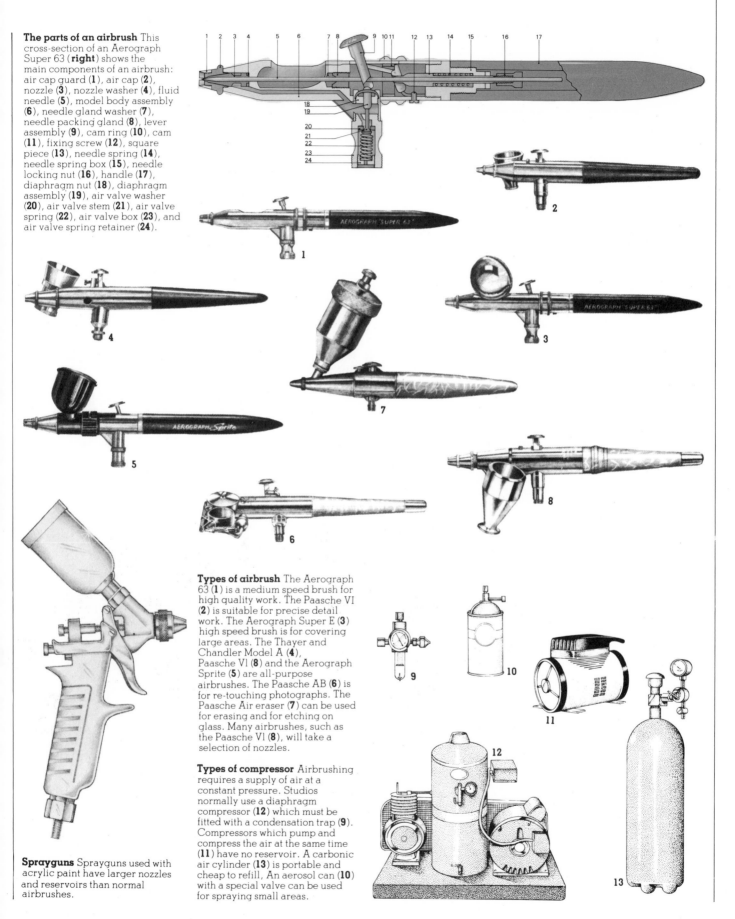

The parts of an airbrush This cross-section of an Aerograph Super 63 (**right**) shows the main components of an airbrush: air cap guard (**1**), air cap (**2**), nozzle (**3**), nozzle washer (**4**), fluid needle (**5**), model body assembly (**6**), needle gland washer (**7**), needle packing gland (**8**), lever assembly (**9**), cam ring (**10**), cam (**11**), fixing screw (**12**), square piece (**13**), needle spring (**14**), needle spring box (**15**), needle locking nut (**16**), handle (**17**), diaphragm nut (**18**), diaphragm assembly (**19**), air valve washer (**20**), air valve stem (**21**), air valve spring (**22**), air valve box (**23**), and air valve spring retainer (**24**).

Types of airbrush The Aerograph 63 (**1**) is a medium speed brush for high quality work. The Paasche VI (**2**) is suitable for precise detail work. The Aerograph Super E (**3**) high speed brush is for covering large areas. The Thayer and Chandler Model A (**4**), Paasche Vl (**8**) and the Aerograph Sprite (**5**) are all-purpose airbrushes. The Paasche AB (**6**) is for re-touching photographs. The Paasche Air eraser (**7**) can be used for erasing and for etching on glass. Many airbrushes, such as the Paasche Vl (**8**), will take a selection of nozzles.

Types of compressor Airbrushing requires a supply of air at a constant pressure. Studios normally use a diaphragm compressor (**12**) which must be fitted with a condensation trap (**9**). Compressors which pump and compress the air at the same time (**11**) have no reservoir. A carbonic air cylinder (**13**) is portable and cheap to refill, An aerosol can (**10**) with a special valve can be used for spraying small areas.

Sprayguns Sprayguns used with acrylic paint have larger nozzles and reservoirs than normal airbrushes.

Preparing color

It is vital that colors to be used in an airbrush are correctly and carefully prepared. The paint should be of about the same consistency as milk. If the pigment is too thick, a grainy, stippled effect will be created and the nozzle may clog. This can distort the needle action and damage the brush.

Each time the pigment is changed or the reservoir emptied, the paint reservoir should be cleaned out with solvent.

Filling the brush

The reservoir or cup should be filled with an eye dropper or syringe. It is also possible to use a brush for this, but it is important to ensure that the bristles are coarse, as fine hairs such as sable will tend to clog the brush.

When the brush is charged the outside surface should be carefully wiped with a clean cloth or piece of tissue in order to remove any surplus paint from the outside. If this is not done, the paint will run down the outside of the brush and damage the artwork.

Techniques

Beginners should spend some time practising with the airbrush in order to develop their technique. It is useful to start by working on some basic forms such as cubes, pyramids, cylinders and cones and to produce as many versions as possible, such as convex and concave, of one basic shape. Other techniques for the beginner are drawing straight lines and vignetting.

Straight line vignetting needs maximum air and minimum color mixture. Spray off the edge of a mask from right to left and hold the airbrush as close to 90 degrees to the working surface as possible. For thick lines the brush should be held further away from the board, and for thin lines close to it. The width of line can be controlled by lowering or raising the brush.

The brush should be held about 4in (10cm) from the board. Then in one constant movement, working from the shoulder, move the brush across the board. Then turn the spray upwards by rolling the wrist. It is important that you do not release or relax the finger pressure on the lever. Retrace the line over the mask by repeating the process in reverse.

To spray a straight line, raise one edge of a steel ruler above the surface of the paper and hold it steady. Spray as you slide the nozzle along the raised edge of the ruler.

For beginners it is also important to practise different effects. To create graded or blended tones you should work from lightest tone to darkest. For fine lines use a ruler. For splatter, a special cap should be attached to the brush.

The airbrush artist should also practise using different types of mask. A mask made of film should be made by tracing the image exactly onto the film before cutting. Liquid mask can be applied with a brush. It should be allowed to dry before spraying. When the paint is completely dry, the mask can be rubbed off. A torn paper mask can be used to create a pattern of wavy lines.

Mediums A wide range of mediums varying in color and consistency are available for airbrushing. Paints should be selected carefully as they will clog the brush if they are too thick. Among the mediums suitable for airbrushing are: Winsor and Newton's gouaches (**7**) and Pelikan Designer's colors (**9**) — both are opaque and useful for covering another color; Luma solar chromatic transparent (**2**) and concentrated (**3**) watercolors; Ecoline transparent watercolors (**1**) which are not waterproof; Dr Martin's concentrated watercolor (**5**); Vallejo liquid color (**6**); Winsor and Newton's waterproof

drawing inks (**4**) and Hyplar acrylic paint (**8**) which is mainly used in sprayguns. The airbrush must be regularly cleaned when acrylic paints are used.

Using the airbrush 1. Press down the button with the index finger to release the air flow.

3. To stop using the airbrush, first disconnect the paint flow by pushing the button back to its original position.

Cleaning the airbrush
1. Soak up any excess paint from the reservoir using a paint brush or an eyedropper.

3. Spray the water through the airbrush. Repeat the process as many times as is necessary until the water is sprayed out clean.

2. Keeping the button depressed, pull it back to release the paint.

4. Finally, stop the air flow by lifting the finger from the brush. Splattering will occur if stages 3 and 4 are reversed.

2. Spray through any remaining paint, then put clean water into the reservoir with an eyedropper or brush.

4. Before using the airbrush again or putting it away, remove any moisture from the reservoir with a clean, dry brush.

Airbrushing effects Blended or graded tones should be created by working from the lightest tone to the darkest (**right** and **center**). For splatter effects (**far right**), either attach a special cap to the airbrush or greatly reduce the air pressure. It is a good idea for beginners to practice their techniques such as shading basic shapes (**below**) to give them a three-dimensional appearance.

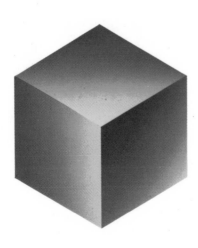

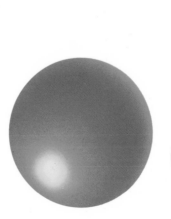

Using masks Masks may be used to gain different special effects. Almost anything may be placed over a surface to act as a mask, but the most common masks are made from paper or transparent film. Great care should be taken when cutting these masks and practice is advisable. Cut the film firmly, so that it does not stretch or lose its shape, but not so hard that the underlying surface is scored.

4. Lift the mask with the tip of a scalpel and peel it back carefully. Place the mask on one side for later use.

2. Hold the torn mask above the surface of the paper. The nearer the mask is to the paper, the sharper will be the line produced.

Using highlights Highlights can be painted on to almost any piece of work to emphasize a particular feature. However, as they are easy to do, the temptation is to add too many highlights which will spoil the work. One simple highlight can be most effective on its own. It is important to choose a color for the highlight that will complement the rest of the painting. White is used most often, but experiment with other colors.

Cutting a mask 1. Cover a piece of paper or board with masking film. Smooth out any wrinkles with your hand.

5. Using the airbrush, paint the unmasked area as required. Use even strokes.

3. Spray along the torn edge of the mask, and move it steadily at intervals until you have painted the required number of lines.

Making a star highlight 1. To make a stencil, cut a thin line in a piece of paper or card with a scalpel. Use a ruler as a guide.

2. Place a sheet of artists' carbon paper between the film and the image. Trace down the image on to the film.

6. When the section has been painted, allow it to dry. Replace the mask and repeat the process as appropriate.

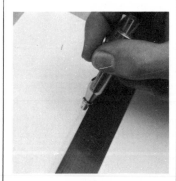

4. The finished wavy lines can sometimes be made to look like the grain of a piece of wood.

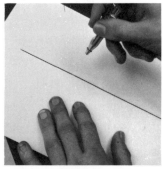

2. Keeping the airbrush steady, spray the center of the line. The paint will spread slightly along it.

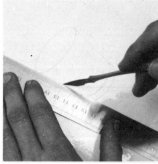

3. Using a metal ruler for any straight lines, cut the film with a scalpel round the shape of the design.

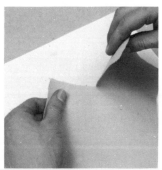

Torn paper mask 1. Tear a piece of fairly thick paper in half. The edge should be rough rather than even.

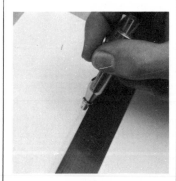

Spraying a straight line Raise one edge of a ruler. Slide the nozzle of the brush along it while spraying the line.

3. The star is complete when 4 lines have been painted at right angles to each other.

Printmaking.

History and methods. Relief printmaking: Lino cuts, Wood cuts, Wood engraving, Relief etching, Ink and paper. **Intaglio:** Engraving, Drypoint, Etching, Aquatint, Lift ground or sugar aquatint, Equipment and materials, Printing. **Lithography:** Surface preparation, Equipment and materials, Printing. **Screenprinting:** Basic principles, materials and methods, Frames and

T he basic way to make a print has been familiar to European artists for the last 500 years and is thought to originate from techniques used nearly 1,400 years ago in China. It was brought to an extremely high standard by the Japanese in comparatively recent centuries. The method, known as relief printing, consists of gouging shapes from a block of wood or other material, leaving a raised image between the areas dug away. The surface is covered with a form of ink. Paper or some substitute is pressed on top, so that it picks up the ink from the raised image. The process sounds simple, and can be carried out at a crude level by a child cutting pieces from a potato. In the hands of such artists as Kitagawa Utamaro (1753–1806) of Japan, the same principles, together with sophisticated materials and great skill, become transformed into a high art form.

Relief printmaking has an exact 'opposite'—intaglio, a method in which paper is pressed on to ink that has soaked into a depressed image after the raised areas have been cleaned off.

Two other fundamental techniques have been evolved. The planographic or lithographic method is that of making prints from a flat surface. Grease, which retains ink, and water, which repels it, are used on the surface. The fourth technique is printing through a stencil—screenprinting.

Printmaking was originally done by hand, then became popular in the centuries after the invention of the printing press, as wood blocks and lithographs became the basic form of illustration for books, magazines and newspapers. In the seventeenth and eighteenth centuries, intaglio printing dominated book illustration, but was lengthy and costly compared with wood engraving and lithography which came more into favor in the nineteenth century. These methods were cheaper and faster and allowed color to be printed in, rather than hand tinted on to the print later, as had been the practice. Various blocks or stones superimposed on the others were used to print different colors. In the nineteenth century, 12 blocks were sometimes used for one color picture, but cheaper color prints were done with three or four.

Finally, the printmaker was overtaken by the photographer as the usual provider of popular illustrations. Printmaking has now returned mainly to the realm of the artist producing limited numbers of prints or posters.

Printmaking Relief printmaking

Lino cuts

Working with lino is usually the student's introduction to relief printing. Here the idea is to cut away those sections of the surface not meant to reproduce or leave a mark. The comparative softness of lino makes it easier to use but less effective in the long term than wood or metal. Picasso (1881–1973) and Matisse (1869–1954), however, both spent part of their artistic careers working with lino and they produced some fine lino cut color prints.

Techniques Hard lino is never used. If there is no other type available, it is softened by heating or by leaving oiled overnight in linseed oil.

The design is drawn on the lino in pencil or Indian ink. A range of cutting heads exists for cutting round the design, and each head can be fitted to a special handle. By cutting away from the design—not towards it—the unwanted areas are then removed with a carpenter's or carpet knife. Small areas are removed with gouges. A special range of lino inks is available. Proofs can be taken at any time during the cutting, to check progress.

Wood cuts

Prints still exist today which were made from wood cuts in the eighth century in China, where paper was manufactured much earlier than in Europe.

Early Chinese and Japanese paper was made from vegetable fibers. In Europe, it was manufactured from linen rags before wood pulp became the basic ingredient of paper.

Paper mills began spreading across Europe in the late Middle Ages, and the invention of printing with movable type raised the demand for books, in turn leading to a demand for illustrations. Wood cuts made picture reproduction in larger quantities a reality. The Middle Ages also saw the spread of playing cards marked with wood cut designs. Later, wood cut illustrations were used in pamphlets on astrology or on religious or political themes.

In a separate development, the Japanese were perfecting wood cut illustration by the eighteenth century. The school of Ukiyo-e made prints showing scenes from everyday life. From this development came such famous artists as Utamaro, Katushika Hokusai (1760–1849) and Ando Horishige (1797–1888).

Tools and techniques Any smooth-rubbed, hard, well-seasoned wood is adequate—even veneered plywood, block board or veneered hardboard, provided the veneer is hard enough. Any wood which can be cut

any way across the grain without splintering is also suitable. A favored wood is plankwood, wood sawn along the grain or 'side grain'.

The design is drawn or traced onto the wood, and then cut round with a craft knife. The wood is then carved away from the outline with a gouge.

Wood engraving

This is a more sophisticated version of wood cutting, made from wood blocks sawn across the grain, known as end-grain. It produces finer results than ordinary wood cuts. Because the cutting is done on the end grain, the blocks are smaller.

The process is delicate and exacting, and engraving tools similar to those used for copper and steel work are applied to it. The basic principle is still the same, however, producing a relief print with a raised printing surface.

As engraving became more popular in the late Middle Ages, many goldsmiths and armorers turned to it. One who was originally an apprentice goldsmith was the German Albrecht Dürer (1471–1528), a skilled craftsman in wood cuts and engravings. He became a member of a guild which grew up for engravers, just as guilds had developed for carpenters or goldsmiths.

By the 1750s, when wood cuts had become crudely-drawn stock blocks kept for cheap illustrations, fine wood engraving continued as an art form.

The English artist Thomas Bewick (1753–1828) was apprenticed to an engraver at the age of 14, when wood blocks made illustrations for cheap popular publications. He later made his name as an illustrator. His two volumes of *British Birds* published after in 1797 were popular and went into many editions.

Author and artist William Blake (1757–1827) made wood blocks to illustrate a new translation of Virgil, and his work influenced Samuel Palmer (1805–1881) and Edward Calvert (1799–1883).

The appearance in 1832 of two periodicals, the *Penny Magazine* and the *Saturday Magazine*, brought a new demand for engravers. These publications were the forerunners of many. *Punch* appeared in 1841, and the *Illustrated London News* in 1842. Many artists were attracted into engraving. For example, Edmund Evans made his name as a color printer. Charles Keene, one of many who made pen drawings on the wood, had a large number of his engravings in *Punch*. Gustave Doré (1832–1883) illustrated many works of literature.

Artists produced many drawings for the medium but often left a great deal for the engraver to do, sometimes later complaining that the drawings had been mutilated.

Apart from fine art and illustration, commercial engravers turned out innumerable catalogs, broadsheets, leaflets, magazines, labels, packages and advertisements. Much of this work was destined to become the realm of the photographer.

Tools and techniques As a basic material, boxwood has a close, even grain and does not fall out of shape. The most practical way to prepare the surface of the wood for engraving is to stain it lightly with a thin ink and make the drawing with a darker ink. The stain enables the artist to see the effect of the tools during the engraving.

Many start out with a small set of gravers (flat, round, lozenge and burin) and cutters (large and small 'U' and 'V'). The full sets of tools fall into categories: gravers, tint tools, scorpers, spitstickers, multiple gravers and small chisels mounted in graver handles. Each tool consists of the metal shank of the cutting tool and the handle. The cutting end is ground back to an angle of 45° to the shaft butt and is less steep than that of metal engraving tools. The small wooden handle is shaped like a half-mushroom to fit into the palm without touching the block surface.

The tint tool has fine parallel lines which imitate washes or tints. Spitstickers can do stipple or line, and scorpers eat away large unwanted areas.

Relief etching

This is done on metal plates either by cutting with graving tools to remove the area not to be printed, or using acid to eat it away.

If acid is used, the design can be painted on in acid-resistant varnish or asphaltum. The plate is then placed in an acid bath so that the acid eats at the non-resistant unpainted areas. As a precaution against accidents and fumes, the acid bath, usually made of plastic or fiberglass, must be situated near a sink and used only in a place which is well ventilated. The plate is removed with a plate lifter and washed under running water. The varnish is cleaned off with turpentine. The plate then has to be thoroughly de-greased. it is sprinkled with powdered chalk and rubbed with a clean cloth. Ammonia is rubbed over the plate with another rag and it is again rinsed and wiped under running water. The plate is dried on a hot plate and given a final wipe with tissue paper to remove any remaining water and residual chalk.

Relief etching can also be used as an intaglio plate. Ink is left in the acid-bitten areas after the surface is wiped clean.

Prints are sometimes made from mixed blocks of lino, wood and metal for varied textures.

Ink and paper

Precise inking comes with practice and can be very refined. Rainbow inking, or color blending, is a favourite Japanese technique in which colors are blended on a single block. The harder the block, the longer it will last and the more prints can be made from it without becoming too worn.

A sheet of plate glass or an old litho stone can be used on which to mix the ink. On the plate or block which has been engraved, the ink is spread evenly with a roller, then rolled evenly over the raised surface

in all directions. A brush or pad can be used for inking up small areas of fine detail. Oil-based inks can be dabbed on small parts of the design with a finger or with a brush.

Newcomers are advised to experiment with proofs from different types of paper. If the paper is too hard, the ink needs synthetic dryers and dries glossy. If the paper is too absorbent, the ink is soaked up and the definition is lost.

The paper is laid over the inked surface. To make a hand print, the back of the paper is rubbed with a tablespoon or a circular tool called a baren. Larger prints are made on presses, the pressure coming from metal plates. The inked block is laid on the bed of a press with printing paper over the top and newsprint sheets as padding over that again. The bed is wound into the press, the pressure lever is pulled and the print taken. The print is peeled back slowly to avoid smudging, being held down at one end at the same time.

Cutting a lino block 1. Draw the design on the block in ink. Cut along straight edges with a knife using a ruler as a guide.

2. Cut away the lino with a small gouge, working towards the knife cut. Work with small cuts to avoid chipping into the straight edge.

Lino cutting tools and equipment
The lino used for lino cutting (**below**) is fairly thick with a coarse hessian backing. The cutting tool can be used with a wide variety of cutting pieces. A set normally includes a device for removing the blade. The ink is applied with a rubber covered roller (**right**).

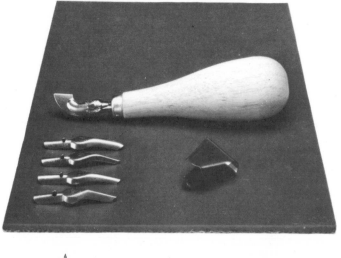

Lino cutting gouges Gouges for wood cutting (**below**) are available in a variety of shapes including: (from **left** to **right**) flat engraver, round engraver, lozenge engraver, burin, large cutter, small cutter, and U-shaped cutter.

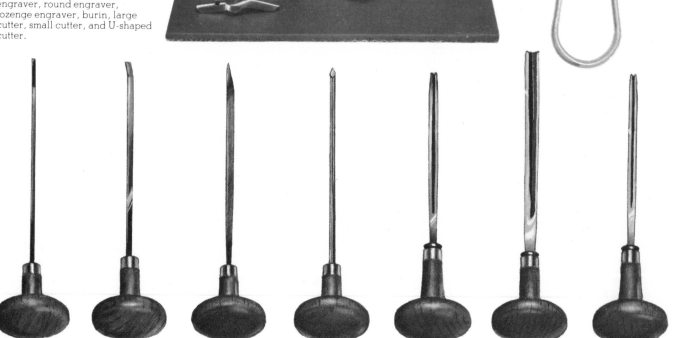

3. Work into a larger area with a different sized gouge. Keep the free hand behind the other for safety and to steady the block.

4. Use a broad gouge to take out more lino. Shallow cuts will make a textural pattern, a deep cut will leave a white area in the print.

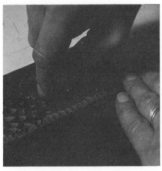

5. Make irregular marks to produce different patterns and textures. Experiment with the cutting tools to make a variety of marks.

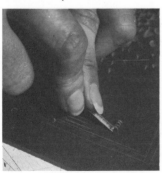

6. Cut fine lines with a small V-shaped gouge. Push the gouge slowly and ease it from side to side if it sticks in the lino.

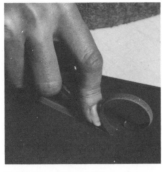

7. Cut broad lines in the same way, using a wide U-shaped gouge. Control the cuts carefully to avoid unwanted marks if the gouge slips.

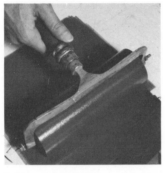

Inking a block 1. Mix up the color of ink required and lay some with a palette knife on a hard flat surface. Roll it out evenly.

2. Roll ink over the block, working from each side until the surface is covered all over with flat, even color.

3. Allow the textured areas to pick up the ink but do not work too heavily or it will color the cut away parts of the block.

Inking a block in graded tones 1. Using palette knives, lay out on a clean, flat surface a quantity of colored ink and some white ink.

2. Mix the colored and white ink together thoroughly with a palette knife. Mix up two tones of the color.

3. Spread the inks out on the surface side by side, making a broad band of each color letting them meet in the middle.

4. Using a roller slightly larger than the lino block, roll out the ink, moving the roller slightly to blend the colors where they meet.

5. Roll the ink over the surface of the lino. Work in one direction only until the ink is perfectly flat over the whole block.

Inking wood to obtain a grain texture print 1. Brush the wood block with a wire brush to bring up the grain.

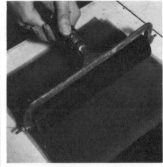

2. Roll out ink on a clean, flat worktop. Keep the ink fairly thin on the roller but make sure it is even.

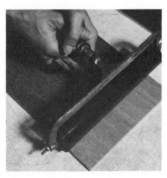

3. Roll the ink lightly over the block. Keep working until the pattern is clearly visible, but do not flood the grain with ink.

Taking a print in three colors
1. Mark the dimensions of the block on a registration sheet. Mark one corner of the paper.

2. Place the registration sheet on the bed of the press. Position the block on the paper inside the drawn marks.

3. Place the printing paper over the block, aligning it carefully with the registration sheet working from the marked corner.

4. Run the print through the press. Hold the paper down on the block and lift one end of the print to check the quality.

5. If the print is satisfactory, peel back the print from the block. If it is uneven, run it through the press again first.

6. Blot off excess ink to prepare for a second color. Cover the print with a clean sheet of paper and run it through the press.

7. Place the second block on the registration sheet. Lay the first print over it, aligning it from the marked corner, as before.

8. Run the print through the press and check that enough pressure has been used. Peel back the print from the block and blot off as before.

9. Lay the third block in position on the registration sheet. Place the two-color print over it and run it through the press.

10. Peel back the finished print. As this is the final color, there is no need to blot it. Leave it in a rack to dry.

Working the press 1. Check the pressure before printing. It may be necessary to add paper as packing. Wind the bed in under the press.

2. Pull the handle of the press across from right to left. Brace one leg against the bottom of the press to get leverage.

Cutting a wood block 1. Brush the block lightly with a wire brush to bring up the grain.

2. Work into the wood with a gouge, paying attention to the direction of the grain. Draw the design first if required.

3. Cut along and against the grain. It is more difficult to work against the grain and the design may need to be modified.

4. At any stage of cutting a wood block it is helpful to ink it up in a dark color to check progress and see the grain pattern.

I ntaglio plates are engraved either by engraving and drypoint, in which the plate is incised by hand, or by etching in which acid bites into the surface. In all cases, the lines of the design are lower than the flat surface. After the plate is inked, the surface is wiped clean and the ink lies in the lines.

Principles and materials

Copper was originally used for the plates, but economy now dictates steel, zinc or aluminium. If copper can be afforded, 16 or 18 gauge must be used. Copper has a softness which is excellent for hand engraving and drypoint, and acid bites into it evenly when etched. The metal also prints up to 100 sheets or so without wear, unlike zinc which wears fast although it is easy to work. Zinc can also oxidize, making pale colors look dirty. Aluminium is similar to zinc but without color problems. Steel is harder to work but will give many prints.

All stored metal plates should be coated in grease or wax, wrapped in greaseproof paper and kept in a dry place. Damp rots the surfaces. The plates must be cleaned of all grease, as in relief etching, before use.

Engraving

This technique, which began with Medieval armory, involves a linear design cut into the metal. The cutting tool is an engraver or burin held at a low angle. It raises and removes a strip of metal as it draws the design line, leaving a tiny trench which is later filled with ink.

Drypoint

This method does not completely remove the metal from the line, and leaves a ridge or burr on each side of the cut. This is later filled with ink and gives a soft-edged picture. Only a limited number of prints can be made from a drypoint plate because the burr wears down quickly from the pressure of printing.

A drypoint needle is either of toughened steel or has a diamond head, and the depth and width of the line depends on the pressure and angle at which the needle is used.

Etching

An etching plate is prepared for easier design drawing by laying it flat on a hot plate and evenly applying with a roller a small melting ball of prepared beeswax, bitumen and resin. The waxed face is smoked—its surface given a carbon deposit—by holding tallow tapers to the waxed side. Care is taken not to scorch the plate. The carbon hardens the wax, making it more acid resistant and causing the marks drawn on it to be more easily visible.

The design is drawn through the wax onto the metal with an etching needle or any sharp tool. The back and sides of the plate are varnished as a protection from acid, and the plate is laid design-side up in an acid bath. The acid bites into the metal freed from the wax and exposed by the needle. The plate is left in the bath from minutes to hours, depending on how deep the artist wants the design bitten. Finally the plate is removed, washed under running water and wrapped in blotting paper to dry off excess water.

Lines intended to create lighter areas are painted over with varnish. When this has dried for at least three minutes, the plate is again laid design-side up in acid to allow the 'darker' areas or lines to etch more deeply.

Any bubbles forming from the acid are removed with a feather to ensure even biting. The plate is washed under running water again. The process is repeated until the desired contrasts of light and dark tones are achieved.

Aquatint

A bed of powdered resin is applied. Resin is resistant to acid which bites only between the particles of powder, forming an area of grained tone. The powdered resin is tapped as evenly as possible onto the plate through a fine muslin bag or stocking, then heated until it melts and covers the plate.

The plate is allowed to cool. The back and sides of the plate and sections of the design not wanted to be acid-bitten are then painted with varnish. The plate, when dry, is laid in an acid bath, removed, washed and dried as above. Then it is cleaned with turpentine and methylated spirits.

Lift ground or sugar aquatint

Here the artist draws a negative to apply an aquatint directly onto the plate. Varnish, again, protects the required areas from aquatinting. The design is drawn onto the plate with a mixture of sugar, water and gamboge yellow or any water soluble paint for the coloring. A solution of varnish and turpentine is then spread over the whole plate. When this is dry the plate is submerged in warm water and brushed so that the varnish over the design will lift or flake away. An aquatint ground or bed is laid onto the exposed area of the plate as above and the plate is submerged in an acid bath, removed and cleaned off with turpentine. A soft ground, which can be bought ready made or prepared by mixing hard etching wax with tallow, is used if a soft sketchy effect or texture impression is wanted. The plate is heated and the ground applied. Pieces of cloth are laid on the plate which is then covered with a sheet of glacé paper (to protect the press blankets) and the cloth is pressed into the wax by running the plate through the press.

If the cloth has been sufficiently pressed, the glacé paper and cloth is removed. The design is drawn by protecting the necessary areas from the acid with varnish. The plate is submerged in the acid bath, then removed and the varnish cleaned off with turpentine. The plate is cleaned with powdered chalk and

ammonia, as in relief etching.

Equipment

A beginner would not immediately acquire a complete set of intaglio tools which consists of various sizes of burnisher—long, short, curved, pointed; scraper—double ended, twisted, pointed, flat and drypoint; as well as a draw tool and a mezzotint rocker.

Also needed are ammonia, powdered chalk, a metal file (plate edges are filed to an angle of 45 degrees so they cannot damage the press), varnish, a heater or burner for the plates, tallow tapers, wax ground (hard and soft), roller, hand vice, brushes for drawing and varnishing, soft and hard muslin, dabbers, printing inks, etching oil, acid bath (a photographic developing tray would do), felt blankets, blotting paper, tissue paper, methylated spirits, turpentine, powdered resin, callipers and a hammer.

Paper Single sheets should be large enough to leave a wide border around the printed picture. Prints are made on damp paper, and therefore unsized papers are best. Cartridge paper is good for proofs and for editions.

Recommended papers are Crisbrook, Copperplate, German etching, American etching, and various papers of Arches, BFK River and Fabriano.

Acids Nitric acid is used for etching copper or zinc plates. Acid for copper should be separately stored in a glass-stoppered bottle, as it turns blue after contact with the metal. For copper etching, one part nitric acid and two parts water are used; for zinc, one part nitric acid to eight parts water. For accurate etching of very fine lines without the heavy undercut which nitric acid possesses, Dutch mordant is used, composed of ⅕oz (5g) potassium chlorate boiled in a little water to which 1oz (25g) hydrochloric acid and 5oz (125g) water is

added. Perchloride of iron is also excellent for etching fine lines but leaves a deposit of iron in them and the plate must be laid face down in the acid bath so that the sediment will drop out.

It cannot be stressed too much that great care must be taken when using acids. Running water should always be available close by in case of accidents.

Printing Hard papers are sometimes soaked in water 12 hours before use and run over with a soft damp brush before printing. In general, it is enough to sponge the softer papers. Practice tells how damp the paper should be. Damp paper can be kept between sheets of plastic until needed.

Powdered ink is softened with a palette knife, a little oil is added and it is ground to a stiff paste on a slab with a muller. The plate is inked and warmed, with the ink worked well into the intaglio areas or crevices. The plate is wiped with muslin in a circular movement so that the surface is cleaned and the ink remains in the crevices.

The ball of the hand is dusted with powdered chalk to polish the plate which is then placed, design-side up, on a press bed on a sheet of paper already marked with the position of the plate according to the paper size. The dampened paper is laid on top of the plate, and the press blankets are placed smoothly over the paper. The bed is wound through the press, the blanket removed and the print slowly peeled from the plate. Care must be taken because if the ink has stiffened it may tear the damp paper. Finished prints are stacked between dry blotting paper with a weight on top to prevent buckling.

It is possible to make a stronger print by bringing the ink to the surface. This is called retroussage and involves heating the inked plate and stroking a muslin pad gently over the surface in all directions.

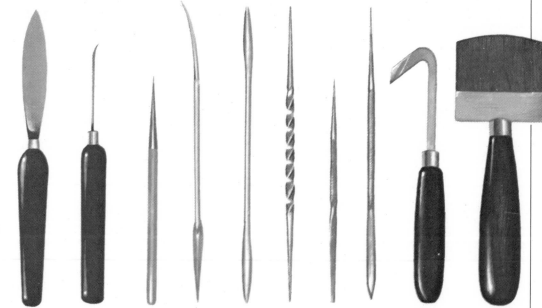

Tools for intaglio Tools needed for intaglio work include (from **left** to **right**) flat burnisher, curved burnisher, pointed burnisher, burnisher and scraper, double-ended burnisher, twisted burnisher, pointed and flat burnisher, drypoint burnisher, draw tool and mezzotint rocker.

Cleaning an etching plate 1.
De-grease plate with a mixture of whiting, water and ammonia. Rub it over the surface with a damp rag.

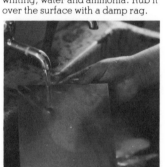

2. Wash the plate thoroughly under running water. If greasy patches remain which repel the water, clean the plate again.

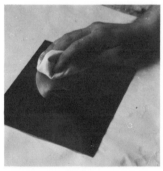

3. Dry the plate on blotting paper or a hotplate, wiping the surface with tissue or a clean rag to remove residual whiting.

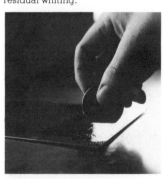

Etching a plate 1. Place the clean plate on a hotplate. Apply hard ground to a small section of the heated surface of the plate.

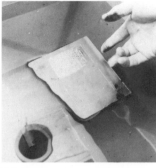

2. Spread the ground over the surface of the plate with a roller, working from each side until the ground is quite evenly distributed.

3. Place the plate upside down in a holder, smoke the ground from underneath with tallow tapers to blacken it. Do not scorch it.

4. Lay the plate on a flat worktop and draw lightly into the ground with an etching needle to expose the metal.

5. Prop up the plate and coat the back with varnish to protect it from the acid. The edges of the plate must also be varnished.

6. Lower the plate into the acid bath. The time this process takes varies with the type of metal and acid, and depth of the bite.

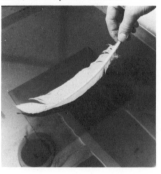

7. The plate should be brushed with a feather to clear bubbles formed in the acid which slow down the bite and make it uneven.

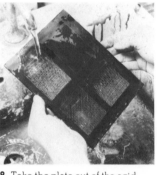

8. Take the plate out of the acid bath and rinse it under running water. Dry it with blotting paper.

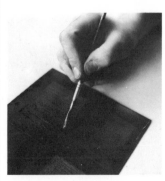

9. Lines which are to be lightly etched can be stopped out with varnish and the plate returned to the acid for biting of other areas.

10. After biting, rinse the plate in water and clean off ground and varnish with turpentine. De-grease the plate as in the cleaning process.

Aquatinting 1. Shake powdered resin evenly over the surface of the plate with a muslin bag.

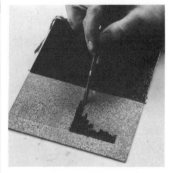

2. Heat the resin from underneath until it forms transparent globules. Do not overheat or it will flood and form an acid-resistant film.

3. Stop out non-aquatinting areas. Varnish back and edges of the plate. Put in acid; allow a few seconds for the bite.

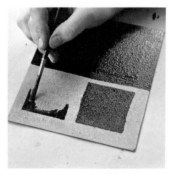

4. Rinse and dry the plate. Areas of light tone can be stopped out with varnish. Repeated biting produces progressively darker tones.

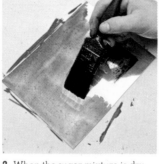

2. When the sugar mixture is dry, cover the whole plate with varnish diluted with turpentine. Allow it to dry completely.

3. Cover the plate carefully with a sheet of glacé paper, or tissue dusted with French chalk.

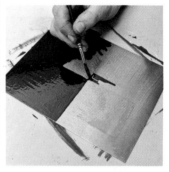

7. Stop out with varnish any areas which will not be textured. Bite the plate in the acid and clean off ground and varnish.

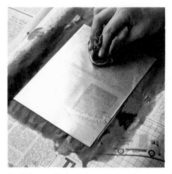

5. When all the biting is finished, clean off varnish with turpentine, then remove the hardened resin with methylated spirits.

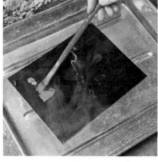

3. Immerse the plate in warm water to lift the sugar mixture. Dry the plate and aquatint the exposed area.

4. Lower the blankets of the press over the plate and paper without disturbing any of the material.

Mixing ink 1. Shake some powder pigment on to a stone slab and make a well in the center with a palette knife. Pour on some oil.

Aquatint box When the handle is wound, a rotating flap causes resin dust to rise in the box. Insert the plate, and the dust settles evenly.

Applying soft ground for texture
1. Heat the plate. Apply soft ground and roll it evenly over the surface of the plate.

5. Run the plate through the press so that the pressure will cause the materials to leave a textured impression in the soft ground.

2. Mix the pigment into the oil thoroughly using palette knives or a muller until a stiff paste is formed. Add more oil if necessary.

Sugar aquatint 1. Mix sugar, warm water and water soluble paint (for color to a thin, syrupy texture. Paint on the plate with the solution.

2. Put the plate on the bed of the press and lay on pieces of cloth, paper, or any textured material.

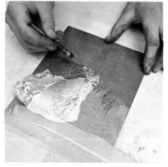

6. Remove the textured materials from the plate without scratching the ground. Use an etching needle to pick up delicate pieces.

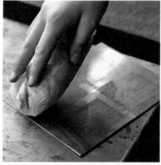

Retroussage Wipe lightly over the intaglio areas with a clean roll of muslin. This lifts the ink to gain maximum tonal effect.

Taking a print 1. Soak sheets of paper in a clean tray of water. The time it will need to soak varies according to the type of paper.

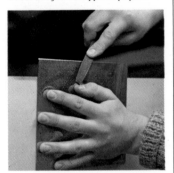

2. File the edges of the plate at an angle. Work along them with a burnishing tool.

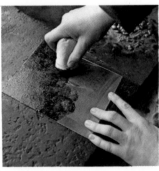

3. Warm the plate on a hotplate. Work the ink thickly over the plate, using a circular motion to rub it well into the intaglio.

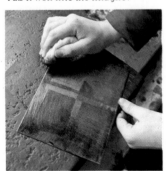

4. Wipe the plate with muslin. Work in varying directions to clean the surplus ink off but do not lift it out of the intaglio.

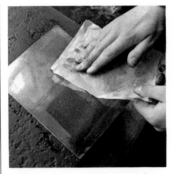

5. Remove the remaining ink from the surface by gently rubbing over the plate with clean pieces of tissue, using a circular motion.

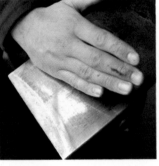

6. Polish up the surface of the plate by wiping gently over it with the side of one hand lightly dusted with French chalk.

7. Take the soaked paper out of water and blot it off. Several sheets can be prepared and kept damp between sheets of polythene.

8. Put the plate on the bed of the press and lay on the damp paper; take care to align the sides and **center the print.**

9. Place the blankets carefully over the plate and paper and smooth them out.

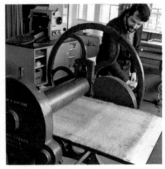

10. Roll the print through the press. Make sure no creases form in the blankets.

11. Lift up the blankets and peel the print carefully back from the plate, starting from one corner.

12. Check the qualities of the finished print against the plate. If the ink is too dry or paper too wet, the print will not be sharp.

Scraping and burnishing 1. Scrape back an area of texture with a scraping tool. Work over the surface without digging into it.

2. Lubricate the scraped area with oil and work over it with a curved burnishing tool to smooth off and polish the surface.

Relief etching 1. Draw a design directly on the plate with varnish and a brush.

2. Put the plate in acid and allow enough time for a really deep bite. Brush the plate frequently with a feather to keep it biting evenly.

3. Remove plate from the acid, clean off all the varnish with turpentine. The depth of the acid bite shows clearly.

Taking a combined relief and intaglio print 1. Ink up the intaglio, working the ink well into the deeply bitten areas.

3. Clean off remaining ink with tissue. Pay special attention to the raised areas and make sure any unbitten surface is quite clean.

5. Run the plate through the press as for 'Taking a Print'. The combination of inks prints in a rich mixture of tones.

4. To print the relief, roll black ink evenly over the plate with a roller. Do not work into the intaglio areas.

2. Wipe the plate to remove all surplus ink, but be careful not to wipe it right out of the edges of the raised areas.

4. Mix up some ink in a contrasting color and roll it out evenly. Roll carefully over the surface of the plate in one motion.

Embossing Run a clean, deeply bitten relief plate through the press with a sheet of thick paper to make an embossed design.

Printmaking Lithography

T he fact that grease will not mix with water forms the basis of lithography, the production of flat surface or 'planographic' images by chemical printing from plates. An image is drawn on stone or metal. The prepared surface is sensitive to a variety of crayons, inks and washes and is an excellent artistic medium.

Principles and history

The traditional surface is limestone, which is fine grained, and hard but porous. The grain retains any design drawn on it with greasy ink or chalk and retains water washed over it—except for the greasy parts. Greasy ink rolled over the surface sticks to the greasy design and is repelled from the water-covered parts. The process was discovered in Munich in 1796 by Alois Senefelder (1771–1834) and its popularity spread. Goya used it (as well as his mixed technique of aquatint and etching) as did Stothard and Fuseli in England. In France artists such as Toulouse-Lautrec

(1864–1901), Edouard Vuillard (1868–1940) and Pierre Bonnard (1867–1947) took up lithography with great enthusiasm.

Commercial lithography today uses flexible zinc or aluminium metal plates which are cheaper and more convenient. Another form of commercial lithography is off-set printing where the image is transferred first from a metal plate to a rubber roller and then onto paper. Metal plates are given granular surfaces, making them function like litho stones.

Surface preparation

On metal plates the surface is lightly etched so that only the design will attract the printing ink. Stone surfaces must be prepared by grinding sand over them with a levigator (a smaller flat stone or metal disc with an upright handle). The edges are first rounded with a rasp to prevent tearing the paper. Water is run over the surfaces, then sand is sprinkled and worked in from corner to corner with circular movements of

the levigator. After ten minutes, the stones are washed before fresh sand or pumice stone is used to give a final grinding. The surfaces are washed and blown dry with hair dryer or fan heater.

Equipment and materials

Litho chalks or crayons as they are called, the oldest tools for litho drawing, are grease sticks, varying from very soft to very hard. Tone can be built up with hard crayon first, adding softer ones as the drawing process continues.

Litho pens can also be used. Special greasy ink is available in solid and liquid form. A solid stick of ink can be rubbed in a tin saucer previously warmed over a candle flame until it turns liquid. It is diluted with distilled water drop by drop until it will run from the pen. The pen is inked from an ink-loaded paintbrush. The use of hand rests will avoid dirtying the stone. Nibs, which should be cleaned frequently, will be worn down rapidly by the stone. Brushes can be used to paint on the greasy litho ink but they require great skill, although they produce very fine washes. Ink can also be spattered over the stone with a toothbrush, masking out protected areas with paper or gum arabic.

Mistakes can be scratched off a stone with a scalpel shaped blade. On metal plates, Erasol or etcho-stick are used.

Strong, soft-surfaced paper is recommended for lithographs, such as Crisbrook, Arches, Rives or J. Barcham Green.

Printing

The designed surface is wiped with French chalk to make it acid resistant. The surface of the stone is covered with gum arabic and then wiped dry with a rag. The ink and chalk are removed by washing the stone with water and turpentine. Printing ink is rolled on while the stone is still damp (the greasy design left on the stone picks up the ink).

The stone is dried again and the ink design is dusted with powdered resin. The stone is dusted with French chalk. This is a good opportunity to scrape away any error, or remove it with a pumice and rubber stick called a snakestone, and water. The stone is then etched with a solution of one part nitric acid to forty parts water, which cleans the surface and opens the pores. Gum arabic is again applied to the stone with a sponge and washed off finally with water, while the old ink is washed with turpentine. The whole surface is now washed clean and fresh ink is rolled on while the stone is still damp.

The stone is finally placed on the bed of the press. The inking roller looks rather like a baker's rolling pin and consists of a padded wooden cylinder covered with leather or plastic and loaded with stiff ink. The design on the stone must be kept damp. The roller is inked and rolled over the stone several times so that the image is at full strength. Printing paper is placed on the stone, and protective layers of newsprint are laid over the paper. The stone is then cranked under the scraper (a strong leather-covered piece of wood) which provides the pressure and movement to make the imprint. The stone will crack if the pressure is too severe. The stone should be kept damp between each print.

Color lithographs are made by taking an impression on transfer paper and reproducing the original design on as many stones as the number of colors wanted. Registration marks on the first plate or stone are carefully transferred to the others. These are crosses cut to position accurately the successive color plates onto the preceding image.

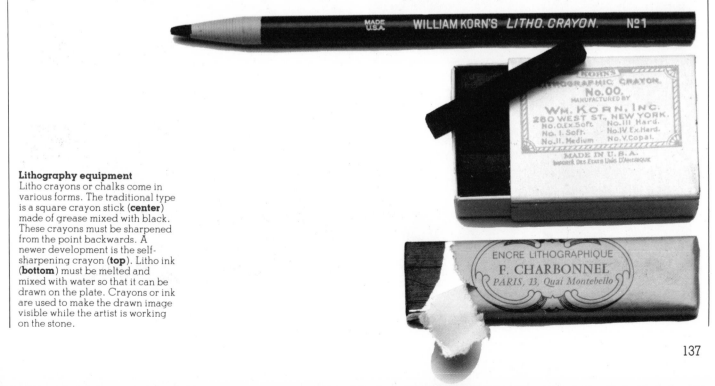

Lithography equipment
Litho crayons or chalks come in various forms. The traditional type is a square crayon stick (**center**) made of grease mixed with black. These crayons must be sharpened from the point backwards. A newer development is the self-sharpening crayon (**top**). Litho ink (**bottom**) must be melted and mixed with water so that it can be drawn on the plate. Crayons or ink are used to make the drawn image visible while the artist is working on the stone.

Preparing the plate 1. A variety of marks can be drawn on a plate. Stick or liquid inks are available for washes and solid areas.

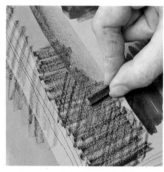

2. Draw on the plate with litho crayon, as if using ordinary pastels or chalks. The drawing materials must be greasy.

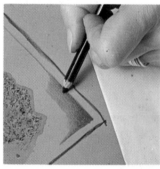

3. A waxy pencil can be used for fine work. Do not rest on the plate or grease from your skin will be picked up. Rest on paper.

4. When the image is complete, dust over the whole plate with French chalk to make the surface dry and even.

5. Dab gum etch over the surface of the plate. Apply it quite thickly and let it dry. This cleans out unwanted marks like thumbprints.

6. Wipe over the dried gum with a fresh layer of wet gum. Blot it off with clean paper so that a thin, even layer remains.

7. Let the gum dry, then wipe over the plate with white spirit to remove the black image and leave only the greasy impression.

8. Rub in asphaltum to boost the image by adding extra grease. Avoid areas of wash drawing, which may fill in too solidly.

9. Remove the gum by sponging with water. Roll over the plate with black ink until the image is again clearly seen, keep the plate damp.

10. Corrections may be made now. A typewriter rubber is adequate for small areas, or use special preparations such as Erasol.

11. Dust the image with acid-resistant resin dust and then with French chalk so that the surface will receive etching fluid evenly.

12. Paint over the surface with Victory etch, to fix the image which may otherwise spread. Leave it on for 1-3 minutes.

13. Sponge off the Victory etch and dry off the plate. Spread a thin even layer of ordinary gum. The plate can be stored in this state.

Printing on an offset press
1. Remove the black image with white spirit. Sponge off gum and roll the damp plate with ink.

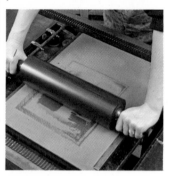

2. Dry off the damp plate with a fan. Pass the roller of the press across the plate so that it picks up the inked image.

3. Position the paper on the bed of the press and pass the roller over the paper so that it lays down the printed image.

History

Modern screenprinting is a refinement of stencil printing used in ancient times. Fijian islanders made some of the earliest known stencils for printing textiles. They cut holes in banana leaves and applied vegetable dyes through them on to bark and cloth. The Japanese made four- and five-color stencils.

In the Middle Ages, stencils with wood block prints were used to decorate prints and playing cards. Stencil craft was often used for religious pictures and illuminated manuscripts in the sixteenth century. In the following century the stencil was used in the manufacture of immensely popular flocked wallpaper in England. In America in the late 1700s, stencil patterns were used on furniture and in some cases directly onto interior whitewashed walls.

Samuel Simon of Manchester was granted a silk screen process patent in 1907 and is usually considered the first to use a silk fabric as a screen or ground to hold a tieless stencil. By 1914, American John Pilsworth developed a multi-color method of stencil printing. This was eagerly adopted by commercial sign shops and display studios. The process produced thousands of prints from one stencil, printed directly onto any flat material. It made prints of any size and needed no machinery. Craftsmen and artists use it and have experimented with stencil even further.

Basic principles

Stencils are usually fitted under a fabric mesh which is stretched and attached to a frame. Silk was once considered the best mesh but now there are excellent versions made of terylene and nylon. The paper is flattened to the underside of the screen and stencils. Ink is poured on the top side of the mesh and forced through onto the paper by drawing a rubber-bladed squeegee across it. The resulting image or screen print consists of whatever is not blocked by any particular stencil.

Materials and methods

There are liquid stencils and solid stencils. The materials are mainly water soluble, to repel the screenprint inks which are oil-based. Gum arabic or ready-made screen fillers such as Sericol blue or red filler can be used to paint designs straight onto the screen. These are applied either with a brush to block out solid areas or stippled with a sponge. The design drawn in this way stops the ink from passing through, appearing white on the paper and forming a negative image on print. A direct or positive image is made by drawing directly onto the screen with turpentine soluble materials: oil-based inks or soft wax litho crayons. This is then dried with a hair dryer or fan heater and coated with a screen filler. The design is next washed out with turpentine. The screen is sealed with masking tape before printing, so that the ink will not squeeze out the edges.

The cheapest and simplest handcut stencil is of paper attached with adhesive tape under the screen, but this can often move during printing. There are better commercially made handcut stencil materials such as Autocut, a gelatin film with an acetate backing. This is laid over the design matt side up, the top layer cut with a scalpel or stencil knife, and the unwanted pieces peeled away.

The cut film is laid on a board with the screen on top of it, and is wiped with a damp sponge so that the film sticks to the screen. Newsprint, placed on the mesh and rolled over, will absorb any excess moisture. The screen is tilted, the film is well dried with a blow dryer, and the acetate backing is peeled off the film. Some other commercial stencil materials, such as Profilm and Stenplex, are treated the same way, but methylated spirits is used instead of water, and a hot iron instead of a roller.

Direct stencil materials come in liquid form, a photosensitive emulsion. The film, positive or negative, is transferred directly to the pre-sensitized screen by exposing the design in an exposure frame in direct contact with the screen. Indirect stencils are cut from photosensitive film with acetate backing.

Photo-silkscreen stencils are made from photographic images. A negative printed onto film rather than paper produces a film positive (the design must be a line image or half-tone). The negative is printed through a screen resolving the design tones into dots on the film positive, which can make a direct or indirect stencil.

Frames and tables Metal or hard wood screen frames, frame supports and stands or leg supports, vary from the very simple to the more sophisticated vacuum screen table.

This table has a vacuum pump connected to its flat perforated surface. A swinging frame to which screens are attached is mounted on the table. The vacuum pump functions the moment the screen begins to swing down, sucking the paper flat, but stopping the moment the frame begins to swing up again. A gap between the screen mesh and the paper surface allows the screen to spring away from the paper as the ink is applied. Any paper can be used, but if it is textured and grainy, it will affect the final result and how the color will finally appear.

Printing

The print paper is laid under the screen and lowered flat. Printing ink is poured over a filled area or side 'basin' and drawn with even pressure over the screen with a squeegee, forcing the ink through the screen onto the paper. The screen is lifted and the print is replaced with more paper for as many prints as are needed, ensuring correct registration. Screenprinting is an extremely versatile and relatively simple printmaking process which has gained greatly in popularity in recent years.

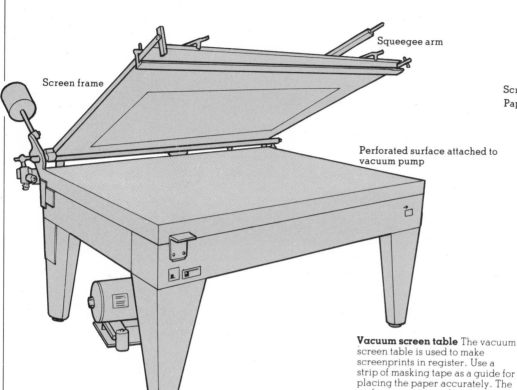

Screen frame

Squeegee arm

Perforated surface attached to vacuum pump

Screen

Paper

Squeegee

Vacuum screen table The vacuum screen table is used to make screenprints in register. Use a strip of masking tape as a guide for placing the paper accurately. The surface is connected to a vacuum pump which engages and sucks the paper flat when the moveable frame, to which the screen is attached, is lowered. There is always a gap between the printing surface and the screen mesh (**above right**) so that the mesh springs away from the paper after the ink-loaded squeegee is passed over it (**above right**). A squeegee arm is attached to the top of the table which enables the ink to be applied with even pressure by drawing the arm across the surface.

Silkscreen with a paper stencil 1. Cut a shape out of a piece of newsprint paper, using a scalpel. Remove waste paper.

2. Attach the paper stencil to the underside of the screen, using masking tape.

3. Place a piece of paper on the screen bed and align it with the stencil. Mark the bottom corners with registration stops.

4. Mix printing ink and pour along the top of the screen, keeping clear of the stencil area.

5. Place the screen flat over the paper and pull the ink across the mesh with a squeegee. This adheres the stencil to the screen.

6. Lift the screen and push the remaining ink with the squeegee back along the mesh to the top of the screen.

7. Remove the print from under the screen. A paper stencil can only be used for one color as cleaning the screen destroys it.

Making a torn paper stencil 1. Place torn paper shapes on a clean piece of paper on the screen bed. Lower the screen on to the paper.

2. Pull ink down across the screen with a squeegee. The torn shapes can be seen adhering to the screen.

3. Lift the screen and remove the print. Return the ink to the top of the screen, ready for another print.

Masking with tape and blue filler 1. Mask the edge of a shape with adhesive tape, spread blue filler outwards from the tape.

2. Spread blue filler over all areas which are not to print. Let it dry thoroughly and peel off the tape.

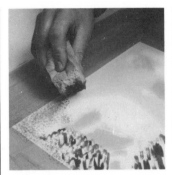

3. Paint irregular designs on the screen mesh with filler, using a brush or a sponge to obtain different marks.

4. Pour ink along the bottom of the design, and with the screen raised slightly, push the ink up to the top with a squeegee.

5. Place paper under the screen and lower the screen on to the bed. Pull the ink down across the design with a squeegee.

6. Remove the print from the bed. Filler is not damaged when the screen is cleaned and can be used to print different colors.

Making a stencil with Hydro-Amber stencil film 1. Stencil film has two layers, the stencil (matt) and backing sheet (shiny).

2. Put the stencil film over the design matt side up. With a scalpel, cut out lightly from the top layer the shapes to be printed.

3. Peel back waste areas of stencil film carefully, using a scalpel to lift the edges. Leave the backing film intact.

4. Place the stencil matt side up on a clean board slightly smaller than the screen. Lay the screen over it.

5. Wipe over the screen with a sponge soaked in clean water. The stencil adheres to the screen.

6. Put the screen to one side and let it dry completely. Then peel the transparent backing film away from the stencil.

7. Cover the whole of the rest of the screen mesh with blue filler. Leave it to dry.

8. Tape along the edges of the screen with adhesive tape to prevent ink bleeding through between the mesh and the frame.

Blending two colors 1. On the bottom of the design, pour a quantity of each color to be used in blending.

Printing with opaque ink If the ink is mixed quite thickly, the color will be fully opaque on black paper.

3. Expose film to ultra-violet light for correct exposure time. Place film in hardener solution.

Preparing a direct stencil 1. Coat the screen with direct photo-stencil emulsion.

2. Pull it back slightly with the squeegee and let the colors merge together in the middle.

Transparent ink Ink mixed with more thinner will print in a clear, transparent veil. Overprinting produces a third color

4. Wash film in warm water. Next, rinse with cold water.

2. Attach positives to mesh side of screen with clear tape.

3. With the screen raised, push the ink up to the top of the design. Lower the screen and pull a print.

Preparing an indirect stencil 1. Prepare photo-positives, fix with clear tape to a thin acetate sheet for support.

5. Lay the film emulsion side up on the board. Place screen over it.

3. Positives should be right-reading from the printing side of the screen. Expose to ultra-violet light in a vacuum.

4. The colors merge in the print and grade through from one side to the other. Each successive print will vary slightly.

2. Lay indirect photo-stencil film over the photo-positives, emulsion side up. Lay the stencil film shiny side down.

6. Blot gently with blotting paper. Indirect stencils are easier to remove from the screen, need no coating, but cannot be reused.

4. Wash unexposed areas of the screen. This leaves the exposed parts hardened and water-resistant.

Presentation and display.

Framing: Mitring, Cutting glass, Window mounts, Assembly, Finishing. Dry mounting. Wet mounting.

Finished pictures need presentation. If they are to be hung for display, they should be backed and framed. If they are for commercial projects, submission to editors, or merely for sale unframed, they should be wet or dry mounted. All three methods can be practised by the artist with the right tools, time, and care.

Framing

To frame your own pictures, you will need a tri-square, a metal ruler, a tenon saw, a hand drill, a claw hammer, a mitre clamp or saw guide, a punch or awl, pinchers and a G clamp.

The first task is to choose a suitable molding for the picture to be framed. The frame, the backing and the glass frontage have more to do than just enhance a work of art. They will protect it from damp, dirt, warping, wearing and accidental damage.

Frames can be made of wood, metal, wood and metal, wood lined with fabric, or plastic. Choose one that compliments the picture. A heavy, velvet-lined oak frame with elaborate corner moldings, would, for example, look out of place around a delicate water-color.

Oil paintings can be framed without glass at the front or backing. Drawings and watercolors need both. Tempera will not need backing if painted on a wood surface, but as it must be covered for at least the first 12 months, you may as well frame it with glass and hang it at once.

Backing for prints, drawings and watercolors should always be hardboard, never cardboard, which is too soft, nor plywood which warps. Watercolors, drawings and tempera paintings can all have window mounts. These not only enhance the display of the picture, but help to protect it by holding it clear of the glass. This is not necessary with prints.

The first step in making a frame is to measure it. Do it not once, but twice, and, if necessary three times. Never cut until you are sure you have got it right. And remember, each length of the frame will be as long as the picture—plus twice the width of the frame. A canvas must always be given an extra ¼in (6mm) all around to allow for expansion and contraction in temperature changes. Allow the space inside the rebate and cushion the canvas with cork spacers or veneer pins.

Mitring This is the stage where most amateurs go wrong. It takes experience and careful use of the right tools to get a mitre right. The job is relatively simple if you use two mitre clamps. Always cut the longer sections of the frame first—if you make a mistake you can always cut them again for the sides. All mitres should be cut at 45 degrees, and always remember that the outside edge must be the longest.

Cutting glass Picture glass is clear and flawless—unless you cut it wrongly. Measure twice and mark it with a felt tip pen. Lay the set square alongside the mark, drawn down the cutter and tap firmly. There is only one way to be sure you will make a clean cut and that is to practise. Confidence is the key.

Window mount Choose a color that compliments your picture. Cut so that the bottom part of the frame is slightly wider than the top. This corrects the optical illusion if they are cut to the same width that the picture is lower in the frame than it should be.

Assembly Two mitre clamps will speed the process, but they are not essential. Clamp the long and short sides tightly together and tap in pins at a slight angle towards the outside of the molding. This will prevent splitting. The bigger the molding the more pins you will need, but never use less than two on a joint.

Finishing Frames can be bought ready finished. If you are working with bare wood, sand down and stain or paint before you place the picture inside. You can decorate the molding with fabric if you wish.

Dry mounting

This is ideal for photographs and commercial art work. Cut a sheet of shellac tissue slightly bigger than the picture and, using the tip of a hot iron, fix the center of it to the back of your print or drawing. Turn the print over and trim off the edges of the shellac tissue. Lay the print, shellac tissue down, on to the mount. Place heat resistant paper over the picture and iron out with a medium hot iron. The mounting can be completed by glueing a window mount over the picture.

Assembling a frame 1. Secure a length of molding in a mitre board or clamp. Position the saw and make the first cut.

2. Measure the required length of molding along the inside of the rebate. Align the ruler with the mitred end of the wood.

3. Mark up the other end of the section of molding using a set square to obtain the 45° angle of the mitre.

4. Mark the waste side of the cut, position the molding in the mitre board, so that the cut is at the mark. Saw it through.

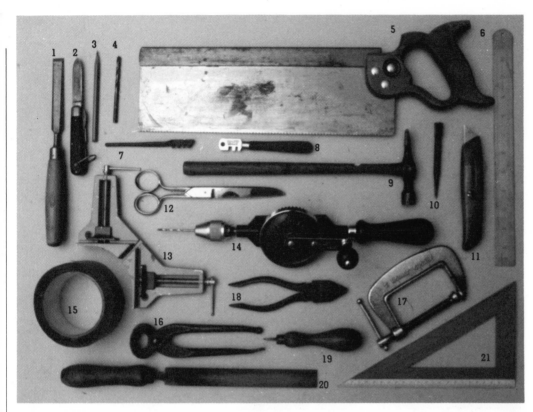

Tools for framing Tools needed for framing include: chisel (**1**), pen or pocket knife (**2**), pencils (**3**,**4**), tenon saw (**5**), steel rule (**6**), glass cutters (**7**,**8**), hammer (**9**), pin punch (**10**), craft knife (**11**), scissors (**12**), corner clamp (**13**), drill (**14**), adhesive tape (**15**), pliers (**16**, **18**), a G-clamp (**17**), bradawl (**19**), file (**20**), set square (**21**). For framing it is best to use a 14in (35cm) tenon saw which will fit most easily into the mitre clamp and enable you to saw with reasonably long strokes. The pin punch is used with panel pins. Hammer in the panel pin until it is just above the surface of the wood. Hammering the pin directly into the wood, would tend to damage the surface, so instead, place the pin punch on the head of the pin and hit the punch with the hammer until the pin is just below the surface of the wood, then fill the hole with filler, so the fixing does not show.

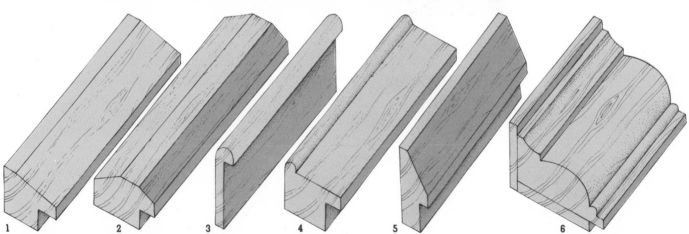

Moldings Popular types of molding for picture frames include box (**1**), reverse slope (**2**), half round or hockey stick (**3**), raised bead and flat (**4**), box (**5**), and a composite of planed timber and architrave molding (**6**): Choose the molding to enhance the picture — the picture should determine the width of the molding as well as its design and color.

5. Cut all four sides of the frame. Apply adhesive to the mitred ends of the molding.

6. Secure two mitred ends together in a corner clamp, so that an L-shape is formed. Make sure that the molding lies flat.

7. Drill small holes into each corner. Secure the pieces with panel pins. Repeat process, join two halves of the frame together.

Cutting glass 1. Measure from a straight edge of the piece of glass and mark the required dimensions with a felt tip pen.

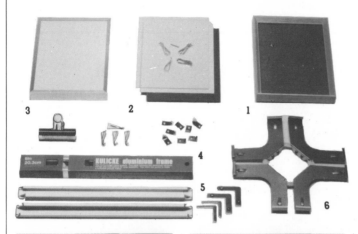

Frame kits There is a wide variety of frame kits on the market today. These include an interchangeable metal frame (**1**), a framer's pack which contains glass, hardboard and clips (**2**), and a ready made frame (**3**). The Kulicke (**4**) Daler (**5**) and Hang-it (**6**) kits do not include any hardboard or glass. Frame kits are easy to assemble, but are more expensive than making your own.

2. Trim the edges of the tissue with a scalpel along a steel ruler so that it is exactly the same size as the print.

2. Place a ruler along the marks and draw the cutting tool firmly along the glass using the ruler to guide it down.

5. Glass for framing should always be cut smaller than the inside measurement of the frame so that it is not wedged inside the wood.

3. The angle of the knife makes a bevelled cut around the picture. Place the mount over the picture to check the fit is correct.

3. Place the print face up on a mounting card and tack the tissue to the card at each corner with the medium hot iron.

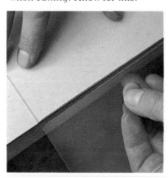

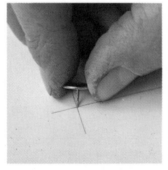

3. The cutting wheel on a glass cutting tool is centered and will be distanced slightly from the ruler when cutting. Allow for this.

Window mounting 1. Mark the window corners on a board by pricking through paper marked with the mount's dimensions.

4. Anchor the picture on the back with a piece of card in the center of each side. Stick the card to the mount with adhesive tape.

4. Lay a thin sheet of paper over the print to protect it from the hot iron.

4. Place the scored mark directly over the edge of a table or board and let the glass drop gently, snap it along the cut.

2. Place a steel ruler along the board from one pin prick to another and cut out round the window shape with a knife.

Dry mounting with an iron
1. Tack a sheet of dry mounting tissue, slightly oversize, to the back of the print with an iron.

5. Run the iron evenly but firmly over the paper, working from the center outwards. The heat adheres print to the card.

Fresco.

History. Equipment and techniques: Preparing the wall, Plaster, Techniques, Paint.

True fresco or *buona fresco* is a traditional process not to be confused with mural painting. Fresco is based on a chemical change causing rock-hard crystallization and cohesion of water-diluted pigments on a wall covered with freshly laid lime and sand plaster. When the lime is fresh, it is still calcium hydroxide or slaked lime. While it dries, the carbon dioxide in the atmosphere turns the lime to calcium carbonate, crystallizing the pigments which become an integral part of the surface, very different from the superficial adhesion of oil and tempera paints.

A fresco must have a matt finish so that it does not reflect light or glare. It must be made from permanent materials as it has to withstand pollution and damp, which affect the wall, and cleaning. Above all, it should be a painting appropriate to the character and architecture of the room of which the wall is part. Frescoes can be painted outdoors, but are much more likely to be affected by pollution caused by soot and acid fumes, unless very sheltered, than if they are indoors. The paint is made from powdered natural or earth pigments diluted with water. Artificial pigments are not stable, and although frescoes of Michelangelo and Raphael may appear to be limited in terms of brilliance of hue, the range of natural pigments have proved over the centuries more than adequately durable.

The earliest frescoes of any technical development appeared in the late Minoan period as excavated in Knossos, Crete. They were painted with native earths, although some Minoan frescoes were painted in *secco*. This is similar to fresco, but the wall is covered with a finished, perfectly dry, lime plaster washed over with lime water, and the pigments are mixed with a solution of casein and thinly applied. Some *secco* painters have mixed pigments with solutions of glue size or thinned egg yolk, but these are inferior to casein, and again inferior to true fresco. The Etruscans painted wall paintings similar to *secco* and fresco, besides their rock wall tomb paintings.

In Italy, frescoes remain from Pompeiian times and the years of the Roman Empire. But fresco was at its height in medieval and late Renaissance times, as seen in the work of artists such as Giotto (1266–1337), Fra Angelico (*c.*1387–1455), Masaccio (1401–1428), Piero della Francesca (*c.* 1415–1492), Michelangelo (1475–1564) and Raphael (1483–1520). The same techniques were used in the eighteenth century by Tiepolo and Goya (1746–1828), but after the Renaissance, fresco in Europe waned in popularity. Outside Italy, there are the ancient Buddhist frescoes discovered in China. Late Byzantine frescoes exist in two of the Kremlin cathedrals in Moscow. There are also fragments of a medieval fresco in Canterbury Cathedral, England, in the apse of St Gabriel's Chapel, called *Christ in Majesty* (*c.*1180). In the nineteenth century, some fresco appeared in Germany, and there was a slight but not notable revival in England.

Diego Rivera (1886–1957) painted frescoes in the 1920s and 1930s in Mexico and experimented with a new type of wall painting. Today, interior murals can be painted in oils or synthetics, porcelain enamel or colored cements, but none of this is true fresco.

Fresco Equipment and Techniques

Some pigments do not combine well with lime, but a good basic recommended palette is: Biancosangiovanni (pure white lime); Naples yellow; yellow ochre; cadmium red; Indian red; red ochre; potter's pink; terre verte; viridian; cobalt green; raw umber; brown ochre; raw perigord; orange perigord; cobalt; cerulean; ultramarine; black oxide of cobalt; iron oxide black; manganese black.

Preparing the wall

The wall must be dry and treated to avoid damp or moisture seepage in the future. It must be in an airy position—sometimes good air conditioning maintains a steady temperature and helps preserve a fresco—and away from too much sun, or at least protected from it while the paint is being applied. Do not use a concrete wall: cement contains impurities which will destroy the fresco. The surface can be even, rough or porous. Smooth brick or tile should be chipped with a hammered wedge to provide a key or roughness which will act as a bond. Three layers of plaster are then laid on to it.

Plaster

The plaster must be made with pure, well-fired, white quicklime, and its preparation can take up to two years. Pliny mentions painters' preference for lime slaked for three years, which apparently avoids cracking. Quicklime is very dangerous and must be stored outdoors in a brick-lined pit sunk in the ground, in a shady spot not open to frost, and covered with a wooden lid. During the course of two years, pure water is flooded through the lime regularly and the whole mixture stirred frequently. At no time should any

chemical impurity be allowed to enter the lime. Sand used must be free of mica and of salt, thus only sand from a clean brook or from an inland sand-pit can be used; it should not come from the sea or river, or a builders' merchants.

Techniques

After the wall surface is chipped and hosed down with fresh water to remove pieces of brick and dust, the first layer of plaster is laid. This is rough cast and called the *trusilar*. It is made of one part slaked lime and three parts clean coarse sand mixed with water on a mortar board with a trowel. This first coat is half an inch (12mm) thick. It has to be hurled forcefully and rapidly on to the wall with a wooden float so that pockets of air are not trapped under it. Press it flat but not smooth. It does not matter if more plaster is laid than that covered in a day's painting, provided it is kept wet with a damp cloth.

The second layer, the * saw*, is a little more than a quarter inch (6mm) thick and is laid when the initial layer is merely set, not hard. It consists of one part lime and two parts coarse sand. What has not been painted at the end of the day, must be cut away.

The top layer, the *intonaco*, is laid when the second layer has just set. It consists of half lime, half fine sand, and is fractionally thinner than the second layer. This,

too, must be removed at the end of the day if unused. It should be cut away with a sloping incision made with an ivory or plastic palette knife. The excess lime is then washed away with clean water.

A full-scale cartoon with a precise, pre-planned color scheme is drawn and squared up. At the start of the day's work, the area to be completed that day is traced on to the wall and scored through with a slate pencil on to the wet plaster. Care should be taken to do this exactly, as errors can only be removed by cutting out and replacing a whole patch of plaster, which is a difficult operation. Also, the borders of each area should be as inconspicuous as possible.

Paint

This is mixed on a palette from pigments arranged separately in saucers. The paint is applied with soft brushes of hair, starting at the top left-hand corner to avoid splattering a completed section. The first applications are thin, transparent washes which are absorbed by the plaster. Then the design is outlined in darker paint. Pure white lime is used over light mid-tones as a highlight with darker tones as shadows. The pre-Renaissance Italians used hatching and shading for definition, but by the eighteenth century, Tiepolo, for example, was using areas of broad tone with cleverly placed accents.

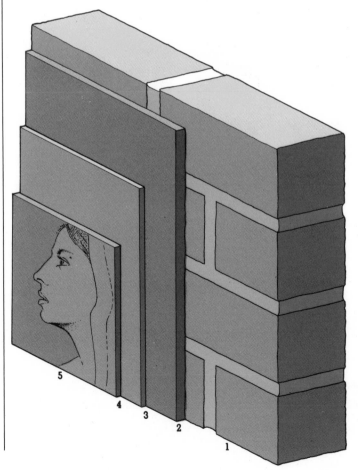

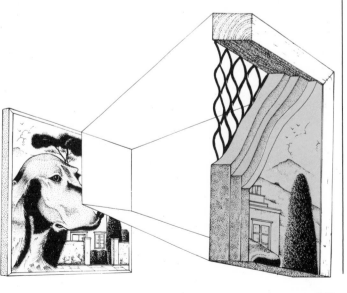

Preparing a wall A section of a wall is prepared for painting in the following way. **1.** The surface of the wall is chipped to give a key for the first layer of plaster, the trusilar. **2.** This first layer is applied thickly. **3.** The second layer, the arricciato, is applied next. **4.** The final layer, the intonaco, is applied to an area which can be painted in one day. The design is traced into the fresh plaster, and paint applied. **5.** As the plaster dries, it absorbs and binds the pigment particles.

Panels Frescoes can be painted on panels which are made of a strong wooden frame backed with wire mesh. The plaster layers are then applied in the normal way. A roofing board, such as Gypklith, can also be used. It is made of wood-wool, bound with gypsum, and is sold by builder's merchants.

Producing a fresco 1. Chip the surface of the wall to give a key. **2.** Soak the wall with clean water to remove loose particles. **3.** Apply the trusilar, first rough-cast layer of plaster, about ½ in thick. Allow to dry. **4.** Apply the second arriccato layer ¼ in thick. **5.** Apply the third layer, the intonaco, to an area which can be painted in one day. **6.** Wash away excess lime. **7.** Trace the lines of the design into the plaster. **8.** Flood thin washes into the plaster, and let them be absorbed. **9.** Redefine the outlines of the drawing. **10.** Add highlights over a light tone. **11.** Add darker tones with a complimentary color or darker shade.

1

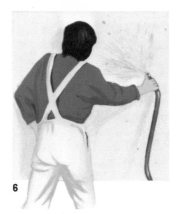

2

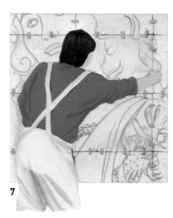

3

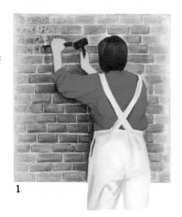

4

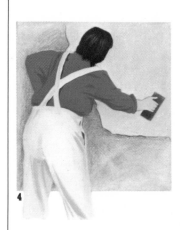

5

6

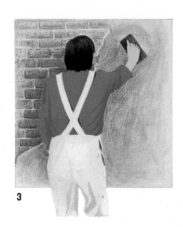

7

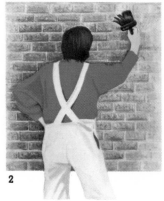

8

9

10

11

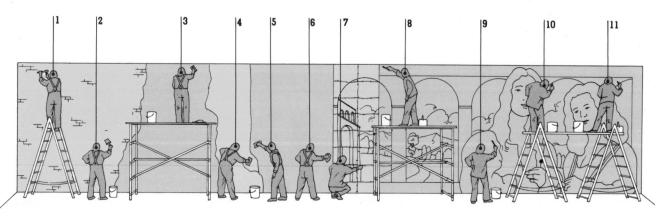

Exterior painting.

History. Equipment and techniques: Preparing a wall, Rendering, Paints.

an began painting on walls and stones. These were the first canvases for the early artist; the oldest paintings in the world are those on the walls of the caves at Altamira, Spain and Lascaux, France. The Mesopotamians painted the strange, pyramid-like ziggurats they built to their gods. Greeks painted a bright frieze around the entablatures that topped the pillars of their temples. The Egyptians designed elaborate, painted bas-reliefs on the walls of their temples and tombs. Until the Renaissance, when portable canvases were first used, most of Europe's paintings were made on walls or panels. With the advent of the great Italian and Dutch masters, painting moved into the studio.

The famous Mexican wall paintings of the 1920s were an attack on revolution and social injustice. There was a similar motivation behind the 20 or so black artists who painted the Wall of Respect on the end of an abandoned block in Chicago in 1967. It was uncommissioned and became quickly a community effort, featuring scenes of the black community's life and becoming a focus for art and jazz festivals.

This spontaneous action of taking art to the people spread. In New York a group of abstract painters called City Walls were backed by city officials to design murals for public buildings. Wall painting spread to Britain, with the Thamesdown Community Centre's spectacular postcard reproductions at Swindon, Wilts, and Steve Pusey's imaginative wall drawings at London's Covent Garden. Now official bodies, foundations and even private citizens are backing the resurrection of this old public art form.

Exterior painting Preparation

Choosing a wall

Most wall paintings are done on ready-built walls. They should be chosen with care. The painting has to be seen, so an exposed wall is essential and this brings its own problems. Walls are constantly attacked by rain, grit, wind, sun, snow, and atmospheric pollutants such as sulphur and acids.

Aim ideally for a wall that faces east so that it avoids the strongest rays of the sun and is part of an occupied house, so that the building is heated. This will reduce the dampness that gets into the wall. A deep gable or an overhang will also help to protect the wall. A strong, stable wall in a good position and properly prepared can last for a good 10 years before wall defects and growths attack it.

Preparing a wall

A wall attacked by fungus should be avoided, but where there is any remove it by scraping. Brush off all soot, oil and dust, then wash the wall with a mix of one part bleach to eight parts water to remove any natural growths. Re-point where necessary.

Check all points such as gable ends, drainpipes and under window sills, where water may splash or drip. Moisture is the biggest problem with wall paintings. Correct the problems before you begin or the painting may be ruined by flaking, staining or patchiness. Old paint must be stripped off the wall by scraping, steam-stripping, mechanical sand blasting or a solvent such as methylene dichloride.

All walls should be primed with an alkali resistant stabilizer to seal the surface, cover any rust marks from metal fixings, and equalize porosity.

Take care when applying stabilizers, they are highly flammable. Leave them for a day or two to see if any mold or fungus reappears. This may sometimes happen on a badly affected wall. If it does, apply bleach solution again.

Rendering

It is possible to paint straight on to primed brick, but a rendered wall gives a smoother surface.

Use a hammer and a chisel to make a key on a smooth brick wall before laying on the first coat of render. Mix four parts of sand with one part of cement and apply with a wood float.

For old walls or walls of light, porous concrete, use a weaker mix—five parts sand, one part lime and one part cement. A strong mix will shrink the wall and break up the surface.

Rendering can be colored by adding pigment to the mix, but do not use more than 10 per cent of the cement weight. A fresco effect can be achieved by brushing pigment on to the rendering before it is dry.

Preparing and rendering a wall

The surface of all walls should be carefully prepared for paint, unless they are new. **1.** Brush away any loose particles from the wall. **2.** Then remove any natural growths, such as moss and mold, by brushing over them with a solution of bleach. **3.** If necessary, repoint the wall to give a smoother surface. **4.** Prime the wall with stabilizing solution. **5.** Using a bristle brush, scrub the wall. The surface can be scraped to provide a key, or it can be given two coats of PVA adhesive, with a paintbrush. **6.** Before the second coat of adhesive is dry, apply the first coat of render with a trowel, in a proportion of 4 parts sand to 1 part cement. **7.** Scratch the render to give it a key. When it is dry, apply the second coat, smoothing out with a float to give a flat surface to the paint.

1

2

3

4

5

6

7

Paints

Stick to the more durable outdoor emulsions for the most lasting results. These paints dry to a matt finish, hiding defects in the wall surfaces and allowing moisture to evaporate through them, reducing dampness in the wall.

The disadvantage with these paints is their limited range of colors, but it is possible to extend this by adding pigment. Stick to organic pigments as they do not upset the emulsion.

Glosses that are alkali- and acid-resistant can be used, but they have a shorter outdoor life than exterior emulsions. Vinyls and water-thinned paints are no good for wall painting.

Silicon-based paints, or mineral paints, have high adhesion qualities and fix well to surfaces such as plastic, metal, tiles, or Portland cement, but their lack of porosity makes them unsuitable for brick.

With all paints, the best results are obtained if a thinned undercoat is applied with a brush. Solvents should be thinned with 10 per cent white spirit and emulsions with 25 per cent water.

A coat of exterior varnish will not protect your wall painting, and far from extending its life is likely to shorten it. Varnishes simply trap moisture, causing blisters and peeling.

Other equipment

The safest and most efficient way to create a wall painting is from scaffolding. A really big wall should be tackled from fixed scaffolding—and it should be erected only by experts—or from a painter's cradle raised and lowered by hydraulic equipment. Both types of equipment can be hired.

The majority of wall paintings are on a smaller scale and can be done from a single section of scaffolding erected on wheels and fitted with a platform of planks. Care is needed—it is very dangerous to try to get extra height by balancing a ladder on scaffolding.

Small walls can be successfully painted using just ladders. Prop them at roughly 70 degrees to the wall and use a hook to hang the paint tins on—that way you can keep both hands free to work.

Techniques

A wall painting needs careful planning. Draw your design in detail first. Later it can be scaled up on the grid system, so that each section of the painting can be copied full size on to the wall.

Study the wall carefully before drawing up your design. Take into account the overall size of the wall, its shape, and the angles of the roof pitch or any overhangs. Sketch the outline and make a note of windows, drainpipes or any other features—it may be possible to incorporate these into the final drawing. Plan angles of your drawing around any chimney breasts and take into account the texture of the walls, you may be able to use them in the final picture.

If the chosen wall is long, plan the picture from the point where it will be seen. Objects at the furthest point may have to be drawn larger to fit in with the proportions. A small design can make a wall look bigger than it really is.

When the drawing is completed, square it up to full scale and outline all the details in each separate grid. When copying the grid on to the wall, draw in all outlines in chalk, charcoal or a thin wash of paint. Where possible, use stencils or repeating patterns to copy the grid sections on to the wall.

Start painting by covering the whole wall with background colors and basic outlines; do not attempt to complete one grid at a time. This will give you the chance to make any changes that become necessary and will ensure that background colors do not create different tones in different parts of the wall.

Work from the top of the wall to the bottom so that any drips will not spoil work already done. Wipe them off at once with a damp cloth. Do not paint below the damp course of the wall—paint there is likely to blister and peel and give the finished picture a ragged look.

Exterior painting This clever optical illusion (**right**) can be seen near the Pompidou Center in Paris. The starkness of the design blends well with the modern architecture in the foreground.

Paints for exterior use

The choice of colors from the range of ready-mixed exterior paints is limited, so a pigment is usually mixed with an exterior paint base to produce different colors. However, no more than 10 per cent of the weight of the cement in the render should be added as pigment, or structural problems will arise. The pigment can be made into a paste to make it easier and quicker to cover. Pigment can be brushed onto the surface before the render has dried to increase the color. This is most successful when performed on a smooth surface with a pigment which is easily dispersed. Powdered pigment can be mixed into a white or colored base, and is widely available. A small amount of soap solution is added to it to distribute the paint. This selection of pigments (**below**) is commonly used for exterior work. White titanium dioxide (**1**) gives a stong, opaque white. Yellow titanium dioxide (**2**) gives a light, opaque yellow. Hansa yellow (**3**) has little opacity. Yellow iron oxide (**4**) gives a grayish yellow. Red iron oxide (**5**) is available in several tints. Brown iron oxide (**6**) comes in both light and dark shades. Black iron oxide (**7**) gives dense color. Violet carbizole (**8**) gives very bright color, but is expensive Phthalocyanine blue (**9**) tends to bronze as it weathers. Phthalocyanine green (**10**) gives good light and is chemically fast. Green chrome oxide (**11**) is both resilient and opaque.

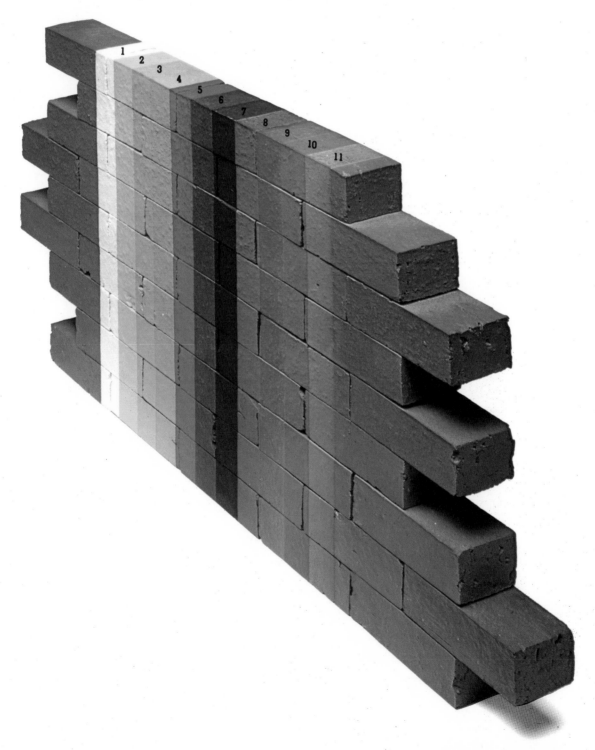

Choosing paint The choice of paint (**right**) is often governed by the composition of the wall's surface. Cement paints can be used soon after Portland cement, stucco and concrete have been laid, and acrylic emulsions or other porous alkali-resistant paints used after 4 weeks. Alkali-resistant paints are also used for new and repaired brick and stone work. Glazed, engineered or other imporous bricks are painted with a strongly adhesive paint, such as polyurethane. Solvent-thinned paints are used for steel and iron alloy surfaces.

Scale drawing Before beginning work, a full-scale drawing of the fresco must be made. A separate tracing is then taken of the estimated area of each day's painting. The borders linking one day's work with another should never be obvious.

Paint	Thinning agent	Durability (years)	Drying time between coats (hours)	Other qualities
General purpose emulsion	Water	3	4	Low alkali, efflorescence and mould resistance.
Exterior emulsion	Water	4-7	2-6	Good porosity. High alkali resistance.
All acrylic	Water	5-10	2-6	Expensive, but superior to emulsions.
Sandtextured	Water	4-10	2-6	More durable if applied thickly.
General purpose gloss	Turpentine, white spirits	3-6	16-24	Hard-wearing and easily cleaned. Low porosity. Makes uneven surface conspicuous.
Polyurethane	Turpentine, white spirits	3-4	6-8	Very brittle. Poor porosity.
Exterior masonry	Turpentine, white spirits	4-7	16-24	Limited colour range.
Rubber resin masonry	Turpentine, white spirits	7-12	12	Good adhesion. Limited colour range.
Cement based mineral	Distilled water with alcohol	5-7	24	Excessively porous. Tends to retain dirt. Limited range.
Silicate	Distilled water	2-100	2	Thin and transparent. Fixative should be applied after final coat.

Graphic design.

History of graphic design.

History: Development of typography, Early typographers, Morris, Bauhaus, Advertising.

The marriage of illustration and lettering, each supplementing and enhancing the other, dates back some 4,000 years to the earliest illustrated scrolls such as the Egyptian *Book of the Dead*.

But graphic design in its modern sense can be said to have begun when there were both mechanical and artistic elements to manipulate—that is, in printing.

One of the earliest graphic designers in the field of book production was the Frenchman Geoffroy Tory (1480–1533). He balanced text, illustrations, borders and other white space in a way that gave visual impact to the whole, laying down traditions of design that still have relevance today.

For more than 300 years from the time of Geoffroy Tory, graphic design—unrecognized as an art in itself—remained almost entirely within the province of book and other text-display printing, with each craftsman-printer also acting as designer.

By the middle of the nineteenth century, graphic design had begun to broaden into those fields of commercial and social importance where it has continued to grow and develop: the fields of packaging, presentation, display and general advertising.

Historically, nineteenth century graphic design and its concern with the word and the image cannot be considered in isolation from other areas of design. In the latter half of the century, as new techniques and materials became available to the graphic designer, there were design developments in architecture, industry, engineering, technology and commerce.

The great mediator between art and design was the Englishman William Morris (1834–1896), an artist, craftsman in many fields, writer and educator. Beauty, he insisted, should be part of daily life; and he saw a challenge to the artist in the poor quality and appearance of many mass-produced goods.

Following his own dictum that 'artists are workmen; workmen, artists'; he learned wallpaper manufacture, weaving, dyeing, textile printing; and gained insight into other production techniques, including stained glass. In 1861, Morris started a firm for designing furniture, wallpaper, textiles and other objects for everyday use.

Morris anticipated one of the basic tenets of the twentieth century *Bauhaus* school of art when he wrote that a large part of an artist's training should be spent in the workshops.

In the last six years of his life, William Morris turned to the original source of graphic design—book printing. His Kelmscott Press, founded in 1880, produced masterpieces of layout with bold 'fattened' text-type and finely detailed illustration.

His use of white space and tasteful ornament might have been envied but could not be emulated by the harassed designers concerned with a late nineteenth century American commercial printing phenomenon: mail-order catalogs.

Starting with simple, sparsely illustrated lists, Montgomery Ward from 1872 and Sears and Roebuck from 1886 began flooding rural America with catalogs which grew fatter and more comprehensive each year. They were crammed with small photo-based line cuts and, later, the newly-invented half-tone blocks. Every scrap of space left over was filled with sales text.

A comparison of these productions with some of today's better catalogs and sales literature, in which color, space and text are subtly balanced, shows how far the art of graphic design has advanced—and been welcomed by commerce.

At the turn of the century, French commercial poster artists made a complaint which today's graphic designers find wryly amusing. They refused to include in

Design and typography One of the first people to exploit the visual and design potential of typography was the sixteenth century French typographer Geoffroy Tory. He not only designed unusual alphabets, such as his 'Fantastic Letters', which were based on household tools, but he also linked the proportion of letters to those of the human face (**4.5**) and body (**3**). Another major figure in typographical design was the nineteenth century artist, William Morris. His work with the Kelmscott Press, which he founded in 1880, used type in both an informative and aesthetic way (**1**). Morris's incalculable influence on graphic design was paralleled in the twentieth century by the *Bauhaus* group. In graphic design, the Bauhaus group developed the sans serif typefaces. This letter 'h' designed by Herbert Bayer (**2**) shows the clarity and legibility, which made these faces popular.

their designs pictures of the actual product they were advertising because the packaging was 'bad art'. It did not occur to them that they could take a hand in redesigning the graphics of the packaging itself.

After the First World War, various art movements influenced graphic and other design. Dadaism carried its anti-aesthetic rejection of bourgeois ideas in art and literature to an extreme of absurdity and nihilism. It might be regarded as a negative or even anti-design movement which 'died' around 1924, although the influence of one of its members, collagist Kurt Schwitters (1887–1948) could still be seen in the junk sculpture and pop art of America in the 1950s and 1960s.

In 1919, Walter Gropius (1883–1960), architect, designer and teacher, founded the *Bauhaus* school of art and design in Weimar. Here, and later at Dessau and at Harvard University in the United States (where he became a citizen), he taught principles which have become fundamental to nearly all aspects of twentieth century industrial and commercial design.

Although his educational program was based on the William Morris principle of the artist as primarily a craftsman, Gropius, unlike Morris, welcomed machines as primary tools of production. The *Bauhaus* curriculum integrated craft and aesthetic training within a framework appropriate to modern society.

These were precepts of *Bauhaus* educational policy: designers must master machines because they are their main medium; designers in all fields must develop their aesthetic criteria accordingly; all creative works are interdependent; all industrial productions are collaborative works; the designer must have a thorough practical as well as theoretical knowledge of his field.

'Our ambition', said Gropius, 'was to rouse the creative artist from his other-worldliness and to reintegrate him into the workaday world of realities and, at the same time, to broaden and humanize the rigid, almost exclusively material mind of the businessman.' The *Bauhaus* has had a vast impact on art education and the approach to design problems in the whole of the Western world.

In the last sixty years, the typographical 'armory' of the graphic designer—the range of typefaces available—has widened enormously. Names of great significance in this period include Eric Gill (1882–1940), sculptor and letterer who designed the Gill Sans and Perpetua type families; Stanley Morison (1889–1967), Monotype Corporation consultant (Times New Roman) who made many new faces commercially available; and Adrian Frutiger, who designed the Univers type family. Advertising display type is undergoing continual change and modification to keep up with modern design fashion.

The scope and commercial and industrial importance of graphic design has grown explosively in recent years. LP record sleeves, frozen food packs, airline timetables, detailed cutaway and exploded-view drawings in the technical press, instruction manuals for sophisticated office and home equipment, cars and cameras; even lettering on the dials of instruments—all call for graphic design skills.

The newest growth area for graphic designers is in those consultancies which establish corporate identity programs. The designer becomes part of a team including marketing people, psychologists, sociologists and economists who work together to provide a business with a uniform image or house style, extending to its signs, which are called logos, product and packaging design, premises, advertising, notepaper headings, vehicle identification and many other aspects of visual recognition.

Graphic design and industry The relationship between the worlds of graphic design and productive industry has not always been harmonious. William Morris, whose work ranged from designing textiles and stained glass to ceramics and typography, was one of the founding fathers of modern graphic design. In his typographic work, Morris tried to combine the decorative and the informative, as can be seen in this page from the edition of Chaucer published by the Kelmscott Press in 1896 (**3**). Morris himself wrote that 'It was only natural that I, as a decorator by profession, should attempt to ornament my books suitably; about this matter I will only say that I have always tried to keep in mind the necessity for making my decorations a part of the page of type'. Morris's work, in whatever field, marked a reaction against the poor design and quality of manufactured articles and in favor of the virtues of skill and craftsmanship.

If Morris reacted to industry in a negative way, the *Bauhaus* group in the early years of the twentieth century sought to educate students in a combination of art, craft and industrially orientated techniques. The quality of the teachers, the workshop teaching methods and the subsequent work of several of the group's members in the USA meant that the influence of the *Bauhaus* spread far beyond its

native Germany. The *Bauhaus* concerned itself with many facets of design — furniture, textiles, wallpaper, lighting, and architecture, as well as typography. This design (**2**) by Herbert Bayer, one of the foremost artists and graphic designers connected with the group, appeared on the cover of the first *Bauhaus* book.

An extreme response to what was seen as a harsh and dehumanized industrial society came from the Vorticist group in the early twentieth century. The group, associated with the British artist Wyndham Lewis, published its views in *Blast*. The design for the second edition of *Blast* (**1**) clearly shows their approach. The apparently chaotic pattern of lines is nevertheless contained within a clearly defined, graphic structure.

Design equipment.

Equipment: Pencils and pens, Drawing instruments and equipment, Papers, Knives and sharpeners, Lights and glasses, Dry transfer lettering, Color selectors, Adhesives.

A comprehensive range of equipment is imperative for a graphic designer to maintain a high standard of workmanship. Some items are commonplace and have long been standard; others are results of recent technological developments. All are important.

Pencils and pens

Graphite or lead pencils come in up to 17 grades of hardness, while colored pencils come in ranges of up to about 72 colors. Clutch pencils or lead holders have separate refillable leads which come in various grades of thickness or hardness. For plastic surfaces or film a Chinagraph can be used, while the all-surface pencil can be used on glass.

Pens are as much an essential for the designer as pencils. The dip pen, although old-fashioned, is still used because of its sturdiness and the variety of inks and nibs it will take. The fountain pen takes a smaller range of nibs and most use only writing or non-waterproof inks, although Osmiroid make a model for waterproof drawing ink.

In technical drawing evenness of line is essential and stylo-tip pens with tubular nibs have been developed for this purpose. The barrel pen has a wide range of nib widths and uses an interchangeable nib unit which can also be used for drawing with rulers or stencils. Special attachments are made for use with compasses. The most common type of stylo-tip is the Rapidograph; the Isograph was designed to help overcome problems of drying ink, gives better ink flow and line quality and is easier to maintain.

Felt tip markers produce a thick line and are less hard wearing than fiber-tip pens. They both use spirit or water-based inks, and come in a variety of thicknesses. A newer development is the rolling-writer ball pen, which has the same features as a conventional ball-point pen but which is filled with a water-based ink which flows evenly and smoothly.

Drawing instruments and equipment

A set of drawing instruments is essential for a designer. A moderately small set would include two sets of spring bow compasses, a small radius compass, dividers, ruling pens and an extension bar for drawing larger circles. A beam compass can be used for drawing circles and arcs larger than normal. Among the various attachments for compasses are a lead holder, a ruling pen, a cutter blade and an attachment for a stylo-tip pen.

Ruling pens are designed for producing lines of constant thickness. A standard model has two prongs between which the ink is held. An adjustable screw varies the thickness of the line. Ruling pens, also called drawing or bow pens, mainly use ink, although paint can be used if thinned down to the consistency of ink. The railroad pen has a double nib attachment for drawing parallel lines.

Proportional dividers are used for copying drawings on a smaller or larger scale, and are commonly used by cartographers. A dotting pen draws dotted lines by raising and lowering the pen tip by means of a wheel mechanism; various types of dotting wheels are on the market today.

There are a number of rules, guides and templates a designer will need. The most basic is a ruler, followed by a T-square. By placing the 'T' over the side of the drawing board parallel lines can be drawn by moving the T-square. A plastic scale rule is often used in technical drawings to enlarge or diminish scale, a compositor's typescale for measuring width of type in points, picas, centimeters and inches, and a depth or typographer's scale for measuring type and column depth.

Set squares come in various sizes, as well as adjustable versions; used with a ruler or T-square they produce parallel lines. Parallel rulers and speedliners do the same task. Ellipsographs, by definition, are used for drawing ellipses, as are various plastic templates. French curves are clear plastic line guides designed to provide as many degrees of curve as possible, while flexible curves can be bent to any desired angle.

Drawing boards provide a smooth surface for designers to work on. Wooden boards may require a backing sheet, while a formica covered board is more easily wiped clean. Adjustable models have a drafting head which can be fixed on any position on the board.

Drawing boards can also be adjusted to various angles; some are clamped to a surface and adjusted for any angle, while others adjust to a set number of positions. A drawing stand offers the same flexibility, with counterweights to help hold position and a movable straight edge across the board. The Rotoboard is particularly flexible and is used for work requiring multiple ruling.

Papers

A designer should have a wide range of papers to hand, and in varying sizes. Among those he or she will need are cover paper, a colored paper for protecting artwork; detail or layout paper for preparing roughs and layouts; tracing-down paper, which has a colored backing and can be used for tracing a drawing; and acetate paper, used to protect finished roughs or dummy books.

Kodatrace, which is matt on one side and shiny on the other, is used for overlays and particularly for colored artwork; while transparent adhesive paper is also used for protecting different types of artwork. Cartridge and tracing paper are also indispensable for all types of design work.

Knives and sharpeners

A range of cutting implements are standard equipment. Surgical scalpels are used for fine cutting, and

have interchangeable blades, while the craft knife has a larger blade than the scalpel and is used for cutting thicker materials such as stencils or board. A trimming knife also takes various blades and is a heavy duty instrument for all types of cutting.

Scissors are an obvious essential for design work, and a more sophisticated instrument is the parallel cutter with two blades.

A designer should also have a selection of sharpeners, and a sandpaper block is useful for finer sharpenings than are possible with a conventional sharpener.

Lights and glasses

A light box is a necessary piece of equipment for checking the sharpness of transparencies and negatives, for checking color separation and, in conjunction with a suitable overhead light, for color correction. A light box provides uniform and color balanced light diffusion over the viewing surface by throwing a fluorescent light through an opalized perspex or acrylic diffuser on to the glass surface of the box.

A vizualizer or enlarging projector is invaluable for enlarging or reducing an image to an exact size. The image is placed on a copyboard and lit from above—or below in the case of a transparency—and is projected through the lens. The degree of enlargement or reduction is controlled by the movement of the copyboard up or down and by the adjustment of the lens. The image is projected on to the tracing paper on the glass viewing screen, and can then be traced off to an exact size.

Magnifying glasses are especially useful for checking work that has to be enlarged, while a special glass is used for viewing transparencies. A repeat glass is useful for repeating patterns to show how the finished design will look, and is mainly used in fabric and wallpaper design.

Dry transfer lettering

Dry transfer lettering is a fairly recent development now invaluable for rough and finished artwork. Manufacturers of instant transfer products supply a catalog with examples of the lettering styles, typefaces, sizes, colors and effects available, each with a reference number for identification. They also supply specialized alphabets, such as Greek, Hebrew and Arabic; Roman and non-Roman numerals; architectural and technical symbols; illustrations; textures and tones; rules and borders; lines and transfer tapes; and color surfaces such as Vinyl and PVC.

Color selectors

Pantone is a range of products for selecting and matching colors, allowing the designer to control and match colors in all stages of the design, printing and reproduction from the initial roughs to the finished print. There are more than 500 colors available, each with a reference number, and the system is in international use.

The products start with color and tint overlays in large and small formats, each with a color guide. There are wide and fine pointed markers and corresponding colored paper sheets with color guides to help select and match colors; paper pickers show all colors in numerical order, and the printer's edition gives them on coated and uncoated paper. A color and black selector gives different amounts of black in combination with 90 of the colors, and a color specifier is provided to specify inks.

Adhesives

There are a number of adhesives suitable for design work. Rubber gum, applied with a spatula, is a basic stand-by, although increasingly popular are spray adhesives. There are also special aerosol glues for mounting photographs. Among the more specialized adhesives are latex glue for bonding fabrics and fixatives for dry-transfer lettering. Waxers can be used for sticking paper, and other useful items are solid glue in stick form and plastic putty adhesive.

There is also a wide variety of tapes on the market. This includes one-sided and masking tape, double-sided tape suitable for mounting and 'Magic' tape, which becomes almost invisible on application. Gum strip is used for stretching paper in watercolor work.

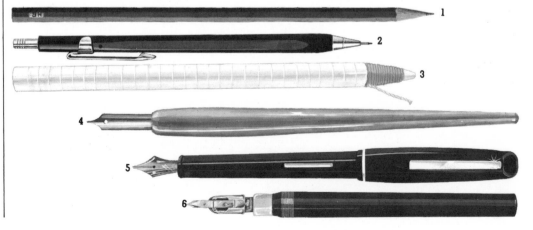

Pencils and pens It is essential for the graphic designer to have a wide range of pencils and pens. The graphite pencil (**1**) comes in up to 17 grades of hardness. The clutch pencil (**2**) is useful as it can be refilled with many leads that are graded according to thickness and hardness. The Chinagraph (**3**) can be used for drawing on both film and plastic surfaces. The dip pen (**4**) is favored by some designers as it can be fitted with a variety of nibs and takes a wide range of inks. The fountain pen (**5**) takes only a small selection of nibs and inks but the Graphos reservoir pen (**6**) can use a much larger range.

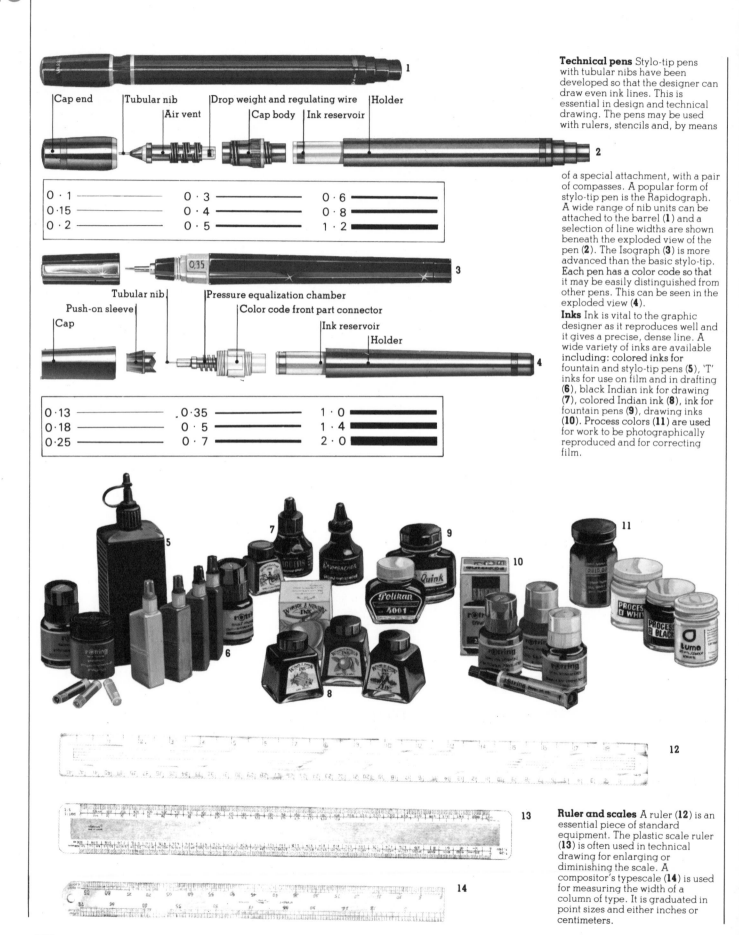

Cap end · Tubular nib · Air vent · Drop weight and regulating wire · Cap body · Ink reservoir · Holder

1

2

0·1	0·3	0·6
0·15	0·4	0·8
0·2	0·5	1·2

Push-on sleeve · Cap · Tubular nib · Pressure equalization chamber · Color code front part connector · Ink reservoir · Holder

3

4

0·13	0·35	1·0
0·18	0·5	1·4
0·25	0·7	2·0

Technical pens Stylo-tip pens with tubular nibs have been developed so that the designer can draw even ink lines. This is essential in design and technical drawing. The pens may be used with rulers, stencils and, by means of a special attachment, with a pair of compasses. A popular form of stylo-tip pen is the Rapidograph. A wide range of nib units can be attached to the barrel (**1**) and a selection of line widths are shown beneath the exploded view of the pen (**2**). The Isograph (**3**) is more advanced than the basic stylo-tip. Each pen has a color code so that it may be easily distinguished from other pens. This can be seen in the exploded view (**4**).

Inks Ink is vital to the graphic designer as it reproduces well and it gives a precise, dense line. A wide variety of inks are available including: colored inks for fountain and stylo-tip pens (**5**), 'T' inks for use on film and in drafting (**6**), black Indian ink for drawing (**7**), colored Indian ink (**8**), ink for fountain pens (**9**), drawing inks (**10**). Process colors (**11**) are used for work to be photographically reproduced and for correcting film.

Ruler and scales A ruler (**12**) is an essential piece of standard equipment. The plastic scale ruler (**13**) is often used in technical drawing for enlarging or diminishing the scale. A compositor's typescale (**14**) is used for measuring the width of a column of type. It is graduated in point sizes and either inches or centimeters.

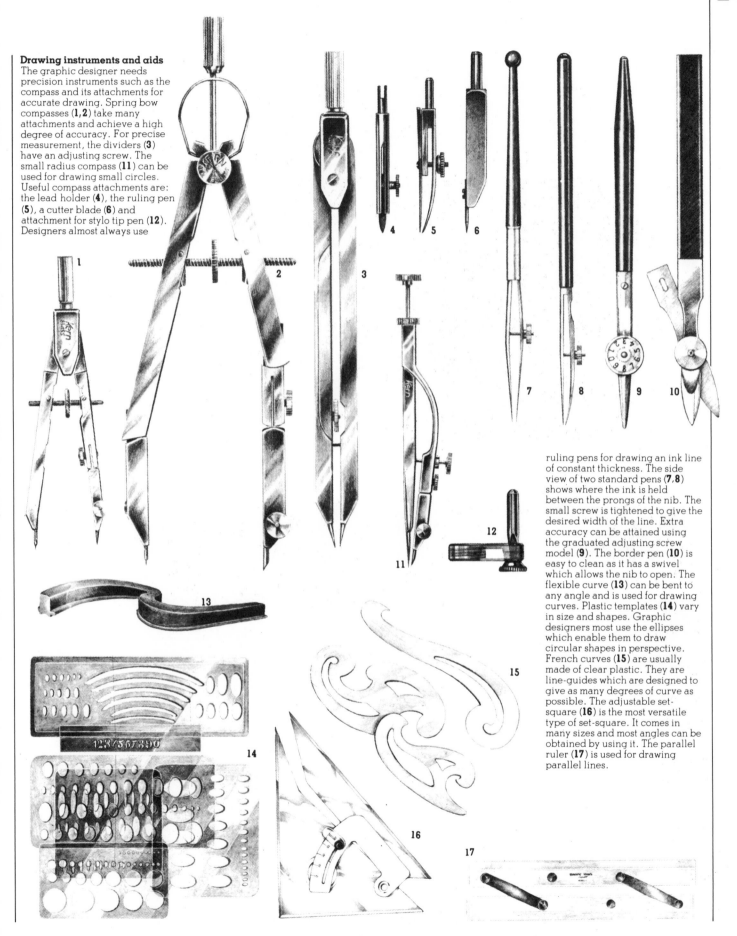

Drawing instruments and aids

The graphic designer needs precision instruments such as the compass and its attachments for accurate drawing. Spring bow compasses (**1,2**) take many attachments and achieve a high degree of accuracy. For precise measurement, the dividers (**3**) have an adjusting screw. The small radius compass (**11**) can be used for drawing small circles. Useful compass attachments are: the lead holder (**4**), the ruling pen (**5**), a cutter blade (**6**) and attachment for stylo tip pen (**12**). Designers almost always use

ruling pens for drawing an ink line of constant thickness. The side view of two standard pens (**7,8**) shows where the ink is held between the prongs of the nib. The small screw is tightened to give the desired width of the line. Extra accuracy can be attained using the graduated adjusting screw model (**9**). The border pen (**10**) is easy to clean as it has a swivel which allows the nib to open. The flexible curve (**13**) can be bent to any angle and is used for drawing curves. Plastic templates (**14**) vary in size and shapes. Graphic designers most use the ellipses which enable them to draw circular shapes in perspective. French curves (**15**) are usually made of clear plastic. They are line-guides which are designed to give as many degrees of curve as possible. The adjustable set-square (**16**) is the most versatile type of set-square. It comes in many sizes and most angles can be obtained by using it. The parallel ruler (**17**) is used for drawing parallel lines.

Surfaces for the designer Most paper is available in the metricated 'A' sizes. Illustrated here are a selection of pads: the A2 pad of detail paper (**1**), A4 pads of tracing paper (**2,5**), A3 block of layout paper (**3**), A4 block of cartridge paper (**4**) and an A4 pad of graph paper (**6**). In addition to cartridge (**10**) and tracing paper (**8**), there is a wide range of paper which the graphic designer requires. For protecting artwork uses colored paper called cover paper (**7**). For preparing roughs and layouts thin detail or layout paper is needed (**9**). Tracing down

paper (**11**) has a colored backing. Acetate paper (**12**) is often used to protect dummy books or finished roughs. Kodatrace (**13**) and transparent adhesive paper (**14**) can both be used to protect artwork.

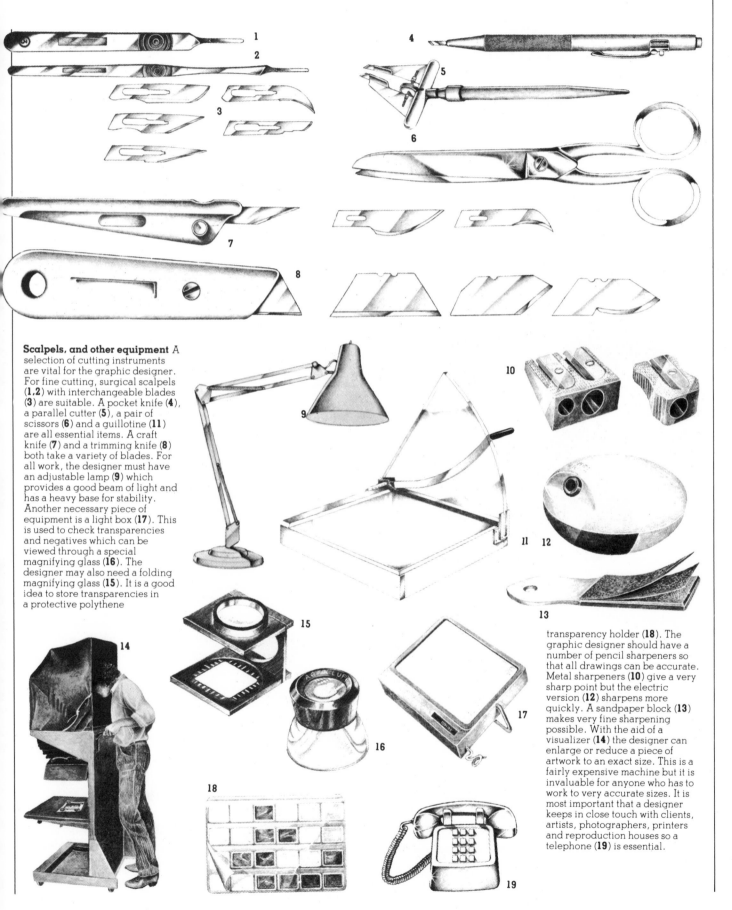

Scalpels, and other equipment A selection of cutting instruments are vital for the graphic designer. For fine cutting, surgical scalpels (**1,2**) with interchangeable blades (**3**) are suitable. A pocket knife (**4**), a parallel cutter (**5**), a pair of scissors (**6**) and a guillotine (**11**) are all essential items. A craft knife (**7**) and a trimming knife (**8**) both take a variety of blades. For all work, the designer must have an adjustable lamp (**9**) which provides a good beam of light and has a heavy base for stability. Another necessary piece of equipment is a light box (**17**). This is used to check transparencies and negatives which can be viewed through a special magnifying glass (**16**). The designer may also need a folding magnifying glass (**15**). It is a good idea to store transparencies in a protective polythene

transparency holder (**18**). The graphic designer should have a number of pencil sharpeners so that all drawings can be accurate. Metal sharpeners (**10**) give a very sharp point but the electric version (**12**) sharpens more quickly. A sandpaper block (**13**) makes very fine sharpening possible. With the aid of a visualizer (**14**) the designer can enlarge or reduce a piece of artwork to an exact size. This is a fairly expensive machine but it is invaluable for anyone who has to work to very accurate sizes. It is most important that a designer keeps in close touch with clients, artists, photographers, printers and reproduction houses so a telephone (**19**) is essential.

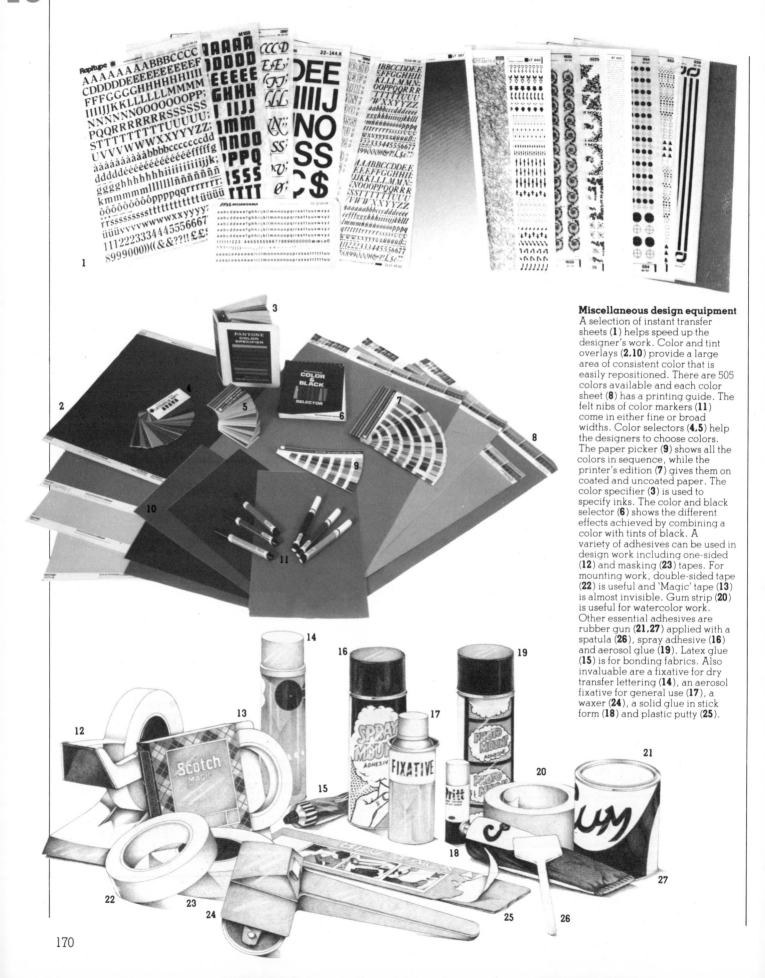

Miscellaneous design equipment

A selection of instant transfer sheets (**1**) helps speed up the designer's work. Color and tint overlays (**2,10**) provide a large area of consistent color that is easily repositioned. There are 505 colors available and each color sheet (**8**) has a printing guide. The felt nibs of color markers (**11**) come in either fine or broad widths. Color selectors (**4,5**) help the designers to choose colors. The paper picker (**9**) shows all the colors in sequence, while the printer's edition (**7**) gives them on coated and uncoated paper. The color specifier (**3**) is used to specify inks. The color and black selector (**6**) shows the different effects achieved by combining a color with tints of black. A variety of adhesives can be used in design work including one-sided (**12**) and masking (**23**) tapes. For mounting work, double-sided tape (**22**) is useful and 'Magic' tape (**13**) is almost invisible. Gum strip (**20**) is useful for watercolor work. Other essential adhesives are rubber gun (**21,27**) applied with a spatula (**26**), spray adhesive (**16**) and aerosol glue (**19**). Latex glue (**15**) is for bonding fabrics. Also invaluable are a fixative for dry transfer lettering (**14**), an aerosol fixative for general use (**17**), a waxer (**24**), a solid glue in stick form (**18**) and plastic putty (**25**).

Copying and photoprinting.

Development and principles: Dyeline copying, Thermal and electrostatic photocopying, Duplicating, PMT reproduction.

19 | **Photo-printing** Principles

Advances in the increasingly complex field of reprographic technology have become so rapid in the past few years that college and university courses in the subject are undergoing constant revision. However, the internal complexity of a machine is of less interest to the studio artist than what it can do for him or her as a design tool.

Dyeline, one of the oldest systems of copying, has undergone a number of improvements recently, including substitution of unpleasant ammonia by another chemical.

A transparent original is placed over sensitized paper and exposed to ultra-violet light. The process is particularly suitable for copying engineering or architectural drawings.

A new version of the technique, the Safir SC process, enables the final appearance of a piece of artwork to be checked without going to the expense of getting it color-proofed. Light through film-base images of the artwork activates a photo-sensitive coating on a white polyester base. Dye adheres to the exposed areas. Successive coatings of dye can be built up to give various color effects.

Photocopying machines come in a wide variety, from the simple office duplicating models to complex equipment capable of copying fine line drawings, half-tone illustrations and sample text. The most useful machine for the designer is one that will produce prints to A3 size—the equivalent of two facing pages of A4 format.

There are two basic types of photocopying machine: the thermal and the electrostatic. A paper negative of the subject is used in the thermal process, which produces prints on the same type of special paper.

The electrostatic machine needs no negative and will print on any paper, or even on to the surface of plastic films.

Photographic copying equipment (as distinct from a photocopier) produces high-quality prints which can be used for reproduction in the same way as the original artwork. By optical means—since a negative is used—the print can be increased or reduced in size.

The Photo Mechanical Transfer (PMT) machine is cheaper to use than other photographic systems, does not need a darkroom for processing, and produces line work of high quality. By using dot or line screens, half-tones can be reproduced which, although not as sharp as those made by photo-engraving, are quite adequate for low-budget work.

The PMT machine can also be used to simulate color in a design, to give some idea of what a color proof would show. First print is on to a film base which is processed to give a color simulation known as a color key. A dye is used to develop the image in one of several stock colors. Both the colors and the film bases are transparent, so when superimposed they create the appearance of two or more colors printed in line or half-tone.

The color key technique also enables a designer to make a single copy of a simulated color image in the form of a transfer which can be applied to, say, packaging material, to give a customer an impression of how the finished job will look.

Recent technological developments in photo-printing have increased the quality and capability of the machines. This has also widened the areas of application, particularly in the design field.

GRAPHIC
Original

GRAPHIC
Negative

GRAPHIC
Copy

Photocopying The copy of the word GRAPHIC (**above**) shows the difference between the main photocopying techniques. The thermal process takes longer as it involves making a negative of the original and then taking the final copy from the negative. The faster electrostatic technique does not require a negative and will print on any paper. In graphic design work, photocopies of layouts are particularly useful as they provide excellent reference material (**right**).

1

6

2

7

3

8

4

9

5

PMT machines The Photo Mechanical Transfer (PMT) machine is an extremely versatile process camera that is relatively cheap to use. In addition, it produces good quality line origination so it is often used for photo-typesetting. The machine can make a copy (**1**), reduce the size of the original (**2**) and make an enlargement (**3**). It can reverse black to white (**4**) and vice versa, and it can also convert color to black and white. One of the more useful features of the machine is its ability to make a copy on to film, either positive (**5**) or negative (**6**). This type of copy is most used for presentation work, such as making a dummy for a book. Film is a versatile medium which can be moved about easily on a layout. Color cels, like this white one (**7**), are also used in presentation work and are available in many colors. Halftones can be screened so as to produce either a positive (**8**) or a negative (**9**) image.

Screening

The reduction of continuous tone images to thousands of dots is termed 'screening'. The dots may vary considerably in size, shape, number and pattern. The type of screen required is usually determined by the printing press and inks, the printing plate and the surface of the paper. A number of special line screens are used by designers who want to gain a special effect. The most striking types of screening, such as denim (**1**) and dot (**7**) are mainly used for commercial purposes such as advertising. The weave plus highlight mask (**4**) and the fine mezzo (**6**) can be used to disguise a poor quality photograph. Other screens shown here are random dot (**2**), straight line (**3**), wavy line (**5**) and cross screen posterized (**8**).

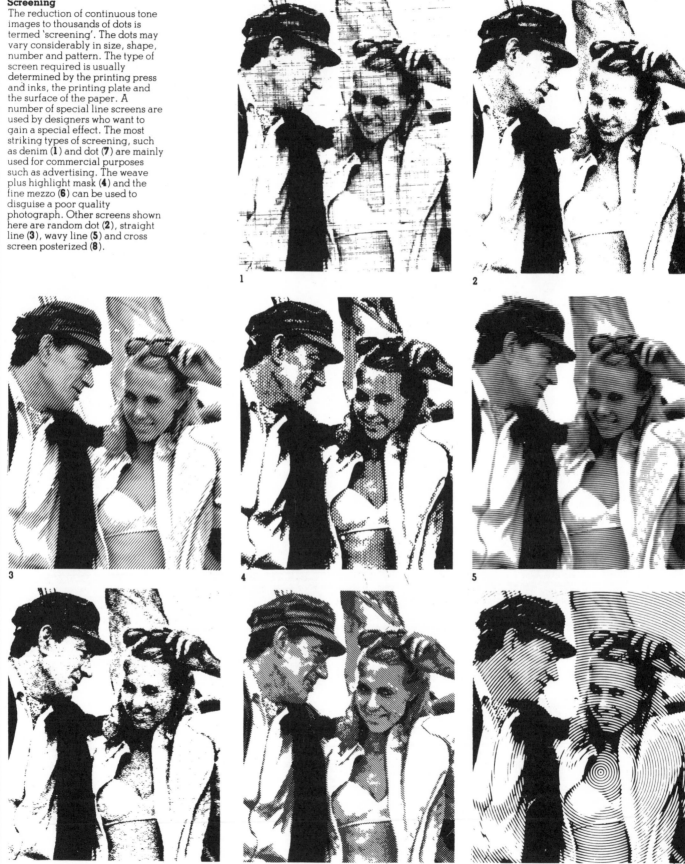

Designing for print.

History. Procedures: Typeface selection, Casting off, Typesetting methods, Marking up copy, Proofs, Imposition and paste-up.

The variety of typefaces available to designers today is manifold; designs exist in their thousands. The advent of advanced printing technology in the nineteenth century allowed purely aesthetic considerations to influence type design to a greater degree than had been possible in the 400 years or so since type had been invented. Before the nineteenth century, the form of type was largely determined by the limitations of the printing processes available.

Early type designs were based upon handwriting. In Germany, the Gothic handwriting led to a type which, although distinctive, was not easily legible.

Printing in Italy began in the late fifteenth century, and there the typefaces were influenced by the handwriting used for official or formal documents known as Chancery Italic. It was lighter and more legible than German Gothic. Italian handwriting had more influence on the development of type than the German. Indeed, the style is to be seen today, notably the Bembo face.

These Old Style faces were distinguished by the heavily accentuated serif, a small line, which is triangular in form, used to complete the main stroke of a letter. Another feature is the diagonal emphasis given to the thicker part of curved strokes. This feature is derived from the manuscripts used as models for the type.

In succeeding centuries type became less influenced by manuscripts as the mechanics of printing became more sophisticated, and as paper, ink and type developed. In due course typefaces came to be designed quite independent of the influences of the manuscript.

That part of the development of type which came to be known as the Transitional period found a classic designer in John Baskerville (1706–1775), who contributed greatly to the development of type by the improvements he made to the manufacture of paper, type and ink. Baskerville experimented at length in order to improve the surface of paper by pressing it between hot plates to give it a smooth gloss similar to what is today known as 'wove'. Experiments with ink produced a blacker impression than that of predecessors, while his type designs tended to be a lighter color than that of Old Style, with a perpendicular emphasis on the curved strokes and the serifs more horizontal than diagonal.

By the end of the eighteenth century the Modern style, introduced by the Italian printer and designer Giambattista Bodoni (1740–1813) was practised. Bodoni used fine, horizontal hairline serifs and emphasized the difference between thin and thick strokes, thus following the prevailing artistic vogue for the Classical style.

The Industrial Revolution of the late eighteenth and nineteenth century brought significant technological advances and at the same time a greater and more varied demand for typefaces, particularly in advertising. These new designs were less modest than their predecessors. They were bold and black. Slab Serif or Egyptian types had serifs that carried as much weight as the body of the letter, while the extreme Fat Face types had serifs that were exaggerated and gross.

These latter types and others designed to be more striking led designers to realize that the silhouette of a letterform can be made too bold and consequently self-defeating, as the white spaces within the letters, known as counters, become so reduced that the letterform becomes illegible. A natural development from this was the introduction of Roman types without serifs.

Sans Serif or Grotesque types were developed initially as poster faces but soon came into general usage. Jan Tschichold (1902–1974) laid down the principles of the Modern Movement that used these faces in his book *Die Neue Typographie* (*The New Typography*) which has come to greatly influence much of the design in this century. The German *Bauhaus* school and the *De Stijl* movement in Holland produced geometric Sans Serif letter forms that are still influential, while Edward Johnson and Eric Gill in Britain between the First and Second Wars produced significant designs in Sans Serif.

Venetian Centaur
This typeface shows many traces of its origins in fifteenth-century calligraphy.

Transitional Bell
Transitional Bell has horizontal serifs and vertical curved strokes.

Perpetua
Perpetua, like the other faces in its family, was designed specifically to meet mechanical requirements.

Univers
Grotesque Sans Serif Univers is one of the most popular typefaces today, and gives a clear effect.

Type families

Gothic
This elaborate early typeface originated in Germany and was derived from manuscript writing. It is fairly hard to read. It is also known as blackletter.

Old English

Old Face
This typeface was influenced by fifteenth-century Italian handwriting, yet is still in common use today. There is little difference between the thick and thin strokes.

Bembo

Transitional
There is less serif bracketing in this typeface than in Old Face. As its name suggests, it falls between the Old and Modern Faces.

Baskerville Old Face

Modern Face
This was developed from Old Face but has thinner cross strokes. There are hairline serifs and stressed vertical strokes.

Bodoni

Egyptian
This group has serifs which are normally unbracketed and appear slab-like. The form is of an even thickness, and some of the more condensed versions are known as Italian.

Rockwell

Fat Face
This face, developed from modern face, cannot be used for setting text. The thick strokes are very broad, making the letters much wider.

Carousel

Sans Serif
This group of typefaces has no serifs. They are fairly recent, and were originally used for posters, before becoming more widely accepted and used in general printing.

Helvetica

Univers

Univers (**below**), a member of the sans serif family, is one of the most popular typefaces today. It was designed in 1957 by Adrian Frutiger, who took into account the effects obtained when using different printing processes. He produced a complete series of letters of different weights and outlines to cater for almost every purpose.

Typesetting variations

These two letters (**right**) have been set, using photo-composition, in different typefaces. The Helvetica face (**left**) has even strokes, but the bottoms of the Univers strokes (**right**) have deep indentations. These allow for fill-in when printing. Many beginners have difficulty in distinguishing between Univers and Helvetica, but generally Helvetica sets tighter.

Condensed
extra light extra

Univers

Light

Univers

Medium
extra condensed

Univers

Light condensed

Univer

Medium condensed

Unive

Bold condensed

Univ

Univer

Unive

Univ

Light

Univ

Medium

Univ

Bold

Uni

Extra bold

Uni

Univ

Univ

Uni

Uni

Medium expanded

Uni

Bold expanded

Uni

Extra bold expanded

Un

Ultra bold expanded

Un

T he two main problems that designers of type have to face are those of the varying width of alphabetic characters and the difficulties of word spacing. The width of alphabetic characters, or the space allotted to them, is largely dependent on the technical apparatus involved. For instance, a manual typewriter, in order to maintain consistent letter spacing, uses exaggeratedly wide serifs on letters such as 'i' and 'l', while some electric typewriters employ a system of three different character widths. Most typesetting machines use a system of nine different character widths.

In order to overcome the problems of word spacing, early printers, who sought to have both margins of text vertically aligned, resorted to a number of extra signs beyond the 26 characters of the alphabet. They were known as contractions and were used to take the place of abbreviated words.

The letterpress printing process allowed for a system of four different width spaces between words, while technological developments in this century have largely obviated the necessity for such devices. The Modern Movement in type design during the 1920s and the 1930s preferred to use consistently equal amounts of word space, which usually resulted in a slightly ragged margin on the right.

Typeface selection

The evolution of type design does not rest solely on historical precedent, but also on the continuing development of production methods, with typefaces being designed, or re-designed, for specific technological innovations. With the introduction of Linotype and Monotype, the first mechanical typesetting machines, at the beginning of this century, the existing typefaces were remodelled and adapted to the characteristics of the two systems. Linotype produces each complete line as a single piece of metal, whereas Monotype produces individual types and spaces with which to form a line.

An important factor in type selection is the printing process to be used. The early typefaces were designed to be printed on cartridge or other uncoated papers. Thus, when printed on modern, smooth papers, they can often appear too light. It is also the case that modern types, designed to be printed on modern paper, have a more robust appearance when printed on cartridge paper. The typesetting equipment can similarly alter the appearance of a typeface—the photographic method, for example, generally produces a lighter effect.

Reversed type, that is white type on a black or colored background, usually demands a heavier typeface, as a type with fine lines as an integral part of the design, such as a Modern face or light weight of type, is susceptible to the erosion of the image by surplus ink.

Besides such practical considerations, type selection will be influenced by aesthetic demands. Sans Serif faces, simple and uncluttered, are sometimes more suitable for technical literature, and are also used for children's books, the letters more closely resembling today's handwriting. Serifed typefaces are more suitable for novels and are used by the majority of newspapers.

Tables, indexes and bibliographies, requiring complex typography, are best suited to a typeface with a wide range of weight and italic, such as Garamond or Bembo, while Times is a particularly popular typeface for mathematical formulae, with the typesetting done on Monotype equipment.

Color and leading are two other important considerations. Each typeface produces its own tone or color, and this color is further influenced by leading, which is the insertion of space between each line. With hot metal processes this is done by the compositor using a blank piece of lead to space out the line; in photo-composition the term used is line feed.

Some typefaces have large appearing faces. These are faces with the overall height of the body of the type (the x-height) being large in comparison with the ascenders (the parts rising above the body, as in 'b', 't' and 'd') and the descenders ('g' and 'y'). Conversely, a type with a small x-height and large ascenders and descenders is known as small appearing.

The British typographer Stanley Morison (1889–1967) designed the Times New Roman typeface for The Times newspaper in 1931 with an exaggeratedly large x-height in order to give the maximum amount of legibility, however small the size.

Type sizes are measured in points or millimeters, depending on which typesetting equipment is used. The point system is based upon division of the inch into 72 subdivisions. The choice of metrication or the point system is usually determined by the typesetters and printers involved in producing the work. Line lengths are measured in picas or ems, units of twelve points.

Once a suitable typeface has been selected the copy must be prepared by the designer. It is important that the designer is well acquainted with the subject of the copy, as it will influence any decision on a suitable typographic structure. This will include the size and position of headings, sub-headings, references and captions, and may also involve additional sub-editing after a design has been formulated.

It is a considerable advantage to the designer if the text is typewritten and typed to the same approximate line length as the final form. This procedure will also help to confirm the design of a page or pages, and will allow the designer to make an accurate estimate of the number of lines a manuscript will take up.

Casting off

Estimating the number of characters and lines which a piece of typed copy will occupy in type is called 'casting off'. This is an important process for the design

of a book or any printed matter.

An approximation should be made of an average line, each inter-word space counting as a single character. This figure is then multiplied by the total number of lines of manuscript to give the number of characters involved. This figure can be used to estimate the cost of setting.

Printers and manufacturers of typesetting equipment will provide sample alphabets in the various typefaces and sizes they have available. When referring to these samples, particular care should be taken, as some typefaces will alter in size according to whether the setting is carried out on hot metal or using photo-composition equipment.

Sets of tables covering a complete range of typefaces are provided by some manufacturers; these tables—called casting-off tables—will indicate the number of characters in a given line length. Other printers provide alphabet sample sheets containing simplified casting-off tables.

However, it is not generally possible to be entirely accurate when judging the length a manuscript will make in type. It is therefore sensible to allow a five or ten per cent margin of error to the estimate. This allowance should take into account the complexity of the manuscript and the number of words per line once it is set in type, although short lines, hyphenated words or exaggerated white spaces due to words being carried over to the next line will further complicate the estimate.

Typesetting methods

There are two basic forms of typesetting—direct or by means of conversion. The oldest of these two forms is the direct method of hand setting. The first types were individually cast, with the space in the interior of the letters or characters produced by individual punches, each cut to the precise form needed. These tools were known as counterpunches—hence the term counters for the white spaces within characters. Type is still produced in limited quantities for use in this way by type founders, and is therefore generally known as founder's type.

Hot metal composition first became widely used at the beginning of this century when mechanical typesetting machines were first built. These machines assemble the brass matrices needed for a line of text and make a casting for them in molten metal, producing individual slugs of lead. In the case of Monotype there was one slug for each character, while Linotype produced a complete line as a solid piece of lead. These castings, with the character in relief, are used to print the text. These machines are limited to a type size of 14 points for body text.

Because the machine operator cannot reduce the inter-character spacing, kerned characters have been developed for some combinations of letters. A kerned letter is one in which some part of the design over-hangs the body of the type and rests upon the body of a neighboring letter or space. The italic letter 'f' is a common example.

Photo-composition is considerably more flexible than hot metal, as the individual characters are projected as light on to photographic film. Text can be set closer together than the original sample alphabet indicates. However, there are some faces, such as Univers, which are best not altered in this way as they were specifically designed to be set across a wide measure.

Other advantages that photo-composition has over hot metal are the comparative ease with which matrices can be produced for variants and complete alphabets, the use of prisms to distort the appearance of type, producing expanded, condensed or italic type as required; the wider range of type sizes available, and, above all, the use of photo-composition type as a matrix for processes such as lithography, gravure and screen printing without an intermediate photographic stage.

Electronic editing and typesetting systems use computers to select and edit information in association with cathode ray tube (CRT) typesetting machines which produce 8,000 characters per second or 300 lines of typesetting per minute. These systems are at their most efficient when used to produce directories or similar large amounts of standard information. These systems are widely used in the United States, and are likely to be increasingly used in the British newspaper business in the near future.

Marking up copy

Instructions from designer and editor to typesetting operators should be clearly marked on the manuscript. Typefaces and line lengths should be marked at the head of each page, while words, lines, headings or paragraphs to be set in a different face should be marked accordingly. In some cases, such as in the tabulation of a chess board or graph where instructions might be especially complicated, it is better to send an accompanying style sheet.

Operators and compositors, who impose or make up the text, are liable to work in different departments of a printing works, and thus manuscript marks should be restricted to the manuscript and lay-out instructions to the lay-out.

Proofs

The first proof (or piece of set copy) provided by typesetters is known as a galley proof, which will have the text set to the correct line length in one continuous column. When correcting galley proofs, the accepted printers' marks should be used. In principle, all editorial alterations and corrections should be incorporated in the manuscript because of the cost of resetting type; however, any late editorial or author's corrections and literal errors should be checked diligently, as changes

after pagination further escalate cost.

The second proof is supplied in page form, and should include proofs of illustrations or artwork. Alternatively, photographic prints, which are called bromides, can be supplied. These are pasted down to form a camera-ready paste-up.

Black and white illustrations do not normally require separate proofs, although they are sometimes necessary for identification when a large number of illustrations appear on a page. Color proofs are essential, however, both for two-color (black plus one color) and for four color (the full color process).

Imposition and paste-up

The imposition or assembly of type and illustration can be done either by the compositor, by an independent artwork team or by the designer. If the work is to be printed by letterpress, the printer will assemble the hot metal type with blocks in a rigid rectangular frame, known as a forme. If the printing process to be used is lithography, screen process or gravure film will be imposed. A designer will probably work with paper, producing artwork suitable for a photo-engraver's camera. A stout white card is best used as a base for this, with a grid drawn up in light relief to work to. Rubber cement, adhesive sprays or a waxing machine can be used to stick down the paper as they will not wrinkle it when drying.

Lines, whether for illustration or margins, can be drawn in directly onto the artwork. If the drawing is complicated it can be prepared by the artist to a larger size more comfortable to work with, reduced photographically and then pasted up. This last alternative can be applied to the artwork as a whole, including the typesetting, producing it to a larger scale than is required for the finished product and then reducing it. A scale of one to one and a half, known as 'half-up', is usually sufficient for work up to A4 size.

Instant lettering, or dry transfer lettering, such as Letraset, can be pasted up in the same way. Some photo-composition machines do not carry large enough typefaces for certain headings or displays and instant lettering is a useful alternative.

Halftones do not reproduce particularly well when pasted up. The best quality halftones are those prepared by a photo-engraver, who produces letterpress blocks or photographic film. The position of illustrations in the artwork must be clearly marked, usually by indicating the exact corners of the illustration in pencil, with the dimensions of the illustration. The photograph itself should also be marked up, either on an overlay or on the back of the photograph, although care should be taken not to damage the photograph. Requests for retouching or trimming should also be indicated in this way.

1. Width (units of set)
2. Beard (space for descender)
3. Body (point size)
4. Front
5. Foot
6. Nick
7. Height (to paper)
8. Back
9. Shoulder

Univers abcdefghijklmnopqrstuvwxyz

Times abcdefghijklmnopqrstuvwxyz

Plantin abcdefghijklmnopqrstuvwxyz

Gill Sans abcdefghijklmnopqrstuvwxyz

Typefaces Some typefaces appear fainter than others when reproduced, and therefore need more spacing or leading. This is determined by the x-height — the height of the lower case 'x' — of the typeface. The difference in size of various x-heights is shown **above**, in four alphabets. The varying x-heights of the letter 'h', set in different faces, are also illustrated. This rectangular piece of metal (**left**) is a piece of type, with the printing surface uppermost, called the face. The block is called the body.

inches

centimeters

picas

ciceros

36 point em

36 point em divided into 18 units

72 point em divided into 18 units

Point sizes Until the eighteenth century, there was no standardized system of type measurement, and each foundry produced a slightly different type. The point as a standard unit of measurement was introduced by Pierre Fournier, a Frenchman. This was developed into the standard European measurement by another Frenchman, Firmin

Didot. Britain and America adopted another system. In the European system, the unit of 12 points is called a cicero and in the Anglo-American it is called a pica. The unit system (**left**) is used on photosetting machines. There are usually 18 units to an em, and the size of the unit varies according to the size of the type.

18 units 10 units 6 units

Photon

ABCDEFGHIJKLMNOPQRSTUVWX
abcdefghijklmnopqrstuvwxyz
1234567890 (£$.,-'‘'!?*½¼¾⅓⅔⅛⅜⅝⅞—[]=†/

APS 4

ABCDEFGHIJKLMNOPQRSTUVWX
abcdefghijklmnopqrstuvwxyz
1234567890 £$.,-'‘':,!?*$\frac{1}{8}\frac{3}{8}\frac{5}{8}\frac{7}{8}\frac{1}{1}\frac{1}{3}\frac{1}{2}\frac{1}{3}\frac{5}{6}\frac{1}{6}\frac{2}{5}\frac{3}{5}\frac{4}{5}$

Monophoto 2000

ABCDEFGHIJKLMNOPQRSTUVWXY
abcdefghijklmnopqrstuvwxyz
1234567890(£$.,-'‘':,!?*$\frac{1}{4}\frac{1}{2}\frac{3}{4}$ —[]=†/+%&â

Bobst Eurocast

ABCDEFGHIJKLMNOPQRSTUVWX
abcdefghijklmnopqrstuvwxyz
1234567890`ßıêûâéèàùöäüœç

Linotron 202

ABCDEFGHIJKLMNOPQRSTUVWX
abcdefghijklmnopqrstuvwxyz
1234567890 ..:;?!()-'‘—–[]/· /æœŒ Æ†

Linocomp

ABCDEFGHIJKLMNOPQRSTUV
abcdefghijklmnopqrstuvwxyz fifl
1234567890£$.,:;'‘'!?*—[]†/+%@

Fine rule

1 point full face

1½ point full face

3 point full face

6 point full face

3 point double medium rule

3 point shaded or total

Broken

Fine dotted or leader

Coarse dotted

Type These characters (**above**) set in Monotype are cast on bodies whose width is measured in units. The 'f' set in Bembo, for example, is cast on a 6-unit body but the stem overhangs. The alphabet lengths (**far left**) have all been set in Times typeface on various machines, with very different results. A depth scale (**left**) is calibrated for many different type sizes, in order to show the number of lines needed to fill a given depth. Rules (**above**) are straight printed lines, varying considerably in size.

Typefaces fall into two groups, those having serifs (that is terminal projections on the stems of characters), and those without this feature, which are known as sans serif. In general, serif typefaces are preferable for the easy reading of continuous text, whilst sans serif typefaces are ideal for headings, titles and all the occasions when the text is not of a continuous nature. Both groups are therefore required

Justified

Typefaces fall into two groups, those having serifs (that is terminal projections on the stems of characters), and those without this feature, which are known as sans serif. In general, serif typefaces are preferable for the easy reading of continuous text, whilst sans serif typefaces are ideal for headings, titles and all the occasions when the text is not of a continuous nature. Both groups are therefore required

Range left

Typefaces fall into two groups, those having serifs (that is terminal projections on the stems of characters), and those without this feature, which are known as sans serif. In general, serif typefaces are preferable for the easy reading of continuous text, whilst sans serif typefaces are ideal for headings, titles and all the occasions when the text is not of a continuous nature. Both groups are therefore required

Range right

Typefaces fall into two groups, those having serifs (that is terminal projections on the stems of characters), and those without this feature, which are known as sans serif. In general, serif type-faces are preferable for the easy reading of continuous text, whilst sans serif typefaces are ideal for headings, titles and all the occasions when the text is not of a continuous nature. Both groups are therefore

Centered

The form typography is to take
The form typography is to take
The form typography is to take
The form typography is to take
The form typography is to take

abcdefgh
abcdefgh
abcdefgh
abcdefgh

Univers Univers Univers

Photocomposition Printers can be far more flexible when they use photocomposition, or film setting, rather than hot metal composition. Characters can be elongated or shortened, and the spacing can be varied by minute amounts.

Justification Lines of type are treated in one of two basic ways by the printer when setting copy. He can justify, or evenly space, the words to make the lines of the same length. Alternatively, he can space the words equally, making the text unjustified. In this case, he has the choice of ranging the text left, right or center (**left**). Sophisticated electric typewriters can now typeset, using interchangeable 'golf ball' heads (**right**). The machines are able to justify text on left and right hand margins.

Casting off

1. Draw a line by the shortest line of copy. Multiply the characters in the line by the lines on the page, add on extra characters.

2. Calculate the number of characters in the entire text, then read a factor figure from the appropriate manufacturer's table.

3. Read this figure against the appropriate pica measure to obtain an exact line character count.

4. Divide this figure into the total number of characters in the text to get the total line count.

5. To cast off from a typesetter's sample, count the characters in 5 lines. Divide this by the lines counted.

6. Divide the total number of characters in the copy by the average number of characters per line to give the line count.

Proof correction marks — Instruction to printer	British Text	Margin	American Text	Margin	New Text	Margin
Delete	pen and ink	ℐ	pen and ink	ℬ	pen and ink	⟋
Delete and close up	pen and ink	ℐ	pen and ink	ℬ	pen and ink	⟋
Leave as printed	pen and ink	stet	pen and ink	stet	pen and ink	✓
Insert new matter	pen ink	and /	pen ink	and	pen ink	and ⟋
Wrong fount. Replace by character of correct fount	pen and ink	w.f.	pen and ink	wf	pen and ink	⊗
Change to italic	pen and ink	ital	pen and ink	ital	pen and ink	⊔⊔
Change to roman	pen and ink	rom	pen and ink	rom	pen and ink	⊔
Insert space	pen and ink	#	pen and ink	#	pen and ink	Y
Transpose	pen ink and	trs	pen ink and	tr	pen ink and	⊔⊐
No fresh paragraph	pen and ink. The first	run on	pen and ink. The first	no ¶	pen and ink. The first	⌐
Begin new paragraph	and ink. The first	n.p.	and ink. The first	¶	and ink. The first	⌐
Substitute comma	and ink the first	,	and ink the first	⌃	and ink the first	,
Insert single quotation marks	pen and ink	⁵⁷	pen and ink	˅ ˅	pen and ink	⁵⁷

Proof correction

When correcting proofs, it is vital that the standard marks are used. Different countries have their own systems, and, for comparison, a selection of the most important marks have been illustrated (**above**). These marks should always be adhered to, as corrections at later stages are both difficult and costly to make. This galley proof (**left**) has been marked up for literal and other corrections by the editor. The corrections are made both in the text and margin to ensure that the printer understands the instructions. The designer should check the galleys for non-alignment of margins and damaged type, for example. The artwork (**below**) has been marked up for the printer, indicating the typeface, type size and spacing.

Design techniques.

Techniques: Briefing, Roughs, Costing and schedules, Grids, Commissioning text, Photographs, Commissioning illustrations. **Processes:** Copy preparation, Selecting photographs, Sizing pictures, Preparing artwork, Color correction, Paste-up, Printing, Book production, Flat plans, Binding, Jackets.

21 | **Design** Techniques

In the production of newspapers, magazines, advertisements, books and related fields, design plays a very important part. Its purpose is always to communicate information in the clearest possible way. To succeed in this task there are two basic factors which have to be considered.

The first is the person or group of people who have commissioned the work. Their aims and ideas must always be borne in mind, and the designer must be prepared for the design to undergo changes before reaching its final form. The second is to be aware of the audience to whom the information is to be communicated. In connection with this, the designer should ask: What is important here? Is the design merely decorative or is it trying to convey the information? If decorative, images are usually allowed to dominate. If informative, the information can be conveyed diagramatically as well as typographically.

Briefing Before the designer can begin, he or she must be given a brief, either by the art director or the client. The idea to be conveyed by the design is clearly stated and design suggestions discussed. It is at this stage that the parameters are set for expenditure and production time.

The designer may be 'in house', that is a permanent member of staff of the company, or working freelance. If the latter, he or she may well be competing with other freelance designers for the commission. But, whether freelance or staff designer, the designer should know how to control a budget.

During the briefing, the designer may simply be given an overall figure to be broken down as he or she sees fit, or a budget in which each component has been costed. Sometimes the designer may be asked to propose his or her own. It is particularly important in the case of a freelance designer that the budget includes a realistic costing of his or her own time. Once a budget has been agreed, it has to be observed.

In competing for a job, a designer must be able to inspire the prospective client with confidence; after all, the client will be paying and authorizing the designer to spend money in the client's interest. How the designer does this depends on who is present at the briefing. The language should be clear, simple and precise; technical language should only be used in discussion with someone who understands it, like an art director. Designers should show flexibility in attitude; sticking rigidly to preconceived ideas could mean that they might lose the job.

The designer should also be prepared in other ways for the interview. He or she should always bring along examples of past work to show their range and approach, or to illustrate ideas. It is also useful to have a notebook and pocket calculator, and even a cassette recorder, if it is likely that complicated technical requirements are to be discussed.

Most important, the designer should be sure to clarify all points, in order to proceed to the next stage with confidence. For instance, if text is to be used, the designer should find out who is to supply it and when. If questions are left unasked, problems are bound to occur. It is helpful to draw up a list of questions beforehand; such an exercise will prepare the designer mentally and pinpoint areas of doubt. The client will not have confidence in a designer who does not ask the right question at the right time.

A designer trying for a commission should be careful to present himself or herself in the best possible light. This applies in the realm of personal appearance as well as in the preparations advised above.

The responsibility of accepting or rejecting a commission lies with the designer alone. But a decision should be made in the confidence that the designer will not let down the client at a later stage. Once the work has been accepted, the client will be paying for it and will naturally expect that the designer will keep to the contract.

Roughs After the briefing the designer goes ahead to produce roughs. A rough can be anything from an outline simply indicating an idea, to a finished rough. The kind of rough produced depends on who is going to see it. An art director is usually able to understand more from an outline, or at least ask the right questions about it, than, say, a salesman. Roughs can be prepared in any medium, although most usually in pencil, felt-tipped pen or crayon. It is best to use pencil to show detail and typography.

The roughs show the designer's approach to the subject. He or she may have decided upon a visual solution, in which case a variety of images or perhaps one strong one have to be selected. The designer also has to decide how many artwork and photographic subjects to use and where, as well as whether they will be in full or two color, black and white, or a mixture.

A typographical solution poses different problems. For example, there are several ways of emphasizing a key word or line. It can be put into capitals, or set in italics or bold type. The size of the type can be varied, as can its weight. It is also possible to emphasize a line by altering the spacing within it. These are all solutions to one problem which the designer has to decide between in the context of the overall design.

There is one main problem which has to be faced by every designer and that is how to present material in a new way. The way to meet this challenge, of course, depends upon the designer's own imagination. Design is the art of visual communication and the best way to attract attention and interest is through a new idea which is well executed. Novelty is not the only factor here: it may have impact, but this is easily lost if the concept is not thought out properly or is badly produced.

Taking the concept one stage further can be done at the roughs' stage. A preliminary rough provides a talking point, establishing the general subject area and whether or not there will be a central image, for

example, but leaving details, like the image to be used, unspecified. In a typographical design, the designer would not have to decide upon the typeface, but the preliminary rough should show how the headings are set out on the page and what size they will be.

Preliminary roughs are likely to be altered several times, so the designer must be prepared to spend time on this stage of the design. Nonetheless, he or she must be constantly aware of the problems of time and cost effectiveness. For instance, it is often tempting to present two or three alternative solutions to a problem, but this is not always necessary or wise. It is just as well to tell the client beforehand how many roughs, and of what standard, will be prepared.

More time is spent initially on a finished rough, because it more accurately reflects the final version. Therefore changes, if there are any, are usually minor. Once again, the images do not have to be exact, but the type of image, the size and color have to be shown. The designer must specify whether photography or artwork is to be used, and examples of the photographer's or illustrator's work should be brought to the meeting to give an idea of the style and standard of the finished design.

The finished rough is always presented in a professional way. Mount the design on black card with a black or colored surround and use an acetate covering to protect it. The text should be indicated by dummy type with dry-transfer (Letraset or Letter-Press) headings, or 'live' (real) typesetting. Live copy, headlines and captions are naturally to be preferred, but are expensive to produce. In choosing what text to use, the designer should consult with the writer so that the illustrative and text material will relate. Even when using dummy text, it is better to use live headings to give some indication of subject matter.

Costings and schedules A designer may be asked at this stage to provide printing estimates for the job, although this is often the function of a production department. He or she must therefore be given the size of the print run by the client. This, plus the complexity of the job, will determine what kind of printer the designer is looking for. Other factors to be considered are time and cost. If the job has to be done very quickly, it is likely to cost more, and is unlikely to be placed with one of the more traditional printing firms. A small printing firm, while possibly less expensive than a larger one, may not have binding facilities, and it will increase the cost if binding has to be done by another company.

If it has not already been determined by a production department, the designer may be required to decide how the job is to be handled technically. First of all, this means that the designer will have to see whether it is better to have the typesetting and origination done by the same company or two different ones. With books and magazines it is standard practice to send illustrations to a reproduction house for origi-

nation including color separation. The type of printing process must be specified, and in relation to this the printer has to be told whether he is to expect camera-ready copy pasted up by the designer, or whether he is required to do the make-up of the film.

In lithography and gravure, the film of the text and the film of the illustrations have to be put together as one piece for printing; this is called make-up.

When costing artwork origination, it is as well to supply a sample showing any special requirements, such as tints.

In fact, to make an accurate quotation, the printer will need all available information about the job. The designer should therefore draw up a detailed layout, marked with all the basic information necessary for his or her own reference and for the printer. If, however, the job is a simple one, a typewritten specification will do.

The aim of the exercise is to obtain the highest standard of printing at the lowest cost. The designer should therefore get as many estimates as possible, or at least a minimum of three, in order to compare available prices.

The printer should supply a timetable indicating how long his part of the job will take. The designer will key this into the overall schedule, which gives dates for each stage of the production process—from roughs to the passing of final proofs.

Grids Grids are devised for consistency in the production of folded leaflets or anything with pages. A single entity, such as a poster, does not require a grid; a book, on the other hand, does.

A grid will show column depths, picture areas, gutters, margins, trim size, folds, type widths, etc. The designer will use this grid for every page in the book, magazine, or whatever is being worked on, so that consistency is maintained. However, the grid will also be used by editors, illustrators, photographers and printers, and so it is important that the information on it is complete. The grid should not intimidate a designer; some of its restraints can be disregarded if an idea demands it.

In large jobs, such as books, grids are usually printed, but in smaller jobs pencil grids are sufficient. Whether to print the grid or not depends on the number of pages and the printing process selected. A grid, however, must always be accurate.

When a grid is going to be printed, it is good to have two types prepared: one on board and one on transparent layout paper. The board can be used for paste-ups and camera-ready copy. The transparent grid can be used for tracing or for checking the fit of illustrations, although the latter is usually done with a film grid which is more accurate than one on layout paper.

Commissioning text Text is normally the province of the editor, but occasionally the designer may have to commission words. It is the designer's responsibility to supply the writer, via the editor, with the number of

lines and the measure to which they should be typed. This saves considerable time in counting or calculating the number of words to see if they fit the grid. It also saves on cutting and resetting time and costs. Designers must beware that their specifications do not impose a rigidity either on the design or the information value of the text.

The text can be the determining factor in a design, especially when what is supplied is 'final', that is it cannot be altered or cut. But this is not usually the case. Before a design is complete the editor often has to cut, add or even rewrite to make it fit. That is why it is essential that the editor and designer work together, so that the final product works from both points of view.

Photographs These can either be specially commissioned from a photographer, or can be bought from picture agencies or museums. The latter often requires the services of a picture researcher. If commissioned, the photographer should be carefully selected; most of them specialize in a particular subject, such as fashion, food or scenic views. Some of them even specialize in certain formats. Once the photographer has been chosen he has to be briefed thoroughly, often in the presence of others who are involved, such as the client or writer.

A photographer usually charges by the day, plus expenses. Expenses cover the cost of film and developing, and the hire of a model, a person to find props, and the props themselves: sometimes the hire of a studio or travelling costs are also included. The designer has to work out what is wanted well in advance, so as not to waste the photographer's time. The designer must specify the format or size of the picture, what its subject is, whether it is in black and white or color, and what type of atmosphere or mood is wanted. The designer's presence is often required at the photography sessions to supervise them.

The designer should also specify whether transparencies or prints are wanted. Unless large format is involved, the photographer will do several shots of a subject, perhaps varying the lighting or the angle, thus giving the designer a choice of pictures.

If pictures are to be bought in, a picture researcher may be hired to find sources and do the preliminary selecting. The picture researcher works from a brief or picture list prepared by the editor and/or designer. The brief gives the number of pictures to be obtained, whether they are black and white, color or both, the subject matter, and the cost. It should also specify how much time the researcher has to obtain the material. This is particularly important if pictures from other countries are required.

The rights required for a picture are another important factor. The person who is selling or loaning the picture will want to know in what form, size and country it will appear, so that reproduction fees can be calculated. If the picture is to be used in a book, sometimes the print run will be requested. Fees are payable on publication and pictures should be returned as soon as possible after use, otherwise holding fees may be charged. These can also be charged if a selection is not made promptly, when the pictures are first borrowed.

Museums will either have the subject required on negative, in which case they will sell the print, or have to arrange for their photographic department to take it. Take care if pictures are on loan: replacement fees can be high. Picture agencies will often supply duplicate transparencies, and as they are not as sharp as the originals, they should be checked for quality.

Commissioning illustrations Like photographers, illustrators specialize in certain subjects or in a particular style. The designer must therefore choose an illustrator according to subject and style; he or she must decide, for instance, whether the subject calls for a diagrammatic, naturalistic or decorative style. Another consideration is working in color—not all illustrators specialize in this.

Illustrators will quote a figure for a job, based on an hourly rate. Because cost in this area is usually high, the designer must keep a careful eye on the quality of the work. Illustrations can cost a great deal more than photographs, and no designer can afford to accept sub-standard work. A rejection fee should be arranged before hand for work that the designer may not be able to use.

A schedule should be established so that the work is delivered on time. This should take account of time for the inevitable corrections.

The artwork is often drawn larger than the size at which it will be printed: usual sizes are half up (× 1.5) or twice up (× 2). If this is done consistently, it cuts costs at the separation stage as fewer camera shots need to be made. Also reduction can make the printed artwork look sharper and clearer. However, there are many illustrators whose technique calls for same size reproduction or enlargement. In this case they will arrange to draw their illustrations same size or smaller.

The designer should see a pencil rough before giving the illustrator the go-ahead. The final version should be on art board or paper; paper is preferable as its flexible surface makes it easier to scan at the reproduction stage.

It must be made clear from the start to whom the finished artwork belongs. Unless it is stated that the client is buying the artwork, it is assumed that the work will remain in the possession of the illustrator, who will also retain the copyright. This can cause problems if the artwork is reused. Commissioned photography, however, belongs to the company or individual who pays for it.

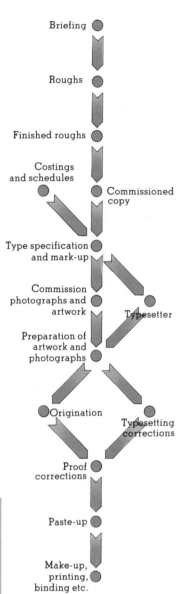

Briefing

Roughs

Finished roughs

Costings and schedules

Commissioned copy

Type specification and mark-up

Commission photographs and artwork

Typesetter

Preparation of artwork and photographs

Origination

Typesetting corrections

Proof corrections

Paste-up

Make-up, printing, binding etc.

Briefings Briefing a designer is the first stage of any job and is extremely important. At this meeting, the client and the prospective designer discuss the design and the image in general terms. The budget and schedule of the project are also discussed and finalized, and the designer will then decide if he or she is able to work within those parameters. If the designer accepts the job, he or she must take careful notes of all details which are discussed, and ask any necessary questions at the meeting. Ideally, the designer should attend the meeting with a list of questions already prepared.

Producing a design This flowchart (**above**) shows the stages in producing a piece of design work. First, the designer is briefed by the client. The designer then prepares and shows roughs to the client, before choosing a final, finished rough. A costing and a schedule are drawn up, and any copy is commissioned. The designer then chooses a typeface and marks up the copy, before sending it to the typesetter, and commissions any photographs or artwork. The illustrations are sent for origination. Finally, when any corrections have been made, the design is pasted up and the paste-up sent to the printer.

Corporate identity Almost every company wants its identity to be instantly recognizable, and large companies place great importance on this, developing what has come to be called a 'corporate identity'. This is the image which the company seeks to project in the eyes and minds of its clients or customers. The elements of this image can be extremely varied — from a logo used on a storefront, to the detailed application of an image or concept, to every aspect of the company's work. This example (**right**) is from a manual produced in 1962 by the Chrysler Corporation. It gives details on aspects of the company's corporate identity, from the paint design on a truck to the specifications of different letterheads: the design of secondary signs (**1**); the logos of automotive brands (**2**); the display of divisional names (**3**); grid patterns of brand logotypes (**4**); lawn signs (**5**); the packaging of spare parts (**6**); the design of canteen crockery (**7**); the design of trucks (**8**); the wrong ways to reproduce the logo (**9**).

21 | **Design** processes

When the artwork, photographs and text are in hand and the grids have been drawn or printed, all is ready for the designer to start. It is the designer's job to arrange these elements according to the finished roughs and mark them with instructions for the printer.

Copy preparation The first check is to see if the text fits the allotted space. If not, the editor has to make cuts or additions. Then the designer marks it up and sends it to the typesetter. The typesetter will send back a galley or page proof; he can only do the latter if the designer has supplied him with a detailed layout beforehand. The proofs are checked for misprints (known as literals) and corrections are made.

Selecting photographs While the text is being typeset, the designer can make a final selection of photographs. Photographers usually supply different exposures of the same subject (known as bracketed shots), to give the designer a choice of color density. Knowing which one is likely to be best reproduced comes with experience; however, the correct exposure usually gives the best result. A slightly underexposed original will tend to give fully saturated color.

To make sure that the color is true, the designer has to check the transparencies on a light-box at the correct color temperature. Transparencies sometimes have a color scale down one side which shows whether the transparency has kept its color over a long time. This is particularly important to know when dealing with fine art reproduction. It is also helpful to the reproduction house in matching up the separation with the original.

The designer may wish to incorporate color in a design where there are only black and white photographs at hand. This problem can be overcome by the use of the four-color process. The reproduction house can combine colors from the four-color process with black and white originals to produce one, two and three color tints, duotones and three colors or sepia. The designer simply has to specify what is wanted within the range that the four-color process provides.

Photographs should always be checked under a magnifying glass for sharpness of line and scratches. This is obviously important when using transparencies from a picture library, since these have probably been used before, or are duplicates. Damaged photographs can be retouched, but this is specialist work and the cost has to be considered. Permission from the copyright holder must always be obtained before retouching. Retouching is also used in obliterating certain parts of a photograph.

Sizing pictures In reducing or enlarging an image, the designer first has to work out the dimensions required. Then he or she draws the picture, scaled up or down, onto a transparent overlay, which is fixed to the layout over the area which the final picture will occupy. In this way the dimensions and position of the final image are communicated to the reproduction house, and any special requirements, such as cropping (cutting away part of the picture) are made clear. When using a transparency, a projector, which also enlarges and reduces the image, can be used to determine the size of the picture. It will project on to paper an image which can then be traced.

The percentage reduction or enlargement should also be calculated. If it is the same on a number of pictures, they can be put together and photographed at the same time, thus saving on cost. As the controls on reproduction cameras are marked in percentages, it also makes the job quicker. The percentage reduction should be marked on both the layout and overlay. Same size is always 100%.

There may be other specifications which the designer should make—for instance if the image is to be squared, that is, made square; or the designer may wish to use a cut out image, that is, an image with its background cut away. For this it is best to use a transparency with a light background, so that the edge of the image is not dark. The outline, too, should be fairly simple. On a black and white photograph, the unwanted areas are painted out in process white. If an image is 'cut into' another one, it means it overlaps. To do this, the originator must be given very clear instructions as to which picture is cut into which. He should also be given a layout showing how the pictures are to be positioned, with all the dimensions marked.

Preparing artwork Artwork is treated in the same way as photography in preparation for reproduction. Sometimes, however, there is a line overlay which is to be printed in another color and this has to be dealt with separately. The artwork has a film overlay put onto it; this has registration marks to indicate where it fits. Then the material to be printed in a different color is drawn or pasted onto the film.

Black and white artwork can be colored with a mechanical tint. Process colors are chosen from a printer's color chart; otherwise they can be specially mixed as long as the designer gives the specification.

The designer need only use one overlay to show all the colors needed. This must be marked with lines defining each area of color. Although this is the easiest method, it is also the most expensive. A cheaper way of doing it would be to have an overlay for each color.

Color correction Proofs of illustrations are made up in two ways—either as scatter proofs, which show the pictures at the correct size, but in random order; or the illustrations appear as they would do in the final printed version.

The most important thing to do at this stage is to correct the color by checking each picture against the original. Color correction is a matter of correcting the balance. Taking out a color is easily done by etching it out to a maximum 10% limit. The other factor affecting color is the inking of the press. The difficulty with correcting this, which can be done during print-

ing, is that all the pictures are affected.

This is also the time to check the proofs for fit, register and damage. The latter can take the form of stains, scratches or broken screens, and the illustration may have to be remade. Although the fit is more important at the printing stage, it should be marked on proof for the printer's benefit.

All the illustrations on one proof sheet are in perfect register when the color is in the correct position. When it is out of position, they are out of register. The designer should check against the registration marks on the proof, and mark the mistakes to be corrected. On the other hand, an individual illustration on a sheet showing colors that do not register indicates an incorrect fit.

It is important to make sure that the pictures have not been reversed. If they have, a new contact has to be made so that the emulsion is on the other side of the film.

Paste-up There are two types of paste-up: one which the printer simply uses as a guide, and another which is used to shoot final film, known as a camera-ready paste-up.

The first type of paste-up requires the galley proofs to be pasted in position; following this, the printer will produce page proofs, showing the text in the right position, and these can be corrected, albeit expensively.

To prepare a camera-ready paste-up, reproduction pulls called repro are used: film-setting pulls are called galley bromides, hot metal ones are barytas. Corrections, set as words or lines, are stripped into place by hand on the paste-up.

The paste-up for the text film must show the body text, captions, headlines, folios and box rules all in position. The length and thickness of the rules must be specified. It is important to be accurate here to avoid corrections, which are costly at this stage.

Both illustrations and text can be shown on the paste-up used as a guide. However, the camera-ready paste-up should only show type; pictures would have to be masked out. To stick down the type firmly, use an adhesive spray or a rubber solution. These also allow the type to be picked up and repositioned without damage. Double-sided tape can also be used.

If there is type to be printed in a different color, it should be put on an overlay. This is clearer than making specifications on the paste-up, which can also be done.

Printing The printer puts the text film together with the illustration and sends the designer a final page proof or ozalid, which is a blue-print. This shows how the final product will appear. It also provides the last chance for any correction to be made, but as this has to be done manually, it often proves too expensive to do. In very commercial work, however, pages are sometimes proofed even after the ozalid stage.

Generally, there are two checks to be made at this stage. The first is a reading check to make sure that there is no broken type and that the film is not marked. The second is a check to see that both the text and illustrations are in position.

Plates are made after the ozalids have been returned, and then the job is put on machine. The designer should be present when the printing begins to make sure that the color is correct. The inking process can be adjusted, but this has to be done right at the start, before too many sheets have been printed—and it should be remembered that presses work very fast!

Book production The production process described above is applicable to books, with the exception of a few factors. The design concept is not presented in roughs, but usually as a dummy book. A blank bulking dummy is ordered from the printer to show the size, quality of paper and binding, and number of pages of the proposed book. Sample spreads (double pages) are pasted inside the dummy to give an idea of how material will be presented in the final book. These can either show real text, headings, captions and illustrations or consist of dummy or nonsense text set in the proposed typeface with picture areas indicated. The latter would demonstrate style and the proportion of pictures to text.

Instead of pasting spreads in the dummy, it can be accompanied by presentation spreads. These are double pages made up or printed on board.

Flat plans Because books are so complex to produce, they should be carefully planned from the start. A flat plan consists of miniature pages, all numbered, which show at a glance how the book is divided into preliminary pages, chapters and endmatter, and where the color falls. The flat plan can be so detailed as to show type and sketched illustrations on every page, but this is often done for selling purposes only.

Binding Books are usually bound in sections of 16 pages, so the designer has to work in multiples of eight. He or she has to work out where the color will fall, according to how the book will be printed. It is often too expensive to have color on every page, so a 'four back two' formula may be used, where a four-color spread is followed by a two-color one. This is achieved by printing one side of the sheet in four colors and the reverse in two colors. Folding then ensures that four-color spreads are followed by two-color ones.

Jackets These are very important ingredients in selling books. A jacket must attract the eye, at the same time giving the buyer an idea of the content and quality of the book.

A jacket is first presented in rough, that is, drawn and colored by hand. It should be covered with self-adhesive film laminate to give the impression of lamination. A sample of the trade color to be used for background or type should also be provided.

1 2 3

Fitting a picture
1. Fit a transparent overlay to a picture, and then square it up.

3. This will show how much of the picture area can be fitted into the space allowed.

2. Draw a diagonal line on the layout across the area into which the picture must fit, using the overlay as a guide.

4. Any areas on the picture which are to be cropped are shaded out on the overlay. The dimensions are marked on the overlay.

Sizing This illustration (**above**) shows how artwork is often drawn twice as large ('twice-up') (**3**) or half ('half-up') (**2**) as large again, or the same size (**1**), as the required size of the finished piece.

Choosing photographs
Photographs of this subject have been commissioned from a photographer by the designer. Three different exposures have been supplied at different light settings, so that the designer can choose the appropriate one.

Selecting transparencies
Transparencies should not be chosen until they have been checked on a light box (**left**). The special magnifying glass will instantly show up any flaws or scratches on the transparency, which may make it unsuitable for use. This reproduction computer (**right**) calculates the percentage enlargement of a piece of artwork for reproduction. The numbers on the outer ring signify the size of the reproduction required, and the inner ring is the actual size of the illustration. By moving the rings until the two appropriate figures meet, the designer can determine the percentage enlargement.

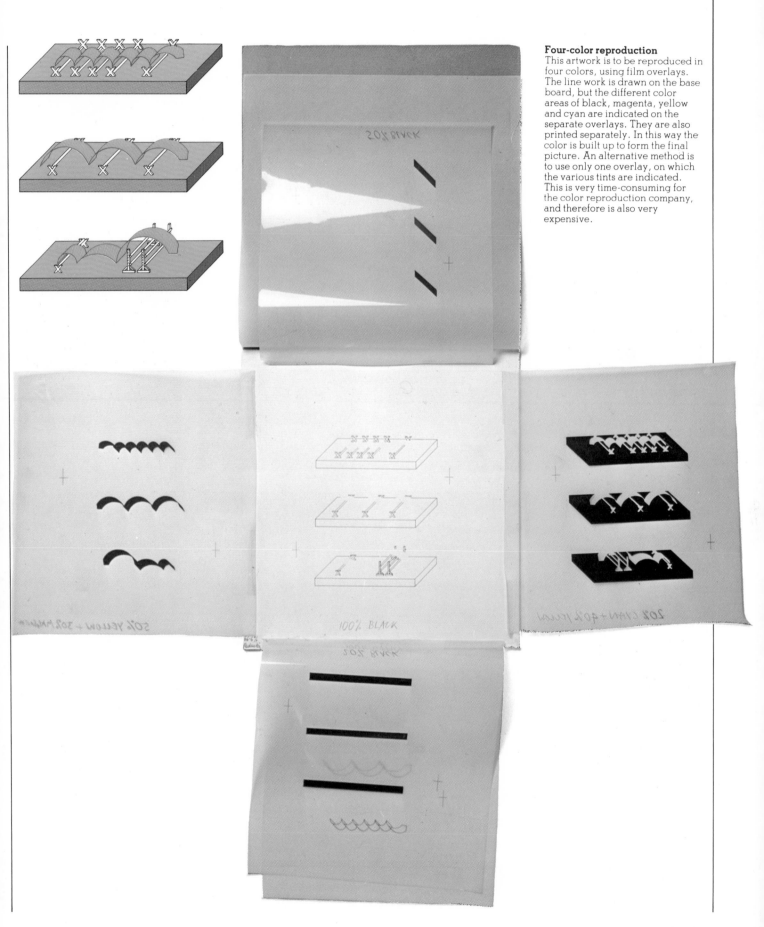

Four-color reproduction
This artwork is to be reproduced in four colors, using film overlays. The line work is drawn on the base board, but the different color areas of black, magenta, yellow and cyan are indicated on the separate overlays. They are also printed separately. In this way the color is built up to form the final picture. An alternative method is to use only one overlay, on which the various tints are indicated. This is very time-consuming for the color reproduction company, and therefore is also very expensive.

196/A BLACK AND WHITE
CUT-OUT BACKGROUND

1

Identification number
Origination instructions

Area to be reproduced

Dimensions

Area to be cut

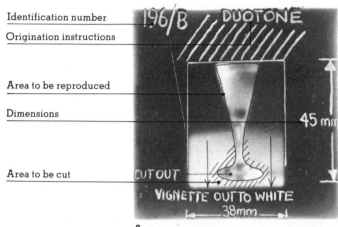

196/B DUOTONE

45 mm

CUT OUT
VIGNETTE OUT TO WHITE
38mm

3

2

4

Marking up photographs This black and white photograph (**1**) is marked up with instructions to the printer. The main image is to be cut out of the rest of the photograph and will be printed without the background. Therefore, the designer must clearly mark on the overlay the dimensions of the cut out, and must also shade, or crosshatch, the background, to indicate the areas not to be reproduced in the final picture (**2**). This color 35mm transparency (**3**) has been marked up, before being sent off for color origination. The resulting print looks like this (**4**). The smaller black and white photograph (**5**) has been cut-into the large picture (**6**), which has been overlaid with a tone.

6

5

Two-color reproduction This
piece of artwork is to be
reproduced in two colors, using
tints on the overlays. The line
drawing appears on the base
board, and the shades of the
illustration are built up using the
four overlays. This is the simplest
and cheapest way to reproduce
such illustrations.

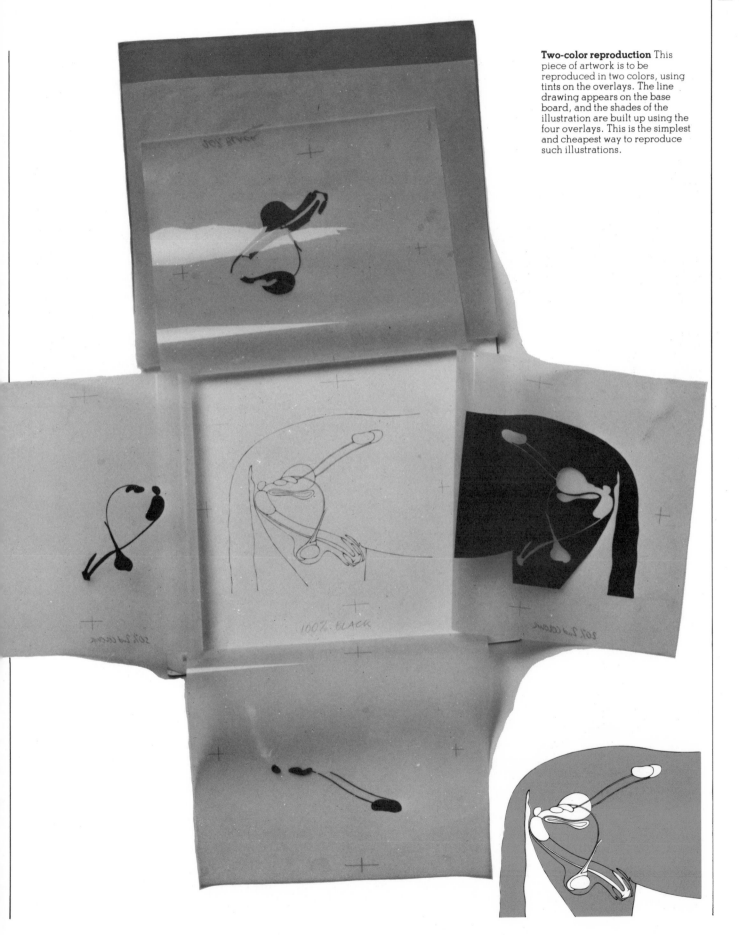

Photo-retouching Developments in technology have enabled the art of photo-retouching to be developed to a high degree of sophistication. The picture (**above**) was created from the two inserted shots. Accurate masks have to be used to blot out unwanted areas of the two shots while they are carefully superimposed.

Scatter proofs These proofs (**left**) of illustrations are printed to the correct size but in random order. They must be checked carefully, to ensure that the color is right, there are no blemishes or spots, and that they are the right size, fit and are in register. They should also be printed the right way round, because it is extremely difficult after this stage to correct a picture which has been reversed.

Grids Printed grids are used if the design job requires consistency and accuracy throughout. They are used particularly in book or leaflet design. The basic grid must show all the essential elements of the book's design, from column depths and type widths, to margins and positions of folios. Very often two types of grid are printed. Transparent grids are used for the rough paste-up, and for tracing off illustrations. Cardboard grids are used for final paste-up and are essential if camera-ready design is needed. **Below** These grids show some of the varying ways in which pages can be designed, using different column and caption widths. This spread (**1**) has a 2-column text and a 4-caption column grid. A 3-column text can have either a 3-column caption grid (**2**) or a 6-column caption grid (**3**). This 2-column text (**4**) has a ½-column caption. This means that the captions can appear in any half column on the grid.

Artist's Handbook

Trimmed page size 192 mm x 248 mm

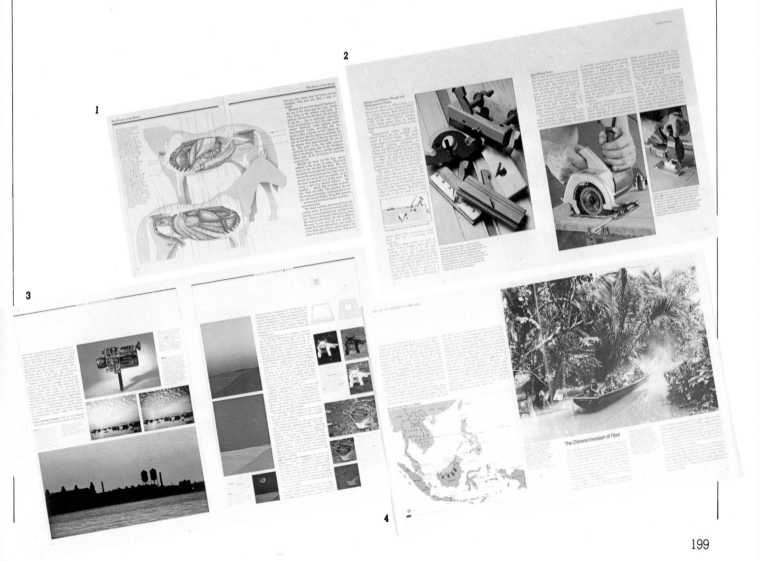

Layouts It is one of the graphic designer's jobs to mark up copy so that the printer sets it in the correct size and weight of type. It is normal for the text, captions, running heads, chapter and cross headings to be set differently. So that the printer or paste-up artist can position the pictures and text correctly, everything must be marked up carefully on the layout. A running head is the heading specifying the chapter; a cross head is a section heading within a chapter. 'Directional' is the term used to indicate the position of the illustration in relation to the caption. A box story is a special feature outside the main text, occurring within its own ruled box.

Running head

Chapter heading

Cross head

Caption

Text

Annotation

Ruled line

Box story

Photograph

Illustration

Directional

Folio number

Sport en ontspanning

Rijden

Het paard in het werk
De mens die voor het eerst paarden in het tuig leerde gaan ging het voornamelijk om snelheid, zekerheid en vurigheid en minder om de kracht. Het zware werk, voornamelijk ploegen, werd door ossen gedaan. Hun rustige, klossende gang en louter brute kracht maakten deze dieren buitengewoon geschikt voor de zware balkenploeg, die van de middeleeuwen tot de achttiende eeuw nauwelijks van vorm veranderde. Waar snelheid geen rol speelde, was de kracht van de os onovertroffen en zo waren ossenspannen, zes voor een ploeg, in vele delen van Europa tot aan de Tweede Wereldoorlog algemeen gebruikelijk. Nog een voordeel van een os was, dat hij, na zo'n vier jaar de ploeg gesleept te hebben, de zomer erop vetgemest kon worden en daarna geslacht, zodat hij voor de boer een dubbele waarde had.

Meer dan 1000 jaar lang, zowat tot aan de zeventiende eeuw, waren voor de Europese boer de meeste paarden die voor de landbouw beschikbaar waren veel te licht gebouwd om voor wat meer gebruikt te worden dan om te lopen voor lichte karren en voor eggen, hoewel ze vooral voor het laatste buitengewoon geschikt bleken te zijn. Zij schrokken niet als de eg rammelde of opsprong over harde grond of brokken zand, iets dat de os, gewend aan de zware, rustige gang van de ploeg, hysterisch zou hebben gemaakt. Maar

Rechts: de stamboom van het paard, die de ontwikkeling toont van de vele oorspronkelijke typen tot aan Equus, het hedendaagse paard. Dit proces omspant zo'n 55 miljoen jaar. Onderaan typische vindplaats van Miocene fossielen in Pakistan.

Noord-Amerika

Zuid-Amerika

Oude Wereld

Pleistoceen en tegenwoordige tijd

2 Plioceen

Eentenige paarden

5 Mioceen

Links: vier soorten hekken. De eerste twee, het hangend hek en de schuifbare balken, zijn het eenvoudigst te bevestigen en het goedkoopst. Ze worden opgetild of weggeschoven en draaien niet open. De twee andere zijn een traditioneel houten weidehek van vijf planken boven elkaar en een modern metalen hek dat tot halverwege van metaalgaas is. Metalen hekken kunnen gegalvaniseerd zijn of geverfd worden. Houten hekken worden geschilderd of met een houtbeschermingsmiddel behandeld.

Sluitingen aan hekken moeten zo geconstrueerd zijn, dat paarden ze niet kunnen openen. Drie goede sluitingsmethoden staan hier afgebeeld. Bovenaan een eenvoudige grendel met een pin die in een inkeping valt. Daaronder een grendel met een ontsluitingsmechanisme en helemaal onderaan een verende grendel met een pin die voorwaarts achter een haak blijft hangen.

Boven: het parcours van de Wereldkampioenschappen military 1978 te Lexington, Kentucky. Het was de eerste maal dat die wedstrijd in Noord-Amerika werd gehouden. De 47 deelnemers representeerden de top van de militaryruiters. Het evenement kostte vier jaar voorbe-

466

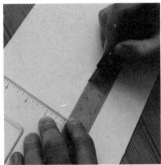

Paste up 1. Mark the positions and lines on the board and use as if on a grid.

2. Cut the type to be pasted up square, as this helps to line it up correctly on the boards.

3. Lightly spray the back of the type with a special adhesive which allows it to be repositioned if necessary.

4. Use a T-square or a parallel motion table to ensure that the type is lined up parallel.

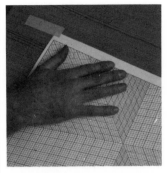

Laminating 1. Tape down the leading edges of the subject to be laminated and wipe it over to remove any lumps of glue or dirt.

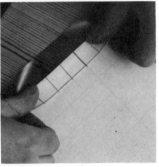

2. Cut the required amount of laminate from the roll, allowing extra for trim. Fold back the backing paper to make crease.

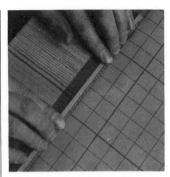

3. Place the exposed underside of the laminate over the end of the subject, with a little overlapping the edge.

4. Firmly push the laminate across the work, using a plastic straight edge. Spread the fingers to keep an even pressure on the laminate.

Types of paste-up On this rough paste-up for a book (**left**), the galley proofs and tracings of illustrations have been pasted down into position by the designer, and the editor has cut or added any lines necessary. On the camera-ready paste-up (**below**), the text, captions, running heads and folio numbers have been accurately positioned and checked. Photocopies or proofs of illustrations are pasted down in their correct positions on the overlay to act as a guide to the printer.

Preparing a dummy book jacket
1. Wrap paper around the dummy and mark folds. Then draw the outline of the jacket, including flaps.

3. Lay the tracing over the color print or base paper and position dry transfer lettering if used.

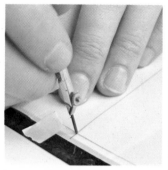

5. Make pin pricks at the corners to know where to trim and fold, and then cover the jacket with transparent self-adhesive film.

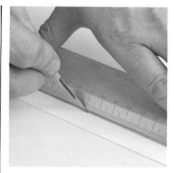

7. Carefully trim the dummy jacket to size.

2. Make a color print from the transparency or artwork which is to be used for the cover.

4. Rub down the dry transfer lettering with a blunt burnisher.

6. Score any fold lines to be made on the back of the jacket.

8. Fold the finished jacket around the dummy book.

Finished artwork This finished artwork for a book jacket includes the front and back flap copy. The text and illustrations have been pasted down onto a board in their correct positions, and directions to the printer have been marked clearly on the overlay. The finished jacket is then wrapped around a dummy book (**inset**).

Using photography.

Uses of photography: Reproducing photographs, Cameras, Films and lenses, Techniques, Effects.

When working with photography the designer has two options—to use existing photographs or instruct a photographer to produce the image which is required.

In the first case the designer will select a picture or pictures from stock in whatever photographic libraries are available; in the second it is the designer's responsibility to understand the capabilities and limitations of photography and to instruct and guide the photographer accordingly.

In design photographs are used either to provide an illustrated record or to add to or enhance an editorial or promotional concept. Success is achieved in the first case by the photographer's skill, and in the second by the co-operation between designer and photographer.

In a studio the photographer can considerably alter the visual appearance of an object by filtration, the use of scale models, illusory backgrounds and special effects, and optically within the camera.

Most studios have a sweep as a basic item of studio furniture. This is a wide roll of paper, perhaps up to 12 feet wide, in a variety of colors which can be pulled down behind and, if necessary, underneath, the subject. In some cases this will not provide a broad or deep enough expanse, when the walls themselves are used to provide a background, the angle between floor and wall being blotted out by a coving made, for example, of plastic or timber.

Neutral backgrounds are often best for small-scale work. Glassware might be photographed on a light box, or on a large glass or acrylic sheet, with the shot taken from above. Great care must be taken with light in these cases so that reflections in the supporting surfaces do not prejudice the illusion of the subject 'floating'. A similar illusion is created by fixing the subject to the backdrop with a long horizontal rod. By placing the camera on the same axis as the subject and rod, the rod will then be hidden by the subject, giving an impression of suspension.

Some subjects require a certain amount of 'doctoring' to bring out highlights, or to lessen them. An aerosol can of dulling spray produces the opposite effect to gloss varnish. A mist sprayer, such as the type used in ironing, can quickly revive a lettuce or tomato, and enhance the droplets on a cooled beer glass. Sprinkler hoses, wind machines and fog generated from dry ice (frozen carbon dioxide) can simulate different climatic effects.

Reproducing photographs

All photographs, whether color or monochrome, are subject to the limitations of the reproduction ratio. On a cinema screen 35mm film is enlarged up to 30,000%, but the distance between the viewer and the screen and the almost constant movement compensates for the degradation of the image. On a printed page, without the benefit of distance or movement, an image appears blurred at an enlargement of only 1,000%, or ten times as large. Thus in book and magazine production a typical enlargement ratio for 35mm film is between 100% (same size) and 1500%. The grain structure of film is the same regardless of film format; larger format sizes thus considerably improve the clarity of the printed reproduction.

The choice of format is largely determined by cost and definition, the larger format films being more expensive. The single-lens reflex 35mm system is by far the most popular format, producing a frame size of 24mm × 36mm. Although it may require a greater degree of enlargement than some other formats, the degree of flexibility the system offers, with a wide range of film emulsions available, enables the photographer to work at high speed. By the law of averages the designer is thus more likely to achieve the required results.

Great care should be taken with the handling of transparencies, and they should be sealed in transparent bags. Although this is true of all film, it is particularly relevant where smaller formats are concerned.

Cameras, films and lenses

Cameras using 120 rollfilm are less popular since the advent of 35mm film. The standard size is 2¼in × 2¼in; there are both single-lens reflex cameras for example the Hasselblad and twin-lens reflex such as the Mamiyaflex and Rollei systems. There are two additional formats using 120 rollfilm, 6cm × 4.5cm and 6cm × 7cm. Three other formats in current use are 4in × 5in, 7in × 5in and 8in × 10in. Although normally only used in the studio, the smallest of these was the standard for press photography before 35mm.

With these cameras, image shapes can be manipulated and depth of field controlled by the use of the built-in movement of lens and film planes. Since the film is produced in single sheets, test exposures can be made during a shooting session, an advantage over 35mm. Use of the formats also allows a scaled tracing of the composition to be taped on to the focusing screen to work to.

Most camera film is panchromatic, reacting to all colors in the visible spectrum, although not always to the same degree. The use of color filters is sometimes necessary to alter the balance of colors, as when using a yellow filter to enhance the appearance of white clouds in a clear blue sky. The yellow filter will reduce the amount of blue light reaching the film; the sky will appear darker and provide a greater contrast with the white clouds.

Another consideration in using film is that an increase in film speed will reduce the quality of the final image, while the so-called high-acutance developers used on slower films can improve apparent definition by increasing contrast locally.

An example serves to illustrate how the choice of film will be influenced by lighting, subject, the context

and degree of enlargement and the chosen format. A medium-speed film of 200ASA in a 35mm camera needs 1/125 sec at f11 under typical bright, but overcast conditions. If a greater field is required than that at f11, the lens can be stopped down to f22, but the shutter speed must be reset at 1/30 sec. At this speed subject or camera movement will blur the image. Thus, a faster film might be used at the original shutter speed, but the resulting increase in grain size may be unacceptable to the designer.

In many ways it is impossible to simulate human vision with photographic reproduction, although a normal lens for any given format is held to approximate to normal human vision. The angle of view of human vision is about 180°, compared with 45° of the normal lens. Within the larger, human field of vision our area of sharp focus cannot compare with that of the camera.

However, in comparison with a short or wide angle lens and a long focus lens, a normal lens can be seen to come closest to normal human vision. Close-up shooting with a wide-angle lens distorts the features of a face, while the apparent compression of perspective induced by extreme long-focus lenses is a regular feature of sport and wildlife photographs.

This compression is an illusion, as the image delivered to the film by a long-focus lens is simply a magnification of a small area of the scene that a normal lens delivers. The shallow depth of field of the long-focus lens highlights the subject against an invariably distorted background.

The focal length of a lens describes its magnifying properties. In the 35mm format, a 50mm or 55mm lens is normal, 28mm or 35mm is wide-angle and 90mm or 135mm is long-focus or telephoto. With larger formats these figures increase.

At either end of the scale are the specialized lenses, such as the fish-eye lens at around 6mm, or a 600mm lens, about as long as the average arm. These lenses need to be supported by a heavy tripod to avoid camera shake, but even so results are sometimes disappointing since the distance between camera and subject is usually so great that intervening atmospheric dust or heat haze degrades or distorts the image.

For extreme close-up work, when the required magnification ratio approaches 1:1 or life size, the camera lens must be moved further from the film plane than an ordinary focusing mechanism allows. Extension tubes or bellows allow ratios of up to 3:1, or three times life size.

The lens-to-subject distance is so small in these cases that great care should be taken with lighting, as the lens itself may cast a shadow on the subject, while the lens-to-film distance is so great that an exposure reading taken from the subject may need modifying to allow for the fall-off in light reaching the film. For extreme magnification, the body of the camera can be attached to a microscope.

It is the photographer's aim to keep shutter speeds as fast as possible, depending on the work undertaken. Lengthy hand-held exposures, i.e. longer than 1/30 sec, allow both camera and subject to move during the exposure, and detailed examination of some 35mm film shows that the camera itself sets up vibrations during the exposure and consequently has an effect on the sharpness of the image. These tests suggest the safe lower limit for such exposures should be set at 1/125 sec. It is not true that the noisier cameras have the worst effect in this way, as the energy of vibration is in fact expended in sound production rather than being absorbed into the camera body.

Conventional cameras have a shortest shutter speed of 1/1,000 or 1/2,000 sec, and pictures taken at this speed have a distinct frozen quality. Faster movements can be captured by electronic flash exposures. At the other end of the scale, it is the blur produced by slow shutter speeds that gives the impression of movement, such as an illustrator or cartoonist might give to the drawing of a running man.

Lighting

Lighting, both inside and outside the studio, affects a photograph more than any other variable. In daylight the photographer can control the effect of light by the use of reflectors and diffusers to alter the contrasts of light that direct sunlight will provide, although, where light is diffused in dim conditions, it is practically impossible for the photographer to achieve hard contrasts. Within the studio there are normally two types of light source, photoflood lamps and spotlights or quartz-iodine lamps. Photoflood lamps give a high level of illumination, and a relatively diffused light, which can be further softened by reflectors and screens. Spotlights and quartz-iodine lamps give a different type of light, producing hard-edged pools of light which can be concentrated on to small areas of the subject.

Additional lighting can be provided by studio flash-guns, or heads, sometimes as single units or as part of a system of up to eight heads run by a single control console. The light given off can be modified by attachments similar to those used on spotlights and photoflood lamps.

Special effects can also be achieved. For example, the ring-flash head was originally developed to aid the taking of close-ups, especially in medical photography. The lens hood of the camera is replaced by the flash tube, which encircles the lens barrel, and at close range a virtually shadow-free result can be achieved. At portrait range, with the subject placed close to a flat background, an intense rim-shadow is cast around the subject.

With all these artificial light sources, and fill-in lights of a lower intensity, it is important that they do not cast shadows of their own as they will disturb the unity of the photograph.

Photographic effects Commercial photographers may be asked by the designer to produce specific effects to fit the concept of the design. For fashion work in particular the photographer must be able to achieve specific effects (**1**). This shot uses dramatic lighting to emphasize the graceful pose of the model. A close-up shot can give a new perspective to an everyday object, as in this photograph of banknotes (**2**), which brings out the patterns on the note and draws attention to the wording. Photographing a skyline at night (**3**) is another way of adding drama to an otherwise ordinary shot of buildings.

Photographing large objects If a designer briefs a photographer to take a shot of a large object, such as this plane in a hanger (**4**), it is up to the photographer to try to add interest and contrast to the shot. A simple photograph of the plane and its surroundings gives a rather cluttered and untidy impression. Two ways of taking the shot in a more interesting way are, firstly, to use a wide-angle lens. Here the background is used to reflect light, so that the plane itself appears almost as a silhouette in the foreground (**6**). Secondly, using a long lens and blocking out the background can achieve the opposite effect (**5**) with the plane's nose emerging from a darkened background.

5 x 4

35mm

2¼ x 2¼

35mm 1000%

2¼ x 2¼ 600%

5 x 4 300%

Film size and enlargements
These photographs of the same subject were taken with films which produce different image sizes: 5in x 4in , 35mm , 2¼in x 2¼in . In much design work, originals have to be enlarged, and the degree of enlargement affects the clarity of the resulting image. The 35mm image was enlarged 1000% , the 2¼in x 2¼in by 600% , and the 5in x 4in by 300% . The quality of the enlargement varies because the grain structure remains the same, regardless of the size of the film. This means that the 35mm enlargement is the least clear and the 5in × 4in is clearest. On the 35mm enlargement, the grain can be seen.

1 2

3 4

Color films The colors which are obtained from different makes of color film vary considerably. The Agfacolor film (**1**) produces strong colors with gray tones appearing almost blue-green. Sharp colors contrasts can be achieved with the Fujicolor film (**2**).

Kodachrome (**3**) gives fairly good color contrast with a slight red bias, while Ektachrome (**4**) produces cooler colors with a blue bias. It is important for the designer, when briefing the photographer, to bear in mind the varied results which makes of film may give.

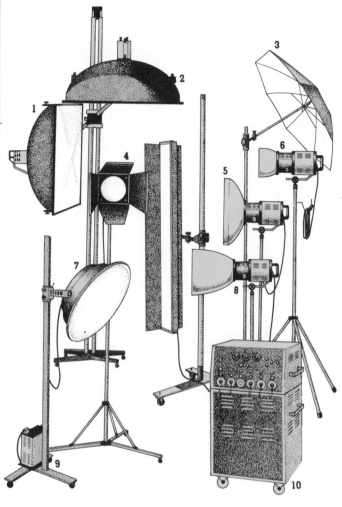

Motor drive A motor drive is a useful attachment for taking several shots in a short space of time so a motor drive is used mainly for taking action shots such as this sequence with a motor bike (**below**). A motor drive can either be used to take a continuous number of exposures, as in this sequence, or to wind on the film automatically after each shot. If the device is set for continuous exposure, the photographer only has to keep the shutter depressed and the camera will operate automatically.

Lighting Good lighting is an essential for all types of photography, whether inside or out of doors. Most photographers will have their own range of equipment, which will normally include a standard reflector (**6**), narrow angle reflector (**8**), soft light (**5**), hazy light (**2**) and reflector (**1**), rondo light (**7**), light with adjustable barn doors (**4**). Also useful are an umbrella (**3**) to diffuse the light and a power pack (**9**, **10**) for the electricity.

Lenses The size of image produced with different lenses varies greatly. These images (**below**) show the comparative size of image as taken with lenses ranging from a 1.5mm to 800mm. The assumption is that the subject and the photographer remain static, the only variable being the size of the lens. It is important to remember that the depth of field becomes shallower with a lens of a longer focal length and that some very wide-angle lenses themselves introduce distortion at the corners and edges of the picture.

| 1·5mm | 50mm | 105mm | 200mm | 400mm | 800mm |

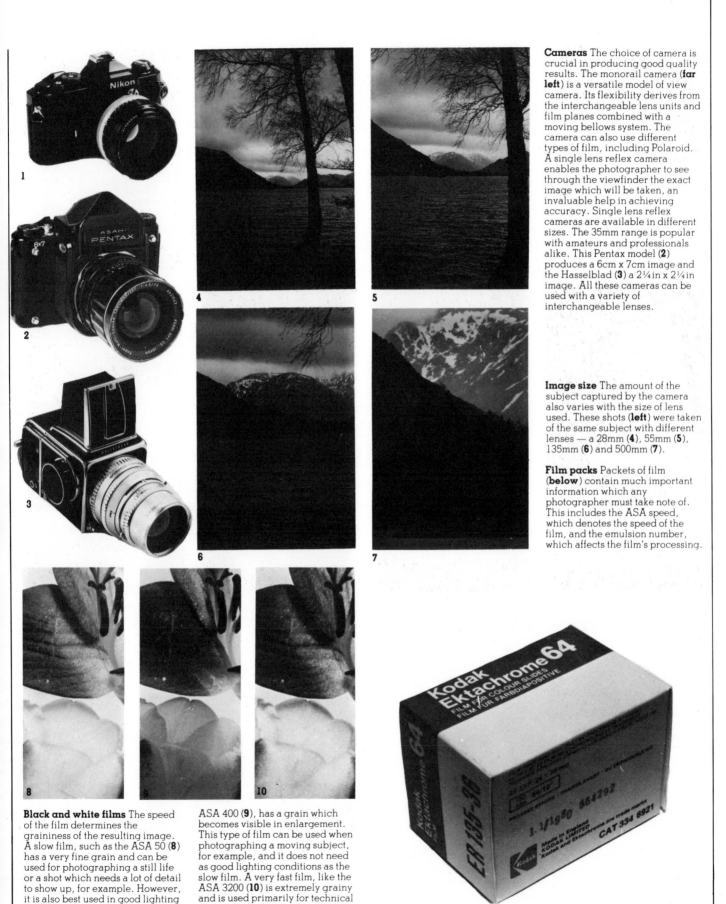

Cameras The choice of camera is crucial in producing good quality results. The monorail camera (**far left**) is a versatile model of view camera. Its flexibility derives from the interchangeable lens units and film planes combined with a moving bellows system. The camera can also use different types of film, including Polaroid. A single lens reflex camera enables the photographer to see through the viewfinder the exact image which will be taken, an invaluable help in achieving accuracy. Single lens reflex cameras are available in different sizes. The 35mm range is popular with amateurs and professionals alike. This Pentax model (**2**) produces a 6cm x 7cm image and the Hasselblad (**3**) a 2¼in x 2¼in image. All these cameras can be used with a variety of interchangeable lenses.

Image size The amount of the subject captured by the camera also varies with the size of lens used. These shots (**left**) were taken of the same subject with different lenses — a 28mm (**4**), 55mm (**5**), 135mm (**6**) and 500mm (**7**).

Film packs Packets of film (**below**) contain much important information which any photographer must take note of. This includes the ASA speed, which denotes the speed of the film, and the emulsion number, which affects the film's processing.

Black and white films The speed of the film determines the graininess of the resulting image. A slow film, such as the ASA 50 (**8**) has a very fine grain and can be used for photographing a still life or a shot which needs a lot of detail to show up, for example. However, it is also best used in good lighting conditions. A fast film, such as the ASA 400 (**9**), has a grain which becomes visible in enlargement. This type of film can be used when photographing a moving subject, for example, and it does not need as good lighting conditions as the slow film. A very fast film, like the ASA 3200 (**10**) is extremely grainy and is used primarily for technical or scientific subjects.

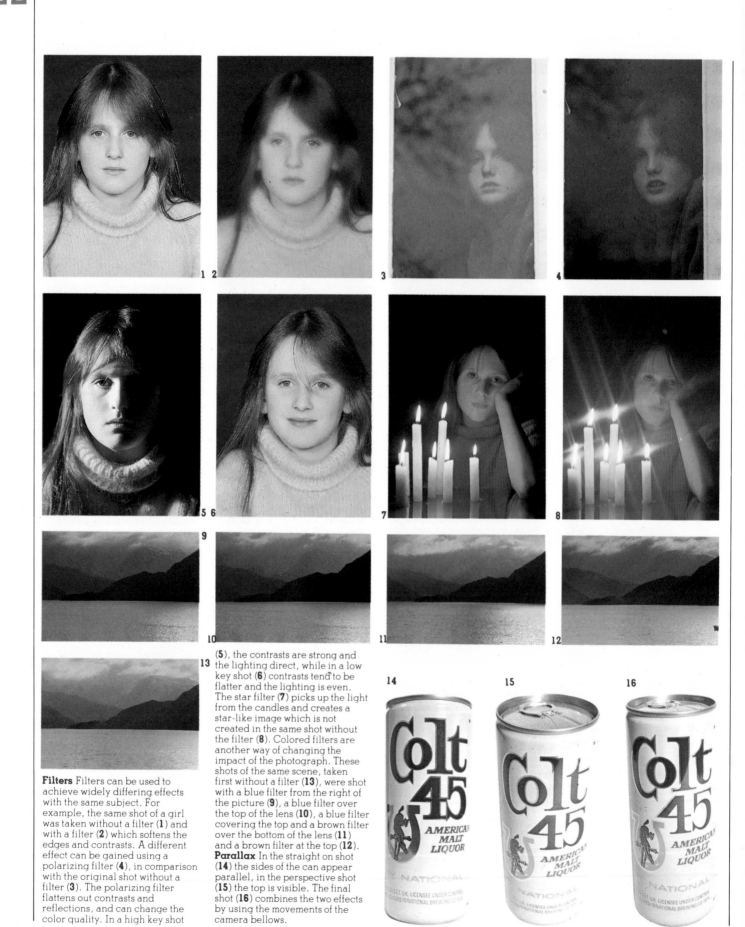

Filters Filters can be used to achieve widely differing effects with the same subject. For example, the same shot of a girl was taken without a filter (**1**) and with a filter (**2**) which softens the edges and contrasts. A different effect can be gained using a polarizing filter (**4**), in comparison with the original shot without a filter (**3**). The polarizing filter flattens out contrasts and reflections, and can change the color quality. In a high key shot (**5**), the contrasts are strong and the lighting direct, while in a low key shot (**6**) contrasts tend to be flatter and the lighting is even. The star filter (**7**) picks up the light from the candles and creates a star-like image which is not created in the same shot without the filter (**8**). Colored filters are another way of changing the impact of the photograph. These shots of the same scene, taken first without a filter (**13**), were shot with a blue filter from the right of the picture (**9**), a blue filter over the top of the lens (**10**), a blue filter covering the top and a brown filter over the bottom of the lens (**11**) and a brown filter at the top (**12**).

Parallax In the straight on shot (**14**) the sides of the can appear parallel, in the perspective shot (**15**) the top is visible. The final shot (**16**) combines the two effects by using the movements of the camera bellows.

Reproduction processes.

Methods and techniques: Process camera, Dot screen ratios, Color separation, Line negatives, Color correction, Screening halftone separations, Transparency quality.

Process camera

Development of the process camera has made possible the precise reproduction of artwork in both black and white and comprehensive color. Pictures, photographs, design, and type can all be reproduced accurately through a variety of printing processes.

There are two types of process camera—the vertical and the horizontal. Both do the same job. They produce finished artwork negatives that can be used for making blocks or plates for printing. The only difference between them is that the horizontal camera can produce from larger originals than the 600mm by 900mm maximum of the vertical models.

The process camera takes a photograph of the artwork under brilliant artificial light and controlled exposure, which gives precise definition to the film. The camera can make reproductions for both types of block printing, line and tone.

Dot screen ratios

Variations of light and shade in a photograph or painting can be reproduced in the printing processes only by breaking up the picture into tiny dots. Ink has a consistent color weight that shows no gradation of tone. This can be achieved only by converting the negative in the process camera into a series of tiny dots too small for the eye to see.

The process is carried out by a half-tone screen, which is made of two plate-glass sheets each etched with black parallel lines. By placing the sheets together at right angles and laying them 1mm or 2mm above the artwork to be photographed, a picture can be reproduced on the negative which is entirely made up of dots. Each dot reflects the degree of light in its own particular section of the artwork.

The network, of course, shows the exact reverse of what the finished print will look like. In a half-tone print, the darker areas will consist of lots of heavy dots crowded together. Light patches consist of fewer, smaller dots. Gray or shaded areas have dots of different sizes.

Screen levels vary and most are too small to be seen by the naked eye. The mass of color in the final print shows up only as a gradating tone. For normal graphic reproduction, the screens have between 22 and 70 lines to a centimeter, and these can be detected in the finished work only with a powerful magnifier. The coarser screens, such as those used in newspaper reproductions, have 22 to 29 lines per centimeter, although up to 40 lines are normal when printing on web offset. These screens are fine enough to give good reproduction on low quality paper such as newsprint.

The screen for litho plate printing is usually between 48 and 53 lines per centimeter and this gives excellent reproduction. Quality of paper surface has less importance in litho printing, because the print is taken from a rubber blanket. Very fine screens leave no margin for error in the etching process, and using extra-sensitive plates can be more expensive than using coarser screen.

For very fine quality reproduction with both litho and letterpress printing, a 60-line screen can be used. A vignetted screen gives dots on the finished plate which fade away towards their edges. The negatives are produced by filming the artwork through a contact screen with a line mesh of between 20 and 100 to the centimeter. Vignette screen can be used for monochrome or full color reproduction. It blurs the gray and shaded areas of the artwork even more than half-tone screen and is ideal for the reproduction of watercolor or fine art printings. The principles of photo-processing and etching for vignette screen are the same as for half-tone screen, but a vacuum-backed camera is essential for quality results.

Color separation

Complex color painting or artwork cannot be printed in a single process. The color has to be broken down into its basic, primary components and the reproduction made from four separate color printings.

The process can be used for line or tone plates in conjunction with any of the principle printing techniques—letterpress, litho, screen or gravure.

The artwork is filmed on the process camera through a combination of filters and on to a panchromatic emulsion in order to 'lose' a particular color on each separate negative. The color that is lost on the negative is the one that will be printed from it when the negative has been converted into a plate.

The object in color separation is to produce four plates: one to print the yellow parts of the artwork; one to print the magenta; one for the cyan; and one for the black. Yellow, magenta and cyan are the basic color printing inks. Black can never be lost from a negative whatever combination of filter is used. In half-tone printing, black provides the under color and gives tones and gradation to the color areas.

To separate the yellow component of an artwork it is necessary to photograph the work using a blue-violet filter, which will absorb all the light reflected from all the yellow parts of the original, even where the yellow is only a component of a color, such as in green. With the yellow light eliminated, the corresponding areas of the negative will appear black and will not be recorded by the photographic emulsion. This is the part which will print from the etched plate. To produce a negative that will print magenta, the original must be photographed through a green filter; and for the cyan negative, it must be photographed through a red filter. The black negative is produced by using no filter at all, or by using a combination of blue-violet, green and red. Choice will depend on the color bias of the artwork.

For half-tone reproductions, the screen can be introduced at the separation stage and this is called the direct method. In the indirect method, the screen

is not introduced until the color correction stage.

Line negatives

Color separation process is the same for line printing, but no screen is introduced at any stage. The color prints solid, but this does not restrict the printer to the basic colors of yellow, magenta and cyan. By overlapping solid colors a wide range of tone can be achieved. Even the shades can be varied by using, say, different tints of yellow and cyan to produce different shades of green.

There is no limit to the range of colors that can be produced by separation for line or tone-printing, but separation of some shades and tones is complicated and expensive. Artwork prepared specially for line printing from color separations is best done with trichromatic colors which match printing ink colors.

Color separation techniques can be used for printing reproduction of such difficult subjects as delicate watercolor paintings, but, even where special inks are used to attain the accurate tints, some degree of color correction in the negatives is usually necessary.

Color correction

Imperfections in printing inks make it impossible to produce perfect color reproductions without some color correction. There are two basic ways to correct color and both methods can be used at the negative or positive stage of the process. One is by the use of skilled hand retouching, the other by photographic masking.

The aim in both cases is the same: to increase or reduce density in a certain area of the negative or plate. Organic dyes of differing strengths are applied by hand to the areas where density is to be increased, or color reducers are laid over the areas where density is too great in the negative. This technique requires great skill.

Unwanted color lying under the black printing areas is removed by a method known as UCR, or undercolor removal. This is important because black cannot be filtered away. Unless UCR masking techniques are applied every color beneath the black printing areas is retained.

There is no need for UCR in slow printing processes, in which each color is left to dry before the next color is applied. In such cases, the only value from UCR is in the amount of ink which can be saved.

Fast printing processes on modern machinery make UCR essential in many color reproductions, or considerable layers of unwanted and unnecessary ink are left underlying the black areas. These color areas can be removed by photographic masking. The mask is produced from the black separation negative or positive and superimposed upon the respective color separation negative or positive.

Screening half-tone separations

The angle of the screen through which each separated color is photographed for half-tone separations must be varied, or the half-tone images will clash, producing a color which will not only be untrue, but often ugly. Unpleasant, periodic pattern waves called *moiré* are also produced when half-tone separations exactly overlap. Angle variation is normally 30 degrees, but this angle can be adjusted to suit the subject being photographed. The result of the altered angle is to produce dots that do not clash, but form instead small rosette patterns which can be clearly seen under a magnifying glass.

Transparency quality

Always use color transparencies for half-tone separations; they alone will give the best results. Even so, avoid transparencies from photographs with textured surfaces. These will always produce sub-standard reproductions. So will any original which has an overlying color bias. It is possible to increase tone in an original that lacks contrast, but do not expect a perfect result from the end product.

Most printing firms lay down strict reproduction requirements. Color transparencies should meet the following four requirements. There should be a moderate range of density; detail should be clearly shown in both shadows and highlights; thirdly, color balance should be neutral with no single color dominating; and finally, there should be sufficient definition of image to stand up to considerable enlargement.

Electronic scanner The electronic scanner is a major technological advance on the process camera. The scanner can perform all the screening processes hitherto carried out by the process camera much faster than with the older methods. Scanners can work with both color reflection originals and have a steplessly variable enlargement ratio. The four-color separations made by the scanner are of very high quality. The scanner is made up of two interconnected rotating drums linked to a color control panel.

Color chart This printer's color chart (**right**) indicates the color values which result when different percentages of the three process colors — yellow, magenta and cyan — are used. A more complex chart could add black to the combinations illustrated. Such charts are very difficult to produce because each color has to be stripped|in individually; this means that they are also expensive. However, a color chart is invaluable in determining color components or selecting tints.

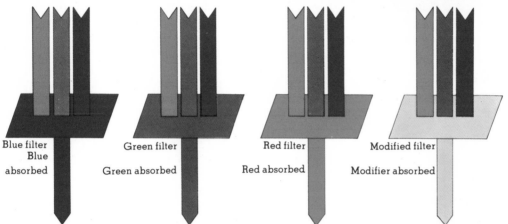

Blue filter
Blue absorbed

Green filter
Green absorbed

Red filter
Red absorbed

Modified filter
Modifier absorbed

Color separation Four-color printing uses the basic colors yellow, magenta, cyan and black in varying combinations to reproduce the full color range of the original. The color printing process is based on the color components of light (**above right**) which divide into the 'additive' primaries (red, green and blue) which, when added together, make white; and the 'subtractive primaries' (yellow, magenta and cyan) which are the colors which result when one of the additive primaries is removed. For example, combining red and green without blue gives yellow. The diagram (**left**) illustrates which colors are absorbed when a filter of each of the additive primaries is used. When the blue filter is used, blue is absorbed and red and green reflected, so the color printed is yellow. When a green filter is used, green is absorbed by the filter, red and blue reflected and magenta printed. If a red filter is used green and blue are reflected, red absorbed cyan printed. To add black, a modified filter is used, which absorbs its own color and prints black. In the separation process the original is photographed four times, once with each filter, to produce the separation negatives which are proofed in the individual colors (**middle row**). The separation negatives are then rephotographed through a special screen, combining the colors so that the full color reproduction results (**bottom row**).

Yellow printer

Magenta printer

Cyan printer

Black printer

Yellow proof

Magenta proof

Cyan proof

Black proof

Yellow proof

Yellow plus magenta

Yellow, magenta plus cyan

Yellow, magenta, cyan plus black

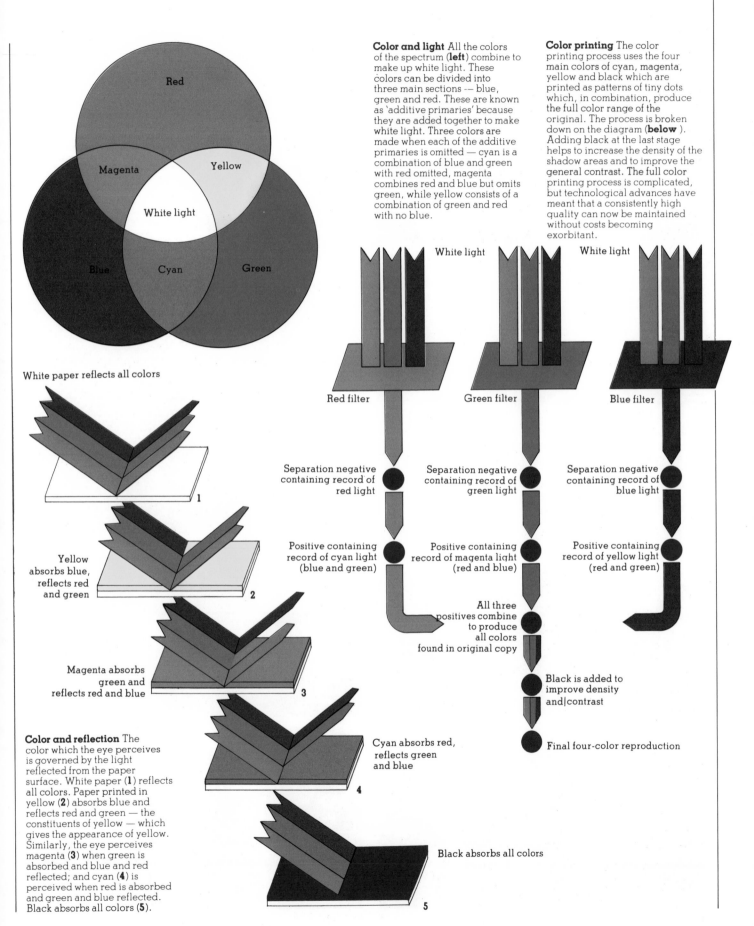

Color and light All the colors of the spectrum (**left**) combine to make up white light. These colors can be divided into three main sections –— blue, green and red. These are known as 'additive primaries' because they are added together to make white light. Three colors are made when each of the additive primaries is omitted — cyan is a combination of blue and green with red omitted, magenta combines red and blue but omits green, while yellow consists of a combination of green and red with no blue.

Color printing The color printing process uses the four main colors of cyan, magenta, yellow and black which are printed as patterns of tiny dots which, in combination, produce the full color range of the original. The process is broken down on the diagram (**below**). Adding black at the last stage helps to increase the density of the shadow areas and to improve the general contrast. The full color printing process is complicated, but technological advances have meant that a consistently high quality can now be maintained without costs becoming exorbitant.

Red

Magenta Yellow

White light

Blue Cyan Green

White paper reflects all colors

Yellow absorbs blue, reflects red and green

Magenta absorbs green and reflects red and blue

Color and reflection The color which the eye perceives is governed by the light reflected from the paper surface. White paper (**1**) reflects all colors. Paper printed in yellow (**2**) absorbs blue and reflects red and green — the constituents of yellow — which gives the appearance of yellow. Similarly, the eye perceives magenta (**3**) when green is absorbed and blue and red reflected; and cyan (**4**) is perceived when red is absorbed and green and blue reflected. Black absorbs all colors (**5**).

Cyan absorbs red, reflects green and blue

Black absorbs all colors

White light White light

Red filter Green filter Blue filter

Separation negative containing record of red light

Separation negative containing record of green light

Separation negative containing record of blue light

Positive containing record of cyan light (blue and green)

Positive containing record of magenta light (red and blue)

Positive containing record of yellow light (red and green)

All three positives combine to produce all colors found in original copy

Black is added to improve density and|contrast

Final four-color reproduction

1

2

3

Reproduced halftones If a halftone which has been reproduced using a screen (**4**) is enlarged the dot pattern becomes clearly visible (**5**). This shows an enlarged 100 screen dot pattern. If a further enlargement is made, the difference between the dark and light appearing areas can be seen. The dark area (**2**) consists of white dots on a dark background, while the light area (**3**) has black dots and a white background.

Screens A screen must always be used in reproducing a halftone original. The screen is a glass sheet which is engraved with lines which breaks the continuous tone into separate units in a regular pattern. The original is photographed through the screen. The enlarged portion of the screen (**1**) shows that the distance between the lines is equal to the width of the lines themselves. This is a '100 screen', there are 100 lines per inch on the screen. A 55 screen (**6**), with 55 lines per inch, is suitable for producing posters. An 85 screen (**8**) can be used with good quality rotary newsprint. For the best quality of coated papers, it is best to use a 133 screen (**9**). The screen is normally placed so the lines run at 45 degrees to the horizontal. However, the screen can be at any angle, this picture shows the results of setting a 65 screen at 90 degrees (**7**).

4

5

6

7

8

9

Tints A range of effects can be achieved by combining tints of varying strengths from 10% to 100%. Tints are used in the reproduction of black and white, line or continuous tone copy. On a pale tint it is best to use positive type and on a dark tint reverse type is best. Similar effects can be achieved when color tints are combined with black and white halftones. The halftone is in shades of black and white. The second color halftone appears in shades of the second color and white, while the combined tint and black and white halftone appears in shades of black and color.

Black and white halftone

Second color halftone

Second color tint over black and white halftone

20% color/10% black

20% color/30% black

20% color/70% black

50% color/10% black

50% color/30% black

50% color/70% black

100% color/10% black

100% color/30% black

100% color/70% black

Pantone color and black selector The internationally recognized Pantone color system uses eight basic colors, black and white. The selector shows 90 shades of these colors. Using the selector, the designer can choose the color desired and specify it to the printer using a reference number.

Duotone A duotone is a two-color halftone made from a black and white original. The original is photographed twice. The first produces a black halftone, the second gives the middle tones in the second color. The two are combined in varying percentages such as 40%, 60%, and full value.

Black halftone

40% color halftone over black

60% color halftone over black

Full value color halftone over black

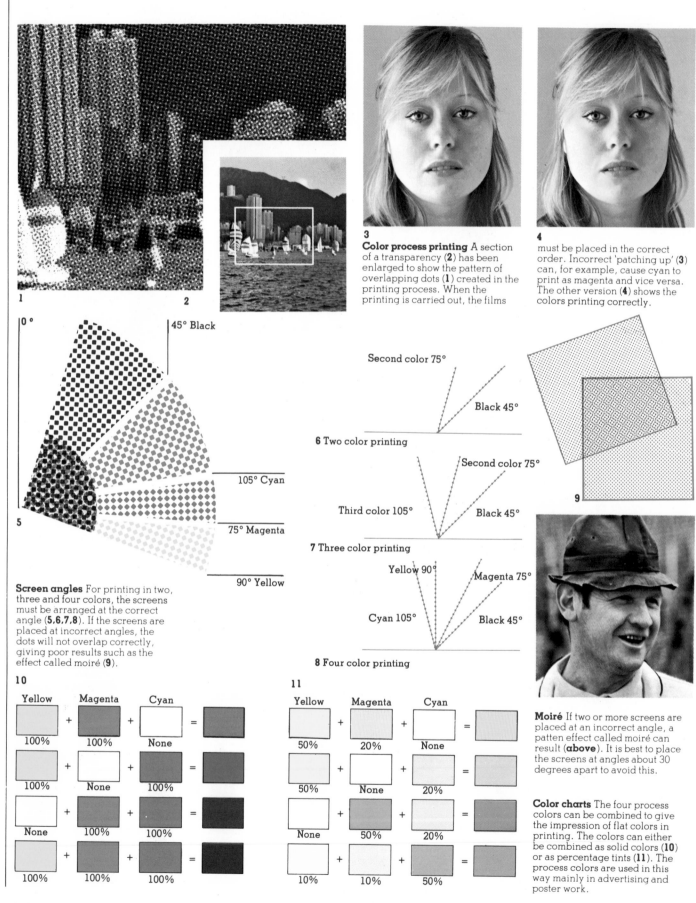

3 **Color process printing** A section of a transparency (**2**) has been enlarged to show the pattern of overlapping dots (**1**) created in the printing process. When the printing is carried out, the films

4 must be placed in the correct order. Incorrect 'patching up' (**3**) can, for example, cause cyan to print as magenta and vice versa. The other version (**4**) shows the colors printing correctly.

0°

45° Black

105° Cyan

75° Magenta

90° Yellow

5

Screen angles For printing in two, three and four colors, the screens must be arranged at the correct angle (**5,6,7,8**). If the screens are placed at incorrect angles, the dots will not overlap correctly, giving poor results such as the effect called moiré (**9**).

Second color 75°

Black 45°

6 Two color printing

Second color 75°

Third color 105°

Black 45°

7 Three color printing

Yellow 90°

Magenta 75°

Cyan 105°

Black 45°

8 Four color printing

9

Moiré If two or more screens are placed at an incorrect angle, a pattern effect called moiré can result (**above**). It is best to place the screens at angles about 30 degrees apart to avoid this.

Color charts The four process colors can be combined to give the impression of flat colors in printing. The colors can either be combined as solid colors (**10**) or as percentage tints (**11**). The process colors are used in this way mainly in advertising and poster work.

10

Yellow	Magenta	Cyan	
100%	100%	None	=
100%	None	100%	=
None	100%	100%	=
100%	100%	100%	=

11

Yellow	Magenta	Cyan	
50%	20%	None	=
50%	None	20%	=
None	50%	20%	=
10%	10%	50%	=

Printing processes.

Methods and techniques: Letterpress, Lithography, Gravure, Screen printing, Offset duplicator, Books, Pagination, Folding, Stitching and binding, Translations.

S everal printing processes are available to the artist or designer who needs more than one copy of a finished work. These range from simple sheet-fed, flat-bed letterpress printers still based on the principles applied by the German Johann Gutenberg (1398–1468) when he first printed the Bible in 1450, to the sophisticated oil-and-water techniques of rotary run, web-offset litho.

Study the section on reproduction processes before deciding which method is best suited to your finished work. Take into account the number of copies required—a handful of moderately good quality copies, black and white or in color, can be run off quickly on instant copy machines using photographic techniques. Where fine quality prints or multiple copies are required, a litho process on high-speed rotary printing may be better.

Letterpress

All processes in which the printing is done from a raised surface, either from type or from a plate, is known as letterpress printing. This is the oldest method of printing. Ink is rolled on to a raised surface and this is brought into contact with the paper.

The Chinese practised this technique, using wood blocks, more than 1,000 years ago. Gutenberg around 1450 was the first to cast type into words and print from them. This method is still used where type predominates, but today the printing surface can be type, or a plate produced by photoengraving.

Pictures are made into half-tone plates, which are locked into a forme with the type. A relief plate is made from the forme, and this is etched or cast in a mold before printing. Some modern methods use thermoplastic material for the printing plates. These are flexible and can be wrapped around the cylinders of a rotary press for rapid printing processes.

Artwork, designs, posters news-sheets and magazines, using mainly type with half-tone illustrations, can be run off on sheet-fed, flat-bed letterpress printing machines, or on rotary presses when there is a big print run.

The type and half-tone plates are laid out to design inside a metal forme, spaced out with lead spacing and rules and borders known as furniture, then locked tightly together.

In the simplest sheet-fed presses, the forme, as it is called, is laid out on the flat-bed and a direct impression taken from it on to the paper. In the oldest technique, used in the platen press, the forme is held vertically and a plate holding the paper is pressed on to it. In other, faster, flat-bed machines, the forme is held horizontally, and the rollers ink the type, then press the sheets down on to it. Two or three color printing is achieved by repeat processes.

For rotary press printing, a *papier mâché* imprint, known as a flong, is taken from the forme. This is used to cast a curved metal plate, which is subsequently clamped or magnetized to cylinders on the press. By feeding a roll of paper into the machine, a continuous process is achieved with one imprint for each revolution of the cylinders. This method is ideal for the long, high-speed runs necessary for newspapers and magazine printing.

In long-run commercial projects, a number of rotary units can be linked together and the paper fed through continuously, so that three and four color printing can be done almost simultaneously. Careful control of ink and color and consistency is vital as all colors are printed wet within seconds of each other. Some machines are capable of printing up to 500ft of paper in 60 seconds. Sheet-fed rotary presses can make up to 6,000 imprints in an hour. These machines are slower than web-offset, but eliminate the cutting process.

Lithography

This is now the most common printing process in use for a vast range of printing from small office duplicators to the large-scale production of newspapers and magazines. It differs entirely from letterpress in that there is no raised printing surface. The process is based on the principle that grease and water do not mix. Image areas are made to attract ink and non-image areas to repel it.

The litho process was first invented by a German typographer, Alois Senefelder, at the start of the nineteenth century. Originally the printing surface was made by drawing onto a polished stone surface, usually limestone, with a greasy crayon. This gave the process its name, from the Greek word *lithos*, meaning stone, and *graphe*, meaning drawing.

Only with the development of high-speed rotary printing and new alloys in recent years has lithography come into its own as the major printing process. Litho plates are now made of a variety of materials, all thin and fairly strong, such as zinc, aluminium, plastic, paper, copper, and chromium. Before each impression, the plate has to be dampened, then inked. Non-image areas are coated with glue to prevent the ink fixing there. The most popular material for litho plates is aluminium, which is strong, light and economic to use.

Complex color designs and artwork can be excellently reproduced by offset litho printing. Litho inks are grease or fat based—both of which are repelled by water. In the reproduction process, described in the previous chapter, plates are produced which attract ink to the image areas, and repel it from the non-image areas.

The plates are then fitted to the cylinders of a rotary press. A dampening roller applies a solution of water, gum arabic and acid to the plate. A second roller applies ink. Water, clinging to the non-image areas, repels the ink. The imprint is taken by a rubber offset sheet, which finally reproduces the whole design in ink on the paper. The offset rubber sheet is used to

protect the delicate surface of the plate from abrasion by the paper. Offset litho machines are available as small office duplicators or as machines large and complex enough to produce a complete book in full color.

Gravure

This is the reverse of the letterpress printing process—the imprint is not made from a raised surface but by a pattern of small cells recessed into the printing surface to different depths. Each cell is filled with ink, which is then transferred to the paper. Because the cells can be of varying size and depth, variable amounts of ink are transferred to the paper. Depth of the intaglio cells varies from 0.0001mm to 0.4mm in the shaded areas. Considerable depth of tone and color gradation is possible within these limits.

Very good color printing results can be obtained with gravure printing, and it is used successfully for a wide variety of reproduction, from newsprint to fine art, for magazines and packaging, floor tiles, wallpaper and decorative laminates.

Three main sorts of cell structure are used in the process. In the first, cells of equal area are cut to differing depths. The second is inert half-tone gravure, in which both the depth and area vary. The third is electro-mechanical engraving, in which a diamond stylus engraving head, operated by an electro-scanner, cuts out pyramids of varying depth and area. In some processes a laser beam is used instead of a diamond stylus.

Gravure is an expensive, but high-speed process used largely for commercial projects. Artwork or designs are etched on to cylindrical copper plates for gravure printing. Carbon tissue, a sensitive gelatin transfer medium, hardens on the cylinder when exposed to light. Ferric chloride is used to etch the image—the depth depending on the thickness of the hardened gelatin. Fine grading can be achieved, and the technique leaves an image etched below the copper surface, and it is this that retains the ink. The etched cylinders are locked into a gravure rotary printer beneath an impression cylinder. This has a hard rubber surface which forces the paper down on to the etched cylinder, leaving an inked imprint.

Gravure is commonly used for packaging, advertising, and some magazine printing. It is also widely used on textiles, cellophane wrappers and vinyl wallpapers, floor tiles and postage stamps.

Screen printing

The use of photographic stencils and developments in ink technology has made screen printing one of the lowest cost methods of reproduction. Printing from stencils is the oldest known form of reproduction, and prehistoric cave dwellers used the principle to decorate cave walls in Gargas, Southern France. They left behind centuries-old hand prints, made by outlining the hand with color. Even the printers of the Gutenberg bible, which was printed by letterpress, used stencils to guide their color outlines.

In screen printing, stencils are held in place by a tightly-stretched piece of nylon, organdie or metal mesh, or a piece of weave silk—the method which gave screen printing its common name of silkscreen.

Knife-cut stencils are used in screen reproductions, usually for artwork that has been hand-drawn, but most screen printing today is now done with photo-stencils. These are reproduced on plastic-backed, highly transparent film, which can resist certain inks.

The photo-stencil can be produced by direct or indirect photographic methods. Direct photostencils are made when a screen mesh, coated with light-sensitive emulsion, is laid in direct contact with the artwork. Emulsion is hardened by light in the non-image areas and the image details are washed out with water. Indirect photostencils have to be exposed, washed out, then developed before the stencil is fixed to the screen.

Screen printing can be used on long, high-speed runs, and gives good color reproduction. It is excellent for designs and hand-drawn artwork.

Offset duplicator

Small accurate copying machines are now common office equipment and are adequate for the reproduction of limited circulation material where sophisticated finished results are not essential.

Pre-sensitized plates of paper, aluminium or plastic are coated with light-sensitive material. These take photographic images of prepared positive or negative copies. These are used to print single-tone reproductions. This system is ideal and inexpensive for sales lists, meeting agendas and factory forms, or wide circulation memos.

Books

The flat-bed cylinder press on which an impression is taken by a roller pressing paper down on to a horizontally held forme is the most common method used for book printing. The paper is turned over for a second printing. Color books can be produced by running the paper through two or more units. Sheet-fed and web-fed processes are both used.

Fine art books, in which high-color reproduction is required, are better produced on rotary gravure presses. The system is more expensive, but essential for top quality results.

Pagination

When printed paper has to be folded and then cut after impression, pagination is critical. Each page must be positioned correctly in the flat-bed forme or on the rotary cylinder before printing begins, and this applies equally to sheet-fed or web-fed presses.

Placing the pages in correct position is known as

imposition. To work out the page planning on a flat-bed forme, printing a simple four-leaf sheet, take a sample sheet and fold it right to left. Then fold the top edge to the bottom. You now have a folder of four leaves, giving eight pages when printed on both sides. Number them one to 8 in correct order. Open out the sheet and you have the correct imposition for the pages. The principle can be extended to 16, 32 and 64 page combinations. Before printing begins make a dummy of each section to give yourself an accurate sequence for page imposition. When folding the dummy, draw dotted lines along the folds which are to be cut.

Folding

Almost all folding is done by machine—it is cheaper by far than hand folding and is more accurate. Plan folders with care. Never use thick paper for more than eight folds. With map folds or double folds, make allowance for the folded-in pages being slightly smaller than the outside ones. Make sure there is a minimum margin of 0.25mm. A smaller margin will magnify any faults, for example if the paper does not fold completely squarely.

Stitching and binding

Thin magazines and booklets can be stapled together. This is the simplest and least expensive method of binding. Lay the finished folders one inside the other and open at the center pages, then staple through the spine. This is known as saddle-stitching. It has the advantage that the finished booklet will open flat for easy reading.

Books that are more than 0.25mm thick should be side-stitched. Place the folded sections on top of each other, numbered from one to the end, and drive stitches through the margin at the spine. Tie, or clinch, the thread at the back. When planning folders to be side-stitched, allow an extra 3mm on the margin at the spine end of the folder, to give room for stitching. Side-stitched books do not lie open like saddle-stitched books, but side-stitching is a more secure method of binding.

Perfect threadless binding is done without stitching. As with side-stitching, allow extra width on the margin at the spine end. Folded sections are then laid together in correct order. Trim off the back; fold; paste with glue and fix direct to the cover. Use a fairly stiff paper or board for the cover.

Translations

Text is often shorter when translated from a foreign language and this presents problems when the illustrations are to be kept. Avoid any overprints in books which are to be published in more than one language—these can send costs rocketing. Use single color for the type whenever possible to avoid block changes, and when text falls short, it is always cheaper to add more words than to put in extra blocks.

Gutenberg's Bible This extract (**left**) is from the Bible which is generally considered to be the first important work to have come from Gutenberg's press. It is also named the 42-line Bible because each page was divided into two 42-line columns. Another name was the Mazarin Bible — after the French politician Cardinal Mazarin who discovered a copy in his library in Paris and drew attention to its religious and typographical significance. Gutenberg's Bible holds an important place in the history and development of European printing. Completed around 1455, it was the earliest book printed from moveable types which had been cast in molds, a process that is still used today. The characters were of equal height in a type derived from handwritten Gothic script, probably resembling the best handwriting of the time. It was printed in ink on handmade paper.

Making prints In relief printing (**1**), raised areas of wood or metal are inked and paper is then pressed on to them. Intaglio printing (**2**) is when lines are incised into a block. The paper absorbs any ink in the lines. For planographic printing (**3**), the design is drawn in grease which retains the ink. Stencils attached to a screen or mesh are used in screenprinting (**4**).

Letterpress printing methods The simplest letterpress machine is the platen press (**5**). When the platen opens, the vertical forme is inked by rollers. When it closes again, the paper is pressed against the inked surface. The sheet-fed rotary press (**6**) will print single sheets of various sizes. The speed at which the machine prints can be regulated. The type forme in the flatbed cylinder press (**7**) lies on a flat bed. Inking rollers pass over this and a rotating pressure cylinder presses the paper against the type.

Platen press

Sheet-fed rotary

Flatbed cylinder

Letterpress blocks The plate (**8**) is made of zinc which is the cheapest available metal. Only the lines raised in relief are printed. The design on the copper halftone block (**9**) is etched using tiny dots arranged in lines. The dots are larger for the shadows in the design. Both these metal plates are mounted on wood.

Typesetting The illustrations and type to be printed are locked into place, with leads for spacing, by hand (**10**) or by setting machines.

A flong is then made of the relief design on the flat forme. A curved metal plate cast from this is fitted on the printing cylinder (**11**).

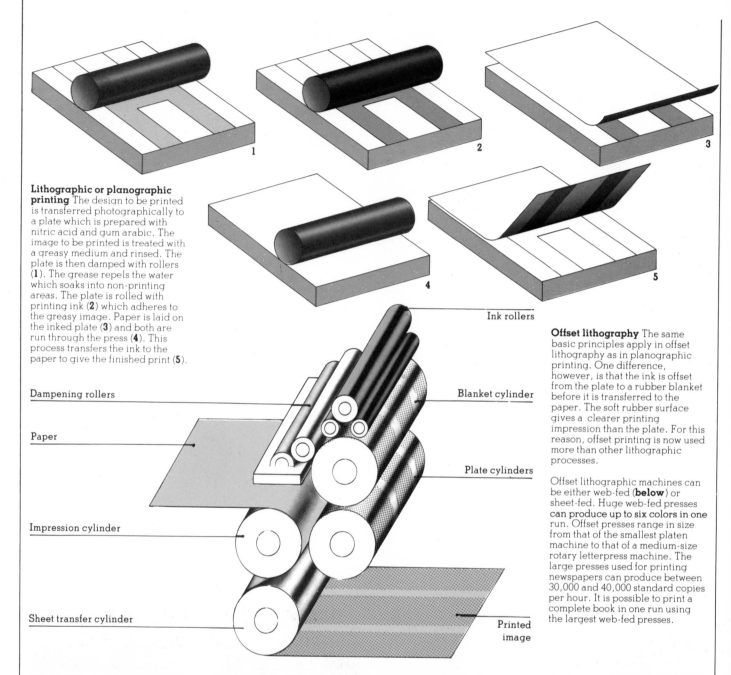

Lithographic or planographic printing The design to be printed is transferred photographically to a plate which is prepared with nitric acid and gum arabic. The image to be printed is treated with a greasy medium and rinsed. The plate is then damped with rollers (**1**). The grease repels the water which soaks into non-printing areas. The plate is rolled with printing ink (**2**) which adheres to the greasy image. Paper is laid on the inked plate (**3**) and both are run through the press (**4**). This process transfers the ink to the paper to give the finished print (**5**).

Dampening rollers

Paper

Impression cylinder

Sheet transfer cylinder

Ink rollers

Blanket cylinder

Plate cylinders

Printed image

Offset lithography The same basic principles apply in offset lithography as in planographic printing. One difference, however, is that the ink is offset from the plate to a rubber blanket before it is transferred to the paper. The soft rubber surface gives a clearer printing impression than the plate. For this reason, offset printing is now used more than other lithographic processes.

Offset lithographic machines can be either web-fed (**below**) or sheet-fed. Huge web-fed presses can produce up to six colors in one run. Offset presses range in size from that of the smallest platen machine to that of a medium-size rotary letterpress machine. The large presses used for printing newspapers can produce between 30,000 and 40,000 standard copies per hour. It is possible to print a complete book in one run using the largest web-fed presses.

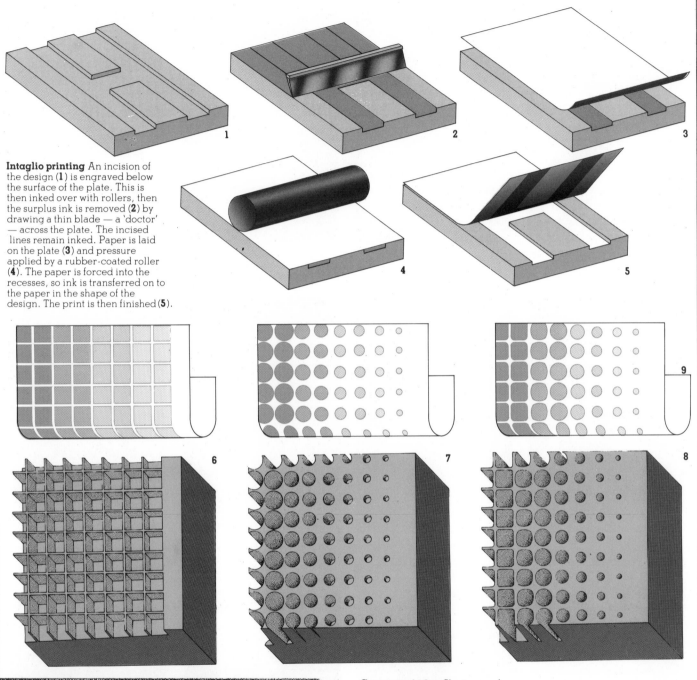

Intaglio printing An incision of the design (**1**) is engraved below the surface of the plate. This is then inked over with rollers, then the surplus ink is removed (**2**) by drawing a thin blade — a 'doctor' — across the plate. The incised lines remain inked. Paper is laid on the plate (**3**) and pressure applied by a rubber-coated roller (**4**). The paper is forced into the recesses, so ink is transferred on to the paper in the shape of the design. The print is then finished (**5**).

Gravure printing Short runs of high quality illustrations are printed best by using conventional gravure plates (**6**). The cells on this plate vary in depth but have equal surface areas. In variable area variable depth gravure (**7**), the size as well as the depth of the cells varies. This is suitable for long run periodical printing. Variable area direct transfer gravure (**8**) is widely used for packaging and textiles. As the image areas do not vary in depth, limited tones are available. In the enlarged detail (**9**) it is clear that an image printed in gravure consists of thousands of dots.

Lithographic printing 1. The surface of a photographic plate is coated with a light-sensitive medium spread with a whirler.

2. The plate is exposed with a negative image in a vacuum frame and then treated with an emulsion developer.

3. The developer dissolves the unexposed coating leaving a gum surface on the main printing areas and lacquer on the image.

4. The plate is developed and thoroughly rinsed with water. The clean surface of the plate is then protected with gum arabic.

5. Any flaws in the plate must be corrected carefully by hand. The plate is then firmly fixed around the plate cylinder.

6. The plate is treated so the ink is attracted to the image. This is finally offset on to a rubber blanket and then on to paper.

Gravure printing 1. The design is transferred from a plate on to carbon tissue which is exposed to light on the gravure screen.

2. Gelatin hardens in the tissue, when it is exposed in contact with the plate. The tissue is then mounted on the cylinder.

3. Paper backing is removed to develop the tissue. Areas of gelatin remain as an acid resist.

4. Ferric chloride is used to etch the cylinder. Grading and tones are produced depending on the thickness of the gelatin resist.

5. The etching incises lines below the copper plate's surface. The first proof is taken and any small corrections are done by hand.

6. The cylinder is usually 'chromed' to give it a durable surface. Then it is mounted on the rotogravure press.

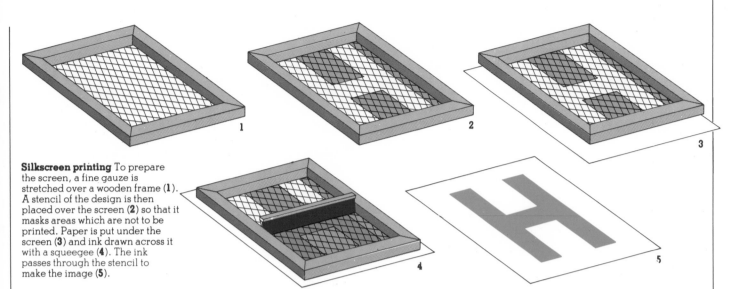

Silkscreen printing To prepare the screen, a fine gauze is stretched over a wooden frame (**1**). A stencil of the design is then placed over the screen (**2**) so that it masks areas which are not to be printed. Paper is put under the screen (**3**) and ink drawn across it with a squeegee (**4**). The ink passes through the stencil to make the image (**5**).

7. The cylinder is rotated in a trough of printing ink so that the surface is covered. Excess ink is removed by a flexible blade.

Silkscreen printing 1. The stencil is taken from a film positive and retouched manually. The screen is coated with emulsion.

3. Any excess emulsion must be scraped from the screen. Paper is next positioned accurately under the screen ready for printing.

5. Ink is drawn across the screen with a rubber squeegee. The screen is pressed down by the squeegee, so the ink prints.

8. In web-fed gravure, the paper is fed continuously through the press, passing between the etched plate and impression cylinders.

2. The positive is exposed to ultraviolet light. Then the emulsion is washed from the image area using cold water.

4. The screen and the paper must be properly aligned in the frame before the printing process, known as 'pulling', can begin.

6. The wet print is carefully removed. It is stacked in a drying rack in front of a fan or blow heater.

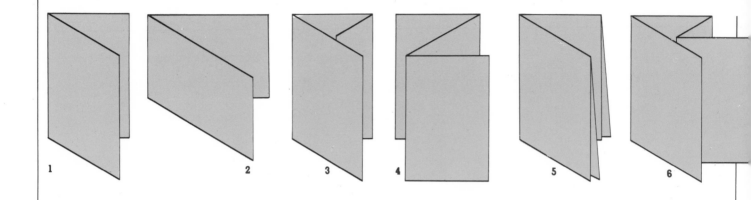

1 2 3 4 5 6

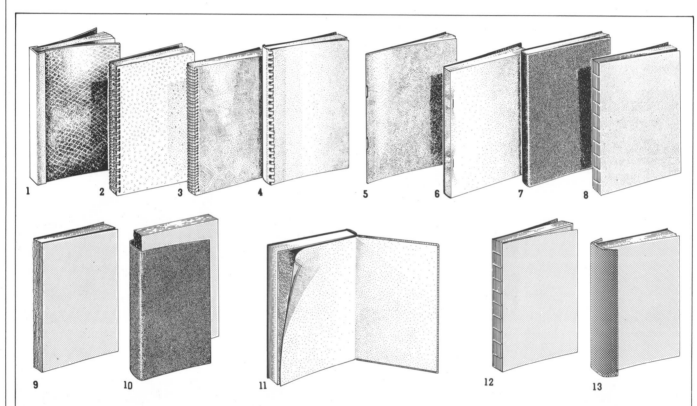

1 2 3 4 5 6 7 8

9 10 11 12 13

Bookbinding methods In mechanical binding (**1**), a plastic gripper slides over the spine to hold the pages and covers tightly together. In open-flat mechanical binding (**2**, **3**, **4**), the pages and covers are punched with holes. A wire or plastic coil through these holes then binds the pages firmly. For saddle-stitch binding (**5**), an open book is stapled along the back fold. In side-wire stitching (**6**), wire staples are inserted from the front, about ¼in from the back edge. They are then clinched at the back. For thermoplastic binding (**7**), the pages are trimmed along the back edge. These are bound together with a hot plastic glue. The strongest stitched method is sewn stitch binding (**8**). Pages are sewn together in sections, and then sewn again as a whole book. Edition binding is the most expensive method — 16 or 32 pages are sewn together in sections by machine. The trimmed back edges are coated with glue (**9**). A strip of gauze is then glued to the backbone (**10**) and a cloth cover is prepared. The book is finished (**11**) by placing it in a casing-in machine which pastes the end-leaves and fits the cover. A cheap method of binding used for paper back books is perfect binding. The spine edge is roughened (**12**) so the glue will adhere strongly. A cover is then glued firmly in place (**13**).

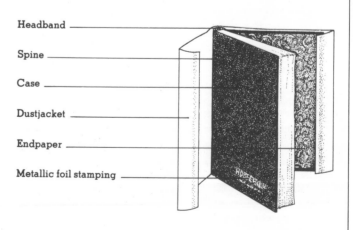

Headband

Spine

Case

Dustjacket

Endpaper

Metallic foil stamping

7

8

9

10

11

Imposition and folding

Imposition refers to the position of each page on the printed sheet. The most common impositions are: four page folder (**12**), six page (**13**), eight page — work and tumble (**14**), eight page — work and turn (**15**), twelve page (**16**) and sixteen page (**17**). The numbers on the diagrams indicate the order of the pages when folded. The letters indicate the folding sequence. The dotted lines show where the paper is to be cut. The pile of printed sheets must be held steady by the grippers before they are folded individually. 'Work and tumble' means the sheet is turned over after one side is printed, and the grippers hold the opposite edge. In 'work and turn', the grippers

hold the same edge, while the second side is printed.

A four page folder is made by folding the paper once, either across the length (**1**) or width (**2**). Six pages are produced by making a double fold. Two types of parallel six-page folds are regular (**3**) and accordian (**4**). The eight page folder is made by folding paper six times — either one parallel and one right angle fold (**5**), two parallel folds (**6**) or three accordian folds (**7**). Twelve pages are made with one parallel and two right angle folds — regular (**8**) or accordian (**9**). The sixteen page folder is one parallel and two right-angle folds (**10**), or three parallel folds (**11**).

12 Four page folder

13 Six page folder

14 Eight page folder — work and tumble

15 Eight page folder — work and turn

16 Twelve page forme

17 Sixteen page forme

Imposition The term imposition is probably derived from printers constantly repeating the words 'in position'. This imposition (**below**) indicates the layout for one side of a printed 32 page signature. When the sheet is folded and cut, the pages will read correctly.

Sculpture.

Design principles in sculpture.

Elements of design: Mass, Space, Plane, Line, Movement, Scale, Texture, Color.

Sculpture has no clearly defined boundaries, and a dictionary definition states that it is the act of carving, especially in stone, extended to clay modelling or molding for casting. The twentieth century, however, has seen this definition extended to include any media, so that a sculpture may now consist of an arrangement of bricks or a huge curtain suspended across a canyon. Such works demand that the spectator should take an active role in the interpretation of the work, and this is the aim of many modern sculptors.

The concept of a sculpture must relate to the medium, and whether working figuratively or in an abstract form this sense of balance or respect for the medium should not be ignored.

Although Rodin (1840–1917) heeded formal values, his chief concern was with nature, rather than with art, and the expression of character and movement: 'Conceive form in depth. Clearly indicate the dominant planes. Imagine forms as directed towards you; all life surges from a center, expands from within outwards. In drawing, observe relief not outline. The relief determines the contour. The main thing is to be moved, to love, to hope, to tremble, to live. Be a man before being an artist!'

Constructivist artists sought to explore and exploit the aesthetic, physical and functional capacities of materials while researching the basic elements of space, volume and color. Although constructivist works lead towards the abstract, Naum Gabo (1890–1977), one of the pioneers, claimed that: '... abstract is not the core of the Constructive ideal. The idea means more to me. It involves the whole complex of human relation to life. It is a mode of thinking, acting, perceiving and living... Any thing or action that enhances life, propels it and adds to it something in the direction of growth, expansion and development is constructive.'

These two viewpoints alone demonstrate that sculpture cannot be viewed as a collection of formal principles.

More recently, Carl Andre (born 1935) has produced work which has attempted to confront the spectator with forms in which inherent significance is minimal. He has summarized his artistic evolution from his early wood sculptures, to his stacking of wood units, to his floor pieces as passing from form to structure to place. Such a development expresses a move away from all representational values to a concern with producing sculptures that allow the spectator to view an object devoid of built-in significance and therefore capable of reinterpretation. Such works should not be confused with the abstract.

Contemporary sculpture differs from the work of previous centuries for many reasons. These include a decreased preoccupation with the human body used as a subject to convey ideas, the development of constructivist processes and the use of modern materials and techniques, the use of color, and changing attitudes to artistic achievement.

The twentieth century has seen the emergence of sculptors who have examined images from many other cultures and this has served to widen a vocabulary which has been almost exclusively related to Greek ideals. Rodin's work breathed new life into sculpture, and artists such as Brancusi (1876–1957), Picasso (1881–1973), Gabo and Tatlin (1885–1953) have helped create new ground into which sculpture has now extended.

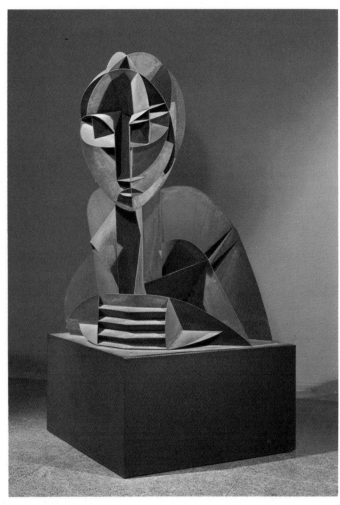

Changing forms in sculpture

Until the end of the nineteenth century, sculptors were largely preoccupied with representations of the human form in their work. In this century, abstract concepts of structure and the development of new materials for sculptors have broadened the range of attitudes towards the design and execution of a sculpture. Rodin's *The Muse* (**above**) shows that he was already beginning to abandon a strict representation of a body in favor of a more tactile, personal impression of the form. The beginnings of truly abstract sculpture appear in the work of the Cubists and Constructivists, as shown by Naum Gabo's interpretation of the traditional portrait bust, *Head* (**above right**). Picasso's painting and sculpture helped to change attitudes, and his Cubist reliefs, such as this *Still Life* (**right**), explored the territory between painting and sculpture, transposing some of his ideas first expressed in paint into three-dimensional form. More recently, the nature of the sculptor's materials has to some extent become the subject of the work, as in minimal sculptures such as Carl Andre's *Last Ladder* (**left**).

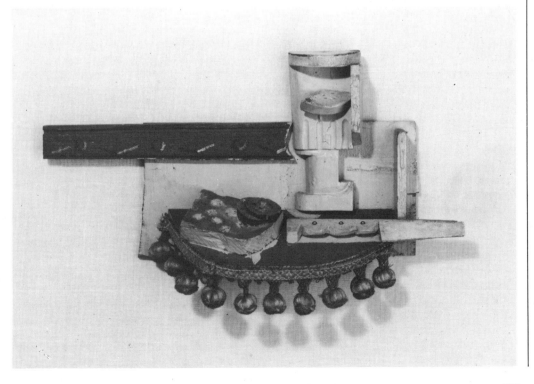

Certain basic elements in sculptural work can be pinpointed: elements, such as mass, scale, line and texture, can extend and realize an idea in conjunction with the medium used.

Mass

This element has always been foremost in the presentation of sculpture. The traditional materials of sculpture, stone and bronze, and their associated techniques make the consideration of volume essential.

Sculptures with a clarity of surface, presenting strong, clear profiles, allow their three-dimensional quality to be comprehended visually. A surface that is highly modelled reflects light in such a way that the solidity or apparent weight of the sculpture is diminished.

Rodin's work is concerned essentially with light and movement in comparison with that of Maillol (1861-1944) which uses the weight and balance of mass to greater effect.

It is advisable to avoid using masses with the same volume in a single work unless conscious repetition and symmetry are desired.

Space

If two related forms are placed next to each other and then slowly moved apart, the space between them changes both in dimension and character. When the two forms are close together the intervening space may seem restricted, whereas when the forms are separated the space may become less tense but it still relates to both forms. If the forms are moved even further apart, they will read as two separate, unrelated forms and the space that was once a part of the sculpture becomes space surrounding those separate forms.

Interaction between space and mass is perhaps best demonstrated in the work of Henry Moore (born 1898). The surface of a mass touches space where the inner tensions of a form are countered, and Moore, by allowing space to penetrate mass, emphasizes this balance.

Plane

A plane is generally considered to be an element that has two dimensions, length and width. The thickness of a plane in sculpture must be minimal in relation to the other elements in order to differentiate between plane and volume.

A plane can be curved or straight and this will affect the way that it is read. The materials usually used bend or fold on only one axis at a time, but those such as plastics and sheet metal can be bent in two directions at once.

From one viewpoint the edge of a plane will read as a line: if, for example, a piece of paper is torn so that it has a ragged edge, the line formed by that edge appears from one view to have a kind of movement in space; from the view at right angles to the first, however, it reads as a line, either straight or curved, and it will have a different relationship to the space through which it moves.

Line

A form or plane can be suggested by line, and line can give a sculpture a sense of space. Vertical lines are associated with support and strength and can give a work a monumental quality. They support structures both physically and visually, whereas the horizontal elements are themselves supported and are more passive. A diagonal line tends to be more active than either a vertical or a horizontal because its inclination to the ground creates tensions which are not familiar. A line, which can be straight, curved or flowing, can be created with string, wire or rods, tensioned between points.

The type of line, its length, the material used and its relationship to other parts of the sculpture create dynamics which affect the interpretation of the work. A convex line, for example, is active in creating tensions, while a concave line appears to be subjected to implied or real forces.

Movement

Sculptors have for centuries produced images with implied movement. Rodin achieved a sense of motion not only by concentrating on poses in mid-movement but by the use of surface modelling, a process that produces a work capable of interaction with light.

Because of their lack of mass, figures sculpted by Giacometti (1901-1966) give the surrounding space a tremendous vibration, as though they are about to move and occupy the space in which they stand.

Alexander Calder (1898-1976) used real movement in his work: his mobiles respond both to the movement of the spectator and the environmental air currents.

It is preferable not to place a sculpture on a revolving base, unless such movement is an integral part of the work, as the spectator should always be able to view the work at his or her own pace and from whichever angle he or she chooses.

When mechanical and electronic movement are used in sculpture, the power source and mechanization is best considered as part of the work.

Scale

This is an essential element to be considered in all sculpture. A sculpture developed through maquettes may need to change as the size increases, as different elements in the composition assert themselves. Mass, for instance, is an element that needs size to make an impact. Sculptures that relate to the human scale are generally better suited to confined areas than monumental works. Monumental sculptures are best exhibited outdoors where they can be seen as part of their environment.

Texture

The varying textures and finishes of sculptural media can be worked to create shadow, or reduce or heighten the reflective qualities of the surface. A heavy texture, produced for example in carving a block of stone, may be used as the final surface so as to create shadow or emphasize the weight. The same texture on a bronze work, owing to its reflective qualities, may destroy the visual weight of the work.

A highly polished surface on a bronze may use light to modify the mass, whereas a highly polished white marble may deaden the image—and this has led to the frequent use of colored or figured stone.

David Smith (1906–1965) has used a grinder on his stainless steel constructions which helps to integrate his sculptures with their environment: the surface absorbs the surrounding colors and light while not reflecting images itself, and thus it keeps the volumes of the work intact.

The techniques used often suggest the finish. Adding texture to a sculpture at the end of the process may mean that the work lacks inherent sculptural value, and this demands a re-examination of the piece or the materials used.

Color

Sculpture often uses the natural colors of the materials. Stone may have a wax polish applied to reveal the true color of its figuring, and wood is often waxed to emphasize the grain. Patinas are frequently applied to bronze sculptures to age the work and to reduce its reflective surface.

Modern sculptors have tended to keep the natural finish of the materials they use especially when working with steel, concrete, wood and stone. Steel sculptures can be made from rusty stock, the surface being retained in the final work.

Wood, metal and plastic sculptures, especially, can be painted both to unify a work of several components and for protection. As paint obscures the natural surface, the spectator is forced to read the sculpture in terms of its lines of direction, movement and color. Thought should be given to the work when deciding whether to use gloss, matt, glazed or polychromed paints. The use of more than one color may draw attention only to the surface of the work, but it can also delineate separate rhythms or elements.

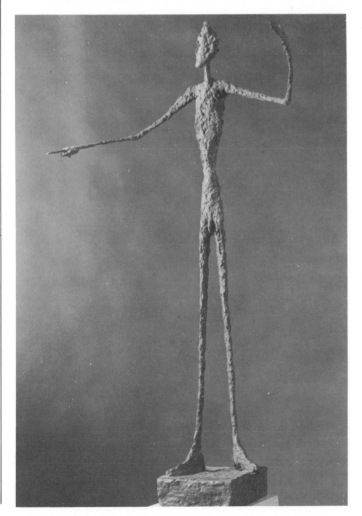

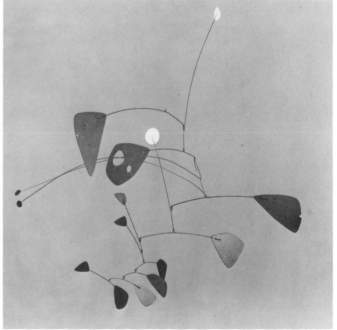

Movement in sculpture The problems of expressing movement in sculpture have to some extent been solved by Kinetic sculpture, in which part or all of the work actually moves. This is quite a recent development and the attempts to imply movement in essentially static objects have given rise to a number of styles of work over the years. The thin, spare figures created by Giacometti, such as *Man Pointing* (**right**), create a considerable impression of mobility, both in their gestures, and in the figures or groups of figures as a whole. Alexander Calder has been one of the most consistent experimenters in the field of moving sculpture, producing a variety of mobiles and power driven sculptures. *Antennae with Red and Blue Dots* (**above**), a typical example of his mobiles, highlights another feature of his work, the use of different colored elements in the composition.

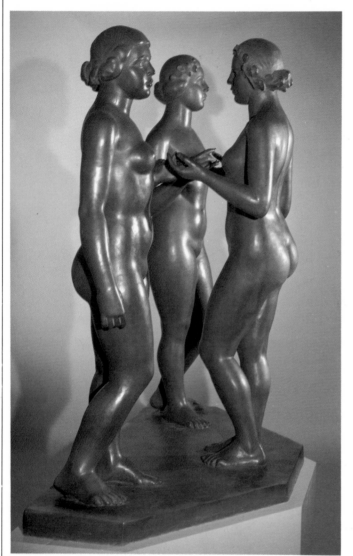

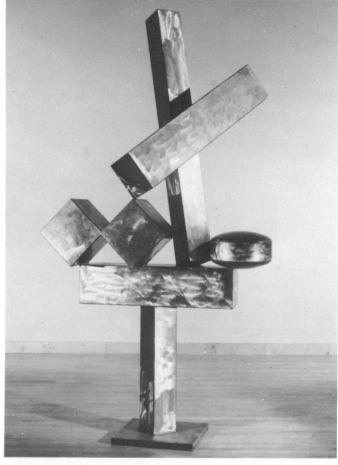

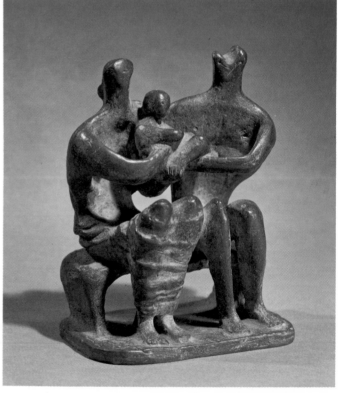

Weight, volume and balance

Until the open structure of modern metal and transparent plastic sculptures evolved, the traditional preoccupations of the sculptor were the volume and mass of an object produced by techniques of carving and modelling. Stone, clay, plaster and bronze all have an unavoidable weight and substance which is part of their very nature, and the sheer physical effort of making a sculpture has been noted by many artists throughout history. Modern techniques of welding and construction have opened up the possibility of overcoming a great many of the physical problems involved in translating an initial design into three-dimensional form, as can be seen in David Smith's *Cubi XIX* (**above right**). This is one of a series of sculptures in which the weight of the material elements seems denied by the precarious balancing of the component parts and by the way in which a solid form can extend into open space. In earlier sculptures, the extension of the forms was limited by the block of stone in carving, or by the balance and structure of the supportive armature in modelling. As can be seen in Maillol's *Three Nymphs* (**above left**), the gestures of the figures were often restrained and there is a very different attitude to balance and symmetry from that in Smith's work. The solidity of the figures is notable, relieved only by the spaces between them incorporated in the grouping. *Maquette for Family Group* by Henry Moore (**right**) is a sculpture which clearly demonstrates his ability to combine traditional principles of form and structure with his own innovations. The pose of the group and his respect for the qualities of his materials show his roots in a long tradition of figure sculpture, but the distortion of the figures in the altered scale and form of the limbs, bodies and heads are characteristic of his personal approach.

Carving stone.

History. Types of stone: Alabaster, Granite, Limestone, Marble, Sandstone, Slate, Soapstone. **Techniques:** Selection, Sawing a block, Boasting and roughing-out, Shaping, Developing, Finishing, Waxing, Making a plaster block for carving, Carving granite, Safety precautions. **Equipment:** Power tools, Carving tools, Finishing tools.

Stones may be divided into three categories: igneous, sedimentary, or metamorphic rock. Igneous rock is formed by the cooling and recrystallization of molten materials in the earth. They are usually extremely hard, even textured and very durable.

The ancient Egyptians were prolific carvers, and for almost 3,000 years their style hardly changed. Both hard and soft stone were used, including granite and limestone. The softer sculptures, including the great Sphinx of Giza, were coated with gypsum before the vivid colors, which the Egyptians used on all stone-carving, were applied. Female statues were usually painted yellow and males dark red. Clothes were depicted in bright colors and eyes were often shown by white quartz with a colored iris.

Historians have relied heavily on the stone-carvings found in ancient Assyria and Babylon, later part of Mesopotamia, for clues to these early civilizations. Marble and stone statues and reliefs excavated from ruined temples and palaces have shown in detail the traditions and costume of people who lived more than 2,000 years ago. Some of the carvings were executed in diorite, one of the hardest and most difficult stones to carve. One of the most notable surviving examples is the statue of Gudea of Lagash, now in the Louvre.

It was not until the fifth century BC in Greece that stone-carving, freed from religious dictates, became an art form. Much of the work was done in marble, the Parthenon statues being the best known examples of the liberated, life-like style. This 'Golden Age', as it is sometimes called, produced most of the classical carving which has had a profound and lasting influence upon sculptors.

Roman stone-carvers initially imitated the Greeks, whose work they greatly admired. By the first and second centuries AD however, when much of the civilized world was part of the Roman Empire, the Romans had developed a realistic, aggressive style of their own. Their marble and stone statues and busts were true to life, and never idealized or flattering. Like the Greeks, the Romans painted stone statues, probably in vivid colors.

After the fall of the Roman Empire, during the period known as the Dark Ages, all the arts suffered a decline. Early Christian crosses, depicting biblical figures and vine-patterns, are almost the only examples of stone-carving to have survived from this bleak period.

Pre-Columbian peoples, such as the Totonac on the Gulf Coast of America (200–900 AD), sculpted monumental stelae from local rock, and later the great temples and palaces of Aztec Mexico, built between 1325 and 1520, were adorned with carved sculptures of the gods.

In the twelfth century the heavy carving of early Christian art gave way to the lighter, Gothic style. Although carving was regarded as an extension of architecture, there is an abundance of carved statues, decoration and gargoyles to be found on churches of this time. Such carvings, though lacking the proportion and perfection of classical works, were usually well observed and often satirical. Stone-carving gradually separated from masonry and became an art form in its own right.

During the Italian Renaissance marble was by far the most popular stone, and the revival of the classical ideals of Greek art, which reached its peak during the High Renaissance (c.1500–1527), exerted a widespread influence on sculpture.

The Italian sculptor, Gianlorenzo Bernini (1598–1680), was the greatest exponent of Baroque carving, a style which emerged during the late sixteenth century. His work in stone and marble excels in absolute detail, and his naturalistic approach rejected many of the ideals of the Renaissance.

The classical tradition, however, continued its influence for the next 300 years. There was often conflict between classicists and artists such as the Frenchman Auguste Rodin (1840–1917), who preferred to express more natural forms.

Much twentieth-century carving has moved away from the representational approach completely. Two British sculptors have played a major role in this. Henry Moore (born 1898) was one of the first to place a greater emphasis on the development of form than on imitation of the subject. Barbara Hepworth (1903–1975), carving directly in stone, was a totally non-figurative sculptor.

The variety of stone and fabricated carving materials plays an important role in sculpture. Although in many respects stone is still used in the same architectural context as it was in Greece, as demonstrated in the works of American sculptor, Isamu Noguchi (born 1904), whose works in marble and granite can be seen throughout the United States, and in the monumental works of the Swiss sculptor, Hans Aeschbacher (born 1906). The scope of the stone-carver today is broader and has resulted in an enormous diversity of approach among the thousands of modern stone-carvers.

Despite this diversity, stone-carving remains a very traditional sculpture medium. Just as the actual materials have changed little over the centuries, so the basic stone-carvers tools have not changed fundamentally. Technological developments have, however, provided the sculptor with tools made of better quality metal, and have made available power tools which are particularly useful for cutting large pieces of stone.

The actual techniques of stone-carving have also changed relatively little; it is how they are used which has changed in the twentieth century. In stone-carving, as in painting, this century has seen the rise of the abstract. While in painting this has tended to be accompanied by a parallel expansion in the artist's technical repertoire, in stone-carving the techniques of centuries have been used to create the new and different forms.

Most stones can be worked in accordance with the following techniques, but granite requires slightly different methods which are described later. It should be noted that choice of stone is just as important as mastering the basic techniques.

Sedimentary rock is made up of tiny particles of stone which have at some stage been deposited in water where they have combined with bone remains and other calcium carbonate substances. They are more porous than igneous rocks, are softer and easier to carve and give a textured, rather than a polished finish. Limestone and sandstone both belong to this group.

Metamorphic rock is igneous or sedimentary rock which has been transformed by heat, pressure, or some other force in the earth's crust. These types of rock are usually soft to carve and include marble, alabaster, slate and soapstone.

The most durable and weather-resistant types of stone are granites and other igneous rocks. Very porous stone is less suitable for carvings intended to stand outdoors, especially in damp conditions where water can freeze in the stone and gradually cause the stone to disintegrate. Wind, sand and dust are all harmful to stone over a period of time, and many urban pollutions, such as soot, are erosive.

Alabaster
Used in ancient Egypt and the Middle East and extensively in Europe in the later Middle Ages, alabaster is a fine-grained, smooth and translucent stone. It is soft and easy to work, and can produce a high finish. It is available in many translucent and pastel shades of yellow or pink as well as white and clear. Alabaster is easily scratched, and is most suited to small sculptures and work protected from the weather.

Granite
It was used in ancient Egypt for many monuments including the Luxor obelisk and Cleopatra's Needle (now on the Victoria Embankment, London). As it is an extremely hard and durable stone, granite is often used for outdoor sculptures. It has a rather rough texture and contains particles of spar and crystal which give polished granite a reflective quality in bright light. Porphyry granite, a specially hard type because of its high spar content, is a particular favorite for its distinctive sparkling quality in light. Granite is not suitable for detailed carving and is usually used for large works. It is difficult to work and requires special tools. The stone has to be pulverized and bruised before chiselling. Colors range from yellow, rose, green and most commonly from light gray through black. It is capable of a very high finish.

Limestone
The texture and color of limestone, a sedimentary rock composed essentially of carbonate of lime, vary greatly, depending on its origin. Textures range from the easily worked and quickly weathered lias and freestone to the fine-grained oolites, some of which weather well and can be carved with precision. Gray and beige are the most common colors, but pink and green varieties exist too. One of the best limestones for carving is the fine, close-textured Caen limestone from France which has been used extensively by the British artist Henry Moore.

Marble
The greatest Greek sculptors used marble, and it is the traditional favorite of stone-carvers. The infinite variety of colors and color combinations depends on where it is quarried. Marble is found in many countries including America, Canada, France and Greece. Belgian Tournai marble is hard and black and much favored by sculptors today. Italian marble is one of the best available, notably the Carrara marble used by Michelangelo. Marble is characteristically easy to carve and takes a fine, glossy polish.

Sandstone
The Egyptians used sandstone from the earliest times, and it was used extensively in England in the Middle Ages and for Cologne Cathedral in Germany which was begun in 1248. The quality of sandstone as a carving material depends largely upon the amount of quartz it contains. If there is no quartz the stone breaks and splinters easily, but too much quartz makes it difficult to carve. Sandstone comes in many colors, depending on the nature of the sand and the cementing matter. The colors include browns, reds, grays and greenish hues. It is generally rather porous and, like limestone, takes a poor finish. Some varieties are insufficiently weather-resistant.

Slate
Although it has a tendency to split, slate is valued for its availability, its high finish and its weather-resistant properties. It is usually blue-black or blue-gray.

Soapstone
Sometimes called steatite, soapstone is a very soft, smooth stone like marble, but with a soapy texture. Its softness and ready availability make it a particularly useful stone for beginners. Soapstone is usually a dull green or a bluish gray, or sometimes brown. It can be used only for indoor sculptures because of its vulnerability in damp conditions.

Other materials for the stone-carver
Less traditional materials for the modern stone-carver include many inexpensive building materials. Different types of concrete blocks, aerated concrete, bricks, chalk and plaster of Paris have all been carved and worked successfully.

Cement and concrete are available in numerous sizes, colors and textures. Although they are generally not suited to detailed work, bricks and blocks have been used for relief carving, assembled structures and small free-standing works. Aerated concrete is particularly easy to carve.

Blocks of plaster of Paris are cheap and effective for rapid, detailed work, and they can be carved either with special tools or with knives, blades and nail files.

The work can be colored with water or oil paints, inks or dyes, and can be easily sealed with a coat of colorless shoe polish.

A lump of chalk, being soft and easy to work, can make good carving material, although it may be necessary to scrape off the weathered outer layer. It is similar to plaster, and it can be carved and colored as described above.

Types of stone There are three main categories of stone — igneous, sedimentary and metamorphic. Limestone (**2**) and sandstone (**1**) are both sedimentary rocks. These are relatively soft, easy to carve and give a textured rather than a polished finish. Slate, such as Welsh slate (**3**) or Westmorland slate (**4**) and marble (**5**) are examples of metamorphic rock, and are also fairly easy to carve. The hardest type of rock is igneous. Granite is the best known example of this category. Granite comes in a wide variety of colors and textures including Emerald Pearl from Norway (**6**), South African gray (**7**), Cornish (**9**). Balmoral (**10**) and Karin (**8**) both come from Scotland. Granite, which is difficult to carve and needs special hard tools, is suitable for carvings which will stand outside because it is a very durable stone. Other stones such as aerated concrete (**11**) and brick (**12**) can also be put to good use by the stone-carver. One of the softer stones is best for the beginner to work with. It is vital to master basic techniques before embarking on either a large scale work or on a carving in one of the harder stones.

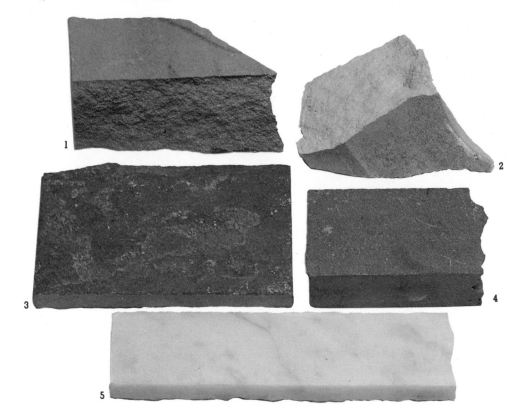

With the exception of the hammers, which are made of iron, stone-carving tools are forged from tempered steel. Tools used for granite-carving are especially hard and often have tungsten carbide tips.

Boasting and roughing-out

Boucharde Sometimes known as a bush hammer, the boucharde has V-shaped indentations and is used for bruising and pulverizing the stone to soften it. This technique is used particularly with very hard stones such as granite. The boucharde must not be used in the final stages as dull marks will show through to the surface of the stone.

Hammer The stone-carver's hammer usually weighs between 2–2½lbs (about 1kg) for stones of average hardness, but they can be much lighter or as heavy as 4lbs (about 2kg), depending on the type of work being done.

Pitcher This is a large heavy implement used with the hammer to remove large lumps of stone in the early stages.

Point Variously sized points are used to remove waste stone. A good carver removes waste stone to within a very small distance of the finished shape using points.

Shaping

Claw This chisel-type tool has teeth and produces a cross-hatching effect. Much of the rough modelling is done with the claw. Claws designed specially for marble-carving have longer teeth.

Chisel The carving is developed with chisels and gouges which come in different sizes with variously shaped cutting edges.

Mallet The stone-carver's mallet, usually made of a hard wood such as beechwood, is used mainly for soft stone, and can be used in conjunction with any mallet-headed tool, such as a chisel, for finer work.

Rasps, files and rifflers These are used in the final stages of the carving to give a smooth finish, for final modelling, and to eliminate the marks made by the claw and the chisels.

Power tools

A variety of electric or pneumatic tools are suitable for carving and shaping stone for sculpture. Pneumatic tools are especially effective for carving hard stone.

Carving

Chisels and gouges Claws, chisels and gouges are available in all sizes to fit power tools. Power carving saves time, but very great care must be taken not to fracture the stone.

Drill Carbide tips are required when drilling stone.

Hammer Electric hammers are less adaptable than pneumatic hammers, the latter being heavier and more effective with hard stone.

Saws Power saws are essential for cutting stone blocks. Special masonry blades are used and it is often necessary to pour water over both stone and blade during cutting to reduce friction and heat.

Finishing

Body grinder Although usually used for metal work, the body grinder can be fitted with a masonry wheel and is very time-saving for finishing large sculptures.

Electric sander This is excellent for finishing and polishing large areas. It can be fitted with all grades of abrasive papers and with a buffer attachment for the final polishing.

Stone-carving tools and equipment Equipment for preparing the stone includes a saw (**4**), mason's hammers (**8**), tape-measure (**7**), dividers (**12**) and adjustable set-square (**9**). The stone is roughed out using the boaster (**18**) and worked with the points (**14**), claws (**16**), flats (**17**) and smaller chisels (**15**). The stone is brushed at intervals during carving with a wire brush (**10**). The stone is smoothed further with the files, beginning with the coarse stone file (**11**) and then the finer two-sided files which come in a wide variety of sizes and shapes (**13**). The stone is finished with different grades of carborundum stone (**6**) and silicon carbide paper (**5**). The finished stone can be waterproofed with a coat of silicon liquid (**2**). A bucket (**3**) is useful for wetting the stone at various stages, and the tools can be kept in a bag (**1**).

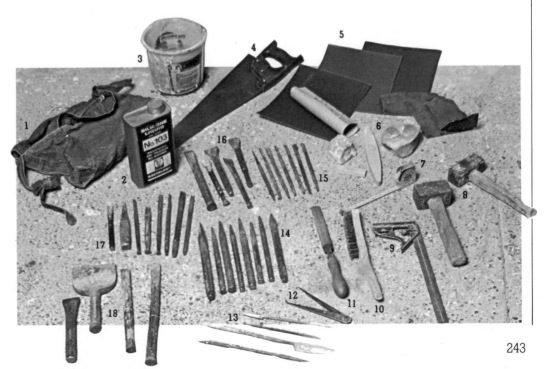

The basic tool kit

A metal hammer weighing between 2–2½lbs (about 1kg), a pitcher and two or three variously sized points are essential for roughing-out. The next stages require a selection of claws with teeth of different sizes and different spacing and an assortment of chisels and gouges, depending on the size and type of carving. A range of abrasive papers for polishing and appropriate filing tools for smoothing are essentials.

The stone-carver's kit is completed with a pair of plastic goggles and a simple respirator for protection against flying chips and dust.

Power tools Power tools are useful for cutting through stone more quickly than is possible by hand. A drill with tungsten carbide bits (**1**) is particularly useful. The bits must be strong enough to cut through the stone, so tungsten carbide is recommended. When using a power saw (**2**), make sure that the blade is suitable for cutting through stone. The sander (**5**) can be used for polishing large surfaces. It is important when using power tools to wear goggles (**4**) and a respirator (**3**) to counteract the fine stone dust which the power tools create.

Stone-carving Techniques

S tone-carving both in art and architecture has existed for many thousands of years. Some of the earliest examples are limestone figurines, found in France during the late nineteenth century, which date back to the Stone Age.

Selection

Freshly quarried stone should be used whenever possible. Stone which has weathered usually has a hard outer crust which makes it difficult to carve.

Dry, rough stone never indicates the true color of the stone. Wetting the surface will reveal the color of the finished, polished stone.

Many pieces of stone and rock contain flaws, cracks or weak layers. Although these are sometimes visible, they are quite often hidden in what appears to be a perfectly sound specimen. Hidden faults can sometimes be detected by tapping the stone with a steel hammer. A sound stone produces a ringing tone, but a bad stone gives a dead, dull sound. A weak layer in a stone often turns darker than the rest when the entire stone is soaked in water.

Sawing a block

Hard stones and large stones are usually cut in a stone-cutter's yard with industrial equipment. Softer and smaller stones can be cut with a portable saw fitted with a special blade. Water should be poured over the blade at frequent intervals to prevent it overheating.

Boasting and roughing-out

These initial stages are accompanied with a pitcher and large points used with a metal hammer. Any large, simple areas of waste are cut with a saw, and the block is laid in position on several layers of burlap or non-slip mats. Holding the point at an oblique angle, the roughing-out is then carefully carried out, the edges and corners being worked first. The carving should be done in short parallel strokes at right angles to each other, creating a criss-cross pattern on the stone. This process removes the waste stone evenly and is continued until the rough shape is achieved. Surplus stone chippings are removed with a stiff brush.

Shaping

After the roughing-out, the first shaping is worked with the claws. The larger sizes are used first, working through to the finer tools. The same criss-cross motion of the roughing-out process should be maintained, giving the sculpture a fine cross-hatched surface.

Developing

The shape is developed using chisels or claws, depending on the detail and design of the sculpture.

After removing the criss-cross ridges with a flat chisel, further shaping can be carried out with rasps and files.

Finishing

Garnet paper or waterproof silicon carbide paper, known as wet-and-dry, is used to produce a smooth finish for polishing. The carving should be soaked first if possible, and must be kept wet all the time. The sediment which builds up during this process should be removed frequently. Starting with the coarsest papers and changing gradually to the finer grades, the surface is rubbed down until all the scratches and tool marks have disappeared. Wet-and-dry should be used wet, a small area being worked at a time. Emery paper or a fine emery cloth may be used after the wet-and-dry. Pumice or putty powder is sometimes applied with a wet pad and the carving rubbed well to produce a final finish. The surface can be polished finally with a dry cloth.

Making a plaster block for carving

Cardboard boxes, milk and fruit-juice cartons and many other containers are ideal molds for making plaster of Paris blocks for carving. The correct amount of water is estimated by filling the mold almost to the top. The water is then poured into a mixing bowl and the dry plaster sprinkled over it until a small mound of plaster rises above the surface of the water. When mixed the plaster should be the consistency of a thick sauce. It is poured quickly into the mold, which should be greased with Vaseline or liquid soap to prevent sticking, and allowed to dry before the mold is removed.

Carving granite

Granite is harder than most other stones and it needs specially tempered tools; such tools are heavier than standard stone-carving tools and some have tungsten carbide tips.

The technique for carving granite is also slightly different: waste stone is removed by first being pulverized or bruised, with a granite axe or boucharde, before being knocked away with the chisel. Granite tools must be held at an angle of 90 degrees to make any impact on the hard surface.

Safety precautions

Plastic goggles and respirators should always be worn when working with stone. Respirators protect the lungs from stone dust, some of which contains dangerous silicates.

Properly ventilated areas to work in are essential, and when power tools are being used and a lot of dust generated a special exhaust system to remove the dust is advisable.

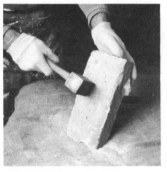

Stone-carving techniques Preparation 1. Tap the stone to test its soundness. An unflawed stone produces a clear 'ring'.

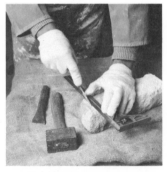

3. Before sawing, mark the cutting line with a serrated file. A hard stone should be marked with a wax pencil.

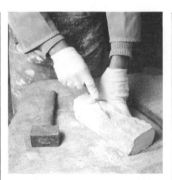

Roughing out 1. Mark the areas to be worked away with a serrated scalpel or, for more precise outlines, a wax pencil.

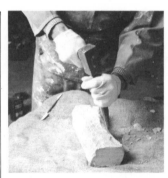

Using the pitcher 1. Cut away unwanted stone with the pitcher and a stonemason's hammer. Work along the edge.

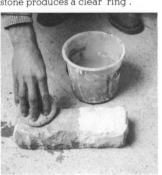

2. Wet the stone to gain an idea of its texture and what it will look like when polished.

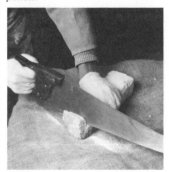

4. Saw the stone with short strokes. Hard stones may need special industrial equipment.

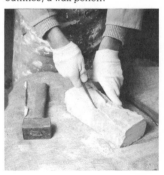

2. Measure any exact distances with dividers.

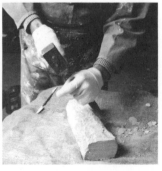

2. To vary the amount of stone which is cut away, change the angle of the pitcher.

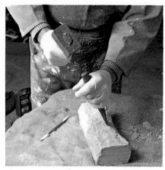

3. Work along the edges of the stone to create the broad outlines of the final carving.

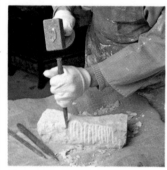

Using the point 1. More exact shaping begins with the point. Hit the point with the hammer at about 90°.

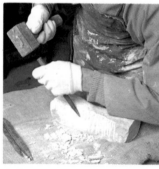

2. Having worked along in one direction, begin to smooth the surface by creating a criss-cross pattern.

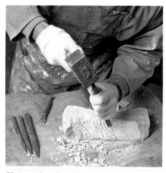

Using the flat The flat chisel is used to create a flatter surface and smoother finish. Work along the surface as before.

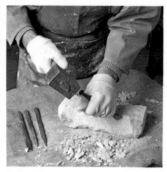

Using the claw 1. Work over the surface in one direction with the claw.

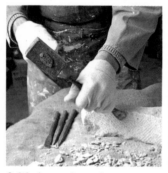

2. Work over the surface again from a different angle to create a criss-cross pattern, as with the point.

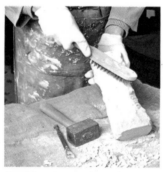

Brushing At intervals during the carving, brush away dust with a wire or hard bristle brush. Use a soft brush in later stages.

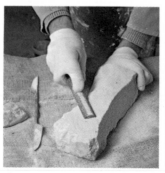

Using files 1. Having outlined the shape, go over the surface with a coarse stone file. Use the curved edge for rougher work.

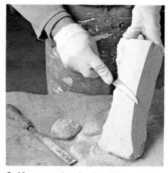

2. Next use the double files which come in several shapes and textures. Start with the coarse file and then use the finer ones.

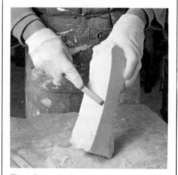

Finishing 1. Work over the surface with the file until it is completely smoothed.

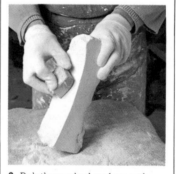

2. Rub the worked surface with carborundum stone. Rub to a perfectly even surface. If the stone is hard, use the carborundum wet.

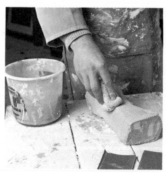

3. Wet the stone completely by squeezing water from a sponge.

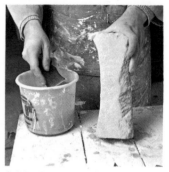

4. Wet the silicon carbide paper in the bucket, rub it on to the stone using a circular scouring motion.

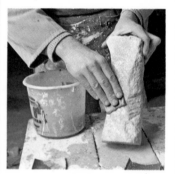

5. Repeat the process, working from coarse through to fine grades of the paper to give a very smooth surface.

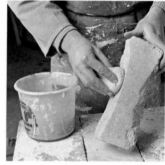

6. Give the stone a final sponge down to remove dust or particles of stone.

7. Finally rub over with emery cloth. When the stone is dry, buff with a soft, dry cloth to bring up the shine.

Carving wood.

History. Types of wood. Tools and equipment: Carving, Shaping, Carpentry, Tool sets, Fixing, Sharpening. **Techniques:** Drawing, Sawing, Gouging, Carving in the round, Finishing.

Wood is the oldest medium known to man. The craft of carving wood has been practised since the earliest times from the decoration of crude weapons and utensils to modern shapes and forms created by present-day sculptors.

The primitive craftsmen of Africa, Australasia, Mexico and Polynesia carved charms and masks for rituals which remained unchanged for centuries.

In ancient Egypt, too, carving held a ritualistic role and wood was used for effigies and tomb statues, as well as being used ornamentally on furniture and friezes. The Greeks were using carved wood inlaid with ivory and gold from about 800 BC, and Roman craftsmen decorated their furniture, boats and chariots with elaborate carvings.

In the eleventh century, wood-carving appeared in northern Europe, starting in Germany and spreading to the Low Countries and Britain. The European Gothic style emerged in the early twelfth century and flourished under wealthy church and private patronage into the early 1500s.

Artists and craftsmen were working in Italy at this time in the classical tradition now known as the Italian Renaissance. The impact of the fine carved interiors and furniture of the Renaissance spread rapidly across Europe, particularly influencing carvers in Flanders, and eventually England.

The prolific wood-carver Grinling Gibbons (1648–1721), working in England with such architects as Sir Christopher Wren (1632–1723), had a far-reaching effect because of his position as Master Carver to the Crown. His distinctive and elegant work gained an international reputation and Gibbons's carvings can be seen in many homes and churches throughout Britain.

Wood-carvers today have moved away from their traditional place alongside architects and cabinet-makers. The severity of twentieth-century design has to some extent changed their role. Wood-carving nowadays flourishes as one of the fine arts, and the free-standing works of such fine sculptors as Henry Moore (born 1898) and Barbara Hepworth (1903–1975) enhance our environment today.

Wood-carving Types of wood

When choosing timber for carving, the color and grain must be suitable for the work in hand. Fairly straight-grained woods, being not too difficult to work, are better choices for the beginner.

The sapwood, the new outside growth of the tree, is paler and wetter than the heartwood which is the mature, inner wood better suited to carving. The sapwood is removed before carving begins, as it tends to split easily. All timbers vary in moisture content and must be seasoned before use to avoid shrinkage and distortion. Woods also vary greatly in texture: oak, for example, is coarse textured while others, such as cherry and lime, have fine, even textures. It is worth noting that some woods give a good, polished finish, but others produce one which is poor and dull.

The softwoods, which include pine and cedar, are readily available and come in large sizes. The wood has a tendency to split and it is advisable to use the slow-growing varieties. Yellow pine is particularly good for carving larger works, but Parana pine should be avoided.

Of the many hardwoods some two dozen are popularly used for carving. Oak, mahogany and walnut are traditional favorites; lime or basswood, sometimes called 'the sculptor's wood', is very easy to work, as are the fruitwoods; cherry is particularly favored for its rich color. Very hard woods such as ebony and lignum-vitae are only suitable for small works.

Alder This is a soft, easily workable wood. It is usually reddish with an indistinct grain.

Apple This is a hard, easily workable wood. It is red in color with an indistinct grain.

Beech Beech is easy to work, and it is not difficult to obtain a good finish. Beech is light brown in color with a close, and rather uninteresting grain.

Boxwood Boxwood is a very hard, dense wood most suited to small work. It is pale yellow with an indistinct grain. It gives a good finish.

Cedar This close-grained, easily workable softwood varies in color from yellow through red to brown.

Chestnut This is a moderately hard wood with a tendency to split. It is light brown in color with a distinct grain. Chestnut is durable, and gives a good finish.

Ebony Ebony is a very hard wood which is difficult to obtain and to work and suitable for small pieces. It varies from dark brown to black and has a distinct fine grain. It takes a good finish.

Elm This hard wood is sometimes difficult to work but it finishes well. In appearance, it is yellow to reddish-brown with a marked grain.

Holly Holly is an easily workable hard wood which is smooth, white and has a fine grain.

Lime Lime—called basswood in the USA—is a fairly

soft, very easily workable wood. It is pale yellow with few grain markings. It is also readily obtainable.

Mahogany This is a rather hard wood, usually easy to work. It has a reddish-brown color with a variable grain.

Maple This close-grained, medium hard wood finishes well. Its color varies from light to reddish-brown.

Oak Many varieties of oak exist but it is generally a hard wood which is fairly easy to work. The wood is very durable, and takes a good finish but continues to check—or crack—for some time. Its appearance varies from yellow to dark brown and it has a distinctive grain.

Pear Pear is a moderately hard, even-textured wood which is fairly easy to work. It is light reddish-brown in color with a close grain. Fruit woods such as pear, apple, holly and plum are only available in relatively small pieces.

Pine This soft wood is easy to work, depending on the variety, but it is prone to splitting and to woodworm, and so is not very suitable for carving. Its color varies from pale yellow to dark orange with a strongly marked grain.

Plum This hard wood is usually fairly easy to work. It is pinkish in color with a distinct grain.

Rosewood Rosewood is a hard wood which is not easy to obtain or to work. However, sculptors value it for its even texture and coloring which varies through reddish-brown, purple and black.

Sandalwood This is a hard, scented wood which is usually used for small, detailed work. It is yellowish-brown in color.

Satinwood Satinwood is a hard wood which can be difficult to work because it splits easily. In color it is light orange with a patterned grain.

Sycamore This moderately hard wood, which is sometimes difficult to work, is white in color. It is obtainable in large sizes.

Teak Teak is a hard wood, which is moderately easy to work. It is yellowish-brown with a distinctive grain.

Walnut Walnut is a hard, easily worked wood with a good finish, although it is expensive and difficult to obtain. It is chocolate brown in color with a richly marked grain.

Yew This is a hard, durable wood with a good finish, which is easy to obtain. In appearance it varies from creamy to reddish-brown, with a distinctive grain.

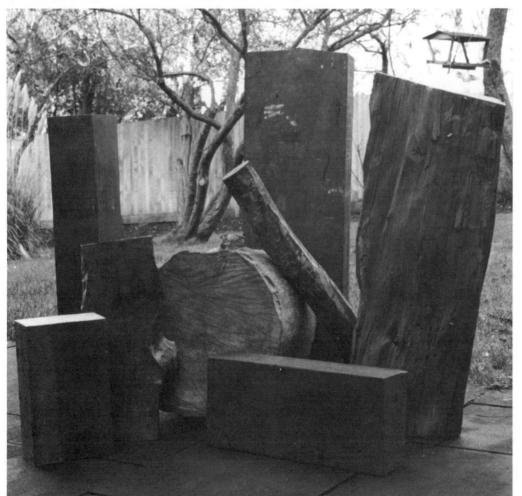

Types of wood
Color and grain are important factors in determining the sculptor's choice of wood. These woods are reasonably readily available and suitable for carving: from **left** to **right**: pitch pine, oak, yew, elm, mahogany, apple, teak and cedar. Wood for carving comes in different shapes and states. For example, the apple is just a trunk with the bark removed, the elm is in the form of a 'cheese', a cross-section of the trunk, the cedar has been quartered and the pitch pine, mahogany and teak are planks. Each wood has particular characteristics which the prospective sculptor should be aware of. For example, the fruit woods like apple, pear and plum are only available in fairly small pieces — determined by the size of the trunk. Many tropical woods such as ebony and mahogany are becoming increasingly expensive and difficult to obtain.

Wood-carving Tools and equipment

T he wood-carver's tools fall into three main groups: carving tools, shaping tools and carpentry tools. A selection of the three types is needed by any prospective carver.

Carving

The gouge and the chisel are essential items. The gouge has a curved cutting edge which ranges from a narrow U-shape to just a slight curve. Both the chisel and gouge come in various shapes including bent and curved, enabling inaccessible hollows to be carved. V-shaped gouges are known as veiners and fluters and are used for fine work.

Shaping

Rasps, files, and rifflers are the basic wood shapers. A file is finer than a rasp; a riffler has a curved edge for rounded shapes. The Surform shaper has a built-in space for shavings to prevent clogging.

Carpentry

Of the many saws the half-rip saw which cuts both with and across the grain of the wood is the most useful. The bow saw is used for cutting curves and the fret saw for flat pieces. A wooden mallet is another essential tool and it is important to select one that is not too heavy and tiring to hold.

Tool sets

It is not necessary to buy a comprehensive set of carving tools at first. Beginners' sets with six or nine basic tools are available and can be supplemented later.

Although carving tools are frequently sold without handles, it is more convenient to buy them with handles already fitted. Handles are usually smooth or fluted, the latter being better for gripping.

When not in use, tools should be kept in a soft case to protect the cutting edges. Cases can either be bought or made from strong canvas.

Fixing

The bench on which to fix the work should be very firm and ideally have a top of at least 2in (5cm) thick—a reinforced kitchen table makes an adequate substitute. For free-standing work a carver's stand is more convenient than a bench as it enables the carver to move around the work more easily.

There are several ways of fixing the work in position. A carver's vice may be screwed to the top of the bench and is more suitable than the carpentry vice, which is fitted to the edge. A carpenter's vice often suffices, however, for smaller pieces. A bench screw, which bolts the work to the bench through a hole in the work surface, can be used for free-standing pieces, while for flatter work G-clamps are useful.

Sharpening

All new tools need to be sharpened and, although sharpening is not difficult, very worn or damaged tools must first be reground by an expert. Hard woods tend to blunt tools very quickly.

Oilstones and slipstones, varying in degree of coarseness, are used for sharpening. The shape of the tool must be retained and the correctly shaped slipstone should be used for each tool. The final sharpening is done with a fine stone such as Washita.

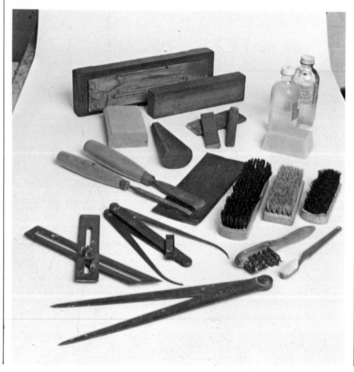

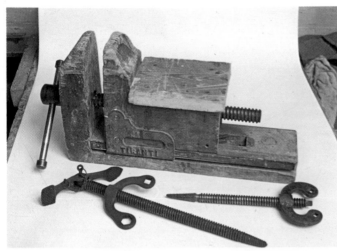

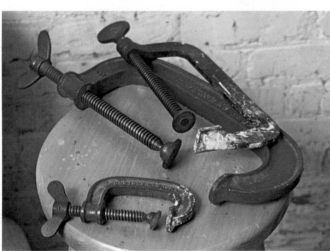

Gouges (bottom) A selection of gouges are necessary for any wood-carving. This selection shows (from **left** to **right**) flat gouges, U-shaped gouges, veiner, back-bent gouges. The size and type of gouge should be suited to the stage of the work, the size of the piece of wood and the effect you wish to achieve.

Rasps and rifflers (below) There is a wide range of rasps and rifflers available for the sculptor to choose from. The rasps come in different degrees of coarseness. The rifflers are available in a wide variety of sizes and shapes which include pointed, flat, spoon-shaped and rounded.

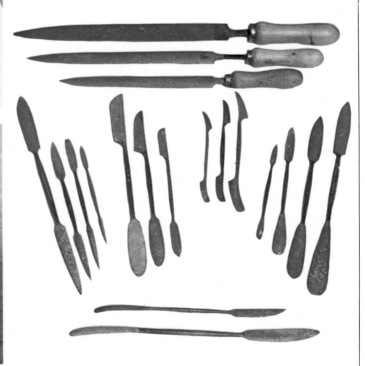

Wood-carving tools and equipment Wood-carving requires a number of different tools for the various processes involved in producing a carving. There is a very wide range available; the beginner would need a basic selection only. Saws (fine and large toothed), mallets and a boaster (**above left**) are used to begin shaping the wood. Mallets are used with the gouges. The mallet should be the correct size for the size of the gouge and the piece of wood. When working the wood, it is important to ensure that the wood is held firmly, for example, in the wood vice or by clamps (**top**). G-clamps (**above**) can be used to hold pieces of wood together or to hold them to the bench. Equipment for finishing (**left**) includes oilstones and carborundum stone (**top left**), linseed oil and real turpentine (**top right**). Brushes (**center right**) and a soft cloth are also used for polishing. The leather strop (**center**) is used for sharpening the tools, while the callipers, dividers and adjustable set-square (**bottom**) are used for measuring the wood.

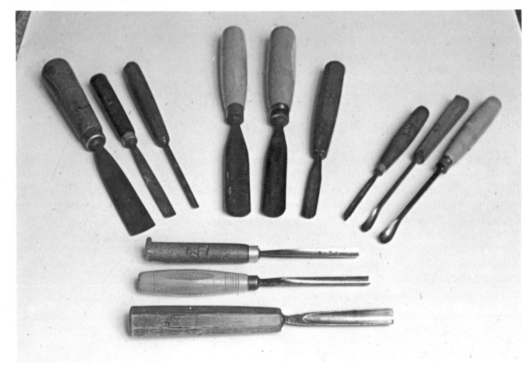

A good carver makes use of the special qualities of wood; natural contours, the direction of the grain and the color variations are each used to advantage because wood, more than almost any other medium, imposes its natural qualities upon the finished product. Carving is nevertheless a craft, and certain basic techniques must be mastered.

Drawing or marking out

It is often helpful to make preliminary sketches before starting work, particularly with more formal carving when it will also be necessary to transfer the drawings on to the wood. This is usually done by taping the full-size drawing on to the wood with carbon paper underneath and then tracing the outline, or, alternatively, by cutting a template and drawing round it.

Sawing

Initially, the surplus wood is removed with a saw. A bow saw can be used for curved surfaces, but care must be taken at this stage to leave plenty of room for finer carving. Difficult or undulating surfaces can be removed by making a number of saw cuts across the grain up to the required outline, and then carving away the remainder with a chisel or gouge.

Gouging

In the early stages of a work, the boasting in, the gouge is used with a mallet. The gouge should be as large as comfort and the size of the piece of wood allows and should be used across the grain of the wood in order not to lift the wood along the fiber. For the later, finer stages the mallet is not needed as hand-pressure on the gouge is sufficient.

When gouging, it is important to note the grain. If a deep U-shaped gouge is being used it must be remembered that two directions of grain are being carved and one or other will often produce a torn finish. This can sometimes be remedied, however, by using a sharper tool or by changing direction.

Carving in the round

Three-dimensional carving known as 'in the round' demands easy access. The wood should be firmly fixed at a convenient working angle and, ideally, there should be sufficient room to view the work from all directions. Time should be taken 'reading' the wood, noticing its special points, and planning the work.

If drawings are used, they should be full-size elevations of the sides plus one other elevation—probably the top, or plan. It is advisable to remove the waste wood from the side elevations first. After this rough shaping comes the boasting in, or rounding, then the more detailed modelling, and finally the finishing.

Finish

The chief reason for a finish, or protective coating, is to preserve the wood. Light colored wood is especially prone to discoloration and shows fingerprints and grease stains. A finish also minimizes the effects of a dry or damp atmosphere.

Wax polish, a traditional finish, can be made by melting lumps of beeswax with an equal quantity of real turpentine and some linseed oil which helps add lustre to the wood. The mixture is applied cold, left for a few minutes, and then polished. Wax polish can also be used over a thin coat of polyurethane varnish which has been glass-papered to dull the gloss, or over a coat of linseed oil which has been allowed to dry. Outdoor sculptures should be sealed against heat and rain with several thin coats of sealing and rubbed down with fine glass-paper when completely dry.

Wood-carving techniques 1. Examine the piece of wood to note any particular features such as the grain.

2. Draw a preliminary sketch of the proposed carving. It is best to draw the plan — or top — view first.

3. Trace the preliminary sketch on to tracing paper.

4. Draw over the outline with graphite or pencil on the back of the tracing paper.

5. Transfer the preliminary sketch on to the wood from the tracing paper.

6. If necessary, reinforce the sketch directly on the wood using charcoal, Chinagraph or pencil.

7. Another method of transferring the sketch is to place a sheet of carbon paper on the wood under the sketch.

8. Transfer the sketch on to the wood by going over it on top of the carbon paper.

9. Reinforce the sketch directly on the wood.

10. A third method of transferring the sketch is to use a template. Draw out the design and cut it out with scissors or a scalpel.

11. Place the template on to the wood, bend to shape. Remember that you are working from two to three dimensions.

12. When the outline sketch is completed, carving can begin. The initial idea will develop during the carving process.

Roughing out 1. To keep the wood steady during carving, place in a wood vice and wedge if necessary.

2. Saw off any excess wood reasonably close to the drawn outline.

3. Use a medium-sized round gouge to begin working towards the final shape.

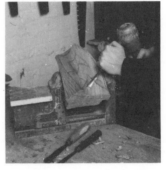

4. The round gouge is used to create a reasonably smooth and even surface.

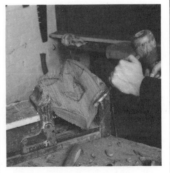

5. The roughing out process should continue until the piece of wood approximates to the proposed final shape.

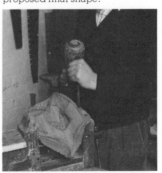

6. Select the size of gouge which is suited to the size of the wood. Move the wood round as you work.

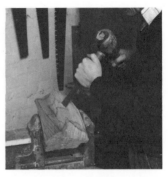

7. Work down to the drawn outline using a smaller flat gouge to smooth the surface further.

8. Mark out the central area using a flattish gouge. Keep well within the drawn outline.

9. Hollow out the central area with a small flattish gouge. Do not carve too close to the outlines.

10. Shape across the grain of the wood to avoid lifting the wood fibers along the grain.

Using the gouge 1. If the gouge penetrates the wood too deeply, as in this picture, it will lift too much wood.

Using the mallet 1. Make contact with the handle of the gouge at about 90°. With a small gouge use a small mallet.

Using the veiner 1. The veiner, a V-shaped gouge, is useful for working in tight or small corners.

2. Use mainly the middle of the rasp for more pressure. Start working with a coarse rasp and then use a finer one.

2. To use the gouge correctly hold at an angle of about 45°. The angle varies with the size of the gouge and the wood.

2. With a large gouge use a larger mallet. The weight of the mallet stroke depends on the wood, tool and stage of the work.

2. It is also used for cutting a deep groove, for example, to create surface patterns.

3. The riffler is smaller and finer than the rasp and gives added smoothness to the surface.

3. Gradually work along the edges of the wood to smooth it out. As in the roughing out, work over the whole surface area.

Using the flat gouge 1. To flatten out the surface use a flat gouge and a mallet. Work along the edges.

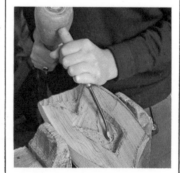

Using the back-bent gouge This gouge is used for digging out wood. Back-bent gouges come in different sizes.

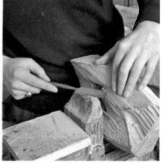

4. Use long strokes where possible and steady the end of the riffler with one or two fingers.

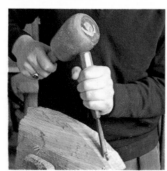

4. Work with the gouge down to within about ¼ in of the desired final surface.

2. Then work along the surfaces again guiding the gouge by hand. This gives you more control.

Using rasps and rifflers 1. The rasp is used for smoothing the surface. Bring the rasp across and with the grain.

5. After a few strokes with the riffler, feel the wood to test the degree of smoothness and feel where to use the tool next.

6. As the surface is smoothed, use progressively finer rifflers. Some have spoon shaped ends for working curved shapes.

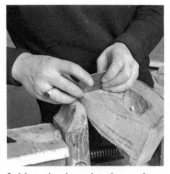

10. Use the rifflers until the surface is smooth enough to begin finishing.

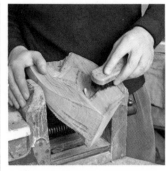

3. Move the drawplate forward to compress the surface fibers. This brings out the wood's gloss.

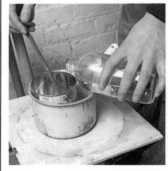

7. Using sandpaper fills the pores of the wood with dust. Brushing the dust away brings up the grain again.

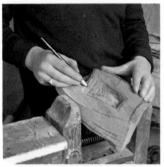

7. Next examine the wood and mark out the final shape more exactly. Use a Chinagraph or similar pencil which will not erase.

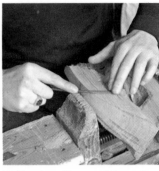

11. While working with the rifflers it is important to keep feeling and looking at the wood.

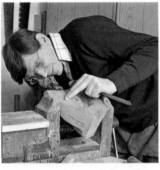

4. Finishing with a gouge creates a lively, textured surface. Use a wide flattish gouge. The bevel of the gouge burnishes the wood.

Polishing 1. You can use a good proprietary wax polish, but many carvers make their own from real turps, linseed oil and beeswax.

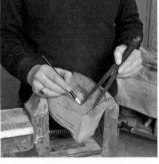

8. Use dividers for any exact measurements such as parallel lines.

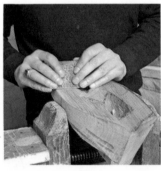

Finishing 1. To finish the surface first use a drawplate which has a bevelled cutting edge. Hold the plate at about 45°.

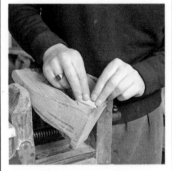

5. For a very smooth finish, use a craft knife blade. Hold at 60°. These blades are very sharp, so use with great care.

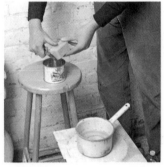

2. To make polish, first scrape or cut the wax into the tin. Small pieces melt more quickly.

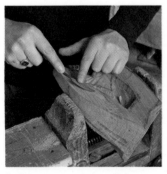

9. Alternate using the rifflers with examining the wood and, if necessary, further marking out.

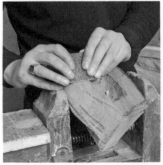

2. Draw the plate towards you. It cuts a thin layer of wood, clears out the pores of the wood and brings up the grain.

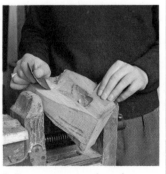

6. To continue smoothing the surface, use silicon carbide or sandpaper. Keep checking the smoothness of the finish.

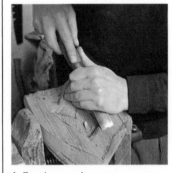

3. Place in a double boiler, melt the wax, add purefied linseed oil. Stir thoroughly to combine the wax and oil.

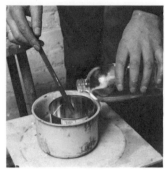

4. Add the real turpentine with great care as it is very inflammable.

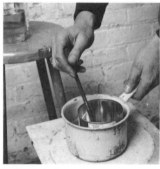

5. Stir the mixture until it is thoroughly mixed. This will take a few minutes.

6. Allow the polish to set before using. It will be a pale yellow color.

7. Apply polish to the wood surface with a soft cloth. Wax polish brings up the grain and adds a shine.

8. Leave the polish on for a few minutes while the turpentine evaporates.

9. Buff up the surface with a soft cloth.

Finished woods
This piece of sycamore has been finished with a gouge. Note the textured surface.

This piece of yew is being worked on with a U-shaped gouge. This gives the wood a ridged surface texture.

This piece of cedar has been finished until the surface is extremely smooth; however, it has not yet been polished.

The surface of this sculpture in cedar has been polished to bring up a good shine and bring out the grain.

The completed sculpture by Rudy Leenders entitled *Demagogus vulgarus* combines polished cedar and polished teak.

This other Leenders sculpture entitled *Caper politicus* is made of polished teak. Note the varied texture of the surface.

Carving foamed plastics.

History. Types of foam: Polystyrene, Polyurethane.
Tools and techniques: Joining and glueing, Coloring,
Heated tools.

F oamed plastics are a comparatively new medium for the artist. Those already established, such as polystyrene and polyurethane, are being explored with enthusiasm by sculptors and designers both for their physical properties and for their ready availability.

Although polystyrene only came on to the market in 1938 and foamed polyurethane is an even more recent development, the use of these foams is already growing in popularity.

Painter and sculptor Jean Dubuffet (born 1901) was one of the first to use carved polystyrene, and many of the monumental works created by the French sculptor, Louis. Chavignier (born 1922), are made of foamed polyurethane.

Foamed plastics are also used extensively as large-scale carved molds for cement and concrete sculptures, and as a light core for heavier substances.

Carving foamed plastics Types of foam

F oams are plastics which have been expanded with gas during their manufacture. They can be hard or soft, rigid or flexible. The two most practical and popular for carving are rigid polystyrene and rigid polyurethane, being strong, light and reasonably inexpensive.

Polystyrene

Being one of the thermoplastics group, polystyrene melts when heated and dissolves in certain solvents. It is non-toxic, but strong fumes are given off when polystyrene foam is heated. Good ventilation is essential, therefore, when heated tools are used. Polystyrene is highly flammable unless specially treated.

Expanded polystyrene, which is the type used for packaging, has a rather crumbly, open-cell texture. However, a denser material, the closed-cell, foamed polystyrene, known commercially as Styrofoam, is also available.

Polyurethane

It is a rigid, closed-cell material which varies in density. Polyurethane is a thermosetting resin so, unlike the polystyrenes, does not melt. It releases toxic fumes when exposed to heat and must therefore not be worked with heated tools.

Tools and types of foam
Foam is available is the form of either sheets (**3**) or blocks (**4**). Tools for cutting the material include a craft knife (**5**), knife (**6**) and scalpel (**7**). The hand-held hot wire cutter (**8**) can make very smooth cuts through the foamed plastic. The saw (**10**) is used for cutting off larger pieces of material. Pieces of foamed plastic can be glued together using PVA adhesive (**1**). The sculpture can be coated with plaster (**2**), which makes the surface more durable and means that you can use types of paint which would otherwise damage the actual polystyrene. It is possible, however, to use acrylic paints (**9**) directly on the polystyrene surface. Paint should be applied with standard paint brushes (**11**).

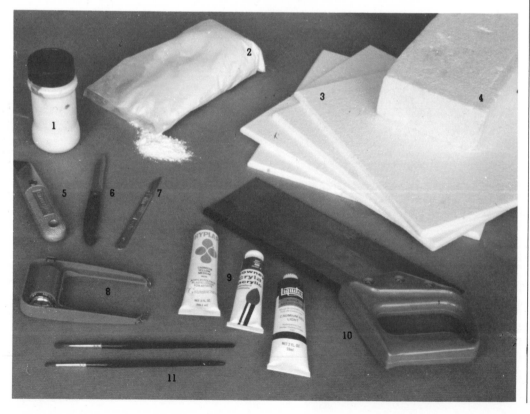

Carving foamed plastics Techniques

Most foams can be worked easily with standard wood-carving tools. The gouge and the chisel are best used with hand pressure only. Rasps, files, rifflers, planes and wire brushes are all suitable for shaping foam. Large blocks can be cut with a general purpose saw, while finer cutting is done with sharp knives and safety razor blades.

Joining and glueing
Of the several suitable adhesives for both polystyrene and polyurethane, a non-solvent glue such as PVA is used for polystyrene, and for polyurethane the rubber contact types are used.

Polystyrene can also be joined by applying solvent to the parts to be joined and holding them together, or by drawing a hot wire between two surfaces which are pressed together.

Coloring
As polystyrene is soluble in some substances, paints which contain such solvents must be avoided, unless the surface of the polystyrene is first coated with a thin layer of plaster of Paris. These include oils and polyester resins, and anything containing acetone or turpentine. Safe colorings for polystyrene include vinyl and acrylic paints.

As polyurethane is insoluble, it is unaffected by such reactions and the choice of paints and colorings is therefore very wide.

Heated tools
Although heated tools are ideal for cutting and carving polystyrene, they should not be used for polyurethane.

Hot wire cutters work on the principle of an electric current passing through a wire which softens and cuts the material. The wire should be of nickel chrome. A table model can be used for cutting large or simple shapes, while for modelling and cutting smaller surfaces a hand-cutter is useful.

An electric soldering iron or kitchen knife makes an ideal carving tool. Soldering irons can be bought with wire accessories of various shapes.

Detailed work is often done with needles or fine metal tools embedded in cork and heated over a flame.

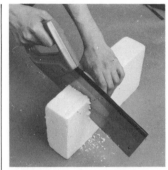

Cutting polystyrene 1. Blocks of polystyrene can be cut with an ordinary saw in the same way as a block of wood.

2. Cut edges of polystyrene can be rough and flaky owing to the composition of the material. The cutting edge should not drag.

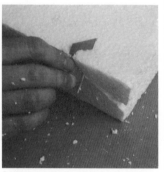

3. A sharp knife blade or safety razor blade is used to carve away small areas from the edges of the block.

4. For extra detail small slivers of polystyrene can be removed with a sharp scalpel. The Scalpel cuts are short and smooth.

5. Knives can also be used to form pattern areas on flat surfaces by chipping into the block in various ways to create a texture.

6. A hand-held hot wire tool will cut away pieces from a block. Hold the tool steady and do not force it through the material.

7. The hot wire melts the surface of the material and forms a smooth cut. Large cuts can be made with a table model of hot wire cutter.

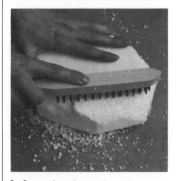

8. A wire brush roughens the surface of the polystyrene and erodes it gradually to make curved shapes and gentle angles.

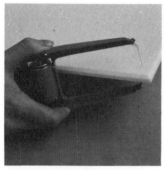

Cutting polystyrene with a hot wire 1. Hold the tool firmly and press the wire against one edge. Cut through gradually.

2. The heat in the wire dictates the speed with which it cuts. Do not force it. When the cut is finished, ease the pieces apart carefully.

3. The hot wire cutter gives a very clean cut through the material and can be used for quite complicated shapes cut in any direction.

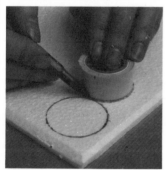

4. To cut a specific shape out of polystyrene, mark out the shape with a felt tip pen. Press lightly or it will dig into the material.

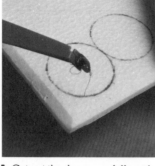

5. Cut out the shape carefully with the hot wire cutter, working just inside the marks so that they are not visible on the final object.

Glueing and joining 1. Coat the surfaces which are to be glued together with PVA adhesive, or other non-solvent glue.

2. Press the pieces to be joined firmly together, and allow the glue to dry. In this case, relief shapes are being added to a block.

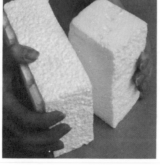

3. Two blocks of polystyrene can be joined in the same way. Press the glued sides together and leave them until the glue has dried.

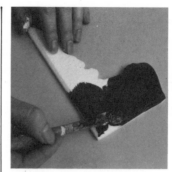

Making a painted relief 1. Cut the sections of the relief out of sheets or thin blocks and paint as required with acrylic color.

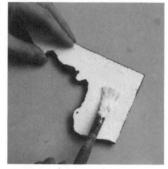

2. When the paint has dried, coat the underside of the pieces with an even layer of PVA adhesive.

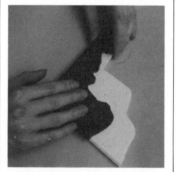

3. Assemble the pieces of the relief as required, pressing the glued surfaces firmly down. Leave them to dry.

4. A relief can be built up of ready painted pieces, or may be assembled first and painted as a whole afterwards.

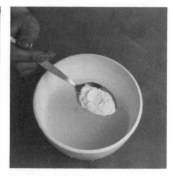

Coating with plaster 1. Mix plaster of Paris with water in a bowl until it has a thick, creamy consistency.

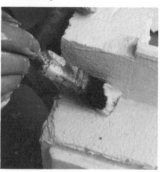

2. Pour plaster over the sculpture and use a brush to spread it into cracks and joints, until there is a thin, smooth layer all over.

3. When the plaster has dried, any unevenness in the surface can be lightly rubbed with sandpaper to achieve a satisfactory surface.

4. The plaster of Paris makes the sculpture more durable and the surface will now take paint.

Modelling.

History. Armatures. Materials and techniques: Clay, Terracotta, Wax, Plaster, Glass fiber reinforced plastic. **Tools and equipment.**

Wax has been used as a modelling material for thousands of years. As it is soft and malleable, it is generally cast into a more permanent material such as bronze. Given adequate protection however, wax is reasonably durable itself, and indeed examples of wax modelling have been found in Egyptian tombs. In China, wax was used to produce ceremonial bronze vessels during the Shang dynasty (c.1766–c.1123 BC).

The ancient Greeks used wax not only for casting but to make toy dolls and religious figurines. The Romans made wax death masks of important personages.

Clay is probably the most commonly used modelling material as it is found throughout the world and indeed many examples of its use by ancient civilizations have survived. Terracotta works provide the earliest examples of man's use of clay as, in its simplest form, it is clay baked in a fire to render the shape permanent. The addition of sands to give the clay a coarser body and the sifting of impurities later allowed potters and sculptors more scope. Terracotta was used by the Greeks, Romans and Etruscans and later became a popular medium with such Renaissance sculptors as Ghiberti (1378–1455) and Donatello (1386–1466).

Pre-Columbian cultures, notably the Zacatenco (2000 BC–AD 100), produced beautiful examples of terracotta work, especially at Tlatilco where many small figures have been found.

Since the early part of the twentieth century modelling has not played a major role in the development of sculpture, despite its use by such figures as Giacometti (1901–1966), Marini (born 1901), Matisse (1869–1954) and Moore (born 1898). Modelling is still mostly concerned with the interpretation of the visual world in a figurative way as in the works of sculptors identified with the Pop era such as Edward Keinholz (born 1927) and Claes Oldenburg (born 1929). The modelling tradition has been kept alive most recently by the works of Ivor Abrahams (born 1935), Robert Graham (born 1938) and Charles Simonds (born 1945).

Modelling Armatures

It is possible to construct an armature—a skeleton on to which 'flesh' is added—simply with clothes hangers or pieces of wood. The only requirement is that it must be strong enough to support the weight of the modelling material. If the work is to be fired the armature is removed first and so the design must allow for this. Depending on the model being produced, the support of a back iron may be necessary to keep it upright.

Lead piping is suitable for small sculptures, although pieces of wood sealed with shellac or French polish may need to be bound on, to prevent sagging.

Aluminium square section wire is commonly used for armatures nowadays as it holds its shape better than lead but is still easily manipulated. Pieces of wood wired to the frame may be necessary to bulk out the model, prevent sagging and provide a key.

If the armature is intended to support a work being executed in plaster, concrete, glass fiber reinforced plastic, or any other material used for direct modelling then a mild steel armature may be more suitable as it will remain a part of the finished piece and will not require external support. Depending on the size of the model it may be made from welded metal conduit or twisted coat hangers. If plaster is to be used directly on to a steel armature, the armature must be sealed with a metal primer or varnish to prevent rust discoloration on the finished work. Binding wire may be found useful wound around the frame to provide a key.

Wire netting and expanded metal can be used to give shape to large models. Either can be used in conjunction with a steel or wooden armature, or it can be used on its own.

As a wooden armature will absorb any moisture in the medium being used, causing cracking or distortion, always seal with shellac or an oil-based primer. Wooden armatures are less satisfactory than those of soft metal, as they cannot be bent or twisted, should an alteration be required.

Armatures can also be made from tin cans, bottles or any other inert material that gives a solid support without increasing the weight of material needed for the finished model.

Polystyrene makes an excellent core for large-volume sculptures as it has good compressive strength characteristics. It can be cut with a hot wire, old saw or craft knife and shaped with a surform or a cheese grater; proprietary adhesives can be used to fix blocks together. Polystyrene should not be used as a core for glass fiber reinforced plastics as the fumes given off during curing attack polystyrene even when a barrier agent has been employed. If hot wire is used to cut polystyrene adequate ventilation and gas-masks should be used as poisonous fumes are produced.

Making an armature 1. Bend the aluminium armature wire to the required shape. Support above the base board using a back iron.

2. Use pliers to wrap binding wire around. Knot the wire on each side and tighten up to hold the armature steady.

1. This wood and wire armature is for a model of a bounding hare. The basic shape and expression of movement are clearly visible.

2. Use wood bound with wire to shape the legs and head. Wind wire around 4 pieces of wood to give the body a box-like shape.

Modelling Tools and equipment

Wood craft shops supply modelling tools in all shapes and sizes. Clay tools are usually made of boxwood, but plastic ones are also available; steel modelling tools are best for plaster work.

Clay

Household items such as kitchen knives, wooden spoons, rolling-pins and penknives are just as effective as purpose-made tools. Broken hacksaw blades are invaluable for creating flat areas and for removing indentations by cross-scraping.

A baseboard made from thick ply sealed to prevent water absorption, plumbline, callipers, tape measure and plant spray complete the basic tool kit.

If working clay regularly a plaster bat (18 × 18 × 3in or 46 × 46 × 8cm) is useful. The clay is soaked until soft and then placed on the dry plaster surface which absorbs water. The clay is turned once or twice and wedged until the desired consistency is obtained.

Wax

Purpose-made plaster modelling tools, dental instruments, craft knives, scribers, nails or pencils are all suitable, and a glass or marble surface is required.

Plaster

A baseboard similar to that required for clay and Surform tools, which are designed not to clog with damp plaster, is particularly useful. Plaster modelling tools with a variety of shaped ends are suited to small works. Improvised tools include an old saw, cheese grater, axe and an old wood chisel.

Glass fiber reinforced plastics

Brushes are needed for impregnating rags with resin, and craft knives, scissors or spatulas are used for modelling. Rubber gloves and barrier creams are essential.

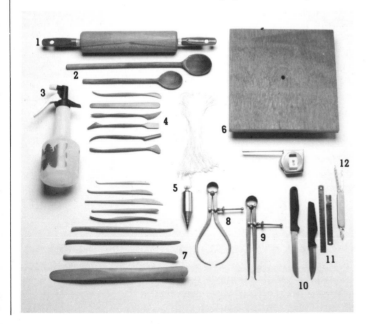

Tools for clay modelling The first essential is a baseboard (**6**) made of a good quality material, such as plywood. Modelling tools come in many different shapes and sizes. The best quality ones are made of boxwood (**7**), although plastic ones (**4**) may be suitable for beginners. Modelling tools are used for a variety of purposes from smoothing out a clay surface to creating texture in clay. Inside callipers (**9**) and outside callipers (**8**) are used for calculating interior and exterior measurements respectively. Other useful tools include a rolling pin (**1**), wooden spoons (**2**), a spray (**3**) for keeping the clay moist, kitchen knives (**10**), broken hacksaw blades (**11**), a penknife (**12**) and a plumbline (**5**).

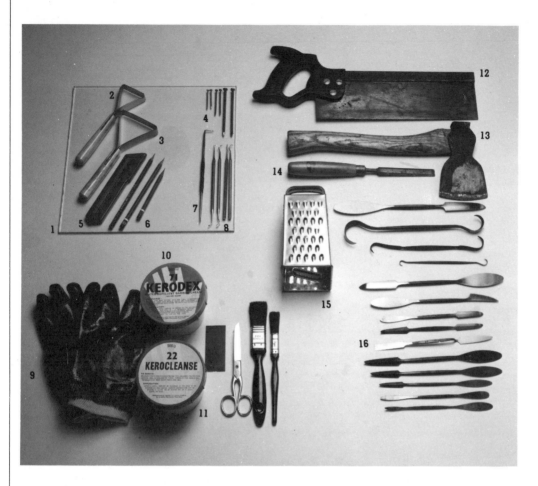

Modelling tools For working with different modelling substances, a variety of tools are needed. For wax modelling, the following are necessary: a glass (**1**) or marble surface, a wax scraper, either small (**2**) or large (**3**), a scriber (**7**), dental instruments for detail work (**8**), nails (**4**), a craft knife (**5**) and pencils (**6**). For modelling in glass fiber reinforced plastics, safety equipment, such as protective gloves (**9**), barrier cream (**10**), and cleansing cream (**11**), is vital. Also useful are scissors (**13**), brushes (**14**) and a spatula (**12**). For modelling in plaster, a range of modelling tools is (**16**) required. These tools come in a wide variety of sizes and shapes. The latter include, for example, flats, spoons, curves and rounds. Each tool has two ends which are different shapes and can be easily manipulated. When modelling, do not be afraid to improvise; many kitchen implements and household tools, such as a cheese grater (**15**), saw (**12**) and axe (**13**) and old wood chisel (**14**) have a place in the modeller's range of equipment.

Modelling Materials and techniques

Clay

Its popularity as a modelling material lies in its sensitivity to handling, particularly for fine detail. It can be used in a firm or soft state or combinations of hardness to produce the surface required. Different hardnesses of clay produce different handling qualities, indeed the French sculptor Rodin (1840–1917) kept clay in varying states of hardness for different stages of the modelling process.

Modelling is essentially an additive process, the shape required being blocked out and the surface form achieved by the addition of pellets of clay in such a way as to reveal the underlying structure. The basic form should be established from the start when blocking out and the clay applied to the entire sculpture, no one area being finalized too early. The viewpoint of the sculptor should be changed frequently both laterally and vertically.

A model that is being worked on should be kept moist by occasional spraying with a plant spray or by flicking a damp brush. Care should be taken not to soak the model as it may sag or lose detail.

If the model is left, even for a short time, it should be covered with a damp cloth and a plastic bag, such as a bin liner, used to make an airtight cover. If the model is very detailed or nearing completion, the damp cloth can be kept away from the surface by inserting matchsticks or nails at the high projection so that they protrude about one inch (2.5cm). Alternatively, a space frame can be constructed to fit over the model and support the cloth.

Terracotta

The advantage of using terracotta is that the finished model is the direct result of the sculptor's skill, no intermediary stage such as casting taking place.

When modelling with terracotta it is important to ensure that no air pockets or foreign bodies such as

plaster are trapped in the clay or it may explode during firing. It is best to avoid attaching thin sections of clay to sections of greater volume, as drying out may cause cracks to appear between the two. This can be overcome by allowing the model, when almost complete, to dry until 'leather' hard; it can then be cut in half with a cheese wire or fine blade and hollowed out to reduce the amount of clay in the thick sections. The thickness of the walls of clay should be kept as even as possible to reduce the likelihood of cracking and uneven drying. The edges of the two halves should then be roughened and slip (liquid clay) applied to one section before pressing the two sections firmly together.

Final cleaning up of the modelling is then carried out so that the joint will not be noticeable; a small puncture must be made into any hollowed-out sections to allow air to escape during firing.

If an armature has been used, the model has to be split to allow its removal. Small-scale standing figures can be produced, using only an external support.

A back iron is fitted with two prongs on to which a ball of clay is added to form the abdomen. A bed of clay is laid on the modelling board (which should first be sprinkled with sand or grog to prevent sticking) and two rolls of clay are then attached between the bed and the ball of clay to form the legs. A piece of clay flattened in the hand is attached to the top of the ball to form the back. Some loosely screwed-up paper is placed against this and a further piece of clay added to form the front. The paper will be burnt out during firing leaving a hollow trunk which, again, reduces the possibility of cracking. Clay is then added to form the head and arms, and as it gradually dries out the detailed modelling can be executed. Thus it is possible to produce a figure that does not require cutting or hollowing out.

Once it is self-supporting, but before it dries out completely, the model is withdrawn from the supporting prongs and the holes made good. Finally a hole is pierced through the navel to allow air to escape during the firing process.

A coarse grade clay is most suitable, especially for beginners modelling in terracotta, as it allows air to escape more easily and is more tolerant of varying thicknesses of section.

Firing should be carried out slowly even when the model has been allowed to dry out for a long period. If after firing the color is raw and flat compared to its appearance in the unfired state, a coat of wax can be applied; this also helps to protect the porous surface from dirt. The model should be melted until it is just possible to handle and a small amount of wax melted in turpentine, using a double boiler, should be applied liberally to the model with a big, soft brush. This process can be repeated until the desired finish is achieved, giving a final rub with a soft cloth to remove excess wax.

Clay is best stored in a container such as a bin with a tight-fitting lid. A damp sack placed over the clay helps it to retain moisture, and if it dries out it can be soaked in a bin or basin until soft and then wedged to obtain an even consistency.

Wax

As it permits alterations and reshaping, wax is an excellent medium for small-scale modelling. Its sensitivity to pressure and detailed work make it superior to many more modern modelling compounds, but its delicate nature generally requires it to be cast into a more permanent material such as bronze.

The wax used for modelling is normally microcrystalline and is a synthetic product. Traditionally, beeswax was used which, with the addition of turpentine, tallow or rosins, could be made in various hardnesses giving different handling characteristics.

Working methods for wax vary from carving from a solid block to building up in a similar fashion to clay. If the form required is best made using sheets of wax, a block should be cut up and melted in a double boiler. It can then be poured out on to a cold, damp level surface such as glass or marble and allowed to solidify. (Sheets of wax may be stored and when needed placed in warm water to make them malleable enough to use—they will need to be dried before they will stick together.)

The shapes required may be produced by building dykes from clay or wood on the surface used and these must be damp too. The form can then be achieved by melting one edge of a shape, with a candle or warm blade, and pressing a second against it. A model can quickly be built up using coils and pellets as well as sheets of wax. Modelling tools warmed over a candle are used to work or cut the model and to shape it.

Plaster

Concrete, papier-mâché and plaster are all considered permanent forms of modelling since they do not need to be cast. Concrete can be built up on an armature of wire netting or glass fiber matting; it is not recommended as a modelling medium, however, since its properties preclude fine work and once set any filing destroys the surface. Papier-mâché is useful for large lightweight structures and is built up on an armature of wire with newspaper bound around it.

Having made a suitable armature, plaster models may require bulking out with paper or wire netting in order to reduce the amount of plaster necessary. Wads of newspaper should be tied to the armature with string, making sure that the padding remains below the final surface.

Scrim dipped in plaster is then wound round the armature and padding to form a jacket; two or three coats suffice for most work. It is advisable to use the scrim in short lengths for easy handling.

When the basic shape has been achieved the final

surface layer of plaster is applied, taking care to keep the model damp. If left even for a short time the model will require wetting; otherwise the hardened plaster will absorb water from the new mix, causing cracking and flaking. The final surface layer can be applied with the hands or any suitable tool, such as a trowel, knife or spatula, but the surface should be etched to provide a key for additional plaster to adhere to. A hacksaw blade or serrated knife is useful for this and also for tracing and removing unwanted indentations.

Should the setting process need to be retarded, a small quantity of glue-size solution is added to the water before the plaster is mixed in. This method provides a long period in which the plaster can be used, and the more glue size solution added the longer the period. It also strengthens the plaster. Alternatively the plaster-and-water mix can be left to stand for 10 minutes without stirring. Although this method provides a weaker plaster, it is useful when undercutting or when patching a broken sculpture.

If a plaster sculpture is to be mended, the pieces are first thoroughly soaked in water until all air bubbles have disappeared. New plaster may then be applied and the pieces held together until the plaster has set. Cellulose fillers—such as Unibond or Polyfilla—provide an easy alternative to this process, but because of the difference in hardness, care must be taken when sanding down.

Glass fiber reinforced plastic

Resins laminated with glass fiber are useful for direct modelling where speed, strength and lightness of weight are important, but they are not as responsive as clay or wax to detail.

The simplest method is to cover a basic armature of wire mesh, steel or wood with rags impregnated with lay-up resin. These can be bulked out with paper or drawn in by tying with string—rubber gloves should be used to avoid skin contact and the work surface covered with polythene. The manufacturer's instructions on the storage and handling of resins and catalysts should be heeded.

Once the rags impregnated with resin have hardened, usually within 30 minutes, the shape can be built up using glass fiber impregnated with lay-up resin to strengthen the form. The final surface is achieved by applying a coat of fiber tissue and gel-coat or thixotropic resin, possibly with a filler added to facilitate application by a spatula or knife.

The surface can be finished with old files or rasps or wet-and-dry carborundum paper. Files tend to clog frequently, but they can be cleaned in well-ventilated areas provided a gas-mask is worn by burning out the resin in a naked flame. Carborundum wheels fitted to an electric drill can also be used in well-ventilated areas provided a mask is used.

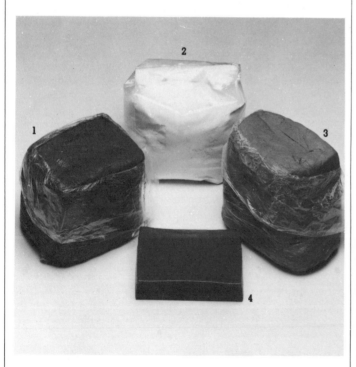

Modelling materials Models can be made of several main types of material. Terracotta (**1**) is modelled and then fired into a finished work. Plaster (**2**), clay (**3**) and wax (**4**) can all be cast into metal or resin, for example.

Modelling is either a finished process or the first stage of the more complex casting process. Resin, a more recent development, is not as responsive as clay and wax, but is quick and light to work with.

Modelling in clay 1. Make an aluminium wire armature. For an animal's head, use an angle bracket for support.

3. When the armature is covered in clay, begin to smooth it out with a modelling tool. In modelling, work from life or drawing .

2. Begin to add the clay to the armature. Start between the ears. In modelling heads, the neck and head proportions are vital.

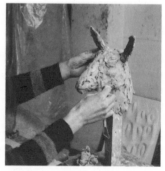

4. Begin to add in texture with a wire tool. This tool is also used for working up detail, such as the eyes.

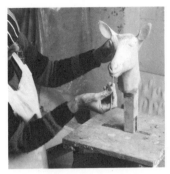

5. Continue to smooth out the clay and work up the detail gradually, until the model is complete.

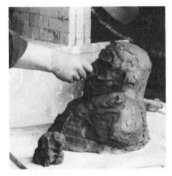

Terracotta modelling 1. Rough out the basis of the model in terracotta clay until the overall shape is apparent.

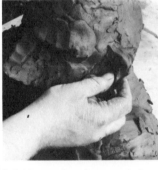

2. Add extra clay where needed and begin to form specific shapes and details, working the fresh clay to the basic shape.

3. Use a spatulate modelling tool to remove surplus clay and carve out shapes. Continue smoothing out the shapes with the fingers.

4. Use a tool to gouge out cavities and detail features. Work with hands and tools until the model is complete.

5. If the model is to be left overnight or for any length of time before further work is done, cover it with a damp cloth.

6. Cover it also with polythene, loosely draped over and weighted on all sides. The model will remain fresh and damp.

7. When the model is finished and has dried out a little (but is not completely dry), cut it in half by drawing wire through it.

8. The clay is still damp, but will not sag with its own weight. Draw the halves of the model gently apart.

9. Hollow out the inside of both halves with modelling tools until all the clay is of the same depth. Smooth down with the fingers.

10. Paint thin clay slip around the edges of the hollowed out forms to soften the edges slightly and act as an adhesive.

11. Press the two halves of the model together, so that they are perfectly joined. Some of the slip will ooze out from the join.

12. Work over the join around the whole model with fingers and modelling tools so that it is completely concealed.

13. When the model is ready for firing, put it in the kiln. Heating to the required temperature makes the clay durable and hard.

Wax modelling 1. The first task in wax modelling is to prepare a sheet of wax. Spread oil evenly over a marble slab.

2. Heat the wax until it is liquid, and scoop some out with a ladle. Pour it quickly and evenly over the oiled marble surface.

3. The wax must be allowed to cool slightly, but not too much. Meanwhile, brush oil over the palms of the hands.

4. Lift the wax carefully with a broad, flat knife, so that it lifts as a whole skin from the marble without cracking.

5. Flip the wax over with the knife so that the other side cools flatly against the slab. It should still be warm and flexible.

6. Knead the wax into a malleable ball. Work it vigorously until it is the correct texture.

7. The wax is ready for modelling when it is in a pliable lump with a texture similar to soft toffee. If it hardens too much, it will crack.

8. Start to model the wax into the basic shape required, and continue the modelling process with hands and tools.

9. A correction or repair can be made to a wax model with fresh wax. Mold the soft wax on to the model with the fingers.

10. Tools for wax modelling can be heated in a flame. Check whether the tool can be left in the flame or just passed through it briefly.

11. The hot tool melts the wax and gently molds the forms together. First work up the basic shape of the form required.

12. Continue to work, heating the tool again when necessary, and begin to describe details of form and surface finish.

13. This type of wax modelling is used for small models. Wax can also be modelled on to a core of a different material.

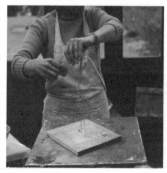

Modelling direct in plaster
1. Make a wire armature and bend it into an appropriate shape.

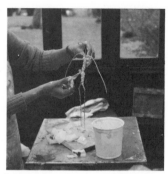

2. Twist some thinner wire around the armature to create a key so that the plaster will adhere to the wire.

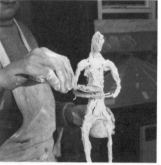

3. Dip scrim or bandage into the plaster and wrap it round the armature. This builds up the core of the model. Allow to set.

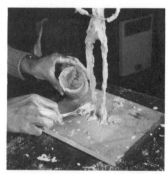

4. Mix a small amount of plaster and apply with a metal tool to work up the detail. For fine detail, use smaller tools.

5. When sufficient plaster has been added, shape with a Surform blade to remove excess plaster and complete the detail work.

Casting.

History. Suitable subjects. Casting molds: Clay, Plaster of Paris, Cire perdue. **Filling molds:** Bronze, Other metals, Plaster of Paris, Polyester resins, Liquid clay.

Suitable subjects

T he basic principles of casting have not changed since the Bronze Age when tools and weapons were made from an open mold carved out of rock. The molten metal was poured into the mold and allowed to set. This technique was universally used by early civilizations and the methods and materials are still being developed today.

The earliest known bronze dates from *c.*5000 BC, although cast bronze tools were not in general use for another 3,000 to 3,500 years. The first Egyptian bronze casts appeared several hundred years later and Egyptian casting was at its best during the Saite dynasty (*c.*600 BC). Works of this period include the statue of Horus, in the Louvre.

The ancient Greeks used bronze extensively for casting small statuettes, and this practice was later extended to larger works. Like many early civilizations they used sand as a mold, as well as developing the cire perdue ('lost wax') method of casting from wax.

Although casting was used in Africa and China, and in much Roman and early Christian art, it suffered a decline during the Middle Ages and did not really emerge until the early years of the Renaissance in the fourteenth century. By the 1400s Lorenzo Ghiberti (1378–1455), creator of the famous Baptistry doors in Florence, had established a studio and foundry, paving the way for such masters as Donatello (1386–1466) and the Pollaiuollo brothers, Antonio (1432–1498) and Piero (1441–1496).

The influence of the Renaissance was widespread and casting flourished in foundries and studios throughout Europe. By the seventeenth century, cast bronze was being increasingly used in furniture-making, especially in France, where many famous sculptors who used metal casting were later to live and work—among them Auguste Rodin (1840–1917) and Constantin Brancusi (1876–1957).

A more recent development in the history of casting is the use of plaster of Paris. The casts of such antiquities as the towering Trajan column and Michelangelo's David, which can be found in the collection of plaster replicas in London's Victoria & Albert Museum, demonstrate the immense possibilities of plaster casting.

Although traditional casting materials, such as bronze, are still being used, many new ones such as plastic and concrete are being developed. Different ways of using metals have emerged too. The Swiss sculptor, Max Bill (born 1908), and the Briton, Eduardo Paolozzi (born 1924), were among the pioneers of metal-plated bronze casts. The British sculptor Henry Moore (born 1898) was one of the first artists to experiment with cast cement in his architectural sculpture, while plastic and other synthetic materials are widely used for casting in all art schools.

M ost objects and pieces of sculpture can be cast, and the only exceptions are works which are too large to make casting practical or works which involve fine constructions of such materials as thread or wire.

The purpose of casting is to reproduce something in a more permanent, durable material than the original, or to make a number of replicas. Everyday items, or 'found objects', provide unlimited scope for casting, and toys, domestic utensils, stones and pieces of wood are just a few of the objects which have inspired contemporary sculptors.

Casting molds

The artist has traditionally relied on clay, sand, wax and plaster of Paris for making molds. Today, however, the choice is wider, encompassing rubber, concrete and plastics, for example. Clay, plaster and polyester are probably the most suitable media for studio casting, especially for the beginner. Metal casting, using either the sand or cire perdue methods, is usually done in a foundry.

Clay

Clay molds can be made quickly and are suitable for casting plaster, wax or concrete. The master cast should first be dusted with talcum powder or French chalk to prevent sticking. The clay is shaped into fairly thick, flat pieces which are then pressed carefully on to the master cast, the edges fitting closely against each other. The back of the clay should be roughened and each piece reinforced with plaster strengthened with gauze, or scrim. The mold pieces are held in a case which is made by taking a thick plaster and scrim impression of the back of each piece. The mold pieces should first be sealed with shellac and treated with the separating agent. The case sections are then joined together by wooden rods fixed with plaster and scrim, forming a tight-fitting case for the mold.

Plaster of Paris

The two basic types of plaster mold are the waste mold and the piece mold. The method chosen will depend on the material the mold is to be taken from and the number of casts required. The waste mold can only be used once and is suitable for use with a soft object, or master cast, such as wet clay, Plasticine or wax; the piece mold can be used many times and is normally used when the master cast is of a hard substance such as set clay, plaster, plastic or metal.

The waste mold is eventually chipped away from the cast and cannot be re-used. A mold taken from a very simple master cast will probably only need to be made in two parts—the main part and the cap. The more complicated the master cast the more caps will be required on the mold, as the caps enable the modelling material of the master cast to be removed.

For a simple shape requiring a two-piece mold a

line is drawn on the master cast to mark the division between the main mold and the cap. The division can be made by building a clay wall using strips of clay about half an inch (1.25cm) wide. The cap is made first, the strips being laid along the dividing line leaving a clean edge on the cap side. These walls can be reinforced with clay supports on the other side. Alternatively, the mold can be divided by using brass strips, or shims. These are inserted evenly into the master cast along the dividing line making a continuous wall at least half an inch (1.25cm) high. The shims can be cut to fit the shape of the master cast.

Small quantities of plaster are mixed at a time to avoid waste, and this is built up in layers on the cap. Care should be taken not to cover the top of the clay dividing wall and the first coat of plaster should be colored with a warning dye. When the cap is dry the clay wall is removed and the plaster edge treated with a separating agent such as wax or grease. The main part of the mold is made in the same way after which at least an hour is allowed for the plaster to dry. The mold is then soaked in water and gently parted along the join. Both pieces are then cleaned and treated with the separating agent before use.

The piece mold, as its name suggests, is made in any number of pieces which are supported and held together by a mold case. This method requires patience and practice, and can be used only when the master cast is made of a hard substance. The main advantage of the piece mold is that it can be used many times over.

The surface of a porous master cast, such as plaster, must be sealed with shellac and then treated with the separating agent. To make a simple piece mold of three parts—the main piece and two caps—the dividing lines are drawn on to the master cast.

The side of the master cast which will eventually form the main piece of the mold is firmly embedded in a platform of clay and a wide clay band fitted round it about a quarter of an inch (0.6cm) below the dividing line. Plaster is then built up on top of this, up to the dividing line, a small neat gap being left between the plaster and the master cast. The plaster is then trimmed and treated with the separating agent. The small gap is filled with clay to mark the seam line.

A clay wall is then built between the two caps and enough plaster mixed to make one of them. When this cap has been formed with plaster, the clay wall is removed and the separating agent applied to the new plaster edge. The second cap is then made in the same way.

Before the work is turned to make the main mold piece, a case is made to hold the two complete caps. This is done by applying the separating agent to the backs of the caps and building up a thick plaster covering. When this is hardened, the whole work is turned over, the bands of clay and plaster removed, and the main mold piece made. The third mold

piece is thicker than the caps and does not need to have a case.

Polyester resins
Polyester can be used to make a cast that is both strong and light. The method is very similar to the piece mold, one of the basic types of plaster mold. A porous master cast must be sealed with shellac followed by a wax polish. The seam walls are built up with Plasticine and the mold pieces are built up with resin reinforced with glass fibers cut to the right length. Resin painted on to the master cast, forms the first layer. As resin can be drilled the seams can be held together with bolts.

Resin must be mixed before use with a catalyst to harden it, an accelerator to speed up the hardening and a filler to make it less runny. Quantities and types of these resin additives vary and the manufacturer's instructions should be followed.

Cire perdue
This ancient method of casting metal from a wax positive is a job for the professional founder. The original master cast can be of any material but a wax positive must always be made from this. Most types of mold are suitable for this, although one of the flexible types is usually selected.

Melted wax is painted in a thin layer on the inside of the mold to ensure accurate reproduction of fine detail. The mold is then put together and filled with wax. This is poured out leaving a thin deposit of wax on the inside of the mold. The process is repeated several times until the correct thickness has been achieved. The wax positive is then ready and the mold can be taken off. The seam marks are removed at this stage. The hollow wax positive is then filled with a core of porous clay, or another fireproof substance, which is held in position by metal rods.

The wax positive is fitted with a system of runners and risers, a series of tubes through which the molten metal will eventually run and the hot gases rise. At this stage they are wax rods joined on to the positive; when the wax has melted, however, they become hollow spaces in the finished mold. A hole is left at the base of the work through which to pour the hot metal.

The wax positive is then ready for its final coat, or investment, which is usually made of plaster of Paris mixed with ground ceramic. The first layer is painted finely on to the wax and the remainder built up into a thick covering. When dry, the whole investment is heated until the wax has melted and run out through one of the runners which has been extended through the investment. Before the molten metal is poured into the runner system, the specially extended runner must be plugged and the whole investment reinforced by being buried in sand.

Materials for casting

Casting materials include plaster (**1**), modelling clay (**2**), French chalk (**3**), separating agent (**4**), polyester resin (**5**), red wax (**6**), glass fiber (**7**), plasticine (**8**) and builder's sand (**9**). Various types and grades of plaster are available, experiment and find which suits your purposes best; a fine grade of plaster is best for making a plaster cast. Dental or medical plaster is suitable. In addition to clay, slip (liquid clay) is sometimes needed. To make this, mix finely ground clay with water to a creamy consistency. French chalk is used as a separating agent, talcum powder may be used instead. Glass fiber is used to strengthen the cast at different stages, particularly in the resin casting process. Builder's sand is used in the foundry for filling the pit in which the mold is placed, before it is cast into metal.

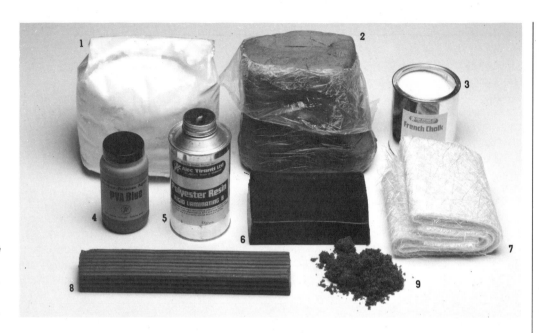

Casting Filling molds

 aving made the mold with the cast in mind it should be noted that each casting material has its own properties and special problems.

Bronze

Whether cast in sand or by the cire perdue method, bronze casting is normally carried out in a foundry. The bronze is melted in a furnace to a temperature of about 1880°F (1010°C). The molten metal is poured quickly into the mold before it starts to cool.

Other metals

Most metals are cast in a foundry. With the exception of lead, metals cannot be poured directly into a mold because of the gases given off forming bubble holes in the finished cast. Casting temperatures for different metals vary considerably. Gold and silver, like bronze, require a casting temperature of about 1880°F (1010°C). Lead, however, requires a much lower temperature and can be melted in an iron saucepan over a cooker. Because it does not give off gases when hot, lead does not need the complex system of runners and risers which other metals require. This makes lead a popular studio metal, but it should be noted that it is subject to some shrinkage during cooling.

Plaster of Paris

For a solid plaster casting, a plaster mold should be lined with soft soap or detergent. As plaster of Paris dries quickly a sufficient quantity should be mixed to fill the mold. This should be poured gently until the mold is full; the mold should be moved a little during pouring to help release air bubbles. When the plaster has set the mold should be turned upright to allow the plaster to drain, and left for at least an hour.

Polyester resins

Resins are the most common plastics used for casting. The cast is usually hollow and built up against the mold using glass fiber for reinforcement. Only the very smallest objects can be cast in resin by the pouring method.

Many mold materials are suitable for casting from in resin, including plaster of Paris, rubber and resin itself. The separating agent varies for different resins, but Polyvinyl Alcohol (PVA) is generally suitable. The first one or two layers of resin, made up according to the manufacturer's instructions, are painted on. The glass fibers are cut to fit the mold and built up to the required thickness with more resin.

Liquid clay

Slip, or liquid clay, is ideally suited to a porous mold such as plaster of Paris. The slip is poured into the mold which absorbs the water from the slip, leaving a sediment of thick clay around the mold. The longer the slip is left in the mold, the thicker the layers of sediment will be. When the correct thickness is achieved the thin clay should be poured away and the hollow clay cast allowed to harden before the mold is taken out.

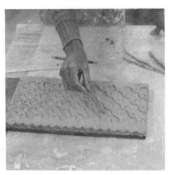

Clay pressing 1. Press a pattern into a sheet of rolled out clay. This simple form of casting can be used for making jars or vases.

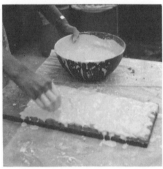

2. Mix some thinnish plaster, flick over the clay bed to cover the pattern. Back up with thicker plaster and make an edge.

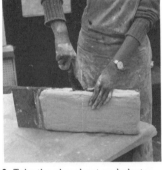

3. Take the clay sheet and plaster mold off the backing when the plaster has set.

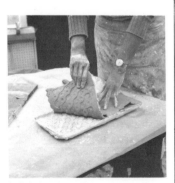

4. Lift the clay off the plaster. Try not to leave any clay on the plaster surface.

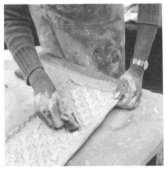

5. Clean and smooth the plaster using a Surform blade or silicon carbide paper. Brush off excess dust.

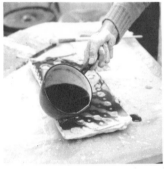

6. Pour melted wax on to the plaster and brush into all the crevices. Allow to set.

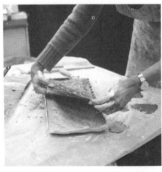

7. Peel off the wax carefully. Wax does not adhere to wet plaster. Bend the wax sheet round to form a vase.

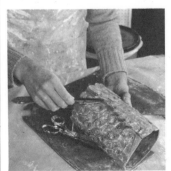

8. Tie with wire or an elastic band. Trim excess wax off the edge. Firm up joint with a hot tool.

9. Measure and cut out a base from a sheet of wax. Scissors can be used. Paint base with hot wax.

10. Put body firmly on the base. Fill in joints with hot wax. The wax can now be sent to the foundry for casting.

Mixing plaster 1. Sprinkle plaster over the surface of water in a bowl until the plaster is just below the water surface.

2. Put your hand in the bottom of the bowl and shake gently to mix the plaster. Do not make the plaster too thick .

Waste mold 1. Start with a clay model (see previous chapter). Roll out a sheet of clay, cut into strips and make a wall.

2. Place the wall along the center of the model. Add pieces of clay to support the wall which will divide the two halves of the mold.

3. Cover the board and any other areas to which the plaster is not to adhere with grease or oil.

4. Add a little blue color to the first coat of plaster. Flick the plaster on so that it covers the whole surface thinly.

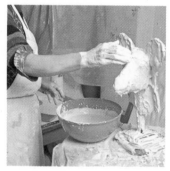

5. Apply a second thicker coat of plaster. Build up plaster gradually with a wiping movement. Build up the edges.

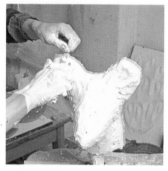

6. When the plaster is slightly dry, cut back on the edges with a knife to reveal the clay wall.

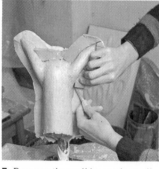

7. Remove the wall by peeling off the clay. Be careful not to damage the plaster.

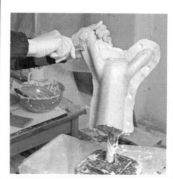

8. Make locating — or key — holes in the plaster with the rounded end of a knife. The holes should be about ¼in (6mm) deep.

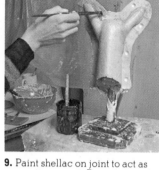

9. Paint shellac on joint to act as separating agent. Repeat steps 4 and 5 to complete the waste mold.

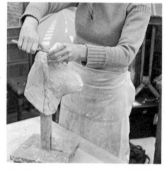

10. Scrape back the completed waste mold with a knife to reveal the shellac-painted joint.

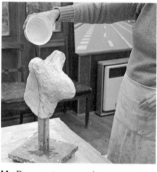

11. Pour water over the seam to swell the clay inside and help separate the joint. Prise the two halves apart with a blunt chisel.

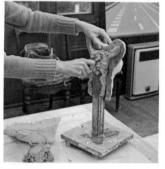

12. Dig the clay out of the mold with a wire tool.

13. Wash out the mold in cold water until it is completely clean. Clay will stain the cast so remove carefully with a brush.

14. Paint the inside of the mold with a separating agent, a weak solution of washing soda (sodium carbonate) and water.

15. Put the 2 halves of the mold together and tie together tightly with thin galvanized binding wire.

16. Mix plaster to the consistency of thin cream. Pour into the mold.

17. Turn the mold round to coat the whole surface, especially any crevices. Build up thickness of the cast to at least 1in (2.5cm).

18. Where necessary, reinforce the back of the cast with scrim which has been dipped in the plaster.

19. When the plaster cast has set, undo the wires and chip away the plaster mold down to the blue coating.

20. Chip the exposed blue coat away. Be careful not to damage the cast underneath.

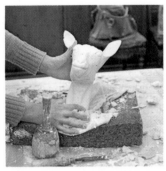

21. Continue to chip away at the blue coat until the finished plaster cast emerges.

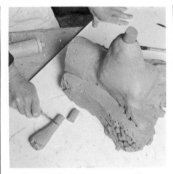

4. Cut a roll of clay into small pieces, the 'chimneys'. Place on the nose and ears. Add a strip of clay around the edge.

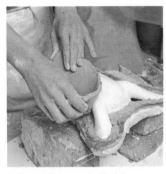

8. Take off the top half of the case and remove all the clay including the chimneys from the case and the original.

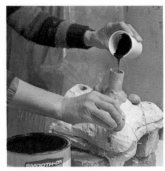

12. When the solution begins to come out of the holes, block them with the clay balls. Allow to cool. Repeat for the other side.

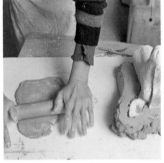

Flexible mold 1. Take the finished plaster cast. Roll out a ½in (1.25cm) thick sheet of clay.

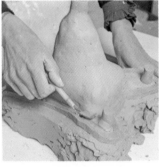

5. Key in with a wire tool. Cover with plaster, allow to dry. Remove from clay bed and turn over. Repeat for the other side.

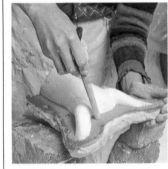

9. Smooth down the dividing layer and add keyholes.

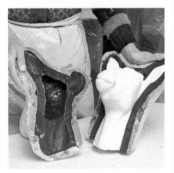

13. Take the halves of the mold apart. No separating agent is required. The finished mold can be used many times.

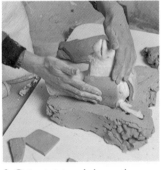

2. Cut out strips of clay and press on to the cast. Repeat until the whole of the cast is covered.

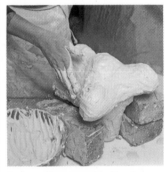

6. Cover the second half with plaster. Allow to dry. A flexible mold has the advantage that it can be reused.

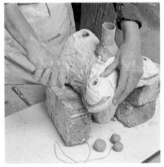

10. Replace the case, tie together with wire, add the funnel and make clay balls.

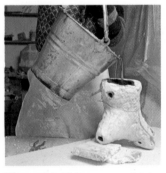

Wax cast 1. Melt wax, pour it into the mold inside the case. Allow to cool. When the wax is about ⅛in (3mm) thick, pour the rest back.

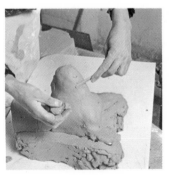

3. Smooth out the surface with a modelling tool or your fingers. The clay represents the rubber compound of the flexible mold.

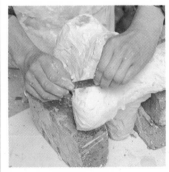

7. Using a knife, scrape back the plaster so that the chimneys show through clearly.

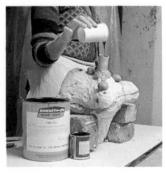

11. Mix the rubber solution according to the manufacturer's instructions. Pour into the funnel.

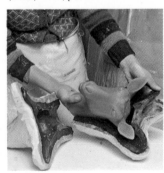

2. When the wax has cooled, take the mold apart carefully, revealing the wax cast, which can be sent for casting into metal.

Casting Casting in metals such as bronze is not a studio process; it must be done in a foundry. For the cire perdue or lost wax process, the sculptor provides the foundry with either a wax positive, such as can be made from a flexible mold, or a plaster master cast from which the foundry produces a wax positive. The wax is filled with a core of porous clay held in place by metal rods. Next, a series of tubes called the runners and risers are fitted, through which the molten metal will be poured and the gases will rise. The final coat of plaster, the investment, is added, the whole is heated, the wax runs out, leaving a space into which the metal is poured. Lastly, the cast is finished by the sculptor. Casting in resin is a more recently developed cold process which can be done in the studio.

Resin casting 1. For resin casting, start with a flexible mold in its case. Take out the master cast.

2. Resin casting equipment includes brush cleaner, resin, pregel paste, catalyst, gloves, barrier cream, metal powder.

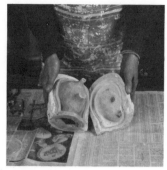

3. Make the resin solution exactly according to the manufacturer's instructions. Add metal powder and mix thoroughly.

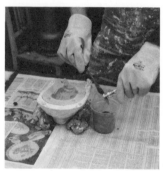

4. Add the exact amount of hardener and mix well. Treat the resin materials with great caution as they are highly toxic.

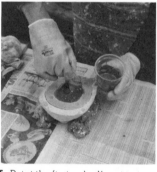

5. Paint the first or 'gel' coat in to the mold. Cover all cracks and crevices. Leave for about 25 minutes to set.

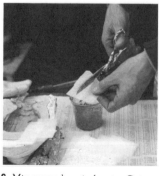

6. Mix second coat of resin. Cut thin strips of glass fiber. These will be used to reinforce the cast.

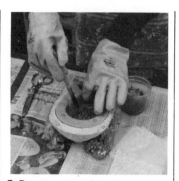

7. Paint in resin, place the strips one at a time in the mold and stipple in to place. Make sure there are no air bubbles.

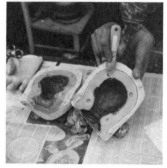

8. Build the cast up to about ¼ in (6mm) in thickness. Trim off excess resin. Repeat process for the other half.

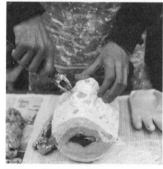

9. When the resin has set, place the 2 halves together and tie with wire.

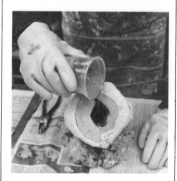

10. Mix more resin with metal powder and pour in to the joint. Make sure that it goes all round the joint. Allow to set.

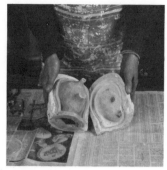

11. Remove the wire, open the mold and take the case off one half at a time. Take care not to damage either the case or mold.

12. With great care, remove the one half of the mold from the cast. Repeat for the other half.

13. Clean up the seam and remove any excess resin. Use a riffler for small works or power tools for large scale pieces.

14. With wire wool, buff up the cast to bring out the metallic sheen.

Metal sculpture.

History. Types of metal: Aluminium, Brass, Copper, Iron, Steel. **Tools. Techniques:** Welding, Annealing, Tempering, Soldering, Riveting, Painting to prevent rust, Finishing.

The art of direct metal sculpture, as opposed to metal casting, belongs essentially to modern times with a large proportion of all contemporary sculpture using metal of some kind.

Although some of the metal-sculpting techniques were known to ancient man, they were employed mainly in craft work such as the hammering and beating of armor and the carving and engraving of jewelry.

The metal-workers of ancient Egypt beating sheets of gold over a carved wooden form and the Roman craftsmen hammering out bronze masks clearly have direct links with skilled metal-workers today. Modern artists use the forging techniques of the blacksmith, the carving and engraving skills of the jeweller, and the welding and riveting processes of the shipbuilder.

The discovery of oxyacetylene welding in 1895 brought many new possibilities and scope for sculptors, both in scale and technique. The first artist to exploit this innovation was the Spaniard Julio González (1876–1942). His welded work appeared in 1927 and he later passed on his skill to Picasso (1881–1973).

Many artists were quick to realize metal's positive qualities as a sculpting medium: it can be cut, welded, molded, cast, polished or patinated and the final result is of a durability that surpasses all but the hardest stones. By the 1940s many of those artists experimenting with welded metal, such as the American sculptor David Smith (1906–1965), were achieving recognition. Within another ten years the art of metal sculpture was firmly established, a development which is demonstrated clearly in the works of such British artists as Anthony Caro (born 1924), Alexander Calder (1898–1976) and Lynne Chadwick (born 1914).

Metal sculpture Types of metals

The experienced metal-worker is aware of the qualities of each of the different metals, notably their malleability, ductility (how easily they can be drawn out into wire) and, of course, availability and expense. Most metals can be bought in bars, sticks, rods, tubes or sheets.

Aluminium
This very satisfactory welding metal is difficult to model because it loses form completely when heated.

Brass
This copper and zinc alloy is commonly used for welding, but care must be taken to avoid inhaling the poisonous fumes which are released. Brass is malleable, takes a high polish and resists corrosion.

Copper
A malleable and ductile metal, copper combines well to make other metals such as brass and bronze. It is unaffected by water or steam, but it reacts with oxygen in the air and turns green.

Iron
Pure iron rusts readily and it is becoming increasingly rare in sculpture. Alloys are more common, and wrought-iron is frequently used because the smelting process makes it tougher than pure iron. Wrought-iron is malleable, ductile and easily welded.

Steel
Of the wide variety of steels, some are too hard and brittle to work. Stainless steel, for instance, is difficult to model but comparatively easy to join; mild steel is one of the most popular for welding.

Types of metal It is important for the sculptor to be aware of the qualities of the metal which he or she is going to use. Aluminium, for example, is available in the form of hexagonal bars (**2**,**6**) or cylindrical bars (**3**, **1**) of different sizes. Among the more popular metals for sculpture are copper (**4**) and brass (**5**), here in sheet form. A wide range of steels are manufactured, but many may be too hard or brittle to work. Like aluminium, steel is made in the form of cylindrical (**7**) or hexagonal (**8**) bars, as well as sheets or rods. Mild steel is the most popular form for welding.

Tools for metal sculpture
Working in metal requires a range of specialized equipment. An engineer's vice (**8**) is an essential piece of basic equipment. It should be firmly fastened to a work bench. An anvil is also a useful piece of equipment; a small model (**9**) can be used on a work bench, but a larger version can have additional attachments such as a swage, which is used with molten metal. The range of hammers needed includes a sledge hammer (**1**) for heavy work, a hide hammer (**3**) which does not damage the surface of the metal, a scaling or chipping hammer (**4**) for chipping away at a welded joint and a ball pein hammer (**5**). Among the wrenches used in metal working are a small and large adjustable wrench (**2**) and a self-locking, adjustable plier wrench (**7**). A choice of chisels, including small and large (**6**), is also vital.

Welding
Any means of fusing metals is known as welding, and it is normally done by arc-welding which requires a sustained electrical discharge or by flame-welding using oxyacetylene.

Oxyacetylene, a combination of oxygen and acetylene, is the most common source of energy for the heat, although other gases can be used. The welder's torch, or flame, is run along the two pieces to be joined until the metals melt and fuse.

Arc-welding is quicker than flame-welding but it is less versatile. The process is most often used for welding steel; it is unsuitable for modelling and detailed work because of the intense heat and light and the necessity to wear cumbersome protective clothing which hinders access to the work.

Annealing
This is an industrial means of heat-treating metals to make them more easily workable when cold. Annealing also corrects stresses inherent within the metal. The temperature to which it should be heated varies according to the type of metal but should not be hot enough to change its structure. Copper may be cooled in cold water after heating. Other metals should be allowed to cool more slowly in the air.

Soldering
A join which will not be required to take any strain can be executed with soft solder, an alloy of lead and tin, which has a very low melting-point. Hard solder always contains a high proportion of the metal being worked on and has a higher melting-point. Both types of soldering require the metals to be cleaned with a flux first; this is a solvent which is painted on to the cleaned surface to dissolve dirt and grease, thus enabling the solder to take properly.

Tempering
Steel can be brought to a required degree of hardness and elasticity by the process known as tempering. The term is usually applied to tool steels, which are heated to a specific temperature before being quickly immersed in cold water.

Riveting
Holes for rivets can be drilled or punched. The rivets can be countersunk, and the subsequent filling and grinding down make them completely invisible. Rivet joins are permanent; for removable joins, bolts and screws can be used.

Painting to prevent rust
Proprietary paint finishes can be clear or colored and are always sprayed on to the work in a succession of thin coats rather than brushed. The surface of the work should first be rubbed down with an abrasive to provide a key for the paint.

Alternatively, rusting can be prevented by spraying the model with particles of a rust-resistant metal, such as zinc.

Finishing
Most metals can be colored by chemicals: copper and brass, for example, turn green when bathed in a solution of hot copper nitrate. Steel turns black if it is subjected to a jet of steam when red-hot.

Welding 1. To prepare the surface of the metal, brush off excess rust with a wire brush.

2. Place the edges which are to be welded together. Welding at the edge gives a stronger joint.

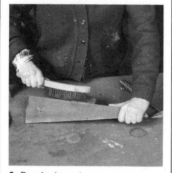

3. Before beginning to weld, balance and, if necessary, support the pieces so they are steady. Clamps can also be used.

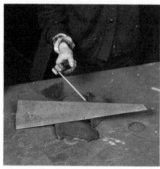

4. Weld the edges by weaving the flow of molten steel from the electrode across the edges.

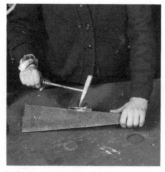

5. Remove balancing pieces or clamps and, wearing safety goggles, chip off excess slag with a chipping hammer.

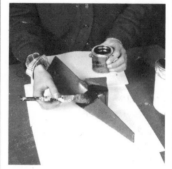

6. Brush along the joint to clear off the slag. The electrode consists of an outer coat of slag and the steel core which is melted.

Using the grinder 1. The grinder is used to clean the joint up. Goggles should be worn because of the dust.

2. The grinder must be held with great care to ensure that it stays steady. The grinder can also be used to remove a faulty weld.

3. The finished seam should be shiny in appearance.

Priming 1. After preparing the metal, paint on a first coat of red or white oxide primer. For large areas use a mask in case of fumes.

2. Two coats of primer will normally suffice. White primer oxide is better if colored paint is to be used to finish the surface.

Painting 1. Apply one coat of emulsion paint to the primed surface.

2. After adding a second coat of paint, apply a coat of matt polyurethane varnish to protect the surface.

3. Spray paint can also be used. It is hard-wearing and comes in a wide variety of colors.

Cutting 1. An oxyacetylene torch can be used to cut through metal. It should only be used under close supervision.

2. The torch is lit with a flick gun. Stringent safety precautions are vital when using this equipment.

Kinetics.

History. Techniques, devices and equipment: Hanging mobiles, Arrangements with wire, Pendulum effects, Electro-magnets, Sources of power.

Kinetic art involves time and motion. Some or all of the elements of the work are designed to show movement, using electricity, air currents, any form of mechanical or magnetic device, water pumps or the controlled play of light across or through a surface. The development of sculptural forms which emit light is a specialized area requiring a basic knowledge of electricity.

The pioneers of kinetic art, intrigued by the development of motion pictures and by the technology of the machine age, began to investigate ways of including real movement in their work, rather than relying on the static, illusionistic forms of traditional painting and sculpture. Despite a few early attempts, kinetics is basically a twentieth century concept. In 1920 Naum Gabo (born 1890) completed his sculpture *Standing Wave*, a vibrating metal rod which appears to create volume. Laszlo Moholy Nagy (1895–1946) made the *Light Space Modulator* (1930), a spotlighted six foot high sculpture of aluminium and chrome plating, which is set in motion by an electric motor. Marcel Duchamp (1887–1968) also experimented with moving sculptures, often incorporating rotating glass discs. But one of the most dedicated of the pioneers was Alexander Calder (1898–1976). Best known for his mobiles, which rely only on the effects of air currents, he worked continually with moving forms throughout his career.

Kinetic works have often been unsubtle and stultified, relying only on the moving elements for their interest. But many complicated and exciting pieces have been produced, most notably among contemporary artists by Nicolas Schoeffer (born 1912), Jean Tinguely (born 1925) and Pol Bury (born 1922). Schoeffer's works are large scale—some more than 164 feet or 50 meters high—and feature flashing lights and mirrored reflections.

Tinguely expresses his ambivalence towards manmade mechanisms by creating complicated constructions of machine parts, some of which are designed to blow to pieces when they have completed their mechanical cycle. In Bury's smaller works the movement of the parts is minute and obsessive, unnerving because the power source is hidden. These and other artists such as Takis (born 1925) and George Rickey (born 1907) made kinetics one of the most inventive art forms of the 1960s, and many painters and sculptors continue to investigate possibilities of movement, some now working entirely in the area of sculpture with light.

Kinetics Techniques and devices

As Calder's *Mobiles* have proved, not all kinetics depend upon machinery. Artists reacting against machinery have used media such as plastic tubes filled with gas, sheets, bicycle wheels, flags, kites, streamers—anything, in fact, which will require only manual movement or the assistance of wind and air currents. Some basic kinetic techniques are covered here, and from these more complex ideas can be developed.

Hanging mobiles
Variously shaped objects of paper, metal, mirror, plastic or fabric are suspended from varying lengths of string, cotton, wire, plastic rope or nylon cord. These are in turn attached to a wooden or metal framework or strip which can be suspended from the ceiling.

Arrangements with wire
Wire can be used quite simply in an arrangement which will exploit its tendency to vibrate. A light ball-bearing, table-tennis ball or flat piece of metal with a drilled hole can be attached to one end of a piece of medium gauge piano wire. If table-tennis balls are used the wire should be tipped with glue and skew-ered right into the ball until it touches and adheres to the other side. The other end of the wire is inserted into a wooden base with drilled holes. Several wires thus mounted will produce a row of antennae which will sway and vibrate if agitated by hand or by wind. The wires can be of varying lengths and part or all of the arrangement can be painted in different colors.

Pendulum effects
Ball-bearings—five, seven or nine, depending on personal choice—are suspended in a row on V-shaped lengths of twine or wire, attached to the longer, top sides of a rectangular wooden or metal frame to make a 'Newton's cradle'. The ball-bearings can be made to demonstrate a cause and effect movement—for example, one ball-bearing collides with another causing it and then the others to move in sequence.

Electro-magnets
Apart from motors and lighting devices, electro-magnets have been used in kinetic sculpture to provide movement. Electro-magnets such as solenoids can be combined with switches, relays and timers to create and control movement.

Sources of power

Slide projections, kaleidoscopic rotations and bursts of color and pattern require a power source such as light, motor or clockwork.

A simple clockwork device which is available from craft stores or a small electric motor will produce movement. An electric motor should be chosen on the basis of voltage, the workload it will perform, the type of motor and the speed at which the shaft turns.

Equipment

Most simple kinetic art concentrates on the movement of the piece and relies on straightforward techniques using a variety of media which ranges through metal, wire, string, paper, cardboard, plastics and wood.

Tools and equipment include whatever has been selected as the principal media and the relevant tools, and any of the following items can be useful: metal, wood, paper, card, cardboard, plastic, balsa wood or plywood, paper bags, beads, ball-bearings, table-tennis balls, matchsticks, string, wire, scissors, craft knife, compass, ruler, pencils, tacks, drawing pins hammer, glue, small hand drill, elastic bands, string and adhesive tape.

Junk and found objects are a particularly fruitful source of material for kinetic works, providing a variety of forms and textures which can add to the finished effect.

Drawing A complex kinetic work using motor power, involving light engineering skills, requires a detailed technical drawing.

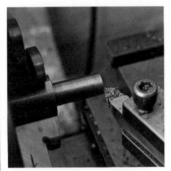

Turning 1. Metal is cut with complete accuracy on a lathe. Do not undertake machine work without expert supervision.

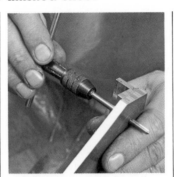

2. Tapping can also be done by hand with a special tool. The principle is the same whether it is done manually or by machine.

Keyway in flexible coupling When attaching a spindle to a motor, a key must be inserted to prevent the device from slipping.

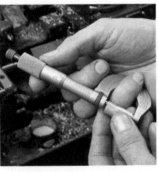

Micrometer A micrometer is a measuring device which is absolutely accurate to three decimal places.

2. While the metal is being turned, it is kept constantly lubricated with soluble oil, to prevent the machinery from heating.

Milling 1. End milling on a vertical milling machine is used to shape or trim metal, or to cut grooves by shaving off thin layers.

Flexible coupling being joined The vibration caused by a motor means that rubber parts will be necessary to absorb the movement.

Sawing metal Metal can be cut to a suitable length with a saw before being machine worked. Keep one hand at each end of the saw.

Tapping 1. A drilled hole is tapped to provide a thread inside so that a screw can be inserted.

2. The metal is firmly clamped into the milling machine and even rounded shapes are securely held. This slot is part of a keyway.

Marking with a height gauge A scribing end can be fixed at a certain height on the gauge and used to mark the metal accurately.

Center punch A center punch is placed on a scribed mark and tapped lightly with a hammer to start a hole for drilling.

Assembling the work to test it The construction should be assembled each time a new piece is made to check that it fits.

Surface finishing 1. The surface of the metal is cleaned first by rubbing it hard with an abrasive such as silicon carbide paper.

Applying an image An image can be applied to metal in different ways. This part was sprayed with paint and a sticker attached.

Checking the punch hole The emphasis on accuracy in this work means that the position of the punch hole must be checked.

Grommets Electrical wiring must not be passed through a hole cut in metal without the protection of a rubber grommet.

2. An attachment can be made for a drill using wood with one end covered in silicon carbide paper to make a patterned finish.

Finished pieces before assembly Keep all parts of the work together in a box throughout the process so that nothing is lost.

Drilling The metal must be firmly held so that it cannot swivel. Pilot the hole with a small drill before using the proper size.

Earth wire Any metal construction which includes electrical wiring must be earthed to prevent the possibility of it becoming live.

3. A fluid known as gun blue turns metal black through oxidization. Rub on the fluid, rinse it in cold water, and dry and oil the part.

The assembled construction Thanks to careful planning, in the finished work the parts are balanced.

Countersinking Drill holes can be countersunk with a special drill so that the tightened screw will be flush with the surface.

Wiring up motor to terminal block Wires should be connected to a terminal block which can be housed in a small box.

Rubber feet The vibration of the motor can be absorbed in a free-standing object by attaching rubber feet to the bottom.

When the motor is switched on the disc revolves so fast that the marks on either side appear to mix into a whole image.

Sculpture with light.

History. Techniques and equipment. Light forms: Light bulbs, Fluorescent tubes, Neon tubes, Strobe lights, Laser beams, Laser holography, Electrical components.

Techniques not usually associated with sculpture or painting are now commonly used by artists: those of electronic devices and circuitry, lasers and computers. The artist today may need to collaborate with such specialists as electrical and mechanical engineers, chemists, mathematicians and physicists. Sculptures designed to emit light are one example of the kind of work in which an artist may have to acquire a range of new skills and be dependent upon the advice of highly skilled technicians.

The illumination of forms has always been one of the prime concerns of sculptors. The source and direction of the light falling on a sculpture may be of great importance in the design and placing of a work, and some sculptors have made environmental settings for their work in order to control the quality of illumination.

Sculpture which is actually made of components which themselves emit light is a relatively recent phenomenon. The earliest attempts to use controlled systems of lighting as an art form were color organs, where the visual effect corresponded to a musical program. Many experiments were made with such constructions during the first half of the twentieth century, and attempts were made to shed the connection with music and present the light patterns as an art medium in their own right, but they never really achieved this status publicly and were regarded only as interesting spectacles.

Light came into its own as a sculptural element after the Second World War and has been frequently incorporated in kinetic sculptures. Lucio Fontana (1899–1968) was most influential in stressing the importance of light in both his art and his writing. A generation of artists whose primary medium is light are now well established, including Martial Raysse (born 1936), Dan Flavin (born 1933) and Chryssa (born 1933). Both Chryssa and Flavin make works which are arrangements of fluorescent tubing in which the color and strength of the light are carefully designed. Flavin's are simple, minimal structures which act upon their whole environment, while Chryssa's works are more self contained, the shaped neon lights often housed in transparent boxes in which the electrical apparatus is all clearly visible. Raysse's work refers directly to commercial neon signs and advertising techniques. Liliane Lijn (born 1939) combines light with perspex and water to create works which constantly change.

Light sculpture Techniques

Working in light may require highly specialized knowledge and it is necessary to pay very careful attention to safety factors. Simple designs may be constructed using ordinary light bulbs and electrical equipment which is easily available and this will require a working knowledge of electrical principles. For instance, light boxes with changing patterns of colored lights, or projected environments of light. But more ambitious work, involving the shaping of glass or neon tubes for instance, should be designed on paper in some detail, and expert advice taken about how to make the construction. Any work which combines water or other liquid with light forms will need special advice on insulation and safety.

Light forms
Light bulbs The light bulb consists of a tungsten filament in a glass bulb. The filament glows because of the heat produced when an electrical current passes through it. Light bulbs are available commercially in a variety of shapes, colors and glass finishes.
Fluorescent tubes The fluorescent tube is a glass tube with its inner surface coated with fluorescent powder. It also contains argon gas and a small amount of mercury. The reaction in the gas mixture when the current passes through the tube between tungsten wire electrodes produces ultra-violet radiation which makes the powder glow and give off light. Fluorescent lights use less current than bulbs and are available in a variety of sizes and colors, and different tones of warm or cool light.
Neon tubes The neon tube is a glass tube filled with neon or other gas, with a high voltage transformer at each end attached to an electrode. Light is produced by the molecular activity of the gas when the current passes through, and the colors in neon are a result of the different kinds of gas, and the use of colored glass. A greater range of colors can also be produced with fluorescent coatings in the tubes. Neon tubes are high voltage and require well insulated fittings.
Strobe lights The electronic strobe light is designed to give brilliant, pulsating flashes of white light.
Laser beams The low power laser beam has a thin beam of light and may be various colors. It is used to produce visual patterns and light environments.
Laser holography This was developed in the 1960s and is a means of using laser beams to produce illusionistic three-dimensional light 'pictures'. Large holographic projections can be used in a theatrical or architectural context. The projections are safe but

precautions must be taken to prevent the viewer looking directly into the light source. Laser holography is still a highly technical form of light sculpture.

Equipment

When working with electrical equipment it is necessary to check carefully that any appliances used are suitable to the supply of electricity. An electric current is measured in amperes (amps) and the force of the current measured in volts. The power produced by the current and voltage is measured in watts. A standard voltage is supplied to homes or galleries and equipment should be designed to correspond to this. An electrical current may also be alternating (AC) or direct (DC). In alternating current, the wires alternate polarity, switching from positive to negative and back at a fixed rate per second. Mains electricity is usually AC; batteries are DC, one wire being always positive, the other negative.

Wires, plugs, sockets and all electrical installations should be the right wattage and voltage for the supply. The size of wire must be right for the load it will carry, and this also relates to the distance it will travel. Wires should always be well insulated and care should be taken to note colors. If a complex circuit is being made in a work, a full diagram should be made. Safety factors are all important, even more so if the work is to be shown in public, and if any doubts arise expert advice must be taken.

Electrical components

Conductors consist of insulated copper wire. These may be solid or stranded, and have a variety of insulation. A large current will require a heavier cable.

Resistors control the flow of current in circuits. The rheostat or variable resistor can be used to increase or lessen light levels in sculpture or environments. It is possible to produce automatic variable lighting by using motorized rheostats which can be set for different time sequences.

Sensors react to temperature, humidity, light, sound, vibration or air pressure, thereby controlling electrical or mechanical devices. Clocks and motorized timers are available from industrial electrical suppliers.

Light sculpture This sculpture outside the Hayward Gallery, London, combines the use of light and kinetics. The 48 ft high tower, which consists of 108 fluorescent tubes, can be clearly seen across the River Thames. The framework is made up of six octahedrons stacked vertically to make a spiralling tower. The five colors — yellow, magenta, red, green and blue — relate to the five different patterns which the designers saw in the structure. With the exception of the red tubes, which are neon, all the colors are cold cathode tubes, filled with argon and mercury. The tubes are lit in a sequence which is determined by the strength and direction of the wind blowing along the river. Passers-by can see shapes in the tower constantly changing.

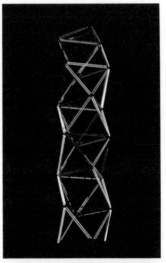

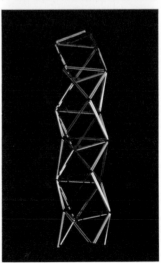

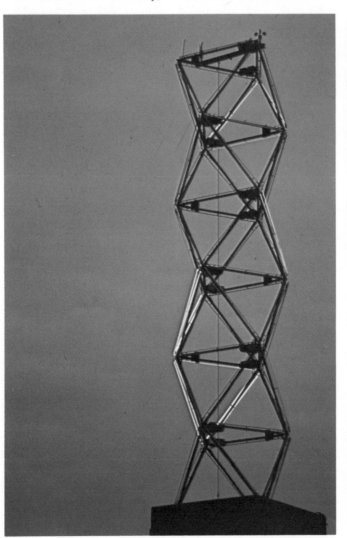

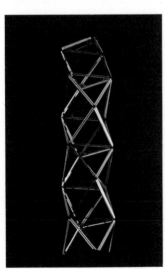

Fluorescent sculpture

Making a light sculpture from fluorescent or neon tubes is both complicated and dangerous. Working with the tubes requires such technical knowledge and skill that designs must be taken to a professional glass bender. The design should be as simple as possible with gentle rather than sharp bends. Most works are made from several tubes. Mark on the working drawing what color and thickness the tubes should be. The most common widths used in sculpture are 9mm, 11mm and 15mm. It is also important to mark where the electrodes should go and calculate how many transformers are needed. Before a coated tube can be bent, it must be checked over a light box for any flaws in the coating. As most coated tubes look white when they are unlit, the color must also be checked under an ultra-violet lamp. Great care must be taken during the bending — for example if the glass is allowed to cool during the process it may crack. When the tubes are finished, an electrician must insulate them and wire them up to the transformers. The backing on which the light is finally mounted must be chosen carefully. Perspex will complement the light with a reflection, whereas velvet will absorb the light. Wood is not suitable as the glass breaks easily if the wood warps.

Drawing design Draw the design to scale in double lines the width of the tube. The bent glass will be the design's mirror image.

2. Place the coated tube on a roller and bake it over a flame for 4 minutes to remove chemical impurities from the coating.

Finishing 1. To remove impurities, the tube is bombarded with a high voltage current. This illuminates the tube.

Bending glass 1. Stop up one end of the tube with a cork. Bend glass when glowing red and then blow down tube to keep circular shape.

2. Fill fluorescent coated tubes with argon. This gas gives a dull light until it is mixed with mercury.

2. Mark where to make bends on both glass and design. Check the tube against the design during bending. Cool bent glass in a rack.

3. As a final check on any faults, hang the lit tube in an 'ageing' bay for between 45 minutes and 4 hours.

Coating a tube 1. Pour suspension coating into a dry glass tube turning it constantly. Hang it to dry for 30 minutes.

Fitting electrodes Seal one end of the tube. Blow a hole in the glass and place electrode in it. Weld join until the glass glows.

Mounting Drill holes and screw porcelain and brass studdings to the backing. Fasten the finished light to the studdings with wire.

Sculpture with chrome and mirrors.

History. Techniques and effects: Use of light, Mirror effects, Working with chrome.

One school of modern artists works with reflected light as its principal medium. These artists use mirrors and chrome to reflect light in various ways, sometimes producing an impression of infinity; sometimes reflecting the light at a multiplicity of angles. Others use mirrors to 'play tricks' on light itself, by using mirrors so that it appears to the viewer that objects have been 'moved', that a portion of the sky, for instance, incongruously appears in some context on the ground. The American artist, Robert Smithson (1938–1973), is typical of this last category. In one of his pieces he placed a series of 1ft (30cm) square mirrors on the ground in a shrubby outdoor setting, each one reflecting a piece of the sky. The result was patches of sky appearing among the earth and scrub, rather like 'windows' in the ground.

Behind the work of many artists involved with light and reflection lies what is to some extent a rejection of the spontaneity, flippancy and often indulgent self-expression of much of the art of the postwar period. They are often seen as a rejection of the concurrent artistic trends of Pop Art and Abstract Expressionism. Instead the more scientific approach to much of their work indicates a tendency to depersonalization. It is often rigid and unrelenting to look at, made as it frequently is from factory manufactured, prefabricated parts. Many of the works are actually made entirely in factories to designs laid down by the artists.

Some of the more notable artists in these media include American Yoyoi Kusama (born 1919) who is associated with the environmental work and the 'happenings' of the 1960s. One of her major works is called *Endless Love Room*. Her own red and white objects are reflected into seemingly endless distances by mirrors. Her *Peep Show* also produced long views done with mirrors, going not only sideways but also up and down. The room gave the impression of being multi-sided. The viewer looked into the room through a peep hole, where formally arranged light bulbs flicked on and off in sequence, and were reflected outwards.

Lucas Samaras (born 1936), a Greek born artist working in America, is also concerned with the environmental approach. He constructed *Mirror Room*, a complicated three-dimensional construction of reflecting surfaces.

The use of mathematics is important in many such art works. Argentinian artist Martha Boto (born 1925) used built-in light sources in her works, many of which were moving. Some of her critics have said that her work is best understood through the medium of mathematics.

Chrome is also often used to reflect and adjust the effects of light. European-born Milan Dobes (born 1929), who now works in America, has used chrome, steel and mirrors in his construction as, for example, in a piece which consists of rows of concave 'cups' of reflective metal.

The 1960s, which produced so much in the way of originality, also seems to have marked a sort of zenith in the work of the artists using mainly mirror and chrome. There has been a slight decline in this trend during the 1970s—with some notable exceptions, however. American Sylvia Stone (born 1928) has been working with huge areas of reflection with tinted mirrors and glass.

Chrome and mirror Techniques

Use of light

Light plays a key role in reflective sculpture. Many works, such as Yoyoi Kusama's *Peep Show* and some of Martha Boto's structures, have the light source built into them, making it an integral part of the work. Other works rely on the external source of light—artificial or daylight. Incandescent, fluorescent, and neon lights are all used.

Externally, lights can be hidden in troughs or behind shields. Often lights are built into the stand of a work. If the stand is made of plain or frosted glass, light can be projected through the stand into the structure itself.

Mirror effects

A principal effect of the careful placing of mirrors is to produce the sensation of having 'removed' chunks of one plane and placed them on another, such as, in a simple case, pieces of one wall being made to appear on an opposite wall. This is often referred to as 'displacement'.

Another effect is distortion. One artist, American Robert Morris (born 1931) placed mirror cubes on a floor, making it look as if the floor extended up the sides of the cubes. A third impression is the sensation of space and infinity, with mirrors reflecting mirrors.

All of these effects can be produced horizontally and vertically to give the viewer the impression of infinite space, reaching up and down as well from side to side.

When working with mirrors, and reflective material such as chrome, there are some basic scientific axioms to be borne in mind.

For instance, the governing law in all cases of reflection by a plane surface is that the angle of reflection (the angle between the reflection surface

and the image reflected) is always equal to the angle of incidence (the angle between the surface and the viewer's eye.)

If more than one mirror is used, multiple reflections result. When the mirrors are parallel a very large number of images are produced, giving an appearance of infinity. When they are placed at right angles to each other mirrors produce three images only.

Whenever the angle at which the mirrors are placed is an exact sub-multiple of 360 (the number of degrees in a circle), an exact number of images is seen; this means that the number of images plus the object, is always equal to this sub-multiple. Hence, when the angle is 90° three images and one object are seen; when the mirrors are placed at 72°, the number of images is five, and so on. This is also the principle on which the child's kaleidoscope is based.

Working with chrome

Chrome is a stainless metal, hard and durable, with a bright and very reflective finish. It is usually used for plating other metals and is often used in alloys. Stainless steel, for instance, is an alloy of steel, chrome and nickel.

Normal metalworking tools are used in the working of chrome. It should be remembered, however, that chrome cannot be soldered, because solder is based on tin which will not react with chrome.

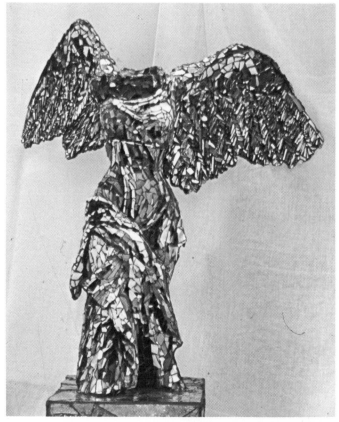

Sculpture with reflective surfaces
The play of light over form and surface texture is an important aspect of any sculpture, usually exploited to emphasize the contour and volume of the work. In these examples, *Nicky* by Andrew Logan (**above**) and *Zemran* by William Pye (**left**), the highly reflective quality of the mirror or polished metal will cause rapid changes in the surface according to the light source and any movement of the viewer. These interfere with the observation of the basic form, sometimes exaggerating and at others appearing to diminish the sculpture's shape.

The fragments are so small that they separately and immediately reflect changes of color or light, forming kaleidoscopic patterns.

The mirrored effect is achieved by painting small fragments of glass on one side only. These are then pressed into resin and left to set.

The base of the sculpture is made up of larger shards of textured glass with a pitted surface which give a frosted effect.

Mirror sculpture The sculptures shown here both incorporate effects which completely disorientate the viewer, who is present both as an observer and within the sculpture itself. The mirror-coated cubes by Robert Morris (**right**) distort the perception of the floor and wall space in which they are displayed. As the viewer moves around and through the layout of the cubes, it is difficult to distinguish between real and illusory space. This is more confusing since the cubes are not of a height to allow for a horizontal view in terms of adult human scale, and attention is focused at floor level. Larry Bell's coated glass screens (**below**) developed from a long preoccupation with paintings and sculptures using mirrors and glass. The method of coating the glass means that each plane of the sculpture may at any time be acting simultaneously as a mirror, a window and a screen. The presence of the viewer in works of this kind is absolutely crucial. Both sculptures produce complex visual effects.

Sculpture with Plexiglass

History and materials. Techniques and equipment: Cutting, Heat forming, Annealing, Joining and glueing, Wet sanding, Laminating, Drawing and painting, Engraving and lighting, Polishing and cleaning. **Tools and equipment.**

The concept of heavy monumental forms was revolutionized by two Russian-born brothers, later known as Constructivists, Antoine Pevsner (1886–1962) and Naum Gabo (1890–1977) in their Realist Manifesto. They claimed that sculpture should be light, airy and transparent. László Moholy-Nagy (1895–1946), who taught at the *Bauhaus* from 1923–1928, worked almost exclusively with plexiglass acrylic sheets, heating and forming them into multi-dimensional shapes. Gabo and Moholy-Nagy during the 1940s were the first exponents of transparent sculptures of heat-shaped acrylic.

Plastics, which are capable of permanent change in shape by the application of heat or pressure, are divided into two basic groups: thermoplastic and thermosetting. Thermoplastic resins, which are discussed here, soften whenever they are exposed to sufficient heat and harden when cool; they will continue to do so no matter how often the process is repeated.

Thermoplastic materials such as acrylic sheet may be heated and formed into many different three-dimensional shapes. They can be bonded together to make opaque or transparent architectural sculpture.

The clear quality of acrylic sheet, sometimes known as plastic glass, refracts more than glass. Acrylic resins, developed in the 1930s, are only half as heavy as glass, and much stronger in impact resistance; the surface is softer, however, and is easily damaged by abrasion. Acrylic sheets do not shrink or deteriorate and are reasonably resistant to most domestic chemicals. They are little affected by exposure to water or moisture, but they are not impervious to lower alcohols and aromatic solvents such as turpentine, benzene, toluene, lacquer thinner, acetone and ketone.

Acrylic sheets are cast by pouring thick acrylic casting syrup between sheets of plate glass, and are made in different surface patterns and textures. Colored sheets are obtained by adding pigments or dyes to the casting monomer.

Sheets are made in shrunk or unshrunk acrylic. The unshrunk form is cheaper, but, when heated for forming, shrinks by about 2.2% in length and increases by about 4% in thickness. Shrunk sheets remain stable when heated. Commercially available plastics include Acrylite and Oroglas in the United States, Perspex in England and Altuglas in France.

Types Sheet acrylic is available in different forms, translucencies and colors. These can be used separately or in combination. The range includes clear acrylic sheet in the form of cylinders (**1**), rods (**9**) and sheets of varying thicknesses (**6,7**). The colors available include brown (**3**), orange (**4**) and turquoise (**2**), opaque white (**5**) and black (**8**).

Tools and equipment Working with acrylic sheet demands certain fairly specialized tools and equipment. These include a power drill (**9**) and bits (**10**), electric jigsaw (**4**) and tungsten carbide blade (**5**), acrylic monomer (**2**) and catalyst (**3**), epoxy resin adhesive and spatula (**7**), dyes (**8**). Also useful are a sponge (**6**), brush (**11**), pliers (**12**), palette knife (**13**) and protective gloves (**1**).

Acrylic sheets can be readily sawn, heat-shaped, drilled with a carbide-tipped drill piece or with purpose-made drill pieces, using oil or soapy water as a lubricant. They can also be cemented, sanded, colored and polished.

Cutting

A table saw with a fine-toothed tungsten carbide cutting blade is adequate; the acrylic sheet is fed slowly through the saw to avoid too much heat caused by friction. Red sealing-wax, beeswax or even soap will keep the blade lubricated. Safety goggles should be worn to avoid particles of acrylic dust.

Heat forming or shaping

When acrylic sheets are heated to about 250°F (103°C) they become soft and pliable. Smaller pieces can be heated in a kitchen stove or with an electric burner or blowtorch. Acrylic sheet will edge-ignite if heated over 700°F (371°C), and interesting effects can be produced if it is deliberately ignited and put out.

Annealing

Tempering or toughening, known as annealing, is carried out by slowly and gradually decreasing heat. Annealing helps to reduce internal stresses which may have arisen during machining or heating.

Joining and glueing

A solvent cement is best for joining acrylic sheets. Ethylene dichloride can be applied to both the cleaned and smoothed surfaces with an eye-dropper, brush or syringe. The surfaces to be joined are softened by the solvent, and the result is a strong, transparent join.

Different materials can be joined to acrylic sheets with epoxy cements. Duco all-purpose cement, for example, can be used to glue loose materials or glass fragments called tesserae to clear acrylic sheet when making a transparent collage or mosaic; catalyzed clear polyester is then poured over the mosaic to bind the loose materials together.

Wet sanding

The best results are obtained with garnet or aluminium oxide abrasive papers. Light surface sanding provides a key for better adhesion of acrylic monomer dyes.

Drawing and painting

Transparent and translucent paints and polyester dyes are available for acrylics from specialist craft shops. Dip-dyeing can be used to provide translucent color.

A Chinagraph pencil is suitable for drawing directly on to the plastic surface, and errors are easily removed with a soft cloth.

Drawings can be traced on the protective paper which comes with the delivered sheet. This remains attached until all the cutting and drilling has been done. A tracing can also be made on a separate piece of paper which is then attached to the protective paper with rubber cement.

Architectural panels with a type of stained glass or mosaic effect can be achieved by drawing on the acrylic sheet with long-tipped tubes of liquid aluminium, steel, lacquer or epoxy-aluminium filled pastes. These form a raised line and the resulting cells are filled with catalyzed clear polyester dye or catalyzed acrylic monomer dyes. As soon as the dye surface sets, it should be left overnight covered with cellophane to exclude air and cause the polyester resin surface to set hard.

Laminating

Acrylic sheets can be sandwiched together with colored laminating cements which are usually made of high strength solvents. Laminating dye can be applied generously with eye-droppers, spoons or sticks. The second sheet is then laid carefully on top and floated very gently on the wet dye, pressing first from the center. Care must be taken to avoid bubbles.

Engraving and lighting

Acrylic sheets can be engraved with intaglio designs with burr cutters attached to flexible shaft tools. The surface designs can eventually be illuminated by edge-lighting. Fluorescent lighting tubes along the top or bottom edges of a carved sheet will light up the interior of the plastic and emit light through the engraved pattern.

Polishing and cleaning

Acrylic sculpture should be cleaned only with a mild solution of soap or washing-up liquid and a soft cloth. Anti-static polish can be applied to help prevent dust and particles settling. The final polishing should always be done by hand using a non-scratch cloth, but the sculpture is first buffed with a double-shaft electric buffing machine. One buffer is charged with white tripoli compound to remove scratches, the other with white acrylic compound for final gloss polishing. Only light pressure should be applied or the work may burn as a result of the friction.

Tools and equipment

Most metal-working and wood-carving tools can be used with plastics. As well as the equipment associated with each technique, the following items are required: electric stove burner and a domestic oven (for smaller pieces), hand drill or high speed electric drill with metal bits; electric jig saw with tungsten carbide blades for curved or intricate shapes; pliers, rubber cement, sponges, protective gloves, acrylic monomer and catalyst, dyes, palette knives, brushes, and sticks. Machine tools include lathes, shapers, routers, milling machines, drills and taps.

Cutting plexiglass 1. This is most efficiently cut on a band saw. The sheet should be guided gently through as the blade cuts.

2. The cut edge of the sheet is rough and dusty and will require careful cleaning up before any joining takes place.

Sandpapering the edges 1. Clamp a piece of sandpaper to a flat surface. Support the sheet at and allow it to dry.

2. The sandpapered edge is now rubbed flat but is still dusty and not completely smooth.

Polishing the edges 1. Hold the edge of the sheet against the rotating wheel of the machine polisher. Keep it moving slightly.

2. Keep the sheet moving slightly. The polisher generates heat so do not hold the plexiglass too close.

3. The polished edge is smooth and ready for glueing.

Polishing flat surfaces Hold the flat surface of the sheet against the wheel. Again, keep it moving and not too close.

Polishing with a rag As the finished effect depends upon sheen and transparency, polishing is a painstaking process.

Joining surfaces 1. To join at right angles, apply suitable adhesive to the edge of one piece.

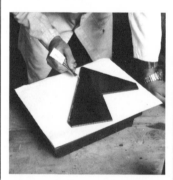

2. Apply adhesive to the edge of the flat surface of the second piece of plexiglass. Use contact glue allow it to dry.

3. Join the glue surfaces together and place the sheet against a right angled support so that a true join is obtained.

Milling 1. A milling machine can be used for trimming or making slots and grooves in the surface.

2. The milled groove is even and of uniform depth. Milling can be used as part of the construction process or as surface decoration.

Driling 1. To drill pexiglass, clamp it firmly to the bed of the drill so that it cannot come loose and swivel.

2. Drill the holes carefully and evenly. They can be used to fix two pieces together or to attach plexiglass to wood or metal.

Paper sculpture.

History. Techniques and equipment: Types of paper, Cutting, Scoring, Folding and bending, Tools.

T he earliest known paper sculptures were made in China, where the first paper was made some 2,000 years ago. In the West, however, paper modelling has only really developed during the last 300 years.

Until the nineteenth century paper was an expensive, handmade commodity used in comparatively small quantities. In the seventeenth and eighteenth centuries, rolled and cut paper work was fashionable, including silhouette portraits which originated in France. Paper filigree was used later to decorate boxes and frames.

Paper sculpture has gained remarkable ground in the twentieth century in several directions, notably in the design field. British cartoonist Bruce Angrave (born 1916) took his work into the third dimension with paper sculpture, and Dorothy Rogers (born 1905) makes small figures in her three-dimensional compositions of scenes which are often taken from Old Masters. Paper's lightness lends itself to kinetic sculpture, and tissue paper, for example, can be stretched over wire.

Types of paper

The size of the model determines the thickness of paper to be used; larger models tend to collapse if the paper is too thin. Cartridge paper, stiff drawing paper or thin card are suitable for most models. Paper can be plain white or colored, and it can be hand-painted or sprayed when the sculpture is completed. Many wallpapers and metallic papers can be used with good results.

Models for architectural and theater design are usually made with thicker card, depending on their size. As this is sometimes black or gray on one side and white on the other, lighting effects can be produced and light or shaded planes can be accentuated.

Techniques and equipment

The basic principle of paper sculpture is to make a three-dimensional object from a flat piece of paper by curving, cutting, folding and bending.

Whether free-standing or relief, paper sculpture can easily be adapted from a sketch or photograph, although ideas should be kept simple at first with a minimum of detail. The sketch should be studied for form and texture which can be translated into paper techniques. Hair and feathers, for example, can be interpreted by curled paper, and fabric can be shown by rolled or pleated paper.

Most free-standing sculpture is made from certain basic shapes, such as cubes, pyramids, cones, cylinders and pleats. Larger models can be built around a wooden support for extra strength.

Relief sculptures rely largely on the effect of light and shadow to create the illusion of space. This is done either by bending and folding the paper into different planes, or by fixing flat shapes at different angles to each other. A surface may be broken up into planes of light and shade by folding the paper into corrugated pleats.

Cutting The secret of good cutting lies in using sharp tools. Blades and knives should be used whenever possible, straight edges being cut against a metal ruler. When cutting cardboard it is important to make several light strokes rather than attempt to make the cut in one stroke.

Scoring When a clean, sharp bend is required, the paper or card is cut partly through first—this is known as scoring. Accordion pleats are made by scoring the paper lightly first on one side and then the other and by bending along the folds.

Folding and bending Paper is bent or folded to make it three-dimensional. When bent it can be made into cylinders and tubes, or partly bent to produce a curved shape. Folding gives a sharper division between different planes and is used to form pleats, cubes and all angular shapes. Sharp folds are obtained by first scoring the paper.

Tools Paper sculpture requires no specialist tools, and a sharp blade or craft knife, a scalpel, a pair of sharp scissors and any fast drying adhesive are often sufficient.

Tools Tools for paper sculpture are less specialized than those for many other types of sculpture. They include: a steel ruler (**1**) and a plastic one (**15**), scissors (**4**), craft knife (**8**), scalpel (**7**) and blades (**6**). Draw lines in pencil (**14**) so that they can be erased if necessary with a putty (**5**) or plastic eraser (**11**). Be sure to erase any lines which will appear on the front of the sculpture. For sticking the paper down, use adhesive (**10**) which should be easily removeable in case it runs. For large areas, spread the adhesive evenly with a spreader (**2**). Adhesive tape (**13**) is also useful, as are paper clips (**3**), a set square (**9**) and protractor (**12**).

Types of paper Paper for sculpture should not be too stiff as it must bend and fold reasonably easily and firmly. Suitable types of paper include cartridge (**1**), Bristol board (**3**), silver and gold foil on card (**4**) and cover paper (**5**). In paper sculpture, effective use can be made of different colored papers, and even wallpaper (**2**) can be put to good use. It is a good idea to experiment with varieties of paper and colors, as well as with different techniques.

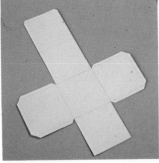

Making a box 1. From a sheet of thick white paper, cut a shape which will form the six sides of a box; add tabs for glueing.

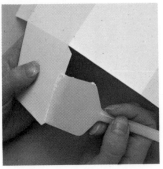

3. Fold the paper along all the scored marks. Apply glue carefully to the joining tabs, keeping it away from the shapes.

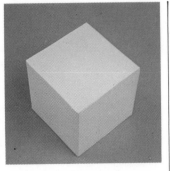

5. Complete all the glued joins to make the final box shape. The weight of the paper should be chosen to suit the size of box.

2. Curve the paper round into a cylinder and slot the tabs inside so the join is smooth. Glue the tabs inside the cylinder.

2. Score along the lines where the tabs are marked, and all sides of the squares which form the faces of the box.

4. Fold the paper into the box shape and join adjacent cut sides by pressing the tabs firmly on to the inside of each corner.

Making a round cylinder 1. Cut a large rectangle of paper with tabs at one end. Cut slots on the opposite side to suit tabs.

Making a faceted cylinder 1. Cut a rectangle of paper and mark it vertically in seven equal parts. Score down the marks.

2. Fold along the scored marks and apply glue to one whole section at one end. Fold the paper round, glue the two end sections.

3. Fold along the scored marks and apply glue to the tabs. Fold the paper into a pyramid and press down tabs on the inside.

Curling paper 1. Cut paper into thin strips, leaving them joined at one end. Draw the blade of a pair of scissors up the strip.

2. Ease the paper into the curved fold gently with the fingers. Fold away from the scored mark, work slowly to avoid unwanted creases.

3. Stand the cylinder up and press it gently into shape. Any number of facets can be made by scoring the appropriate number of marks.

Pleating paper 1. Mark a long rectangle of paper with equal divisions and score alternately on the back and front of the paper.

2. Repeat to form another curl. The scissor blade must be held firmly and flat to the paper, but not so hard as to tear it.

3. Scored curves add variety to relief surfaces. Use quite gentle curves so that the paper can be eased into shape but not forced.

Making a pyramid 1. Cut a template for the shape of one side and draw round it four times, each adjacent to the one before.

2. Fold along the scored marks, alternately one way and then the other, so as to create a pleated concertina effect.

3. The amount of curl in the paper depends on the length of the strip. Vary the width of the strips also for different effects.

Paper relief 1. Cut small shapes in a piece of paper with a scalpel and fold them back. Several layers of paper can be used.

2. Mark tabs on the sides to be joined and cut out the shape with a knife and steel rule. Score along sides to be folded.

3. Pleated paper can be bent into cylinders or cones, used as surface detail or formed into a fan.

Scoring curves 1. Paper can be folded into curves by scoring first. In this case, the lines are scored alternately back and front.

2. Cut a sheet of backing paper and place under the cut pieces. Arrange the relief shapes as desired.

Mixed media.

History and forms: Dada, Collage, Pop art, Found objects, Total art and environments, Sculptures and sculptors.

The term 'mixed media' covers a broad spectrum of work and these works often use objects which, until quite recently, would have been considered bizarre material for artists. It is a field of art in which a bicycle wheel, undisguised and unadorned, can be a prop or even a centerpiece, and in which smell, sound and lighting can be used effectively.

Most of the modern art movements, from the Futurists, Dadaists and Surrealists to conceptual and performance art, can be classified as mixed media art. Performance art is especially typical of the flexibility of mixed media, for the distinction between performance art and the living theater is blurred: it is a form which can make use of the theater, sound, props and performers.

Collage

The technique of collage, which was developed by the Cubists and uses all kinds of objects, news cuttings and photographs to create a three-dimensional form on a flat surface, was one of the forerunners of mixed media sculpture. As early as 1919 Georges Braque (1882–1963) and other artists were using collage, and the idea gradually evolved into sculptural collage—collage without the flat framework. The two-dimensional surface of the painter is extended in collage, and the three-dimensional form of sculpture is also extended until it becomes a type of environment. The viewer does not necessarily have to be 'outside' the work.

The collaged environment is exemplified by Kurt Schwitters' (1887–1948) famous *Merzbau*—objects and wood arranged as a 'house' which contained mementos, objects and surfaces. Tom Wesselmann (born 1931), the Pop artist, uses the same sort of relief collage in some of his Great American Nude series. He uses objects such as tables and chairs, which protrude from a painted canvas.

Objects

Some of the mixed media works produced by the Dadaists, the Surrealists and the Futurists were direct forerunners of works produced by many modern environmental artists. The Surrealists and Dadaists were among the first to promote the idea that any object could become art in its own right. From this arose the expression 'objet trouvé', meaning found object. Marcel Duchamp (1887–1968) elevated a humble pissoire (entitled *Fountain*) to the status of a work of art merely by exhibiting it—a public outcry ensued. Another example of Duchamp's 'objet trouvé' works was a signed bicycle wheel mounted on a kitchen stool.

A found object 'composed' is one which has been altered or rearranged, and the term 'objet trouvé' has also been extended to describe pieces of natural material such as wood and shells which can be used as raw material for carefully worked art forms. Sculptor Louise Nevelson (born 1900) used discarded pieces of

Mixed media Combining different art media, such as painting and three dimensional work, brings with it problems of classification. For example, John Latham's work *Film Star* (**right**) combines an appearance of a conventional painting in a frame with a sculptural three-dimensional structure. The work consists of books and sections of books which have been burned, glued to a panel and the pages fixed with wire and cord. This work was completed in 1960. The work can be seen as a metaphor for the re-evaluation of knowledge through the destruction and recycling of those conventional vehicles of knowledge, books. Another artist working at the same time as Latham and on similar ideas was the American Louise Nevelson. Her work *An American Tribute to the British People* (**far right**) was created between 1960 and 1965. It uses objects such as wooden furniture legs and brings them together in an assemblage of objects which are sprayed gold. The work is on a large scale, measuring 122in by 171in and has a depth of 46in. Nevelson's work has some religious overtones and this piece bears a certain resemblance to an altarpiece.

furniture and scrap in some of her earlier constructions. Jean Tinguely (born 1925) has used pieces of scrap metal and other miscellanea in his sculptures.

Total art and environments

Mixed media flourished with the adoption of the concept of 'total art', a concept which extends art into a total, special environment. Some of the best examples date from the 1930s in the form of zany environments composed of unlikely, obscure or obscene items. One exhibition included a gramophone with a modelled pair of female legs protruding from the speaker, and the ceiling was festooned with building sacks while German dance music played in the background.

Ed Kienholz (born 1927) created a series of total environments; his meticulous research produced an uncanny realism, such as a period room showing every minute detail. His work entitled *State Hospital* allowed the viewer to look through a peep-hole of a hospital ward which contained two bandaged figures strapped on to metal bunks. Their heads, however, consisted of goldfish bowls with black fishes swimming around in them, and a disturbing smell of disinfectant pervaded the tableau.

The American sculptor Claes Oldenburg (born 1929), one of the most well-known artists to use mixed media, has produced enormous environmental sculptures. His exhibitions have included huge objects of plastic and other materials which are everyday items—telephones, plugs, hamburgers—and each has been enlarged to such a degree that they assume an entirely new visual meaning.

Some conceptual artists develop the concept of mixed media to its fullest extent by using the landscape itself as part of their work. Christo (born 1935), for example, hung a huge orange curtain several hundred yards long across an American canyon with a road running underneath. A variation on this idea, known as 'documentary art', portrays an activity: British artist, Dick Long (born 1945), for example, recorded country treks in the form of maps and photographs. Another Briton, John Latham (born 1921) liquefied a book by chewing it up, with the help of friends, and spitting the resulting saliva into a jar. Latham has also featured books in many static sculptures, using music, sound and spray paints—the latter making the books appear burnt or old to give an 'antique' effect.

Papier-mâché is one of the most useful materials for the mixed media artist as it is cheap and can take any form. It has evolved from being the material of a Victorian drawing-room craft to being the medium of such eccentric contemporary artists as Niki de Saint-Phalle (born 1930) who has used papier-mâché for her balloon-like, painted figures.

The idea of using different materials in sculpture originated partly as a result of developing technologies and partly in an attempt to break away from the confines of such traditional materials as marble, stone and wood. Much early mixed media art was a gesture, a form of mockery, but it has played a significant part in the acceptance of a wide range of innovative materials which are now the mainstay of many serious modern sculptors.

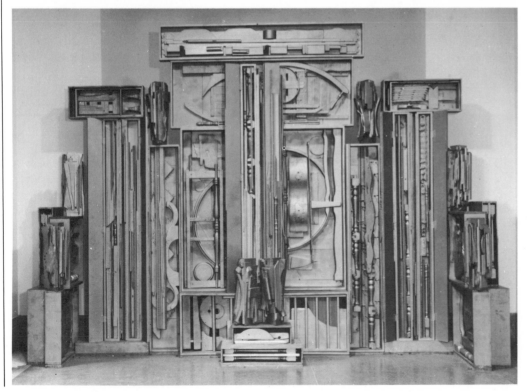

Early mixed media work Interest in the use of mixed media was stimulated by the Dada group early in the twentieth century. The Dada artists sought to shock and outrage their audience and viewers. The German artist Kurt Schwitters was not accepted by the Dada group, but his interests were similar. Technical innovations made by such artists included the use of collage and montage to combine disparate elements, often, for example, cuttings from newspapers, cigar wrappers, feathers, shoe soles or even pieces of wire. Schwitters wanted to recycle discarded objects and make art out of them. Schwitters, who also wrote poetry, took his art extremely seriously. His work was neglected during his lifetime and, having been exiled from Germany during the Nazi regime, Schwitters died in 1948 in near obscurity in Westmorland, England. This collage (**overleaf**) *Opened by Customs* was created between 1937 and 1939 and, although a late work, is typical of Schwitters's collage work. His first collage was completed as early as 1917.

Happenings.

History and development: Bauhaus, Dada, Surrealists, Experiments in the 1960s, Events and performers.

E arly 'happenings', or events, emerged with the performance art of the Italian Futurist movement, when Filippo Marinetti (1876–1944) announced in 1909 that his aim was to shock audiences out of their role as 'stupid voyeurs'. The theory that the viewer should participate rather than merely observe is still an important aspect of much performance art today.

In the *Bauhaus* stage workshop under the direction of Oskar Schlemmer (1888–1943), pre-empted another characteristic of happenings by breaking down the traditional barriers between drama, dance, painting and technology, and incorporating them all into its internationally famous multi-media performances.

Closer in spirit to many contemporary happenings, however, were the events staged by artists of the Dada and Surrealism movements, who revolutionized traditional artistic values and used the absurd or unexpected to comment on contemporary cultural, social and political attitudes.

The development of environmental art after the Second World War brought a greater recognition to contemporary happenings. Although the Dadaists and Surrealists had produced environmental works—Marcel Duchamp (1887–1968), for example, exhibited a room threaded with twine in 1942—it was not until the advent of Pop art in the 1950s, which such exponents as Claes Oldenburg (born 1929), that environmental art became widely accepted.

The more recent happenings, which have come to represent the 1960s, were largely inspired by a group of artists at Black Mountain College in the United States, where in 1952 painters Robert Rauschenberg (born 1925) and Jasper Johns (born 1930) with musician John Cage (born 1912) staged what was later to be recognized as the first real happening: an empty cup was placed on each person's seat and music, poetry, bizarre sounds, film and dance were then performed simultaneously, after which the cups were filled with coffee by performers dressed in white.

The simultaneous activity of the Black Mountain event, which made it impossible for the spectators to absorb any one contribution, coupled with the use of seemingly meaningless, long periods of silence and inactivity, were a foretaste of the many happenings which were to come, when artists would attempt to make the audience aware of time.

One of the leading exponents and documenters of the American happening was New York artist Allan Kaprow (born 1928). His involvement derived from an increasing interest in the making of his paintings and assemblages rather than in the finished product. The act of creating became the dominating factor and an audience was invited to watch; sound and lighting later became part of such performance and eventually the audience became participators.

In the 1960s happenings flourished all over the world. Japanese artist Yoyoi Kusama (born 1940), whose work was largely devoted to the cause of feminism, punctuated her colorful and costumed environmental performances with several nude public demonstrations. British artists involved in happenings and events included multi-media artist Jeff Nuttall (born 1933) and John Latham (born 1921), who was sacked from his teaching post for liquefying one of the college library books and returning it as a sticky liquid in a jam-jar.

Although happenings declined in the 1970s, the underlying spirit still exerted a widespread influence in much environmental theater, individual performance and conceptual art.

Happenings The British artist Ian Breakwell has created a number of performances since the middle of the 1960s the origins of which can be traced back to the Dada artists, Breakwell tries to disturb his audience and, in so doing, to make them reconsider their assumptions about, for example, language and communication. He approaches this in various ways. For example, in *Unword*, a series of performances given during 1969 and 1970 (**right**), the backdrop appeared like a forest or wall of language. During the performance, which lasted over an hour, the words were torn down by the artist, and wrapped around the figure of a woman, while another figure at the back appeared to be suffocating and unable to communicate his plight. The series of pictures of another Breakwell performance (**below**) shows *Restaurant Operations*, as performed in 1967. Here the artist attempted to make a speech but appeared to have been struck dumb. Then, in increasing desperation and frustration, the artist tried to communicate his message to the audience, without success. Finally, after failing to destroy the table of food with a revolver, the artist dived into the banquet and demolished it in a fit of violent rage.

1

2

Happenings Joseph Beuys (**1**) is
one of the best known modern
creators of happenings. His work
reflects the desire to break down
barriers of tradition and
convention which have divided art
from other disciplines and which
have subdivided art itself. Beuys
puts over his ideas in a highly
individual way. His work is a cross
between a lecture and a theatrical
performance, interspersed with
highly visual elements. Here he is
performing at his exhibition in
Ulster called *A Secret Block for a
Secret Person in Ireland* in 1974.
The *Masterwork* (**2**) a multi-
media event which took place in
London in 1979, was created by
two British artists, Paul Richards
and Bruce McLean. The highly
visual performance also included
elements of theater, such as an
acrobat, juggler, dancer and a
sound score, as well as a fork-lift
truck. The work of the Kipper Kids
(**3**) has many elements of theater,
circus and music hall, but they
always perform in art galleries.
Like the other artists who work in
this area, the Kipper Kids try to
undermine cultural and social
assumption by juxtaposing
disparate aspects of everyday life,
behavior and objects.

3

Display and transport.

Transport: Moving large sculptures, Packing a sculpture. **Display:** Outdoor siting, Interior display, Light and space.

All types of sculpture, whether small and fragile or heavy and unwieldy, present problems in packing and transporting. If they are to be dismantled and later reassembled, each part should be numbered. A plan or sketch can be drawn to ensure correct assembly, and in some cases a photograph is useful.

One-piece sculptures, such as a stone statue, have to be levered into place with levers and a jack. The sculpture must be protected from the metal tools by pieces of wood.

Large works can be padded with as much soft material—such as blankets—as possible. Corners and projections need special protection. One of the professional methods for packing a piece into a crate requires diagonal struts to be erected between opposite corners of the crate so that they pass through the center of the cube of space. The piece is then inserted into the crate so that it is supported by the struts, and soft materials are then packed around it to absorb jolts.

When lifting by hand, canvas or leather slings are ideal for works which are not too large. Gloves should be worn to protect the work from grease marks and to protect the lifter from any sharp material.

Stone works, particularly, can be moved by means of a pulley in the studio. One of the common systems uses three pulleys. A low trolley with small, strong wheels, known as a sampson, is often used for moving heavy works. The sculpture is usually levered into place.

Monumental stone works are usually transported by crane or forklift truck. They must be well protected and secured with ropes; the sculptures can then be guided into place by hand.

1

2 3 4

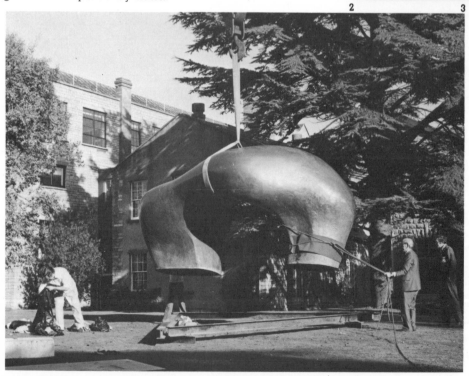

Transporting sculpture These pictures (**left**) show the British sculptor, Henry Moore, supervising the siting of his large sculpture *Sheep Piece* in an outdoor setting in Street, Somerset, England. This sculpture consists of two pieces, each of which had to be moved individually. For moving large pieces of sculpture a crane may be necessary (**1**). However, it is vital that the sculpture is kept in balance and that the surface is not damaged. The sculpture will eventually stand on a triangular base (**2**) which will be buried in the ground. Before this can be done, the exact positioning of the sculpture has to be checked (**3**). Note how the sculpture is guided by being pulled with a rope. The surface is protected by a guard made of soft material. As a safety precaution, a chain is added for moving the second and larger piece of the sculpture (**4**).

Packing a sculpture for transport
1. A crate is specially made to a suitable size. The sculpture is first wrapped in tissue paper.

2. The sculpture is then wrapped completely in polythene sheeting which is firmly secured with adhesive tape.

3. Corrugated cardboard is laid in the crate and then padded cushions of paper stuffed with straw are laid in as a bed.

4. Thick layers of foam rubber are placed over the bed and are allowed to hang over the sides of the crate.

5. The wrapped sculpture is placed in the crate on the foam rubber bed. Using waste pieces and offcuts can save expense.

6. The overhanging foam is tightly packed around the sculpture in the crate and another layer added on top and tucked into the sides.

7. More paper parcels stuffed with straw are laid on top and pressed firmly down on to the rest of the packing.

8. Corrugated cardboard is laid over the packing and folded in to the sides of the crate. The inside packing is now complete.

9. The lid of the crate is put in place and nailed down around all four sides so that the crate is quite solid and secure.

10. Metal bands are passed round the reinforcing battens on the wood crate and are tightened and fixed firmly.

11. Instructions for handling and transporting must be clearly shown on the outside of the crate.

12. The finished package is quite secure and strong, clearly marked with instructions and given added protection by the metal bands.

Effective lighting is a crucial factor in the successful display of sculpture and shadows, for example, should be avoided. Ideally, the light should surround the work, rather than emanating from one particular source. The color of lighting needs thought too—warm light, for instance, can detract from the essentially cold appearance of metal.

The size and shape of the piece dictates its positioning. A piece can be spoilt by being too low so that the top is visible, or too high which produces a distorted view. Plinths should be unobtrusive so as not to detract from the sculpture.

Free-standing works are often mounted on a stand—of stone, metal or wood, for example—and this is carefully chosen to match the sculpture, setting it off in the same way that a frame sets off a picture. The base can be stuck, screwed or nailed to the work, and the bottom can be covered with felt to protect surfaces.

Of vital importance in the display of sculpture outdoors is the 'contrast of line', the lines and outlines not only in the piece itself but also in the environment—the line of the horizon and of the trees and the lines created by buildings. There has to be sufficient space to display the work: two prominent sculptures close together, for example, may detract from one another, whether outdoors or in a gallery.

Atmospheric conditions must be noted as heat and damp, particularly, can have disastrous effects. Many materials, including wood, ferrous metals, chalk and plaster, must be sealed or the pieces will not last. Although soft stones are vulnerable to the elements, stone is usually preferred because of its relative resistance to the weather. However, water-proofing substances are available today for most materials.

Scale and setting In some sculptures the scale of the work, determined in the original conception, may have a vital bearing on the way in which it is displayed. Whereas it is sometimes possible to display sculptures in very different ways, according to whether they are presented in a gallery, private home or out of doors, the two examples shown below contain elements of scale and structure which make a particular type of setting crucial to the work. Anthony Caro's *XLIX* (**below right**) is one of a series of small sculptures which were specially designed to be placed on tables. In this way a range of scale was fixed from the outset and part of the wholly abstract conception was to emphasize the height of the display in relation to the ground and the table by allowing part of the work to extend over the edge, below the level of the table top. This precludes the possibility of showing the pieces on the ground, as his larger works are displayed, and fixes the relation of the work to its setting. Henry Moore's large scale works are often displayed in the open, in parks or civic settings. The massive scale of his *Arch* (**below**) and its reference to architectural structure make it stand out amongst tall trees and in large open spaces,

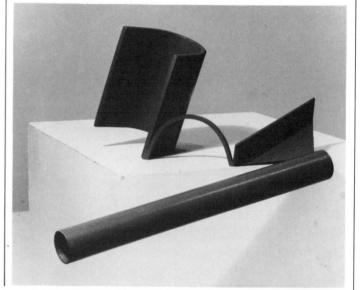

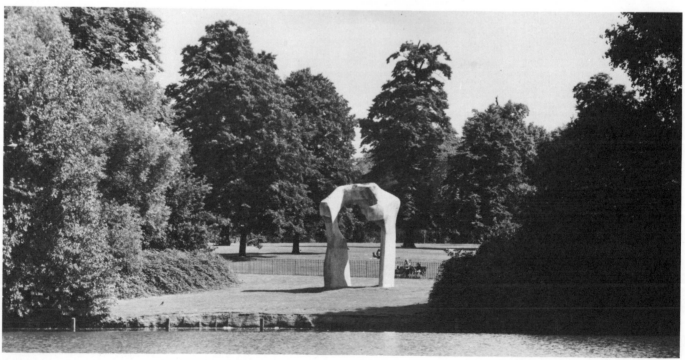

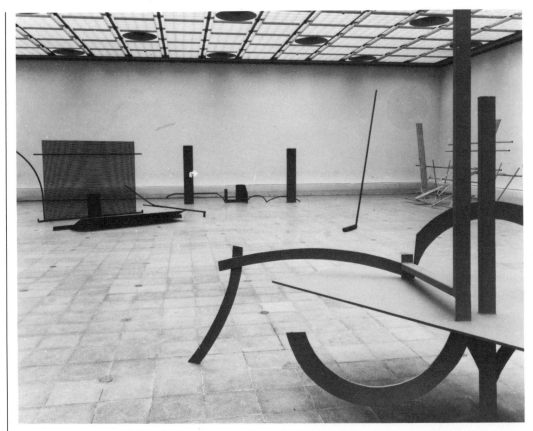

Displaying groups of sculptures

The long-standing relationship of sculpture and architecture has often meant that the sculpture had to be designed to fit into an already determined site, and that the base or pedestal on which it stood may have been part of the architectural structure, or specially made to suit the surroundings as well as the sculpture. Until quite recently, it was usual for a sculpture to have some kind of base even when displayed in a gallery or kept in a private collection. Caro's large sculptures have pioneered the idea of designing work to stand directly on the floor, without any extra element of presentation. The installation view of his 1969 exhibition at the Hayward Gallery, London (**left**) shows a number of his sculptures displayed as the artist intended. The sculptures in a Parisian shopping center by Julio Silva (**below**) have been placed on a base which echoes the design of the surrounding buildings, though less complex in form. This is nevertheless in keeping with the forms of the sculptures and the whole scene has abandoned the usual rigid aspects of architecture to form a series of fluid, curved shapes.

Index

Numbers in italics refer to illustrations.

Acknowledgements

pp 14, 15, 16, 22, 24, 28-9, 30-31 Clive Boden;
p 33 Jon Wyand;
pp 34-5, 36 Clive Boden; **p 37** Jon Wyand;
pp 39, 40-1 Clive Boden;
pp 44-5, 46-7, 48 Jon Wyand;
p 51 (left) Clive Boden; (right) Jon Wyand;
pp 52, 56 Jon Wyand;
pp 60, 61 (top) Clive Boden; **p 61** (bottom) Jon Wyand;
p 62 Clive Boden; **pp 63, 64** Jon Wyand;
p 65 Clive Boden; **p 66** Jon Wyand;
pp 70, 71 (top) Clive Boden; **p 71** (bottom) Jon Wyand;
pp 73, 74-5, 76-7 Clive Boden; **pp 81, 82-3, 84** Jon Wyand;
pp 87, 88-9 Clive Boden; **pp 90-1, 92** Jon Wyand;
pp 97, 98 (left) Clive Boden; **pp 98** (right), **99, 100, 103** (top) Jon Wyand;
p 103 (bottom) Clive Boden; **p 104** Jon Wyand;
pp 106-7, 113, 114-5, 118, 122 Clive Boden;
pp 123, 124 Jon Wyand;
pp 128-9, 130, 133, 134-5, 136 Jon Wyand;
p 137 Clive Boden; **p 138** Jon Wyand;
pp 140-1, 142, 144-5 Jon Wyand; **p 154** Alastair Campbell;
p 155 Clive Boden; **pp 168, 170, 189** Peter Cogram; **pp 190-1** material:
© Chrysler Corporation, photo: Clive Boden;
p 194 Jon Wyand; **p 195** Clive Boden;
p 196 (top right) Ian Howes; (bottom) Jon Wyand;
p 197 Clive Boden; **p 198** (top) TPR Slavin, (bottom) Jon Wyand;
pp 201, 202 (top) Jon Wyand; **p 202** (bottom) Clive Boden;
p 206 pictures 1,3 Chris Kopolka; pictures 2,4,5,6, Michael Freeman;
p 207 (top) Robert Unsworth; (bottom right) Ian Howes;
p 208 Ian Howes; **p 209** (left) Robert Unsworth; (rest) Ian Howes;
p210 Ian Howes; **p 213** Jon Wyand; **p 214** Clive Boden;
pp 216, 217 (top) Edward Kinsey; **p 217** (right) Peter Cogram;
(bottom) Jon Wyand; **pp 223, 226-7** Jon Wyand;
pp 234-5, 237, 238 Tate Gallery; **p 242** Clive Boden;
p 243 Peter Cogram; **p 244** Clive Boden;
pp 245, 246, 249, 250-1, 252-3, 254-5, 256 Peter Cogram;
pp 258-9, 260 Jon Wyand; **p 263** (top) Peter Cogram; (bottom) Clive
Boden; **p 264, 266** (left) Clive Boden;
pp 266-7, 268 Peter Cogram; **p 272** Clive Boden;
pp 273, 274-5, 276 Peter Cogram; **pp 278-9** Clive Boden;
p 280 Peter Cogram; **pp 283, 284** Jon Wyand;
p 287 Hayward Gallery (photo) Jon Wyand;
p 288 Peter Cogram;**p 291** (top) Andrew Logan; (bottom left) William Pye:
GLC (all photos) Jon Wyand;
p 292 Tate Gallery; **p 294** Clive Boden;
pp 296, 298-9, 300 Jon Wyand; **pp 302-3, 304,** Tate Gallery;
pp 306-7 Ian Breakwell; **p 308** (top left) Ulster Museum;
p 310 Henry Moore; **p 311** Jon Wyand;
p 312 Art's Council of Great Britain; (bottom) Henry Moore;
p 313 (top) Art's Council of Great Britain; (bottom) Alastair Campbell.